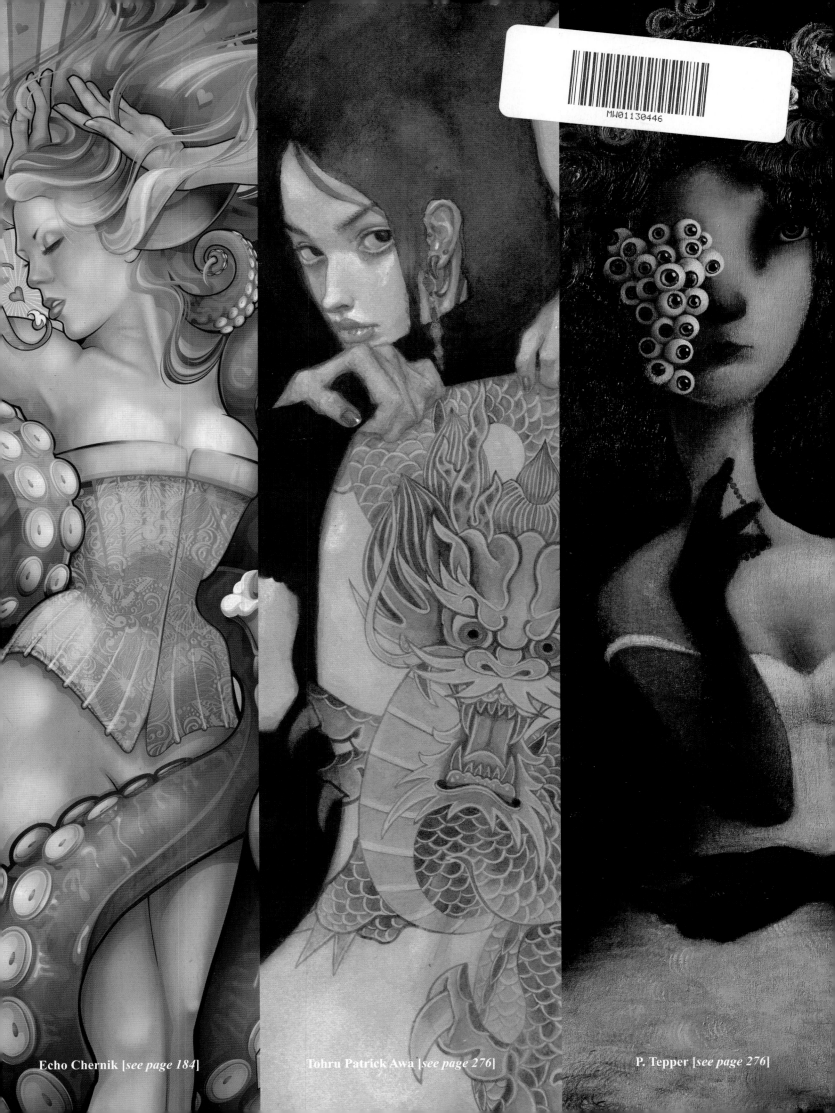

Echo Chernik [*see page 184*]

Tohru Patrick Awa [*see page 276*]

P. Tepper [*see page 276*]

S P E C
N I N E

The Best in Contemporary Fantastic Art

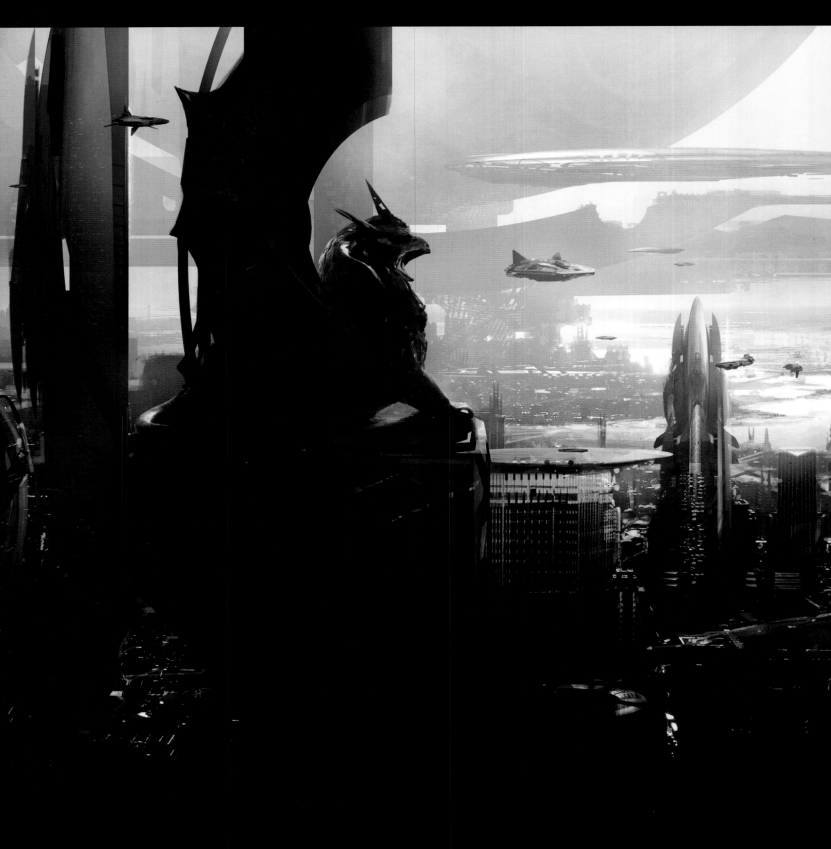

Stephan Martiniere [see page 66]

T R U M
T E E N

Edited by Cathy Fenner & Arnie Fenner

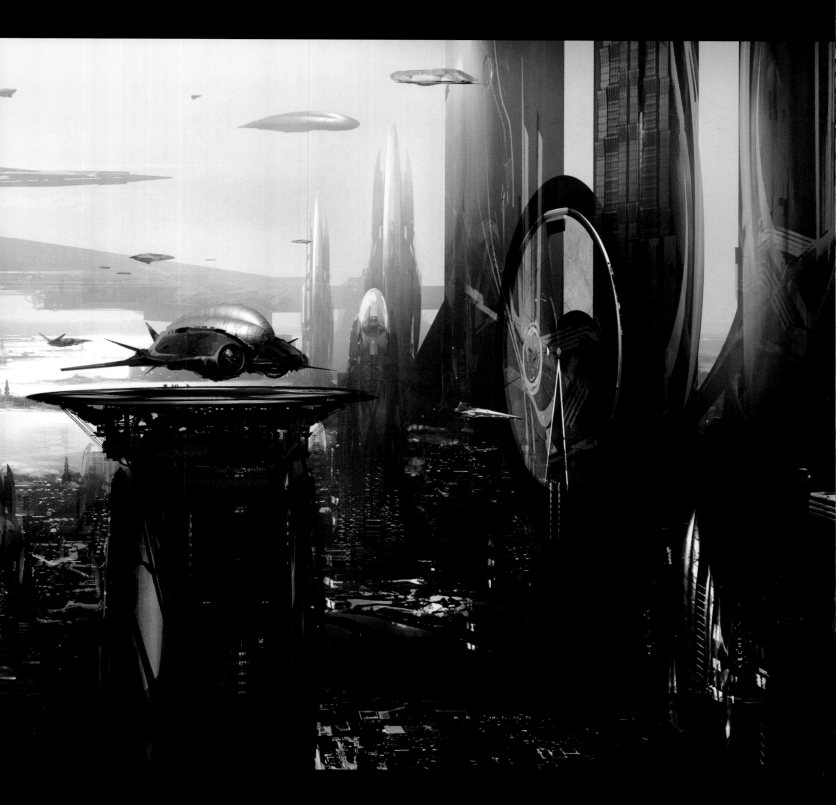

UNDERWOOD BOOKS
Fairfax, CA

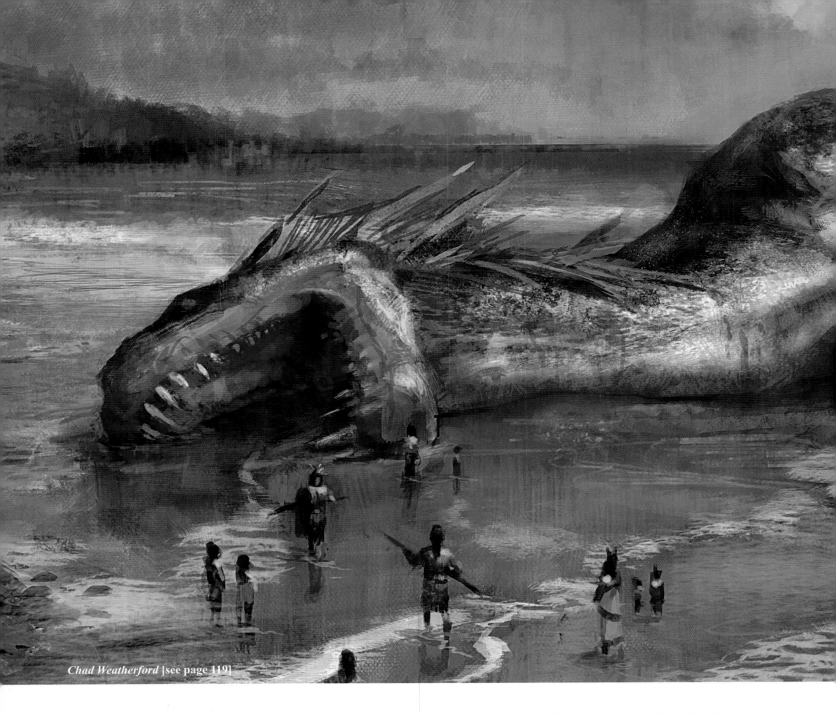

Chad Weatherford [see page 119]

Trade Softcover Edition ISBN 1-59929-063-4 ISBN-13: 978-1599290638
Hardcover Edition ISBN 1-59929-064-2 ISBN-13: 978-1599290645
10 9 8 7 6 5 4 3 2 1

Artists, art directors, and publishers interested in receiving entry information for the next *Spectrum* competition should send their name and address to:
Spectrum Fantastic Art, LLC, P.O. Box 4422, Overland Park, KS 66204
Or visit the official website for information & printable PDF entry forms: **www.spectrumfantasticart.com**
Call For Entries posters (which contain complete rules, list of fees, and forms for participation) are mailed out in October each year.

P U B L I S H E D B Y
UNDERWOOD BOOKS, P.O. Box 459, Fairfax, CA 94978 www.underwoodbooks.com **Tim Underwood**/Publisher

CONTENTS

THE SHOW

2011 *Chairman's Message by* Cathy Fenner

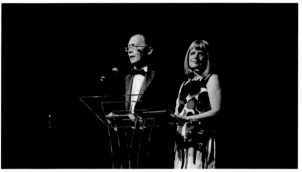

Above: *Arnie & Cathy Fenner at the Spectrum Awards Ceremony. Photo by JHS.*

What a year! You would think that our plates would be full enough already organizing the *Spectrum* competition and designing the book each year, but *no*: besides editing a book by Harlan Ellison (*Bugf#ck* indeed!), we decided to add putting together a *Spectrum* convention, too. (As our friend Mark Chiarello joked, "You guys never learn!")

Well, it wasn't *quite* like that. Spectrum Fantastic Art Live! is a natural extension of what we've tried to do with the books these past nineteen years: give the artists the respect and recognition they deserve. We had discussed some sort of event for years, even before the first *Spectrum* show at the Society of Illustrator's Museum of American Illustration in New York in 2005. But what? Where? How? Honestly, we had mulled it over for a long time without reaching any solution: it took Bob Self, publisher of Baby Tattoo Books and founder of the first intimate collector/artist confab, Baby Tattooville, to walk us to the end of the diving board and give us a gentle kick in the pants.

2011 was the year of assembling our team—Arlo Burnett, Jim Fallone, Bunny Muchmore, Lazarus Potter, Bob Self, and Shena Wolf—making plans, negotiating contracts with Kansas City for their convention center and with the hotels for rooms and with security companies for staff; for reaching out to artists, for reaching out to fans and collectors; for talking to PR firms and possible sponsors and decorators and caterers and performers and advertising venues, and talking, talking, talking.

As I write this intro, Spectrum Fantastic Art Live! is several weeks in the past and, as Arnie says elsewhere, a book about 2011's highlights is not the place to talk about something that happened in 2012. Nor is it the place to talk about 2013, even though we're already in the thick of planning SFAL2 and *Spectrum*'s 20th Anniversary as well as other...*things*. Some significant changes are in the works, all with the goal of growing the appreciation of the artists and our field and in keeping *Spectrum* fresh, vibrant, and relevant. We're excited about the future...but I'll have to wait to talk about all *that* until the *Spectrum* panel at, *ahem*, Spectrum Fantastic Art Live 2 (May 17-19, 2013)—and if we can persuade Sidebar Nation's Dwight Clark and Swain Hunt to come again and handle the discussion, all the better! (And *do* visit Sidebar's website for some amazing interviews: www.sidebarnation.com)

What I *can* chat about is how the volume you're holding came about. The *Spectrum* jury met on Friday, March 9 in Kansas City—we were again pushed out of our customary Oscar® weekend judging by other events at the Sheraton (formerly Hyatt) Hotel. The judges all arrived without incident and we hosted a Friday night meet & greet dinner at Milano's Italian Restaurant; the jury was a mixture of old friends and new and once again it became clear that we had fortunately put together another winning panel. After all, we may be the editors, but it's the jury that calls the shots! On Saturday morning the judges gathered for an early breakfast before leaping into piles of art at 8:30 AM sharp. We used the same extremely large ballroom as last year (fortunately set up properly); a break for lunch and then they were back at it until the awards discussions ended around 6:00 PM. Since we planned to give the Gold and Silver Awards out at the ceremony during SFAL [see page 15], we didn't announce the winners, but posted a video showing the top five contenders in each category on the *Spectrum* website following the final votes. Suspense! (And *no*, we didn't inform the winners prior to the awards ceremony at the Midland: they were as surprised as the audience when their names were read.) Everyone met in the hotel lobby for the short walk to Pierpont's in Union Station for our traditional dinner in a private dining room to celebrate the conclusion of the judging.

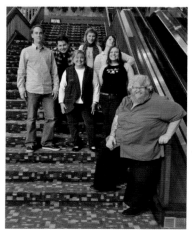

We were again assisted by a group of great friends who selflessly gave up their Saturday to help keep the judging moving along in a smooth and organized manner. Our thanks to Arlo Burnett, Lazarus Potter, Tracy Crawford, John Fleskes, Allison Muller, Gillian Titus, Bunny Muchmore, and Angela Wheeler for making our job much more manageable. You can bet that we'll need them again in 2013!

Correction: *Crap.* In *Spectrum* 18 we miscredited **Chris Rahn**'s art ("Dungeon #187", page 33, seen at right) to Lucas Graciano. Chris' signature is even on the work! *Yesh!* Our apologies to both Chris *and* Lucas for the error. www.rahnart.com • www.lucasgraciano.com

At left: *John Fleskes, Arlo Burnett, Bunny Muchmore, Tracy Crawford, Allison Muller, Angela Wheeler, and Lazarus Potter.*

Brun Werneck [see page 193]

Jeremy Cranford

As the Senior Art Manager of Blizzard Entertainment, Jeremy utilizes his history in and knowledge of the gaming industry to guide the studio artists in the creation of riveting graphics for *World of Warcraft*, *Starcraft*, and *Diablo*.

Peter de Sève

Whether painting covers for the *New Yorker* or designing characters for such films as *Tarzan, Robots, Mulan, Finding Nemo*, and the *Ice Age* series Peter de Sève is indisputably one of the most prolific, brightest, and influential artists working today. One of the funniest, too.

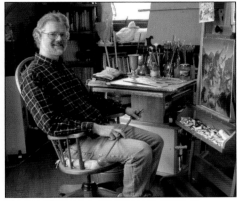

Scott Gustafson/Jury Chairman

In a career spanning 25 years, Scott has created art for *Playboy*, The Bradford Exchange, and DreamWorks, but it is his luminous series of fairy tale paintings and children's books for the Greenwich Workshop and other publishers that have gained him an international following.

Jon Schindehette

Jon Schindehette is the the Senior Creative Director for *Dungeons & Dragons* and has the opportunity to not only work with some of the field's major talents, but also to help develop the skills (and outlooks) of young artists just embarking on their careers. Many of tomorrow's stars are getting their starts with Jon's guidance.

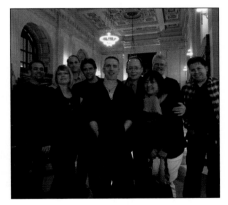

Dawn Rivera-Ernster

As the Director of Walt Disney Animation Talent Development & Recruitment, Dawn nurtures creativity and matches artists with appropriate projects. Her film credits include *Chicken Little, Meet the Robinsons, Tangled,* and *Winnie the Pooh.* Dawn majored in Advertising and Design from the American Academy of Art, Chicago, Illinois; she continues her studies in Art and Anthropology and is a member of ASIFA, AIGA, The Society of Children's Books and Writers, and Women in Animation.

Grand Master Award

James Gurney

Born June 14, 1958

Musician James Brown was once dubbed "the Hardest Working Man in Show Business." Watching him perform or listening to him in interviews, it was easy to see why: intense, focused, and always giving 100% to everything he was involved with—and thoroughly enjoying himself while he was doing it—all combined to prove the description accurate.

So in thinking about this year's Grand Master recipient, it might be apt to dub James Gurney as "the Hardest Working Man in the Art Business." Jim might demure— partly out of modestly, but mostly because he has such a good time doing what he does—but it's an accurate description nevertheless. He paints, he draws, he writes, he lectures, he blogs, he sketches, he advises; he travels and teaches, he shares and enlightens and entertains. James Gurney lives the life of an artist, with one foot planted in the classics and the other in contemporary art scene. Respected by peers and lionized by students, Jim is a favorite of academics and fans alike.

It's easy to see why. His art not only displays amazing craft, but also exhibits both intellect and—far more difficult to achieve— *sincerity.* Looking at Jim's work, audiences immediately recognize not only the skill that has gone into its creation, but in the *thought* as well. Whether he's painting historical tableaus or SF vistas or creatures of the Cretaceous or people on the street, James Gurney's approach to each is with the same intensity, the same devotion, the same care. His passion is vividly on display in each canvas.

Of course, Jim is best known for his illustrated books about *Dinotopia* (which was turned into a mini-and-regular-series for ABC)—but as popular as the four books that he wrote and illustrated are and the spin-off novels by Alan Dean Foster, Peter David, and others have turned out to be, it's only a small part of the Gurney resumé. Perhaps the must succinct description of what James Gurney actually *does* for a living is this:

Jim Gurney specializes in painting realistic images of scenes that can't be photographed, from dinosaurs to ancient civilizations.

He is also a dedicated plein air (outdoor) painter and drawer, firmly believing that making studies directly from observation super-charges his imagination. Visits to his blog rewards readers with everything from watercolor studies of the exterior of a movie theater to studies of a tattooed train passenger in New York to a video travelogue. The constant about James Gurney is his innate curiosity and infectious *delight* in the world around him.

Born in California in 1958, the son of a mechanical engineer, Jim taught himself to draw by reading books about Norman Rockwell and Howard Pyle. He studied archaeology at the University of California at Berkeley and received a BA in Anthropology with Phi Beta Kappa honors in 1979. Prompted by a cross-country adventure on freight trains with a college compadre, the late Thomas Kinkade, he coauthored *The Artist's Guide to Sketching* in 1982. During the same period, he worked as a background painter for the Frank Frazetta/Ralph Bakshi animated film *Fire and Ice.*

Jim's illustration career began shortly after with paperback book covers, where he developed his characteristic realistic renderings of fantastic scenes, often using posed models and handmade maquettes for reference; he painted more than 70 covers for science fiction and fantasy paperback novels and magazines as well as working on dozens of assignments for *National Geographic* magazine, for whom he painted reconstructions of Moche, Kushite, and Etruscan civilizations. The inspiration that came from researching these scenes of ancient life led to a series of lost world paintings, including "Dinosaur Parade" and "Waterfall City" (both of which appeared in *Spectrum* Volume 1 nineteen years ago). With the encouragement of renowned publishers Ian and Betty Ballantine, Jim committed two years' time to writing and illustrating *Dinotopia: A Land Apart from Time,* which was published in 1992 and which became a *New York Times* bestseller.

It's only gotten better from there.

Solo exhibitions of his artwork have been presented at The Smithsonian Institution, The Norman Rockwell Museum, The Norton Museum of Art, The Delaware Art Museum, and *many* other venues. His most recent bestselling book, *Color and Light: A Guide for the Realist Painter,* is based on his wildly popular daily blog, Gurney Journey (http://gurneyjourney.blogspot.com).

Amateur "experts" have recently tried to explain Jim's work to the public by comparing his art to that of Lawrence Alma-Tadema or the Orientalist movement of the nineteenth century, but that is little more than clumsy justification of an artist's work where none is needed.

James Gurney's paintings are comparable *only* to the works of...*James Gurney.* Which is as it should be for any creator with an original voice, as it should be for anyone who achieves the distinction of Grand Master. Jim has earned the honor. Obviously.

G r a n d M a s t e r H o n o r e e s

Frank Frazetta Don Ivan Punchatz Leo & Diane Dillon James E. Bama John Berkey Alan Lee Jean Giraud Kinuko Y. Craft Michael Wm Kaluta

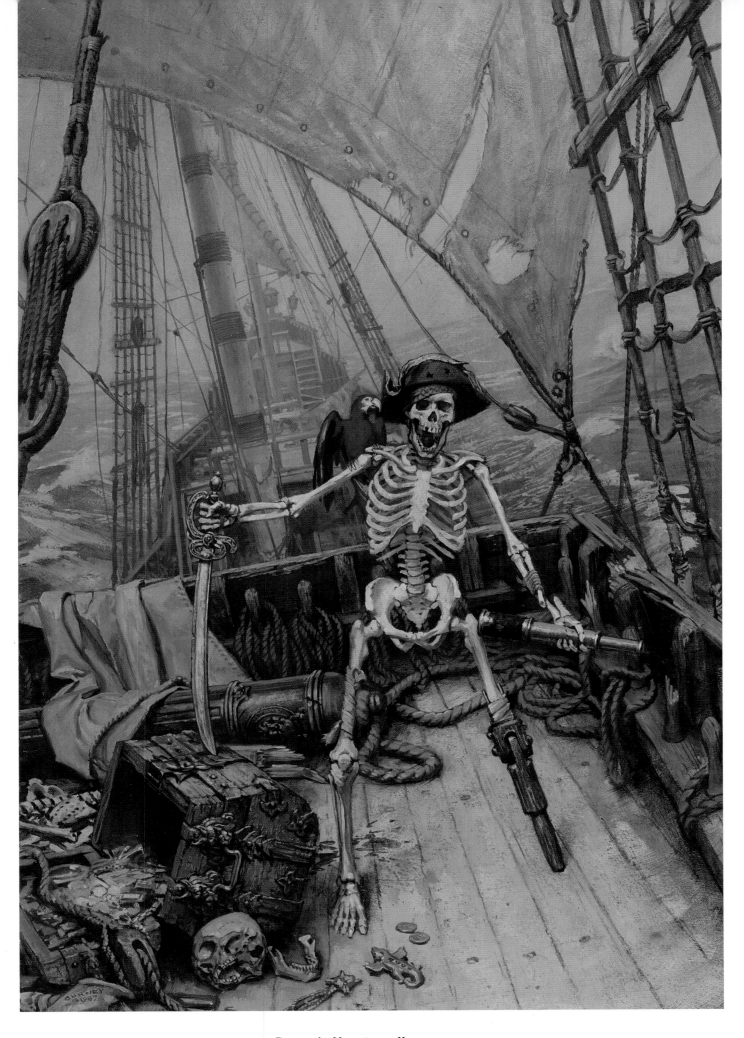

Grand Master Honorees

Michael Whelan H.R. Giger Jeffrey Jones Syd Mead John Jude Palencar Richard V. Corben Al Williamson Ralph McQuarrie James Gurney

2011, Briefly Noted

by Arnie Fenner

Talent gravitates to places where it can have an impact. Newspaper comic strips are still the high end of cartooning with a daily audience in the tens of millions, but the mass-media model seems to be disintegrating before our eyes. The sudden climate change may offer great opportunities ahead for the scrappy little mammals that used to cower in the underbrush, but it's probably bad news for those of us who liked thundering around with our heads above the treetops.

 —*Calvin and Hobbes* creator Bill Watterson on today's industry as compared to the one he retired from in the '90s

As far as that mask is concerned, well, I'm happy it's being used as a multi-purpose banner of protest. It's like [Alberto Korda's] Che Guevara image on T-shirts and such that was used so often in the past as a symbol of revolutionary spirit—the difference being that while Che represented a specific political movement, the mask of V does not: it's neutral. It just represents opposition to any perceived tyranny, which is why it fits easily into being Everyman's tool of protest against oppression.

 —David Lloyd, *V for Vendetta* co-creator, on the Guy Fawkes mask adopted by Occupy and Anonymous groups

"If this is going to be a Christian nation that doesn't help the poor, either we have to pretend that Jesus was just as selfish as we are, or we've got to acknowledge that He commanded us to love the poor and serve the needy without condition and then admit that we just don't want to do it."

 —Stephen Colbert

"Oh wow. Oh wow. Oh wow."

 —The final words of Apple Computer co-founder Steve Jobs, who died on October 5, 2011

Ever so slightly paraphrasing the late Charles Schulz's Snoopy (who in turn was parodying Victorian novelist Edward Bulwer-Lytton's infamous opening to his 1830 novel *Paul Clifford*), "It was a dark and stormy year. Suddenly, a shot rang out! A door slammed. The maid screamed. Suddenly, a pirate ship appeared on the horizon! While millions of people were starving, the king lived in luxury. Meanwhile, on a small farm in Kansas, a boy was growing up."

In other words, 2011 was another incredibly full twelve months with much that was good, much that wasn't, and much that we honestly won't know which it was for sometime to come (if we ever really will).

So let's just jump into some of the things that happened and leave it to future generations to figure out the significance, shall we?

The ten-year war in Iraq (*ten years*: criminitly!) finally drew to a close with the official withdrawal of combat troops (though the Pentagon acknowledged keeping several thousand contractors in the country for security). Sectarian violence increased following the U.S. exit, but that drew less and less press coverage as the weeks passed. In the meantime the war in Afghanistan heated up with a surge of ground forces, increased drone strikes and an infusion of money. But NATO began to learn what the Russians came to realize in the 1980s (and the Brits found out a hundred years earlier and the Indians learned prior to that): regardless of corruption or brutality or poverty or illiteracy, the Afghanis are incredibly tenacious in their desire to maintain their autonomy. And, God, they're *patient*. It's almost a certainty that, no matter the strategy, Afghanistan (as a potential refuge for the Taliban and al-Qaeda or whatever passes for them) will continue to be a troubling itch that

Above: *Actress Diana Terranova visited our booth during the San Diego Comic-Con, which prompted something of a fanboy traffic jam.* **Opposite:** *A previously unpublished painting by late Grand Master Jeffery Jones.*

will probably need to be scratched long after the projected U.S. troop drawdown in the next few years.

Whatever unfolds in the future, Osama bin Laden (the architect of the 9/11 terrorist attacks which wound up causing the entire world a whole lot of grief) won't be around to see it. Tracked for a decade by the CIA, a Seal Team finally caught up with al-Qaeda's titular head in Pakistan and killed him. It didn't particularly help relations with Pakistan, but it *did* provide a certain sense of justice.

Aided by Twitter and Facebook, the so-called Arab Spring toppled the governments of Tunisia, Egypt, and eventually (thanks to U.S./NATO airstrikes) Libya. Revolutions, even those that are relatively peaceful, never wind up being quite as neat or tidy once the dust settles and the citizens of the affected countries spent the rest of 2011 trying to figure out what to do next. Protestors in Bahrain, Yemen, and Syria weren't as successful and things got messy as entrenched powers used their militaries to fight back.

The West wasn't immune to violence either: a self-styled anti-Islamist-immigrant right-wing extremist set off a car bomb in Oslo, Norway, killing 8, before donning a fake police uniform, gaining access to an island summer camp for children, and murdering 69 and wounding 110. Of course, I don't believe any of the people the arrested perpetrator—Anders Behring Breivik—killed were Muslim immigrants.

Fueled by unemployment, a lingering (if not deepening) recession, and a class system with scant social mobility, riots ravaged cities in Britain (including London) for nearly a week in August, while Greece's citizens expressed their anger with their government's austerity programs by battling with authorities in Athens. Though the Occupy Movement (protesting the

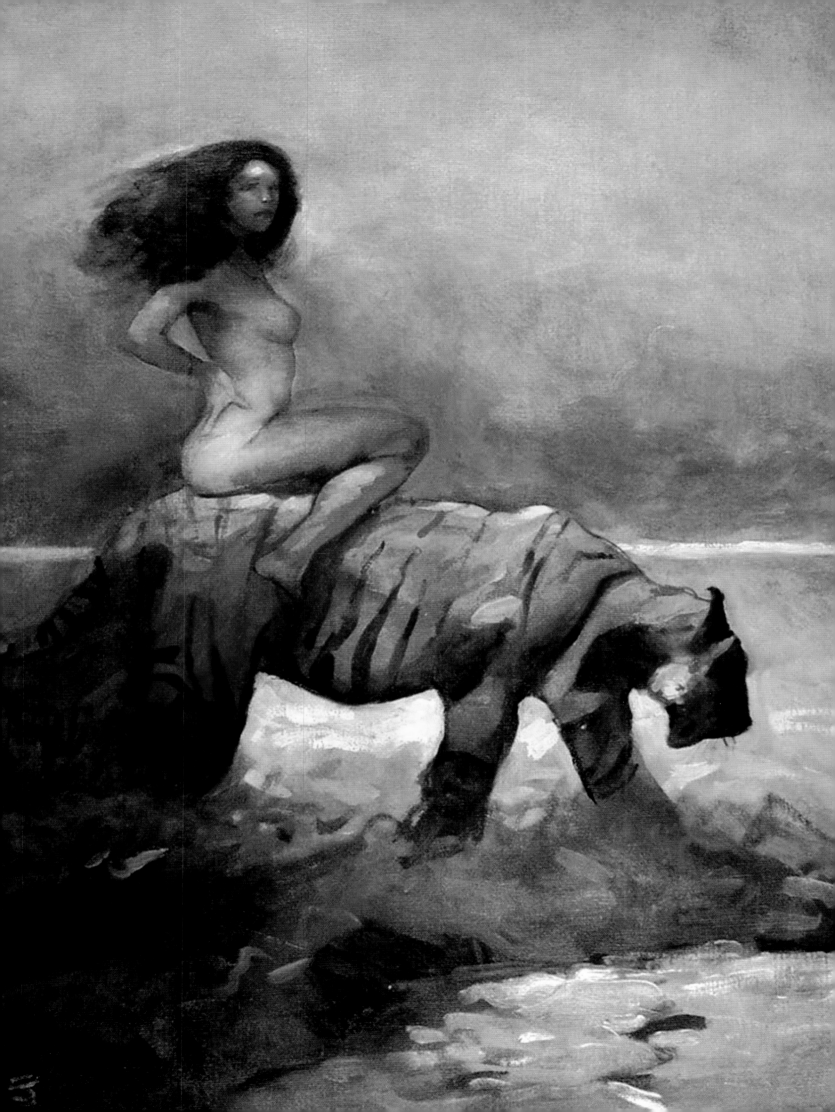

widening disparity between the rich and everyone else) in the States were largely peaceful, there were occasional clashes with the police, with those in New York and Oakland grabbing the most headlines. Unfortunately for the "Occupy Movement," it lacked both a spokesperson and a specific message (other than "No fair!").

The economic recovery from the recession in the U.S. was much slower than anyone hoped or analysts expected. Though corporate profits were at an all time high, worries that there was more trouble ahead limited hiring and left the official domestic unemployment rate above 8%. When combined with concerns over the debt crisis in Europe the economic outlook remained troubling—and perfect fodder for politicians stumping for office, all of whom took absolute delight in refusing to cooperate with each other.

And then there was all this talk of "fracking": I thought some overenthusiastic *Battlestar Gallactica* fans had taken over the media before learning that it referred to a controversial method of extracting natural gas from dense rock that resulted in contaminated ground water. Frack.

A massive undersea earthquake triggered a deadly tsunami that hammered Japan, causing a nuclear crisis as the reactors at the Fukushima power plant were damaged and released radioactive matter into the atmosphere and ocean. The long-term ecological impact won't be determined until years in the future. Closer to home (much closer!), an F-5 tornado slammed into Joplin, Missouri, devastating the city and killing 162. Hurricane Irene hit the east coast, Tropical Storm Lee and hurricane Katia caused extensive flooding from Louisiana to New York, and wildfires (compounded by extensive drought) raised havoc in Texas. Let's just say that Mother Nature hasn't been very nice lately.

Oh...and the final space shuttle mission (the *Atlantis*, commanded by Chris Ferguson) took place in 2011. Until something new comes along the Russians will play taxi driver for Americans flying to the space station at a cost of $63 million per mission: the government hasn't been doing a whole lot of forward thinking about the space program, preferring to shift the burden to the private sector for solutions.

So fold in all of the tensions about North Korea (though the death of leader Kim Jong-il in December briefly led to hopes of some sort of diplomatic relationship since the funeral procession in Pyongyang consisted entirely of Cadillacs), Iran, Pakistan, China, Russia, Greece, Italy, Syria...oh crud, practically everyone...with all of the domestic drama and that left us all with the impression that there has to be something better than 2011. Right? *Right?* Please say there is!

But wait. Hold on. Take a deep breath. Yes, yes, of course there were some neat things—many good things—that happened last year. Yes, indeed. Whew. Panic attack averted (as long as I can actually think of the good stuff, that is).

On the science front, breakthroughs in AIDS therapy using stem cells raised hopes that a vaccine which increased the immune system's resistance to HIV was achievable in the near future. Engineers made significant progress in

Above: *A clever painting by Michael Koelsch to advertise the SciFi (aka SyFy) network.*

the creation of silicene, a cousin to and proposed successor of silicone, that will allow for even thinner mobile devices that process information 100 times faster than current chips. Astronomers reported that water appears to still be present on Mars, not just in the form of ice at the poles but as flowing streams during the planet's spring and summer months. Lytro, a Silicon Valley start-up, unveiled a no-focus camera that allows you to shoot a photo first and, utilizing 11 million light data points, focus even the fuzziest shot to clarity after the fact. And—shades of Hal 9000—Watson the supercomputer won the battle of Man Vs. Machine, at least when it came to a game of *Jeopardy.* Former human champions Ken Jennings and Brad Rutter probably should have been made to sing "Daisy" as Watson shut them down.

Artistically speaking, X-rays confirmed Rembrandt's authorship of "Old man with a Beard" in November while restoration work on "Salvador Mundi" corrected the previous belief that it was created by a protege and properly credited Leonardo Da Vinci as the painter (making the art now worth north of $200 million). Currently the search is on for a Da Vinci that is suspected to be hidden behind Giorgio Vasari's mural "The Battle of Marciano" in Florence, but some art experts have started a petition drive to halt the hunt until Vasari's art can be properly preserved.

Non-traditional (from a conventional standpoint anyway) museum shows were hugely popular in 2011. Director Tim Burton's fantasy/horror works were a hit at the Los Angeles County Museum of Art, making it into one of the institution's top

five exhibits ever; the crowds for the exhibit of Alexander McQueen's couturier designs, "Savage Beauty," at the Metropolitan Museum of Art were so large that the show and its hours were extended three times to accommodate the demand (the final attendance numbers placed it as the eighth most popular show ever, beating Van Gogh and Jeff Koons); and "street art" got some official recognition at MoCA's extremely popular "Art in the Streets" show that brought in the highest attendance in the museum's history.

In October, South African explorers discovered an artist's workshop, containing evidence of the tools and methods used by prehistoric craftsmen to create paint. The studio was estimated to be 100,000 years old (and not nearly as cluttered as mine).

Another slight different artist-centric first also took place in October: artist Chuck Close and the estates of Robert Graham and Sam Francis filed lawsuits against the Sotheby's and Christies auction houses, claiming a right to 5% profits from the resale of works previously they'd previously sold to collectors. The suit asserts the auctions violated California's 1977 Resale Royalty Act, which was inspired by the European "Droit de suit" laws enacted to protect artists after they "lose" (i.e. sell) ownership of their work. Several months later a bill proposed to Congress in December requires large auction houses to pay 7% on sales over $10,000, with half the proceeds going into an art acquisition fund for nonprofit museums. The Equity for Visual Artists Act of 2011 supposedly would help visual (i.e. "fine") artists gain a more equal footing with illustrators who can benefit from additional income thanks to the copyright laws (of course, the same copyright laws apply equally to gallery art/artists so I'm not quite sure where the distinction is).

Speaking of auctions, Gustav Klimt's "Litzlberg am Attersee," a 1915 landscape that was stolen by the Nazis from its Jewish owner and was only recently returned to the woman's grandson, sold at Sotheby's for $40.4 million. Much closer to our profession, an original page from *Batman: The Dark Knight Returns* #3 by Frank Miller and Klaus Janson became the single most valuable piece of American comic art to ever sell when it fetched $448,125 as part of Heritage Auctions' Vintage Comics and Comic Art Auction on May 5. Heritage also continued to bring in significant sales figures for paintings by Gil Elvgren, Dean Cornwell, and other works from the late Charles G. Marignette Jr collection. But if you want to talk *serious* bucks for a comic drawing, the crown goes to the Hergé cover for *Tintin in America,* which fetched a neat $1.6 million at auction in June, 2011.

The kinks finally got ironed out of the *Spider-Man* Broadway musical and started to turn a profit. On the small screen AMC's zombiepalooza *The Walking Dead* continued to grow in popularity and audience share while HBO's first season adapting *A Game of Thrones* not only drew rave reviews and

solid ratings, but helped keep George R. R. Martin on top of the best-seller lists—as well as prompted critics to describe him as the contemporary Tolkien.

Once again fantastic-themed films once again owned the 2011 box office: *Harry Potter and the Deathly Hallows Part 2, Transformers: Dark of the Moon, Pirates of the Caribbean: On Stranger Tides, The Twilight Saga: Breaking Dawn Part 1*, and *Kung Fu Panda 2* were the biggest hits. The animated *Adventures of Tintin* from Steven Speilberg and Peter Jackson, though generating $374 million in world receipts, was generally considered a disappointment while the highly anticipated and visually arresting *Sucker Punch* (directed by Zack Snyder) and *Conan the Barbarian* (directed by Marcus Nispel) failed to find their audience. Which I guess is further proof that when it comes to the entertainment industry it's all a roll of the dice (and a little praying).

Okay, jumping head-first into the Categories (as best I can): **ADVERTISING** continued to be something of a mixed bag, as print-ad revenues remained in the doldrums, posting a decline of just over 8%, while digital promotions (either through traditional web purchases or, increasingly, via access by smart devices and social media) rose to a record $25.8 billion in creation-and-placement expenditures. Google and Facebook were the most popular avenues for marketers, accounting for more than 53% of the advertising dollars spent.

Where all this is going is anyone's guess. The classic quote (widely attributed to either Mark Twain or British Prime Minister Benjamin Disraeli, depending on the source) of "There are three kinds of lies: lies, damned lies, and statistics" would seem to apply perfectly to the ad biz: all of the graphs, figures, analysis, projections and calculations don't amount to squat if consumers don't buy what you're selling. Just like the entertainment industry (as mentioned above), despite the best efforts and the amount of money spent there are simply no guarantees when it comes to a return on investments. No one has yet provided any hard evidence that Internet or social media advertising generates one cent more in profits than ads in the print media. (Television...well, TV still delivers the largest number of eyes and the biggest bang for the buck, but even then there are significant challenges as Tivo—and even more advanced technologies—allow viewers to skip commercials entirely).

Still, there's no shortage of newspapers, magazines, and billboards in the world and print advertising—and the art generated for same—isn't going away: Don Draper would still be employed (though he'd have to take his cigarette breaks outside). And fantastic imagery continues to be a popular way to sell...stuff...regardless of whether that "stuff" is Absolut Orient Apple Vodka or rock bands or theatrical productions. I spotted some memorable ad illos by Yuko Shimizu, Greg Manchess, Dan Augustine, Denise Gallagher, and (naturally) *all* of the creatives you'll find in the pages ahead.

Oh. And my favorite TV spot in '11? "The Force" for Volkswagon Passat, which featured a pint-sized Darth Vader who finally masters The Force.

Well, how about the **BOOK** industry? I guess it could best be described as "still in transition." Transition to *what* exactly? Honestly, I don't know. The disappearance of the Borders chain (the rat bastards) translated into a lot less shelves of books for sale in 2011: the failure or Borders didn't drive customers to Barnes & Noble or Books A-Million or independent sellers, who really couldn't pick up the slack in the marketplace, but rather further benefited on-line giant Amazon, who were still able to offer the variety of titles that weren't available elsewhere. Still, total book sales fell 2.5% in '11 to $27.2 billion, though, conversely, unit sales actually rose something like 3.4%, the discrepancy due to higher sales of lower-priced e-books.

The increase in the popularity of e-titles was probably the big story in publishing last year. For trade titles sales of e-books rose to $2.07 billion as total units increased 210% to 388 million. E-books (whether for the Kindle, Nook, or iPad) accounted for 15% of all trade sales in 2011, up from 6% in 2010. But electronic publishing was also the reason for an investigation by the Justice Department leveled at Apple and various publishers over allegations of price-fixing: that probe would

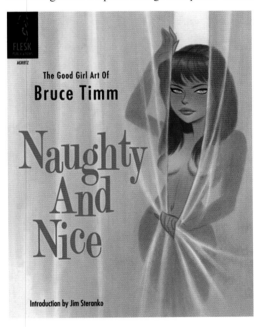

Above: *The Bruce Timm book from Flesk is one (of many) that is so damn good that I wish that I'd published it.*

be played out more thoroughly in 2012, but since we're talking about 2011, I'll leave that for next year's review.

Anyway, the impact of e-books on the future of publishing is evidenced by the 35% growth reported by online retailers in 2011: reportedly electronic downloads for this-reader-or-that via the Internet grossed more than $5 billion last year. Whereas sales through all traditional brick-and-mortar stores fell a significant 12.6% last year to $8.59 billion. Purchases by institutional accounts—libraries, business, schools, etc.—represented 20% of sales, or something akin to $5.39 billion. Blame

the sluggish economy or blame a cultural shift (partially sparked by the irresistible sexiness of technology) or blame a generational mind-set that not only makes reading for entertainment passé and un-cool but goes a step further and equates books with elitism and class division—blame whatever seems right, but the simple truth is that changes are a-brewing. For publishers, retailers, creators, and society as a whole. We are already seeing the impact on the artists as rates remain flat (or drop), stock houses replace freelanced original work, and e-rights (or *all* rights) are routinely demanded without the offer of additional compensation. What the future might bring...is e-worrisome.

On a more personal note, our close friend and Spectrum Advisory Board Member Bud Plant announced last year that he planned to sell his legendary mail order business and focus on his and partner Anne Hutchison's smaller antiquarian book business. To say that Bud is one of the pioneers of the direct market and an influential proponent of fantastic art in all its guises is a gross understatement: he literally helped to shape our field. He introduced us to many of the European artists with imported titles, helped create the Direct Market with the late Phil Seuling, published fanzines and comics, and supported many small press publishers. So it's understandable that the news left me more than a little sad and feeling that an era was passing—because it was! Happily for us (said for purely selfish reasons), Bud didn't find a buyer that he felt was a perfect match and decided to pare down his operation but keep it up and running. *Whew*, folks: we dodged a bullet there!

Let's put the melancholy meandering back in the box for the nonce and talk about some of my favorite books of 2011. That part's easy. For single artist collections some of the titles I gladly added to my bookshelf included *Man of a Thousand Faces: The Art of Bill Nelson* (an exceptional and *highly* recommended book) [Creatures Features], *Rebus* by James Jean [Chronicle], *Overkill* by Tomer Hanuka [Gingko Press], *Yuko Shimizu* [Gestalten], *Blue Collar/White Collar* by Sterling Hundley [AdHouse Books], *Jeffrey Jones: A Life in Art* [IDW] (admittedly, the repro is not good, but *something* is better than a goose egg), the absolutely terrific *Velocity* by Stephan Martiniere [Design Studio Press], *Dave Stevens: The Complete Sketchbook Collection* [IDW], *Al Williamson Archives Volume Two* [Flesk], *Mark Schultz: Various Drawings Volume Five* [also from Flesk], *Genius, Isolated: The Life and Art of Alex Toth* by Dean Mullaney and Bruce Canwell, *Taxidermied: The Art of Roman Dirge* [Titan], *Stay Tuned: 30 Postcards* by Nathan Fox [Chronicle], *Hardware: The Definitive SF Works of Chris Foss* [Titan], *Robert Fawcett: The Illustrator's Illustrator* edited by Manuel Auad [Auad], *Ed 'Big Daddy' Roth: His Life, Times and Art* [Car Tech], *Shigenori Soejima Artworks* edited by Atlus [Udon Entertainment], *Saul Bass: A Life in Film and Design* by Jennifer Bass & Pat Kirkham [Lawrence King Publishers] and, *just* squeaking in

before the end of the year, one of my very favorite books of 2011, *Naughty and Nice: The Good Girl Art of Bruce Timm* [Flesk].

Some of the "anthology" art books I noted last year included Vampires: *The World Of Shadows Illustrated* [Heavy Metal], *Fantasy +3: Best Hand-Painted Illustrations* edited by Vincent Zhao 9 Gingko Press], *Exotique 6* and *Exposé 9*, both edited by Daniel Wade [Ballistic], *Masters of Science Fiction and Fantasy Art* edited by Karen Haber [Rockport], *Flesk Prime* edited by John Fleskes [Flesk], Steampunk: The Art of Victorian Futurism by Jay Strongman [Korero Books], *The Comics: The Complete Collection* by Brian Walker [Abrams], *Illustrators Unlimited: The Essence of Contemporary Illustration* by R. Klanten & H. Hellige [Gestalten], *Masters of American Illustration: 41 Illustrators and How They Worked* by Fred Taraba [The Illustrated Press, Inc.], *The Art of Sketch Theatre Volume 1* [Baby Tattoo Books], *Trickster* [Global/Trickster], and, of course, the must-have annual, *Illustrators 52* [Harper Design].

There had to be more illustrated books than these in '11, but to be honest the only ones that truly remained fresh in my memory were *The Sword Woman & Other Historical Adventures* by Robert E. Howard, illustrated by John Watkiss [Del Rey], *Eddie: The Lost Youth of Edgar Allan Poe* [Simon & Schuster], written and illustrated by the brilliant Scott Gustafson, *Grandpa Green* by Lane Smith, and *The Man in the Moon (Guardians of Childhood)* by the one-and-only William Joyce [Atheneum].

When it came to stand-out book covers last year (beyond what the jury selected for inclusion in the Books Category, of course), a few that caught my attention included those by Jon Foster (*Ganymede* by Cherie Priest [Tor]), Dan Dos Santos (*Alien in the Family* by Gini Koch [DAW]), Jeremy Geddes (*Eclipse Four* edited by Jonathan Strahen [Night Shade Books]), Jason Chan (*Spectyr* by Philippa Ballantine [Ace]), and Jon Sullivan (*The Curious Case of the Clockwork Man* by Mark Hodder [Pyr] among many, *many* others.

Okay, the clock keeps ticking so let's move right along to **COMICS**. The biggest stories? Hmmm. Pretty much the same as last year. Marvel fought the Jack Kirby Estate, DC battled the Joe Siegel Heirs, publishers and distributors and shop owners scratched their heads over digital comics, and Alan Moore remained angry about pretty much everything that had happened 30 years in the past.

Tokyopop rather dramatically folded its tent in May and closed its American operations, leaving many series unfinished and some licenses in limbo; questions about royalties-owed as well as rights ownership caused a lot of drama for awhile but were eventually resolved with a reversion to the respective copyright owners. Also putting up an "out of business" sign was The Comics Code Authority, a largely powerless organization for the past 30 years (at least) which might best be remembered as a shameful symbol of First Amendment abandonment and cowardly subservience to the Joseph McCathy/

Estes Kefauver era. DC Comics decided to use their own ratings, and the remaining member of the Comics Magazine Association of America, Archie Comics, stated that they, too, had decided to drop it years ago. And the once-dominent (if often derided) *Wizard* (focused on comics news and prices) and *Toyfare* (which covered statues and action figures) magazines went belly-up; the announced on-line incarnations failing to reach fruition, which didn't surprise observers.

DC sort of overturned the applecart with their audacious *The New 52* program: *all* of the existing titles (with the exception of the Vertigo line, which is sort of an entity unto itself) were cancelled and 52 new series debuted in September 2011 with #1

Above: One of a batch of exemplary covers created in 2011 by Raymond Swanland for Dark Horse Comics.

issues. *Batman, Superman, Justice League*: all new. And...it worked! Sales were great, fans and critics were (for the most part) happy, and when the year ended DC sat comfortably on top of the sales charts with promises of more changes in 2012.

One of my "favorites" from 2011 was *Cover Story: The DC Comics Art of Brian Bolland*, a properly hefty hardcover compilation of exceptional covers including Bolland's influential runs on Wonder Woman and Animal Man. DC/ Vertigo also published knock out work by Rebecca Guay (particularly *A Flight of Angels*), Jock, Adam Hughes, João Ruas (the *Fables* covers could not be better), Tony Daniel, John Lee Bermejo, Stanley "Artgerm" Lau, J.H. Williams, Dan Dos Santos, Ryan Sook, and literally an army of others.

Did Dark Horse deliver some *Hellboy*...uh... *goodness* last year, courtesy of Mike Mignola and collaborators like Duncan Fegredo, Scott Hampton, and Grand Master Richard Corben? Absolutely! Except that Mike actually *killed* his hero at the conclusion of *The Fury* mini-series (which he promises will only make Hellboy more interesting

in the story arc that he has planned for the future).

DH continued with its heady mix of licensed and creator-owned titles (with properties like *Star Wars* and *Conan* as the former and Eric Powell's *The Goon* as the latter): some exceptional art appeared across the line including works by Chris Scalf, Aleksi Briclot, Joe Quinones, Ryan Sook, Greg Manchess, and Raymond Swanland (who really hit it out of the park with every cover he did, whether they featured aliens, robot fighters, or barbarians). And, again, I have to give a standing ovation to Jim and Ruth Keegan's biographical strip about Robert E. Howard, "Two-Gun Bob," that runs in every issue of *Conan the Barbarian*. These half-page portraits do more to preserve Howard's memory than the majority of the essays and books about him. Personally, I'd like to see them give the same treatment to Lovecraft or The Futurians or even Harlan (wouldn't *that* be an eye-opener).

Marvel (now firmly nestled beneath the Disney umbrella) continued to perk along quite nicely despite the successes of its competitors. It almost seemed that the popularity of films based on Thor, Captain America, and X-Men, allowed the comics to explore a diverse range of stylistic interpretations of the company's stable of characters. I noted some excellent work by Frank Cho, Esad Ribic, Michael Kaluta, Jae Lee, Terry Dodson, Michael Komarck, Skottie Young, Marko Djurdjevic, Paolo Rivera, and Travis Charest.

There are, of course, a lot of comics companies besides the Big Three (Big Five, really: IDW and Image *are* major players), but finding their titles can be a challenge. The model of comics shops these days is all about pre-ordered pull-lists for regular customers: limiting unsold inventory is a logical move, particularly in tough economic times, but it also almost certainly guarantees a limit to new customers as well. Speaking from personal experience, I became a reader of *this* series or fan of *that* artist because I stumbled across them by accident at a favorite bookstore or comic shop. I don't have that opportunity very often anymore— and I'm sure others feel the same way I do. Part of being a retailer is attracting new customers, and that's hard to do if there isn't anything for a new customer to buy if they come into the store on a Friday instead of on Wednesday (new comics day). And then there was the whole Kickstarter trend where artists and writers (and even the odd publisher, too) raised funds—staggering amounts in some cases—to create a project. But when they're done—*if* they're done—who will see them beyond the initial patrons? Something to think about. Where was I? Oh...the *other* publishers. I got a kick out of the *Rocketeer Adventures* from IDW (even though I am absolutely certain that my late friend and *Rocketeer* creator Dave Stevens would be apoplectic about the series), enjoyed Joe Jusko's testosterone-fueled covers for the various ERB-based *Warlord/Princess of Mars* comics from Dynamite Entertainment, was thoroughly charmed by Sonny Liew's *Malinky Robot* [Image], loved

The Spectrum Nineteen *Awards Ceremony*

Presented at Spectrum Fantastic Art Live 1 • May 19, 2012 • Kansas City, MO

Phadroid

[Unless noted otherwise, all photographs are by Mollie Hull, M&E Photo Studio.]

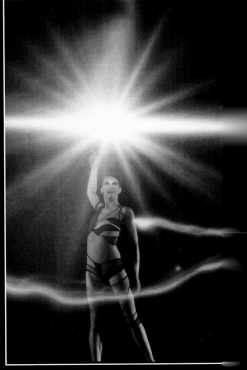

Quixotic Fusion

Phadroid

Quixotic Fusion

Quixotic Fusion

A 19-year ambition to present the Spectrum Awards with both the proper amount of respect *and* pageantry the arts community deserves was finally accomplished as part of the first Spectrum convention in May, 2012. Utilizing the historic Midland Theater and featuring bookend performances by Phadroid (Android and Phaedra Jones) and a central performance by the renowned Quixotic Fusion, the ceremony was an energetic celebration of the artists. Presenters joining us on stage were Irene Gallo, Mike Mignola, Iain McCaig, Brandon and Jerrod Shiflett, Gregory Manchess, Greg Spalenka, Donato Giancola, and Michael Whelan, with assistants Tracy Crawford and Calandra Ysquierdo. Ceremony Director Lazarus Potter and the rest of the convention staff—Arlo Burnett, Jim Fallone, Bunny Muchmore, Joshua Rizer, Bob Self, and Shena Wolf—all pulled together to create an unforgetable weekend. And, *yes*, we're doing it again in 2013. Visit www.spectrumfantasticartlive for dates and information about SFALive2.

The Midland Theater entrance

Phadroid: Phaedra & Android Jones

Edward Kinsella III

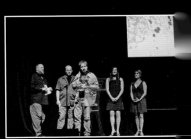

The Shiflett Bros. & Thomas Kuebler

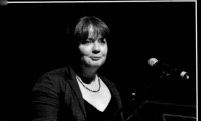

Virginie Ropars [Photo by Irene Gallo.]

Jean-Baptiste Monge

Donato Giancola & Justin Gerard

Tyler Jacobson

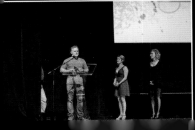

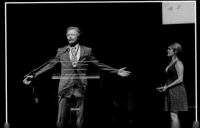

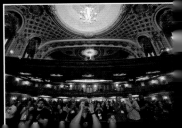

Gary Gianni's cover for *Atomika: God Is Red Vol 2* from Mercury Comics, and, when it comes to Uncle Frank Cho's *50 Girls 50* [also from Image]...what can I say? Frank is a master of fine line art (okay, and at drawing extremely bodacious heroines, too).

Which I think seems like a nice (if accidental) segue into **DIMENSIONAL** (if you're familiar with Frank's art, you'll understand; if not, trust me, it's clever).

Okay...a confession. I don't know what it is, maybe an extension of playing with Marx army men and G. I. Joes when I was a sprout (not those shrimpy 6" action figures, kid: I'm talking the 12" articulated, honest-to-God *real* G. I. Joes, dammit, with M1s and bazookas and flame throwers that I, uh, sold for a few bucks to the kids down the street when I discovered girls...). Or maybe it was building the old Aurora monster model kits (with the great Jim Bama box art—which looked *nothing* like the models) or seeing classic statues or dioramas during field trips to museums: I dunno—but what I *do* know is that I *love* dimensional artworks. As I mentioned last year, if I had the room I'd have one of Tom Kuebler's life-sized creatures waiting to greet visitors in my front hall or one of Tony McVey's dinosaurs staring over the fence at my neighbors. It must be nice to be Guillermo del Toro, who has a separate house devoted to his collection.

But I'm not an Oscar®-winning film director. Shoot. I guess I just have to make do.

As I did when I picked up the Jack Mathews-sculpted/Adam Hughes-designed "Poison Ivy," "Hawkgirl," "Supergirl," and "Batgirl" statues [DC]. Cathy give's me such a look when I walk through the door with a box tucked under my arm. "Been to Clint's Books [a favorite local comics shop] during lunch, I see," she says and what can I do but nod sheepishly before shuffling off to find some shelf space?

Despite my purchasing habits, the economy *has* had an impact on the 3D market in recent years as reflected in the lower production runs and fewer outlets for products. ZBrush, too, is having an impact on traditional sculptors as companies choose to send a digital file to Chinese vendors that are fed into the computers to create action figures and statues. Factor in the chilling effect of a lawsuit that DC finally felt had to be filed against a garage kit maker who chose to ignore numerous C&D letters and you'd undoubtedly come away with the impression that there was a dearth of interesting dimensional art in 2011. Obviously that's wrong. Artists *have* to create, regardless of what's going on in the marketplace. Duh.

Anyway, I really liked Dark Horse's statue based on the art of Milo Manara (I'm sorry I don't know the sculptor's name). "Ritual" by Shin Tanabe (based on the art of Luis Royo [Yamato], "Komodo King" by the brilliant Brandon and Jarrod Shiflett [Shiflett Bothers], "Cthulhu" by Alexi Bustamante [Ebot Productions], Ashley Wood's incredibly intricate wooden Robots [threeA Productions], and

the trio of Hammer busts ("Countess Dracula," "Van Helsing", and "Dracula" respectively) that Titan Merchandising released at the end of the year. But, frankly, it's hard to keep up with all this neat stuff and I have to fall back on my standard suggestion of regularly picking up copies of *Amazing Figure Modeler* to get a decent idea about what's going on in the fantastic 3d field.

A mention of a magazine in the last paragraph seems like a proper way to lead into the **EDITORIAL** category. Perhaps the biggest question coming out of 2011 is: are apps or digital incarnations the "new" preferred magazine format?

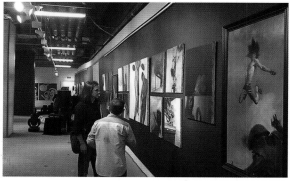

Above: *Phil Hale oversees the installation of his art as part of a ThreeA gallery show in Bejing, China.*

The answer so far is: kinda, but mostly *nope*.

Digital versions of newsstand magazines accounted for less than 1% of any title's circulation: while there are definitely a lot of e-readers in people's hands these days, those consumers have remained resistant to subscribing to digital incarnations of their favorite magazines. Not surprising, considering the limitations of the software and the attitude that a magazine is generally considered to be both immediate and disposable, not something that sits on your iPad...forever. Heck, according to the *Press Gazette* even *Wired* only had 622 digital subscribers last year. Of course, magazines with modest print circulations in the first place were grateful for any digital subscribers so in some cases e-formats were a positive. Still, getting free browsers to turn into paying customers remains a challenge.

I will say that the industry seemed to stabilize a bit last year. There weren't as many closures, circulations seemed steady (with some titles reporting modest increases), and newspapers began to experience gains here and there in readers and advertisers. Things are still dicey for many (and the phone-hacking scandal in the UK brought down Rupert Murdoch's once-invulnerable *News of the World* tabloid), but when 2011 drew to a close everything wasn't all gloom and doom for a change.

In our little neighborhood, *Realms of Fantasy* was the fatality of 2011. Closed, sold, and restarted, it just did not have to have the steam (or deep pockets) needed to succeed. It did feature a last couple of excellent covers by Brom and Tom Canty though, so they went out on a high note. *The Magazine of Fantasy & Science Fiction*, *Weird Tales*, *Asimov's SF,* and *Analog* continued to chug along as the genre's main fiction titles and featured art by

Jacques Barbey, Mauriozio Manzieri, Benjamin Carre, Vincent DiFate, and David A. Hardy among others. *Clarkesworld* featured some solid covers by Julie Dillon, Facundo Diaz, Ferdinand Ladera, and Georgi Markov, while *Weird Tales* benefited from the art of Lee Moyer and *Black Gate* sported excellent work by Donato Giancola. Yet again, my favorite artist-focused magazines were Dan Zimmer's outstanding *Illustration*, outsider flag-bearer *Juxtapoz, Communication Arts, Print, How, Art Scene International, Hi-Fructose* (truly a fun magazine with tons of outstanding work), and *Blue Canvas* (which was one of the sponsors of the reality/competition show, *Work of Art: The Next Great Artist* on the Bravo cable channel).

And, of course, with a little looking, fantastic art could readily be found in *Time, National Geographic* (some great work by Daniel Dociu), *Prehistoric Times* (lots of Jim Gurney and Bill Stout!), *Cinefex, Entertainment Weekly, Discover, Playboy,* and *Rolling Stone*—and, heck, San Diego Comic Con International even has their own magazine (called—wait for it—*Comic-Con*) and, I have to say, it's pretty good. For news, interviews, and reviews I found *Locus* (whom I stopped designing covers for last year after more than a decade: it was time for some new blood), *Sci Fi* and *SciFiNow* extremely useful.

Ah: now for the **INSTITUTIONAL** category for art that was created for greeting cards, prints, package design, promotions, gallery shows, and an infinite number of other uses is what we mean my "institutional" (we could have said "Everything Else," but that lacks panache). And, yes, yes, there's Concept Art and Unpublished, but I'm in the same boat as everyone else and only know about the works you'll find in the pages ahead...so let's get back to Institutional, if you please. Some of the art calendars I saw and liked in '11 included those by William Stout (Yow! *Zombies!*—though I'm slightly biased since I was the art director), Daniel Merriam, Simon Bisley, Ciruelo (dragons, dragons everywhere!), Boris Vallejo and Julie Bell, and Luis Royo. Wizards of the Coast not only was the source of an amazing array of fantastic imagery, but definitely were a bright spot on parent company Hasbro's year-end financial report, while the artists for *Portal 2, Batman: Arkham City,* and *The Elder Scrolls V: Skyrim* propelled those games to the top of the sales charts. The cast of the #1 CBS comedy, *The Big Bang Theory*, continued to sport T-shirts from Bob Chapman's Graphitti Designs (you can't blame them: Graphitti's shirts are *the best*) and, really, wherever you looked—whether at lunch boxes or logos or promotional graphics—you were likely to find some sort of fantastic art.

Publishing traditionally provided the gateway for collectors interested in fantastic art, but, as the marketplace changes and artists begin exploring different opportunities, galleries—or contacts with the artists directly—are becoming the new "normal" for patrons seeking to add works to their walls. There were major shows in 2011 by Glenn Barr,

Martin Wittfooth, Tran Nguyen, Kent Williams, Billy Norrby and many others, but a growing tend has been for collectors to commission new works by their favorites rather than wait for something to appear in print or at a gallery.

As I mentioned last year, "live" events are growing in popularity as the artists seek out opportunities to cultivate new clients and collectors and search for ways to interact with fellow creatives without having to brave crowds of actor/media-obsessed fans. Baby Tattooville (the fifth sell-out event took place last October) created a unique one-on-one atmosphere others have unsuccessfully tried to copy (as the saying goes, there are those who initiate and those who imitate), so it's little surprise that we partnered with BT's founder Bob Self to launch Spectrum Fantastic Art Live!...but that took place in *2012*, not '11, and shouldn't be mentioned beyond the page devoted to the *Spectrum* 19 awards ceremony, right? Okay, so I can't really report how it turned out until *Spectrum* 20—though I *wish* I could sneak in a mention that it *was* successful and that it *will* happen again in 2013 and you *should* definitely start making plans now if you want to attend an event that is all about the art and artists... but I *can't* really talk about it here, you know?

So I won't.

JEFFREY JONES
[1944-2011]

I'll be the first to admit that I did not really understand Jeffrey Jones. He was at once contradictory and perplexing and inexplicable as an artist and as a person; an odd amalgam of illustrator, cartoonist, and painter; a philosopher, a sly comedian, and a nerd. His transgender exploration, rather than providing concrete answers only succeeded in making his story even more confusing. When asked to explain "...what's up with Jeff?" in recent years I could only shrug in reply. I always tended to think of Jeffrey as a fragile and somewhat lost soul, but—again, contradictorily—also as a person of great strength and resolve.

The one certainty was that I liked Jeffrey: I respected his *work* (and there was some that I truly loved), I admired *him*. His art—whether created with paint, pencil, or pen—was inspiring, evocative, and memorable; as a person, he was thoughtful, humble, and kind. There was a southern charm and gentility about him that tended to emphasize his emotional struggles and often elicited both a pang of sympathy and a feeling of sad frustration.

Jeff started out as a science fiction fan—an amateur rocket enthusiast and avid reader of Heinlein, Bradury, Campbell, and Clarke—and honed his artistic skills drawing for fanzines like *ERBdom, Amra,* and *Trumpet.* He turned pro illustrating comic stories for *Eerie, Creepy,* and *Flash Gordon* as well as providing paintings for *Red Shadows,* a hardcover collection of Solomon Kane stories published by Donald M. Grant. A move from Atlanta to New York with his pregnant wife, Mary Louise "Weezie" Alexander, led to a career creating paperback covers; he was fast, versatile, and had a style vaguely reminiscent of Frank Frazetta's (who was much in demand, but rarely interested in increasing his workload), all of which made him extremely popular with art directors. Besides providing paintings for books by Fritz Lieber, Jack Vance, Andre Norton, and Robert E. Howard, he produced numerous romance, adventure, horror, and spy covers. Jeff also maintained a relationship with the comics industry and for a number of years provided monthly strips for *National Lampoon* and *Heavy Metal.* But even as his popularity grew and the quality of his work increased, he became

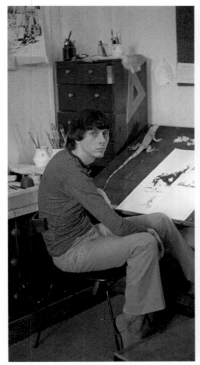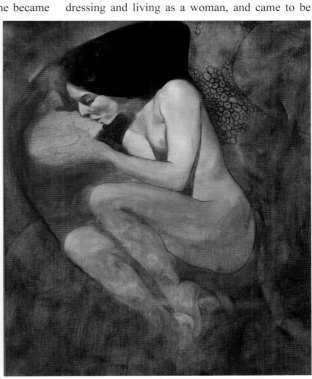

Above left: *Jeffrey Jones, circa 1970s. Photograph by Robert K. Wiener.* **Above right:** *One of Jeff's unfinished paintings.*

more disenchanted with commercial art and his life in general. Jeffrey always seemed to be searching for something—just as he was never quite sure what that "something" actually was. Following a separation from Weezie, he and his friend Vaughan Bodé openly experimented with cross-dressing (which Jeff had been doing secretly since childhood) and female hormones, but both became alarmed with the changes taking place in their bodies and stopped the treatments.

He produced some of his most accomplished paintings while a member of The Studio with Michael William Kaluta, Bernie Wrightson, and Barry Windsor-Smith, but the experience meant much less to him than it did to observers who desperately wished that they could have been a part of it. A difficult childhood relationship with his father, the dissatisfaction with his career path, his failed marriage, his self-doubt about identity, and Bodé's accidental suicide in 1975 undoubtedly contributed to Jeff's abuse of alcohol and ultimately his clinical depression. He once said, "My life describes the stories of boys and men for thousands of years: boys who were beaten by their fathers, boys whose capacity for love and trust was crippled almost at birth. Men, whose best hope for contact with other human beings lay in detachment, as if life were over. It's how we keep, in turn, from destroying our own children and terrorizing the women who have the misfortune to love us, how we absent ourselves from the tradition of male violence, how we decline the seduction of revenge." He was hospitalized several times through the years when his emotional turmoil became unbearable.

In the late 1990s Jeffrey renewed a series of treatments with female hormones, married Maryellen McMurray, added "Catherine" to his name (though he never changed it legally), began dressing and living as a woman, and came to be described as "she" by many. Family and long-time friends, however, continued to call him "Jeff" and refer to him as "he," often to the consternation and anger of those who didn't know Jones as well. The truth was that the changes compounded his unhappiness rather than resolved it. The quick dissolution of his second marriage made matters worse; an arrest for a traffic violation and being held in jail with the male population was his darkest period. Tim Underwood came to Jeffrey's rescue and posted bond for his release, but the trauma was too severe: he experienced a mental breakdown and prolonged hospitalization beginning in 2002. Jeff lost his home, his studio, and most of his possessions and only made it through the hard times with the help of his daughter Juliana and friends Robert Wiener and Allen Spiegel. Though eventually he was able to move into a small apartment and begin to paint again, Jeff was never entirely whole. His new art lacked the skill and, above all, passion of his earlier works. Conversely, he became very active on eBay and Facebook and interacted with an expanding circle of fans and admirers.

For a time I never knew how to properly address Jeff after the hormone treatments and the adoption of the Catherine name. It's often been misreported

that Jeffrey had undergone sex-reassignment surgery, but he never did (and said he had no intentions of doing so); I had always known him as a lanky, bearded guy and he was distinctly male in all of the photos he would send Cathy and me for inclusion in his books. So I was flummoxed as to what to call him in e-mails or conversations or when writing about him...so I asked him directly years ago around the time that we were working on *The Art of Jeffrey Jones* just prior to his major collapse. He told me to call him "Jeff" or "Jeffrey" and since the law considered him a man, it was perfectly fine with him if I did, too.

Though he lived the rest of his days as a

Above: *Darrell Sweet's fold-out cover for* The Eye of the World: Book One of The Wheel of Time *by Robert Jordan*

transgender person he told me candidly in 2006, "It was a mistake. I was convinced that my turmoil was because I was a woman trapped in a man's body and for a time I was happy with my decision. But I came to realize that I still think like a man and desire women like a man does. I thought it would make me less depressed and I was wrong. I drove down a dead end road and now I can't back up or turn around; the only thing I can do at this point is accept things as they are. And I think I have. Besides, what other choice do I have?"

We had asked Jeff how he wanted his nameplate to read on his Spectrum Grand Master Award and it says, per his instructions, "Jeffrey Jones." "That's how people know me," he said. "That's how I want to be remembered."

Jeff is survived by his daughter Julianna Jones Muth and three grandchildren: Nikolai Muth, Adelaine Muth, and Merryn Arm. Director Maria Paz Cabardo of Macab Films has finished an ambitious documentary devoted to his career (Cathy and I are proud to be among the producers), *Better Things: Life & Choices of Jeffrey Catherine Jones.*

The easiest thing some might say about Jeffrey is that he was born out of his time; others, of course,

would agree with his occasional statement that he was born the wrong sex. He has always been portrayed as a brooding and mysterious talent, both troubled and romantic: the Byronic figure of the fantasy art world.

And perhaps he was. But for my part, I'll always remember Jeff as someone who was on a journey that was sometimes uplifting, sometimes terrifying, and sometimes heartbreaking—but he always had hope of finding a place where he felt he truly belonged. Like so many in our field, Jeffrey Jones' brilliance was both a blessing and, sadly, a curse.

I hope finally, at long last, he has found the peace that he was looking for and so deserved.

DARRELL K. SWEET [1934-2011]
by Irene Gallo

I was extremely sad when I reported the death of Darrell K. Sweet's on December 5 at the age of 77.

Since the mid 1970s, Darrell's illustrations defined many of fantasy's most beloved series—including Robert Jordan's *The Wheel of Time*—among literally thousands of genre book covers. An avid history buff, Darrell also spent much of his time painting frontiersmen and the American West. His paintings evoked the classic storytelling narration of the Golden Age illustrators. A Sweet cover promised an adventure to be had.

Darrell was one of the first painters I called when I started my career at Tor, eighteen years ago, and we've worked together continuously throughout these past near-two-decades. He was the 2010 World Fantasy Guest of Honor and I was very grateful to spend a full weekend with him and his son, after so many years of talking on the phone and trading notes through express mail. Regardless of how many years he had in the business, or how many paintings off the easel, he was as eager to talk about technique and craft and his passion for painting as any student at the beginning their career.

I'm particularly sad that he was unable to finish

Memory of Light, the final book in Robert Jordan's epic fantasy series the *The Wheel of Time*. He has been a vital part of this series since its beginning, 25 years ago. I know he was hoping, to the end, to be able to see this epic body of work to its completion.

His son stated, "He lived his life as an artist — seeing the beauty that surrounds."

REQUIEM

In 2011 we also sadly remember the passing of these valued members of our community:

Jack Adler [b 1917] Comic Artist
Lee Judah Ames [b 1921] Artist
Edward Barreto [b 1954] Comic Artist
Ivica Bednjanec [b 1934] Cartoonist
Charles Bell [b 1916] Cartoonist
Bill Blackbeard [b 1926] Comics Scholar
Simon Bond [b 1947] Cartoonist
Charles Brooks Sr [b 1920] Cartoonist
Douglas Chaffee [b 1936] Artist
Gilles Chaillet [b 1946] Comic Artist
Gene Colan [b 1926] Comic Artist
Preston Dean Jr [b 1915] Cartoonist
Osamu Dezaki [b 1943] Animator
Lucien Freud [b 1923] Artist
Bill Gallo [b 1922] Cartoonist
Paul Gillon [b 1926] Comic Artist
Ismail Gülges [b 1947] Cartoonist
Dave Hoover [b 1955] Comic Artist
Nestor Infante [b 1957] Comic Artist
Eiko Ishioka [b 1938] Costume designer
Steve Jobs [b 1955] Computer Pioneer
Jeffrey Jones [b 1947] Artist
Bill Justice [b 1914] Animator
Bill Keane [b 1922] Cartoonist
George Kuchar [b 1942] Comix Artist
Bill Kunkel [b 1950] Artist
Frank Lewis [b1921] Cartoonist
Francisco Solano López [b 1928] Comic Artist
Kevin McVey [b 1928] Artist
Félix Molinart [b 1930] Artist
Bob Monks [b 1927] Cartoonist
Minck Oosterveer [b 1961] Comic Artist
Anant Pai [b 1929] Comic Artist
Bill Rechin [b 1930] Cartoonist
Harry Redmond Jr [b 1909] SPFX Artist
Eric Resetar [b 1928] Cartoonist
Bay Rigby [b 1963] Cartoonist
Jerry Robinson [b 1922] Comic Artist
Hy Rosen [b 1923] Cartoonist
Kazuhiko Sano [b 1952] Artist
Lew Sayre Schwartz [b 1926] Comic Artist
Ronald Searle [b 1920] Artist
Joe Simon [b 1915] Comic Artist
Clement Sauvé [b 1977] Comic Artist
Darrell K. Sweet [b 1934]
Gene Szafran [b 1941] Artist
Jean Tabary [b 1930] Comic Artist
Shinja Wada [b 1950] Manga Artist
Albert Weinberg [b 1922] Artist
Jerry Weist [b 1949] Art Scholar
Dylan Williams [b 1972] Cartoonist
Tom Wilson [b 1931] Cartoonist †

#19 Call For Entries Poster *by* **Rebecca Guay**

Title: **Figure Eight** *Medium:* **Oil on board**

Tyler Jacobson

Art Director: Kate Irwin *Client:* Wizards of the Coast *Title:* Talon of Umberlee *Medium:* Digital

Android Jones

Client: Boom Festival *Title:* Boom Drop *Size:* 15.8"x24" *Medium:* Painter 12

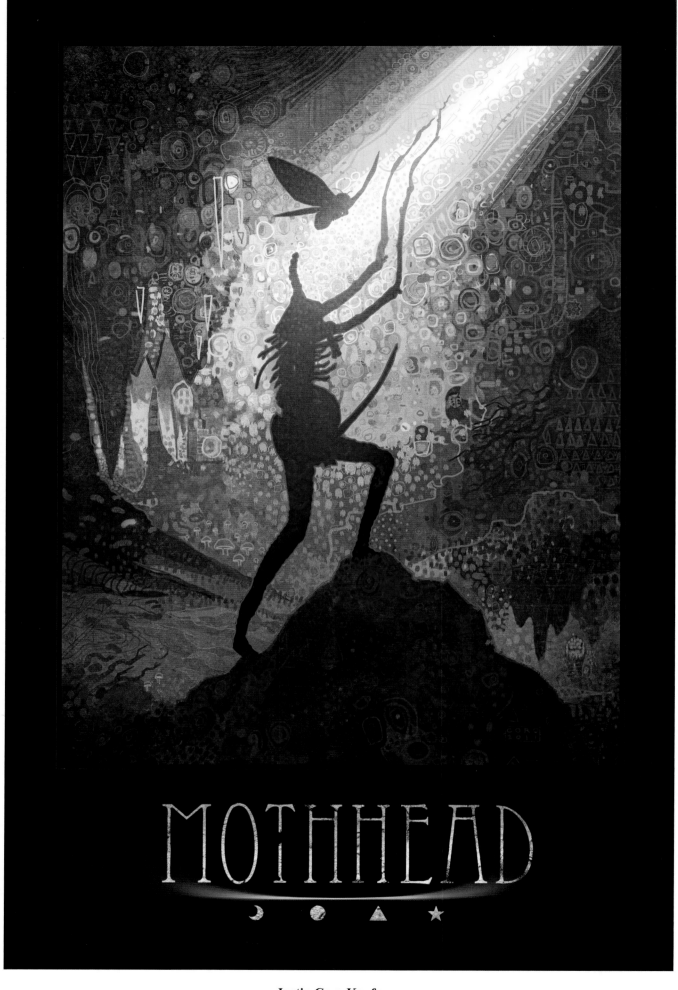

Justin Coro Kaufman
Art director: Justin Coro Kaufman *Client:* Massive Black *Title:* Mothhead Promo Poster *Size:* 24"x36" *Medium:* Digital

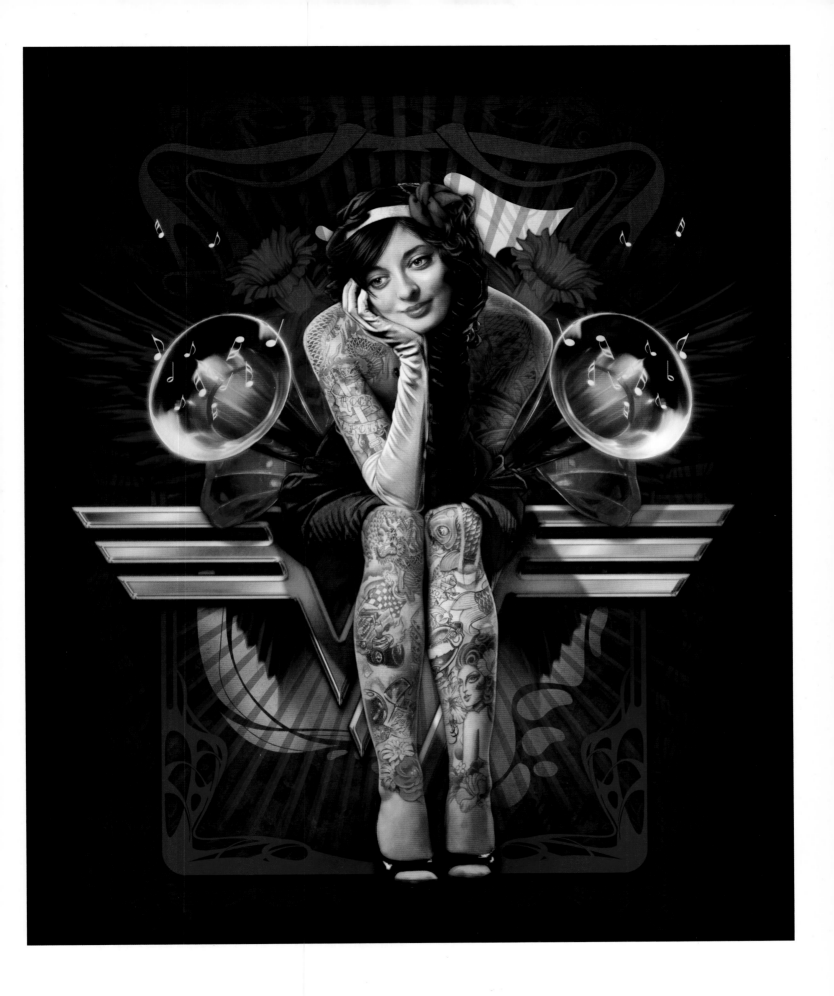

Craig Howell
Client: Fea Merchandising *Title:* Nouveau Ink *Size:* 14"x17" *Medium:* Digital

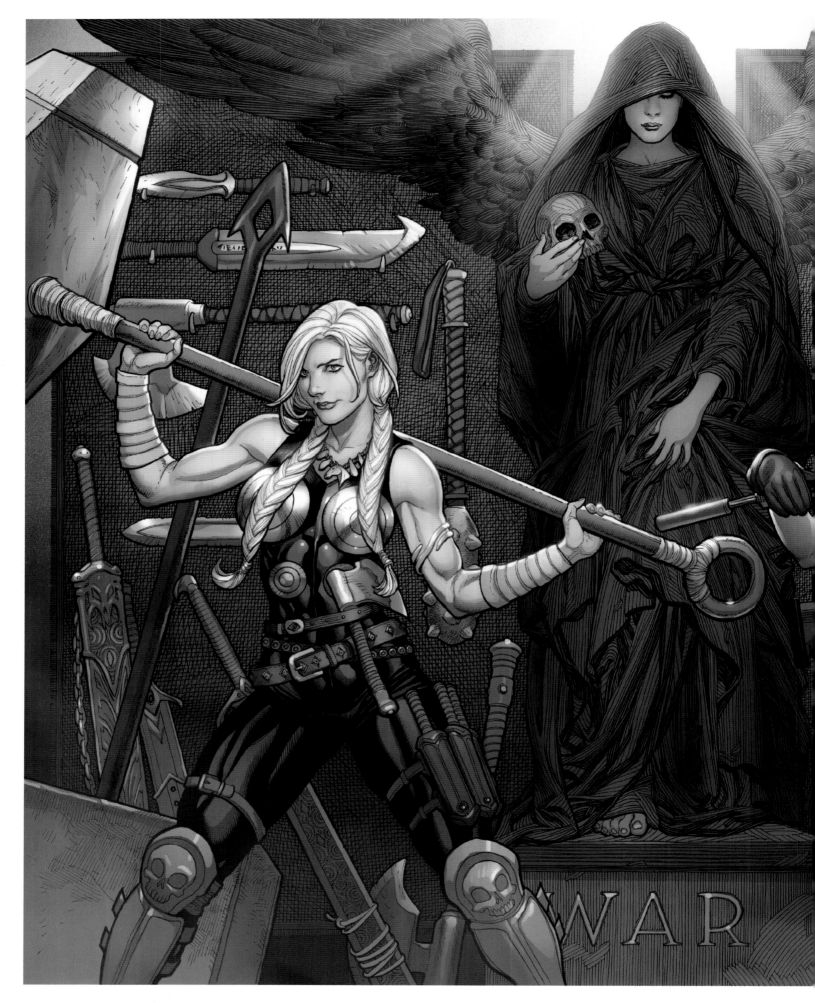

Frank Cho
Designer: Frank Cho *Colorist:* Jason Keith *Client:* Marvel Comics *Title:* The Fearless *Size:* 24"x19" *Medium:* Pen & ink with digital color

Glen Orbik
Art director: Peter Bickford *Designer:* Laurel Blechman & Glen Orbik
Client: Human Computing **Title:** Comic Base #16 *Size:* 17.5"x25" *Medium:* Oil

Eric Joyner
Client: Corey Helford Gallery **Title:** All Wrapped Up
Size: 36"x48" *Medium:* Oil on panel

Advertising 25

Brad Rigney
Art director: Jeremy Jarvis *Client:* Wizards of the Coast *Title:* Planeswalker Pantheon *Medium:* Digital

Joe Madureira
Art Director: John Mueller *Colorist:* Jonathan Kirtz *Client:* Vigil Games *Title:* Death Lives *Medium:* Digital

Marc Sasso
Client: Adrendaline Mob *Title:* Omerta *Medium:* Digital

Gyula Havancsa'k
Client: Annihilator *Title:* Sinister *Size:* 21cm x 27.5cm

Gyula Havancsa'k
Client: Svartsot *Title:* Maledictus Eris *Size:* 21cm x 21cm

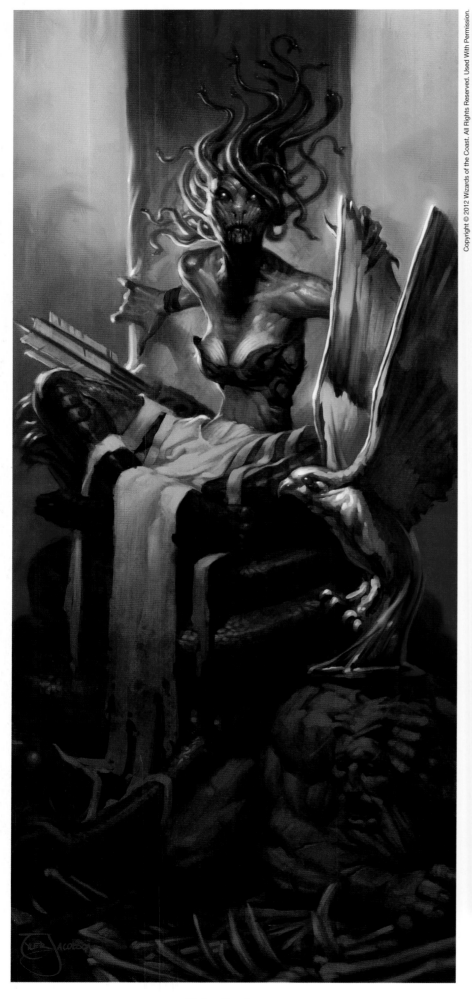

Tyler Jacobson

Art Director: Kate Irwin *Client:* Wizards of the Coast *Title:* Daask Crime Lord *Medium:* Digital

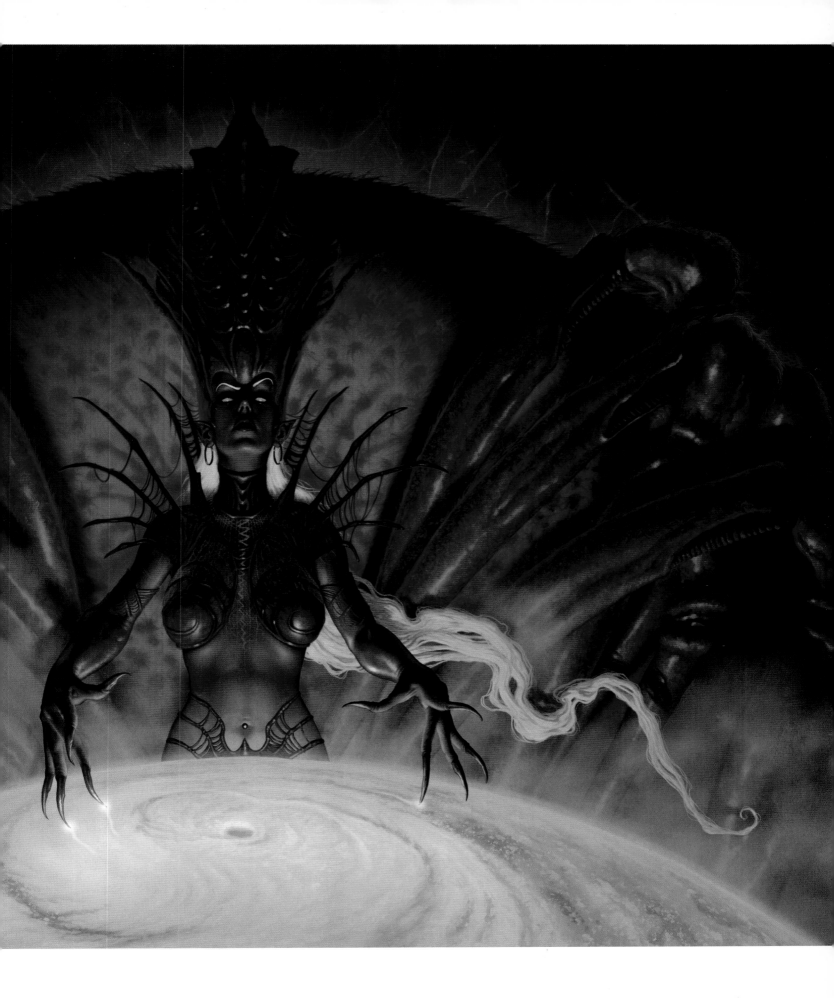

Fred Fields
Art Director: Jeff DePuy *Client:* Dungeons & Dragons Online Turbine/Warner Bros. *Title:* Lolth *Size:* 24"x18" *Medium:* Oil

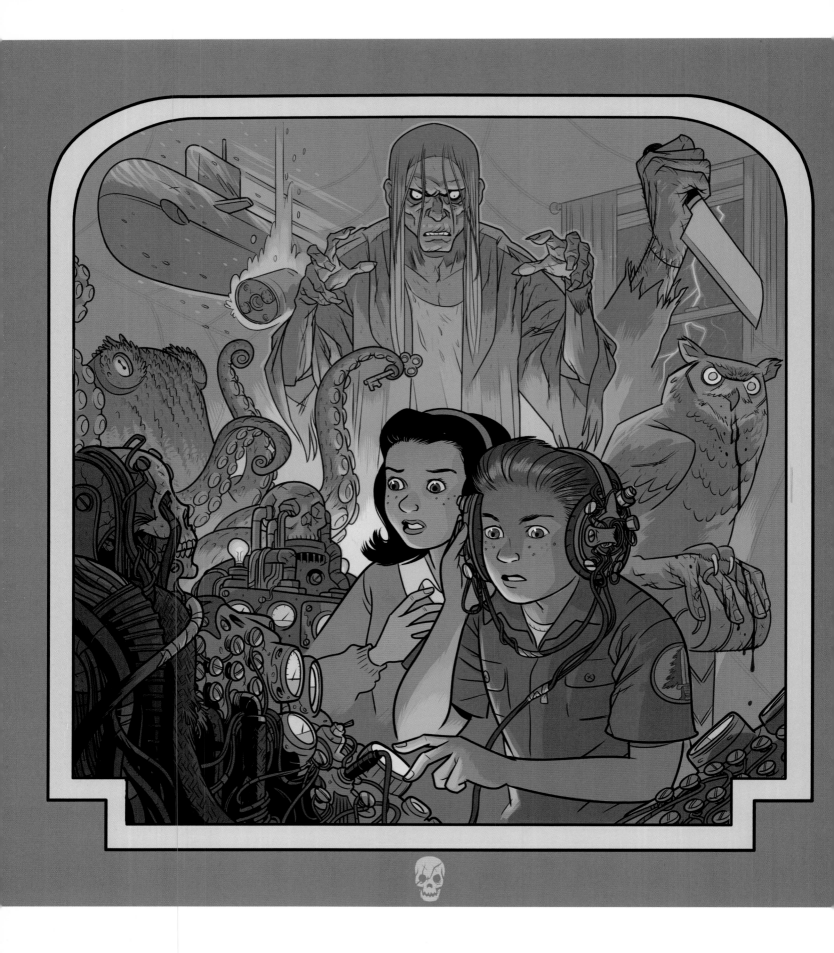

Matt Smith

Art Director: Aidan Baker *Designer:* Matt Smith *Client:* Aidan Baker [music CD] *Title:* Spectrum of Distraction *Size:* 12"x12" *Medium:* Digital

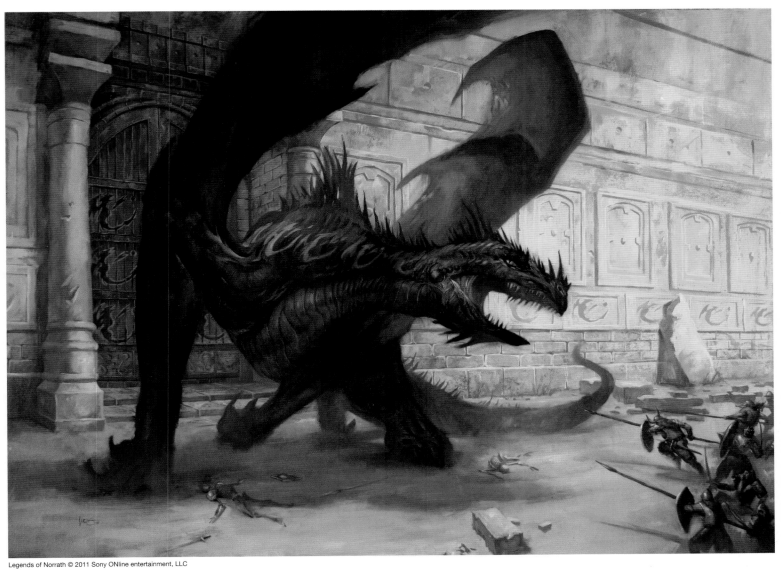

Lucas Graciano

Art Director: Joe Shoopack *Client:* Sony Online Entertainment *Title:* Temple Guardian *Size:* 20"x16" *Medium:* Oil

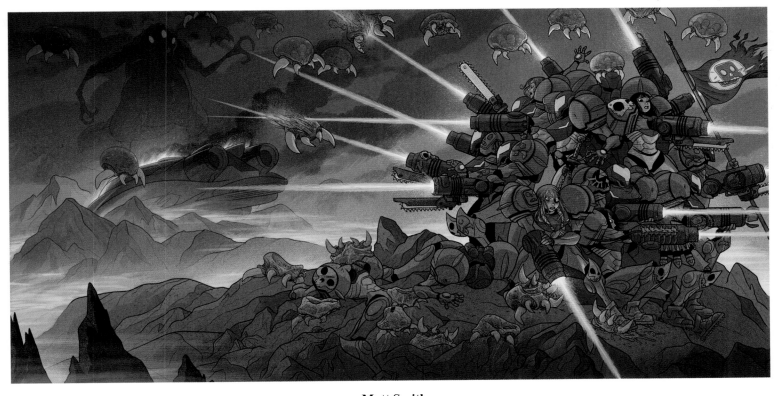

Matt Smith

Art Director: The Minibosses *Designer:* Matt Smith *Client:* The Minibosses [band] *Title:* Brass 2 *Size:* 24"x12" *Medium:* Digital

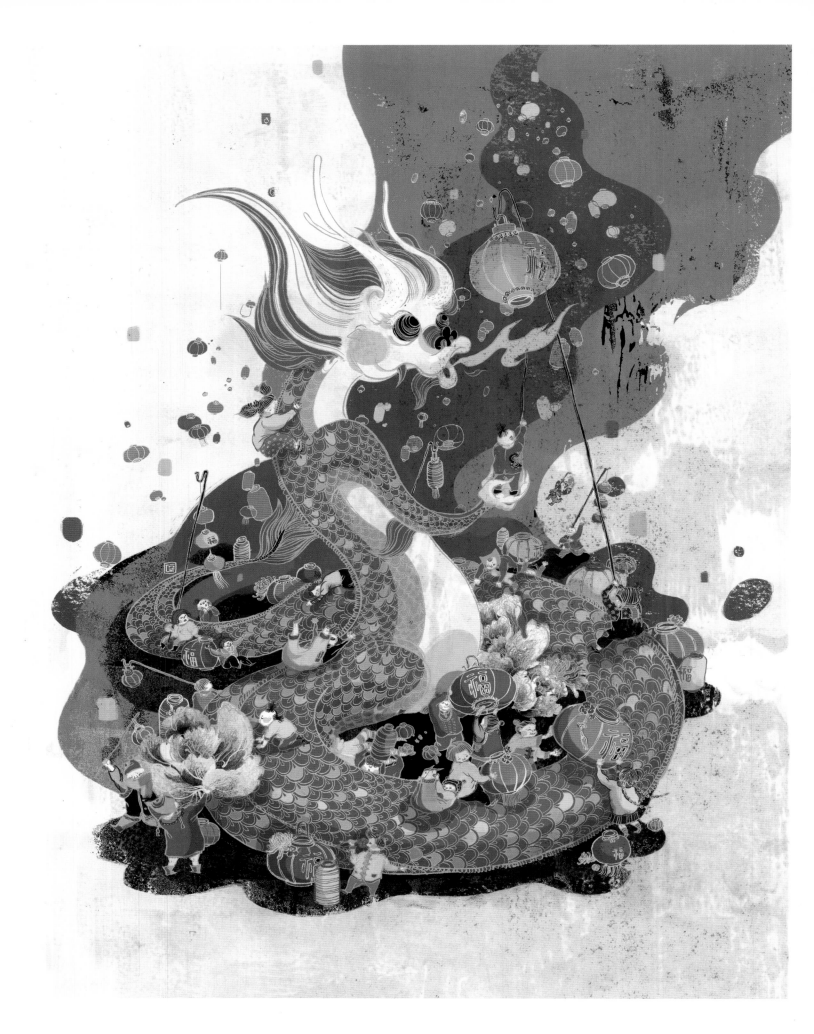

Victo Ngai

Art Director: Benjamin Milam *Designer:* Jason Fisher *Client:* McDonald's® *Title:* Dragon Year Poster *Size:* 24"x36" *Medium:* Mixed

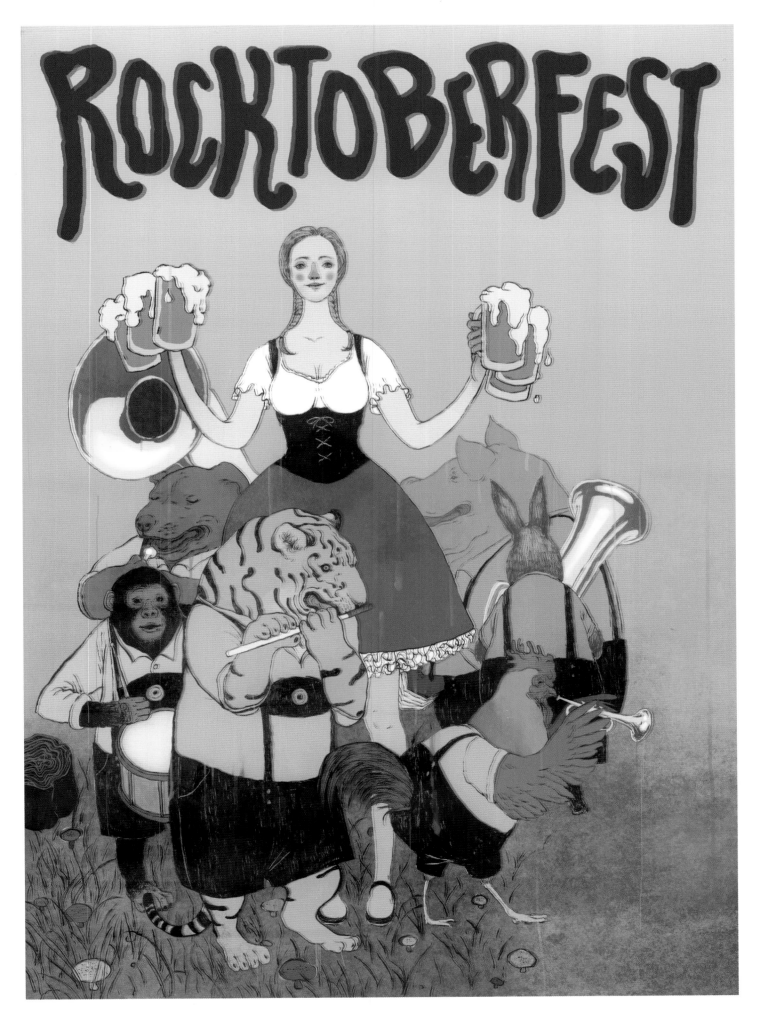

Tony Huynh

Art Director: Alan Lucchesi *Client:* Soundwave Studios *Title:* Rocktoberfest *Size:* 16"x20" *Medium:* Mixed

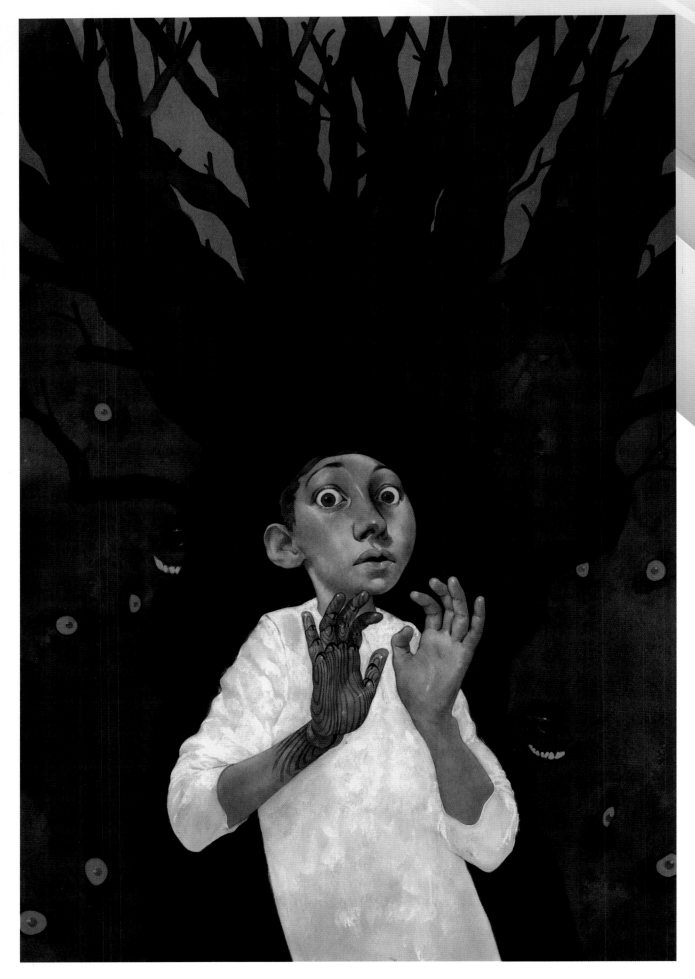

Edward Kinsella III
Art Director: Laurent Linn *Client:* Simon & Schuster *Title:* Wooden Bones *Size:* 18"x22.5" *Medium:* Mixed

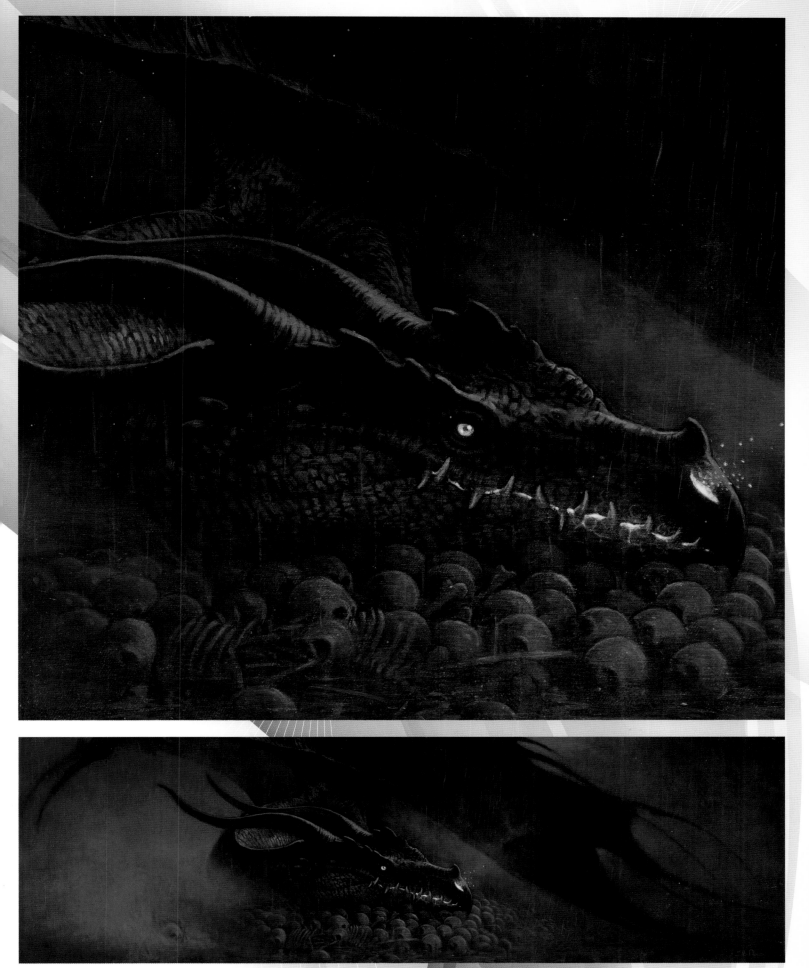

Jean-Baptiste Monge
Client: Daniel Maghen Editions *Title:* Ragnarok *Size:* 43"x13.75" *Medium:* Oil on canvas

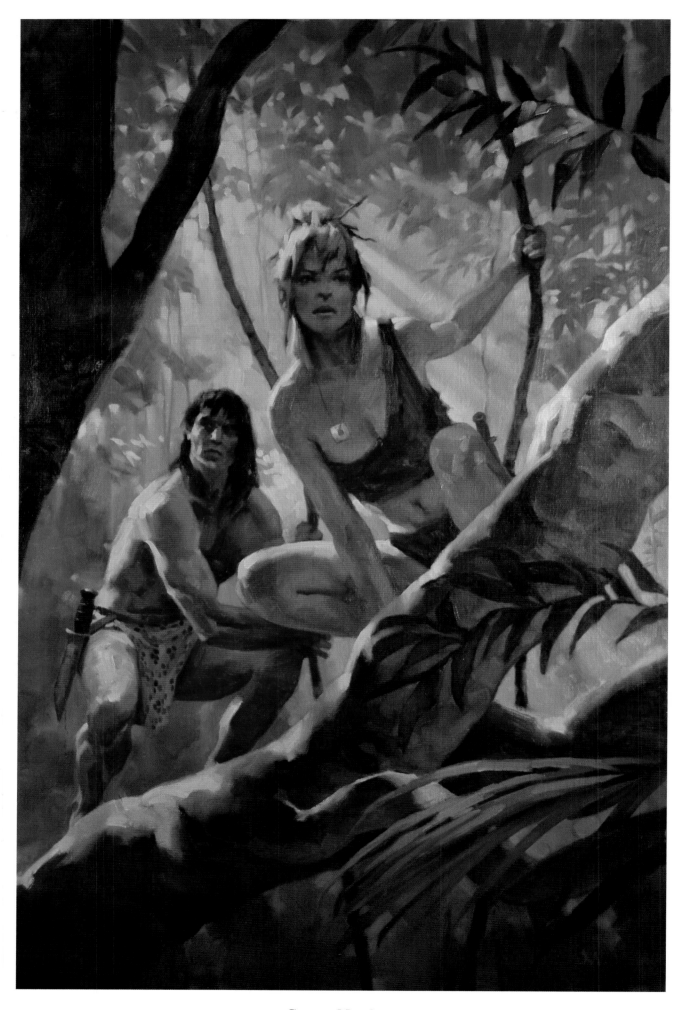

Gregory Manchess

Art director: Irene Gallo *Client:* Tor Books *Title:* Jane *Size:* 24"x36" *Medium:* Oil on linen

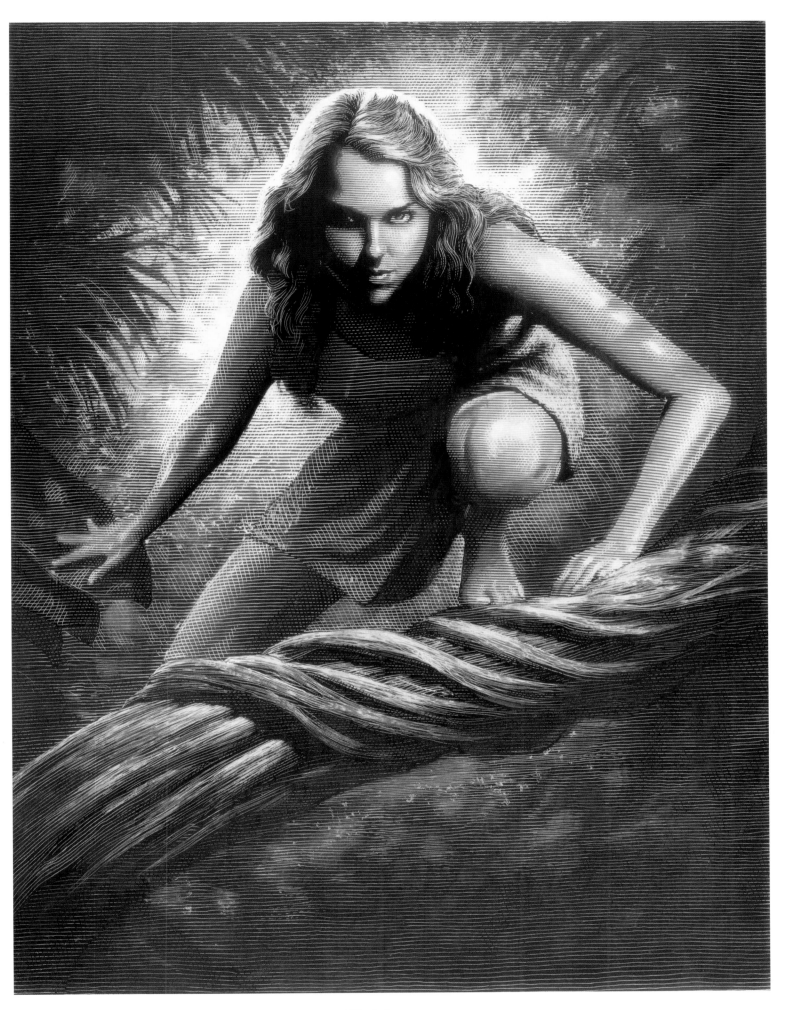

Mark Summers
Colorist: Irene Gallo *Client:* Tor Books *Title:* Jane *Medium:* Scratchboard/mixed

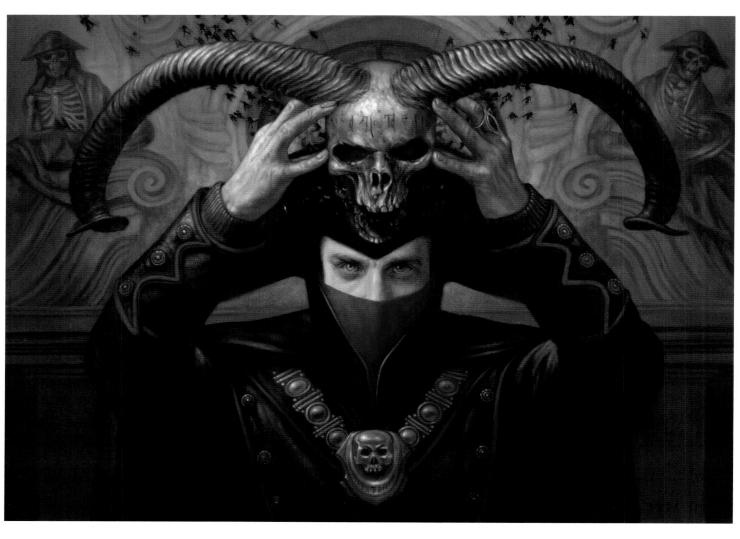

Volkan Baga

Art Director: Jeremy Jarvis *Client:* Wizards of the Coast *Title:* Increasing Ambition *Size:* 20"x14.5" *Medium:* Oil

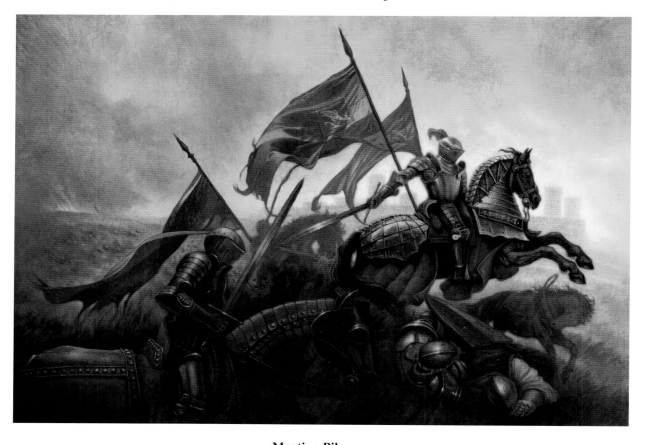

Martina Pilcrova

Designer: Martina Pilcrova *Client:* Talpress, Prague *Title:* A Storm of Swords—My Battle *Size:* 17"x12" *Medium:* Acrylic

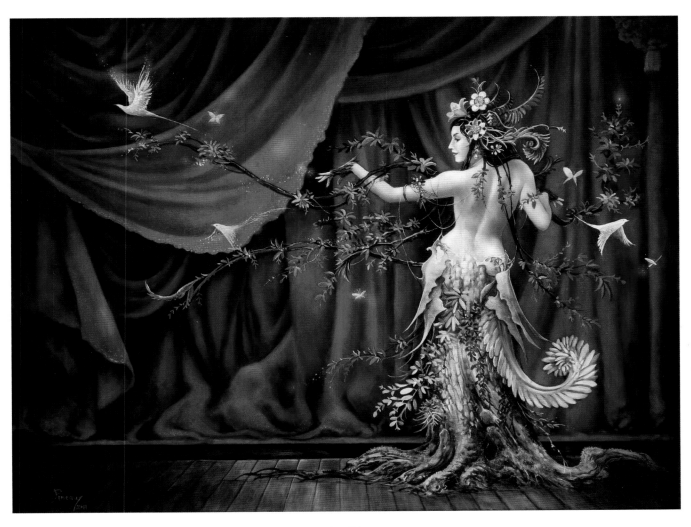

Severine Pineaux

Client: Au Bord des Continents *Title:* Gothic Faërie—The Dancer *Size:* 65cm x 50cm *Medium:* Oil on canvas

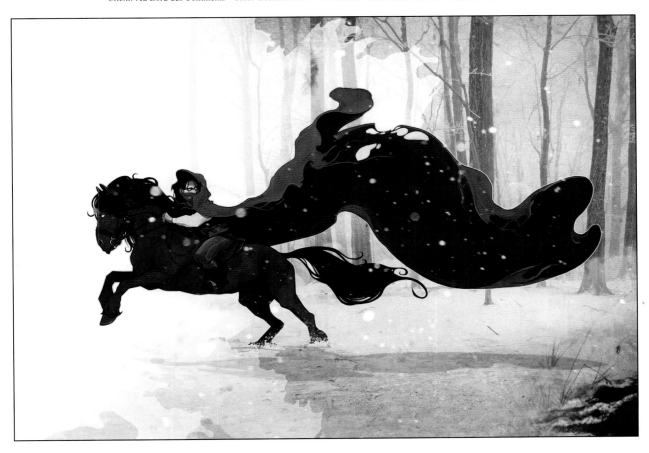

Vanja Todoric

Client: Orfelin Izdavastvo *Title:* Trivun Kalaba Riding His Black Steed *Medium:* Digital

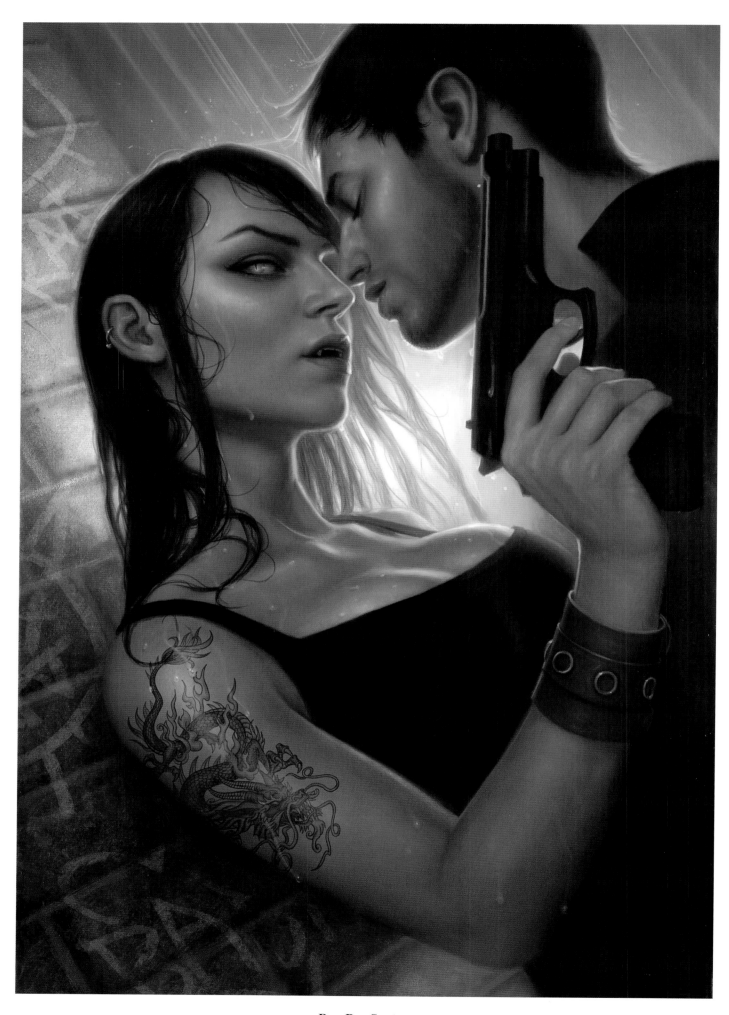

Dan Dos Santos
Art Director: Toni Weisskopf *Client:* Baen Books *Title:* The Wild Side *Size:* 20"x30" *Medium:* Oil

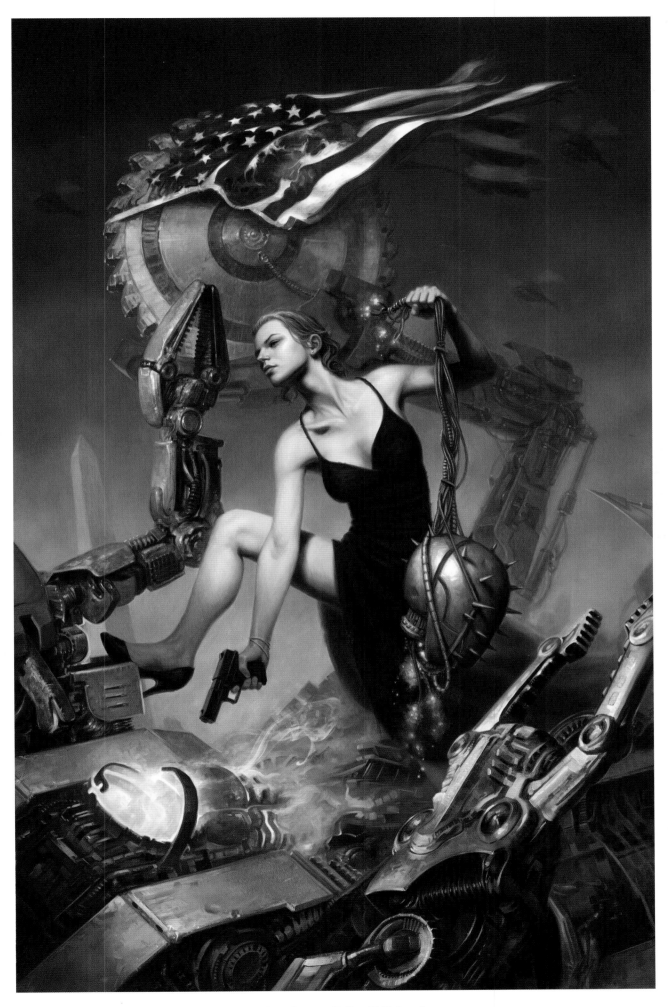

Dan Dos Santos & David Palumbo

Art Director: Sheila Gilbert *Client:* DAW Books *Title:* Alien Diplomacy *Size:* 20"x30" *Medium:* Oil

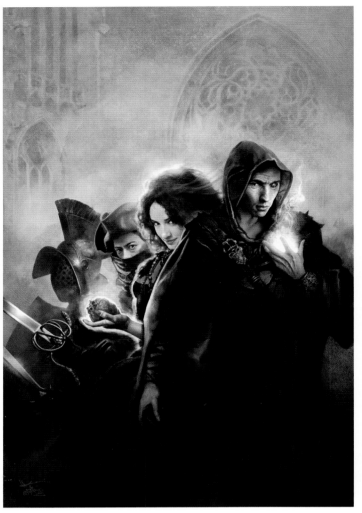

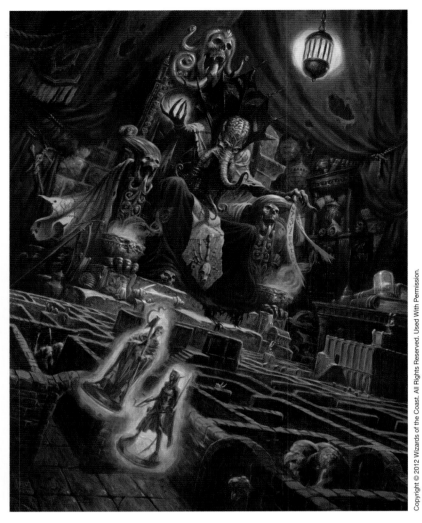

Peter Tikos & Richard Vass
Client: Delta Vision *Title:* Ifin Nights 2 *Size:* 7.2"x10.6" *Medium:* Pencil & digital

Ralph Horsley
Art Director: Kate Irwin *Client:* Wizards of the Coast *Title:* Dungeon Map Control *Medium:* Acrylic

Jean-Baptiste Monge
Client: Daniel Maghen Editions *Title:* The Beast *Size:* 27.5"x19.75" *Medium:* Oil on canvas board

Mark Zug

Art Director: Lizzy Bromley *Client:* Simon & Schuster *Title:* Princess of Mars *Size:* 15"x22" *Medium:* Oil

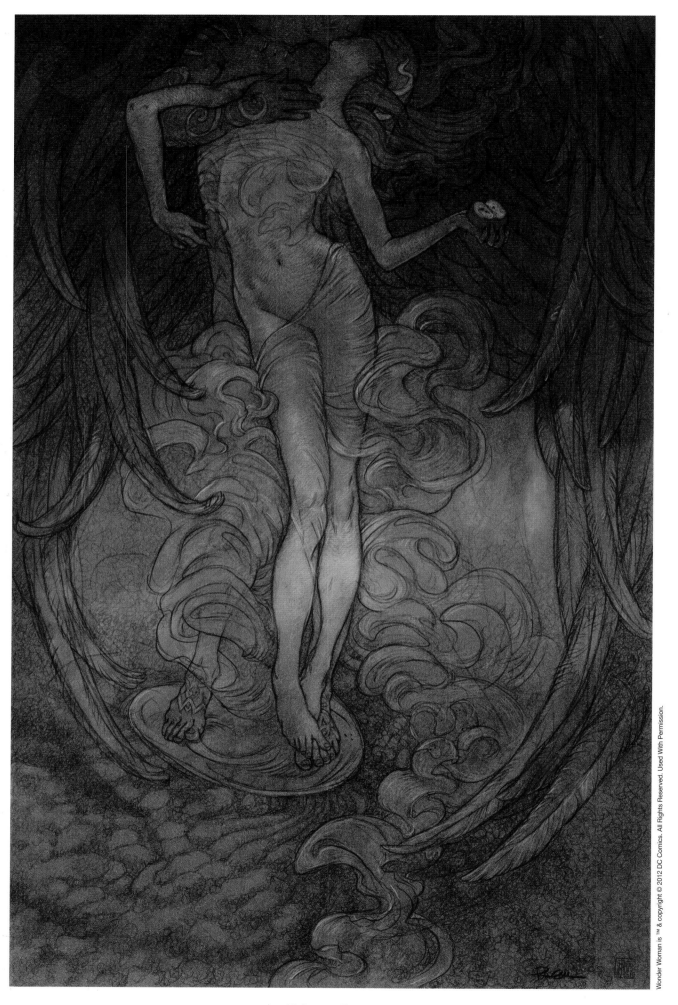

Rebecca Guay

Art Director: Karen Berger *Client:* Vertigo *Title:* Kiss of Knowledge/Flight of Angels *Size:* 9"x12" *Medium:* Pencil & gouache

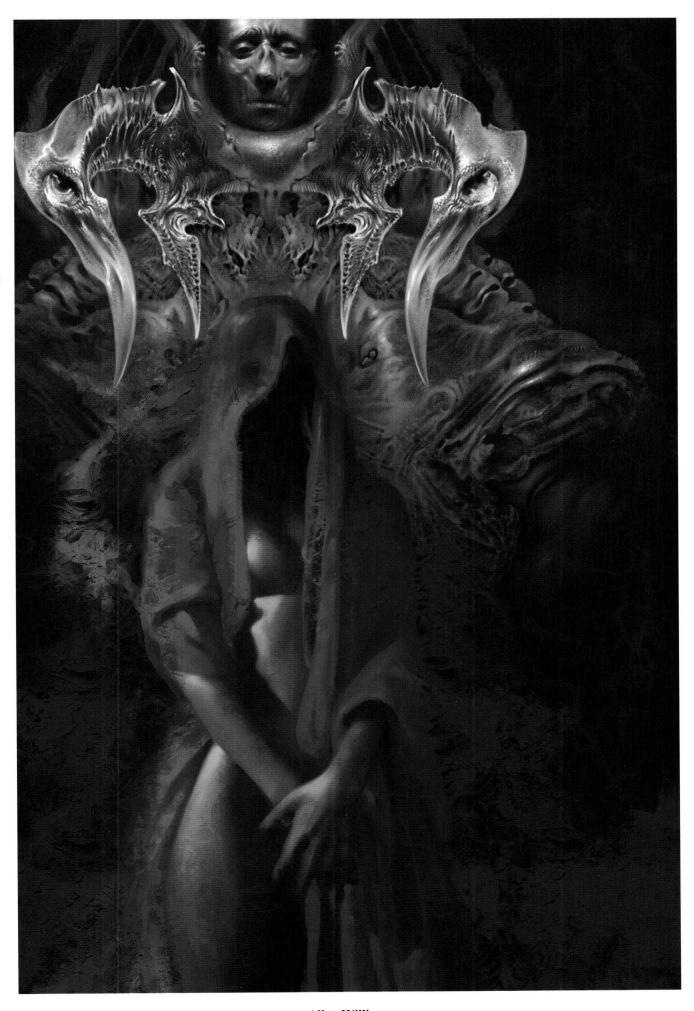

Allen Williams

Art Director: David Palumbo *Client:* Night Shade Books *Title:* The Keeper *Size:* 14"x20" *Medium:* Mixed

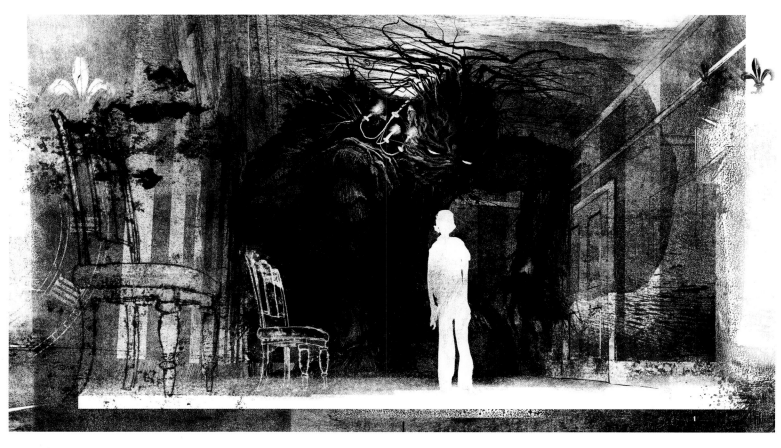

Jim Kay
Art Director: Ben Norland *Client:* Walker Books *Title:* A Monster Calls: Sitting Rooms *Medium:* Digital

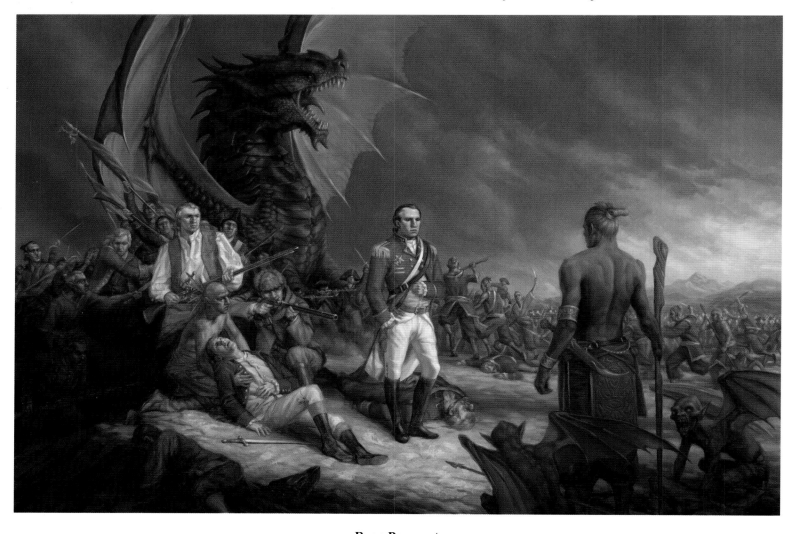

Ryan Pancoast
Art Director: David Palumbo *Client:* Night Shade Books *Title:* Of Limited Loyalty *Size:* 30"x20" *Medium:* Oil on canvas

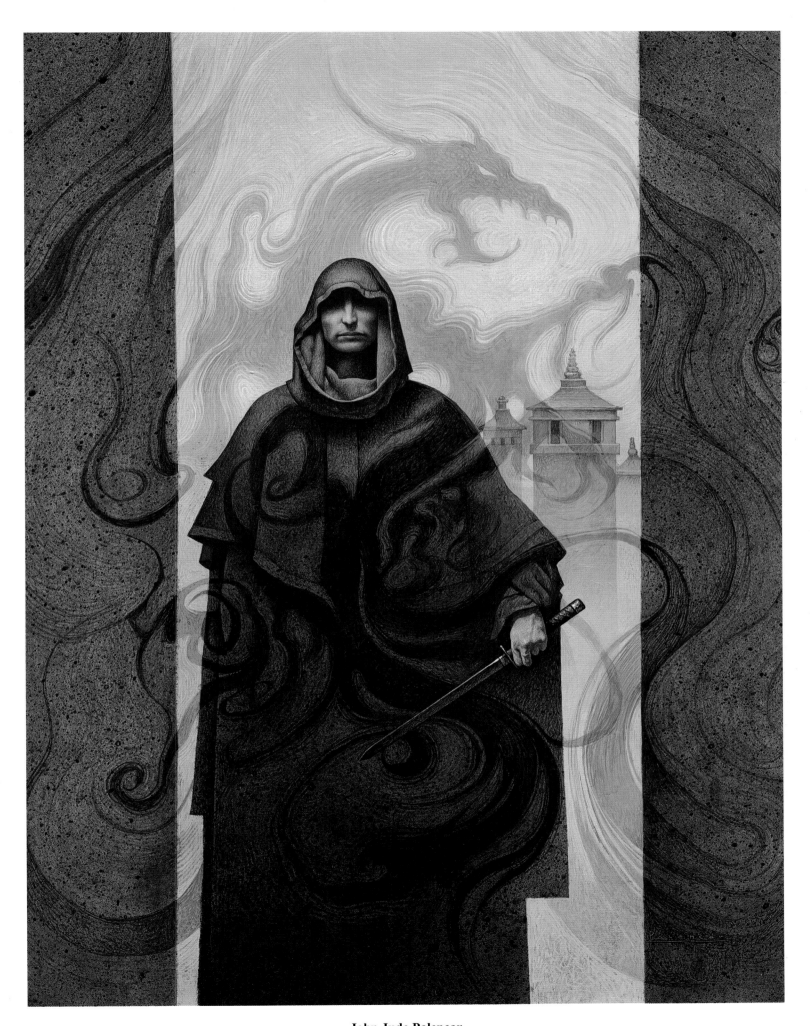

John Jude Palencar

Art Director: Judith Murello *Client:* Ace Books *Title:* The Keeper *Size:* 20"x27" *Medium:* Acrylic

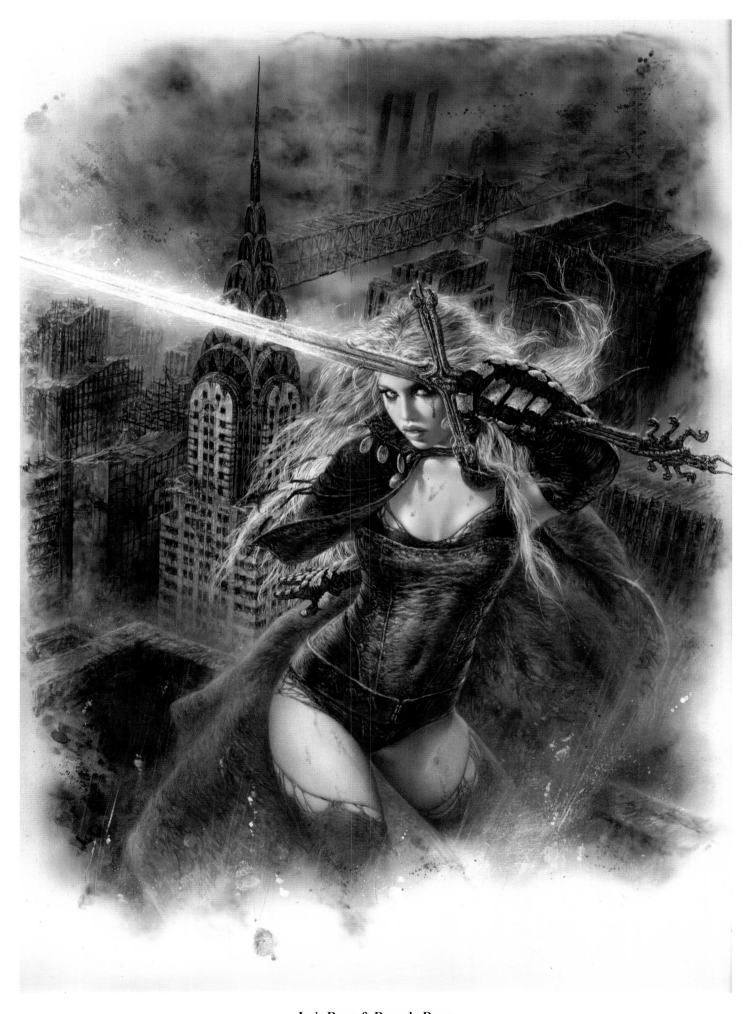

Luis Royo & Romulo Royo
Art Director: Luis Royo & Romulo Royo *Client:* Norma Editorial *Title:* Malefic Time/Apocalypse *Medium:* Colored inks, acrylic

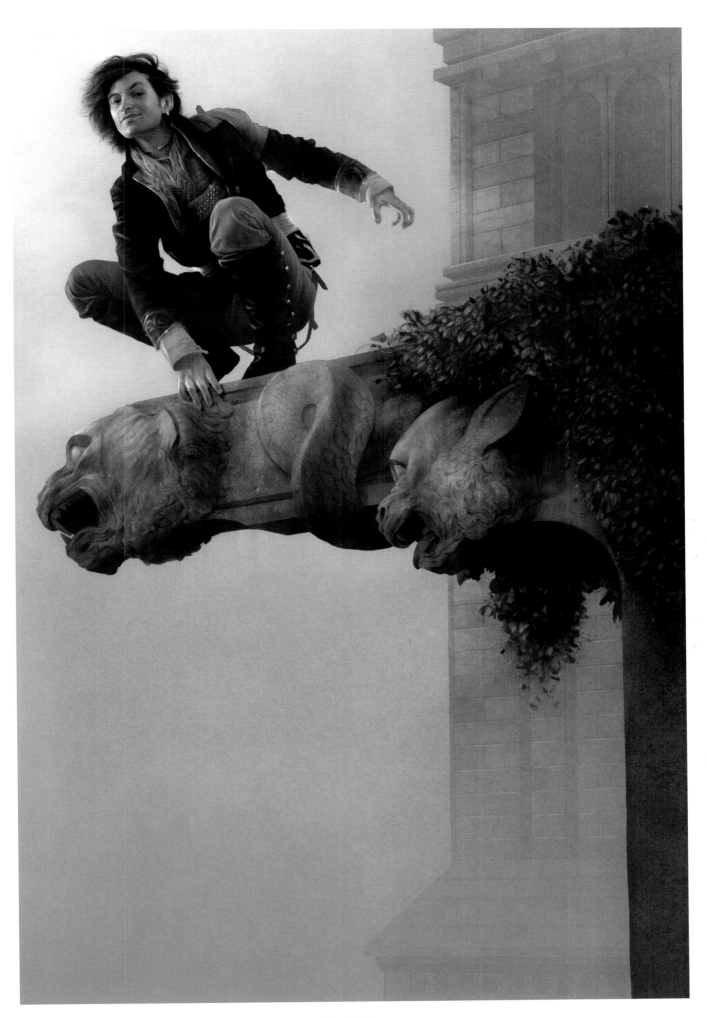

Sam Weber

Art Director: Lauren Panepinto *Client:* Orbit Books *Title:* The Legend of Eli Monpress *Medium:* Acrylic, watercolor, digital

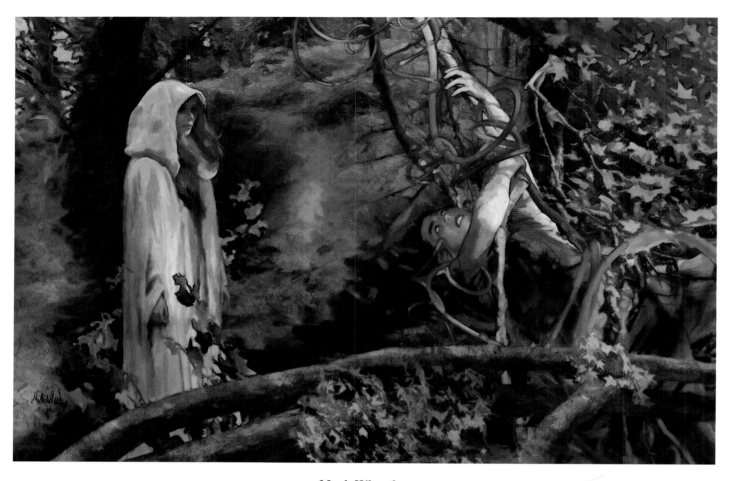

Mark Wheatley
Art Director: Mark Wheatley *Client:* Insight Studios *Title:* Bride of the Forest: Feeding Time *Medium:* Digital

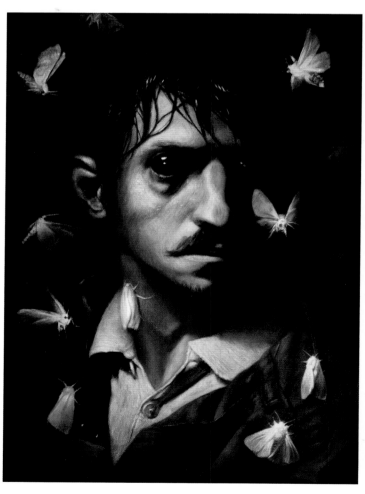

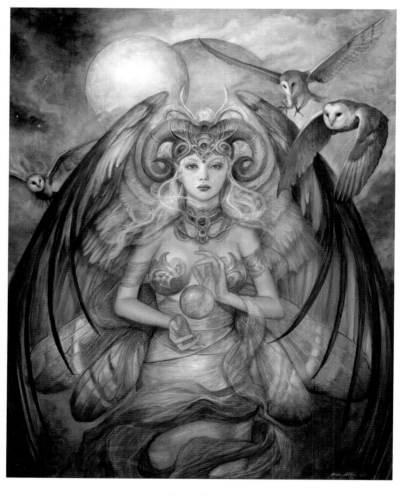

Dragan Bibin
Client: Orfelin Izdavastvo *Title:* Vid the Vampire *Size:* 12"x16" *Medium:* Oil on linen

Annie Stegg
Title: Celestial Muse *Size:* 24"x30" *Medium:* Acrylic on wood

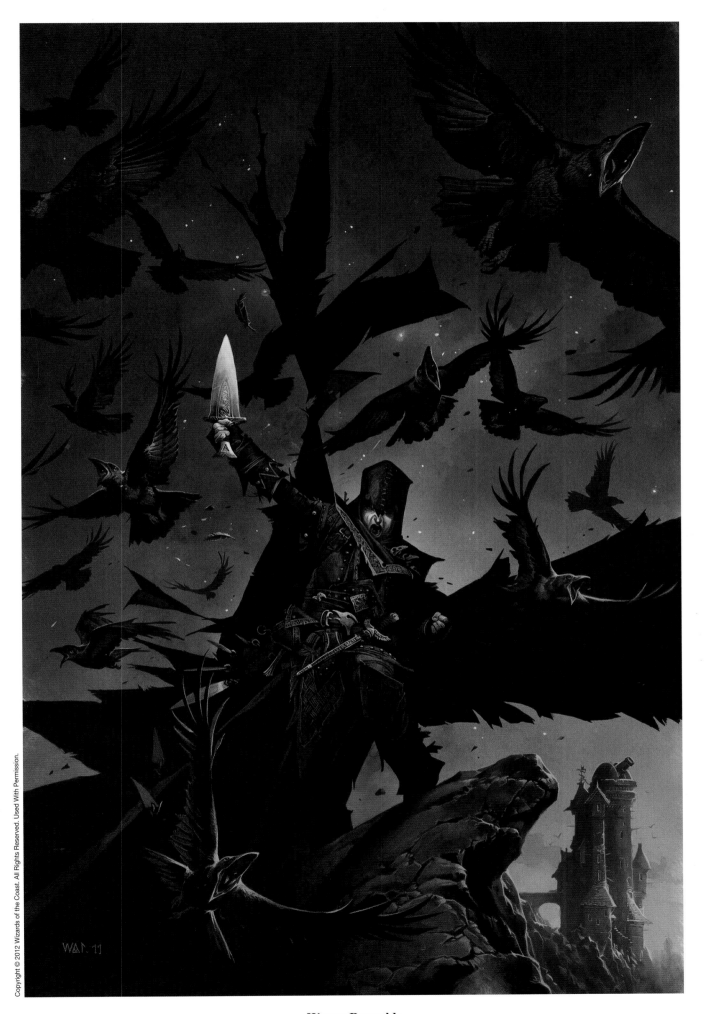

Wayne Reynolds

Art Director: Matt Adelsperger *Client:* Wizards of the Coast *Title:* The Last Garrison *Size:* 10"x20" *Medium:* Acrylic

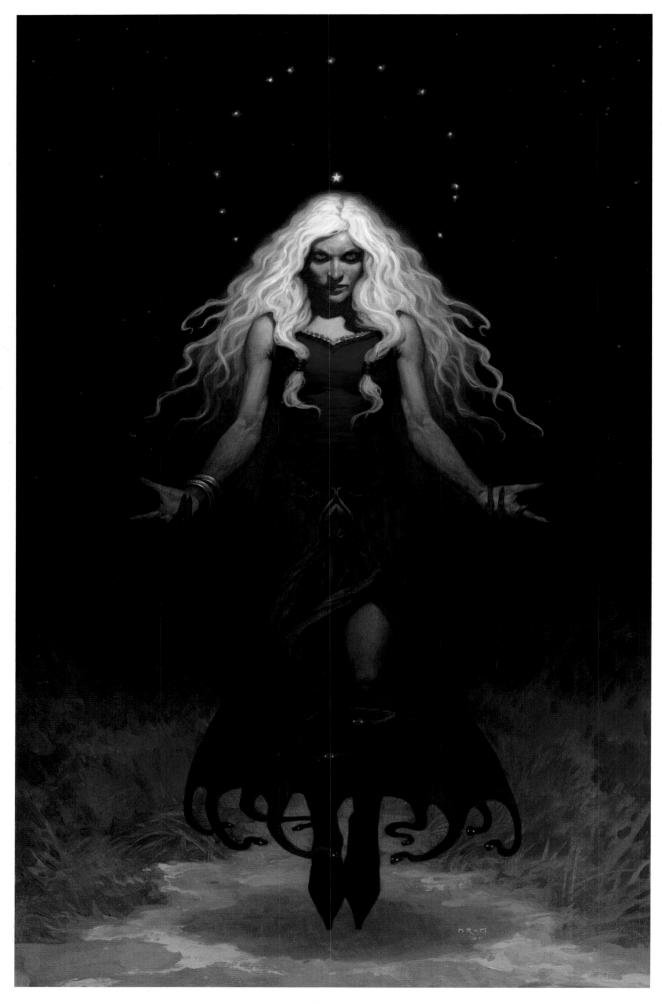

Brom
Client: Eos Books *Title:* Perchta *Size:* 19"x30" *Medium:* Oil

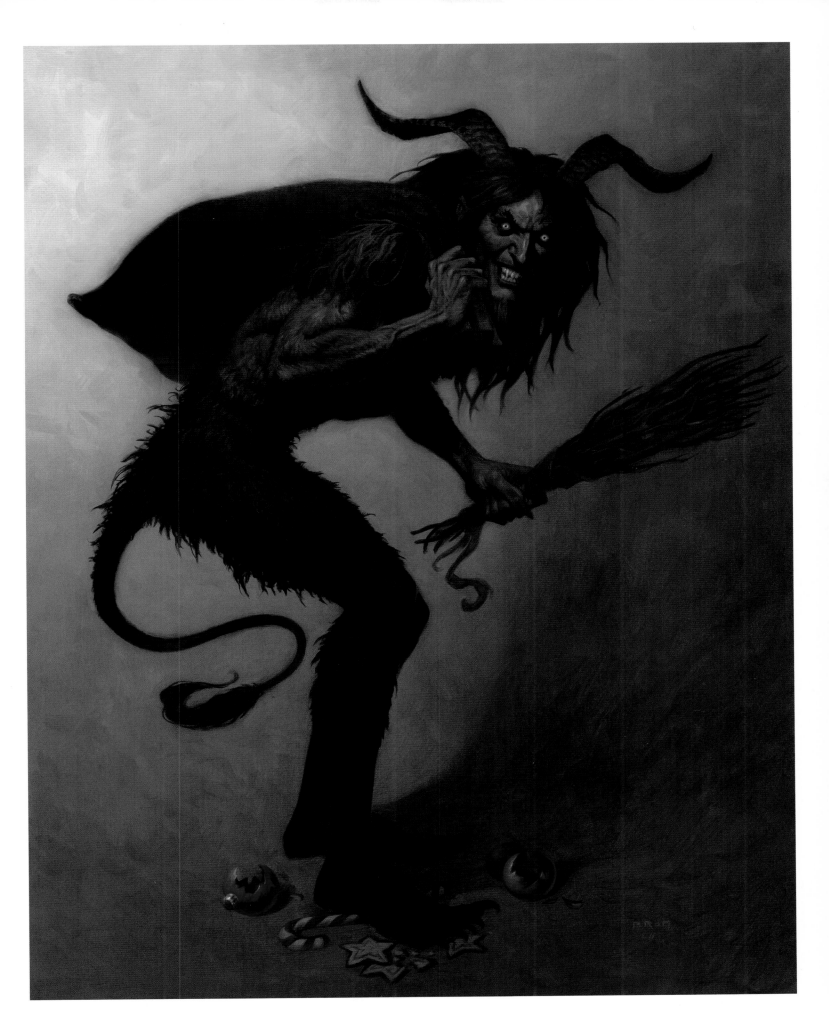

Brom

Client: Eos Books *Title:* Krampus *Size:* 17"x23" *Medium:* Oil

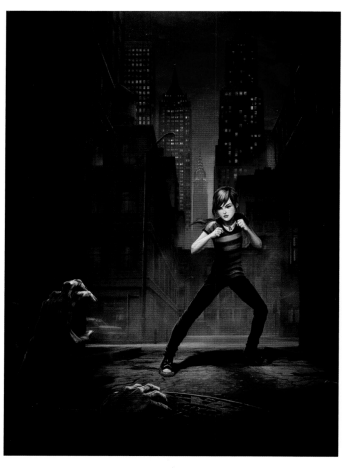

Nigel Quarless

Art Director: Lisa Vega *Client:* Simon & Schuster *Title:* Dead City *Medium:* Digital

Tony Huynh

Art Director: Chris Koehler *Client:* Strange Ghost *Title:* Silenced *Size:* 7"x7.5" *Medium:* Mixed

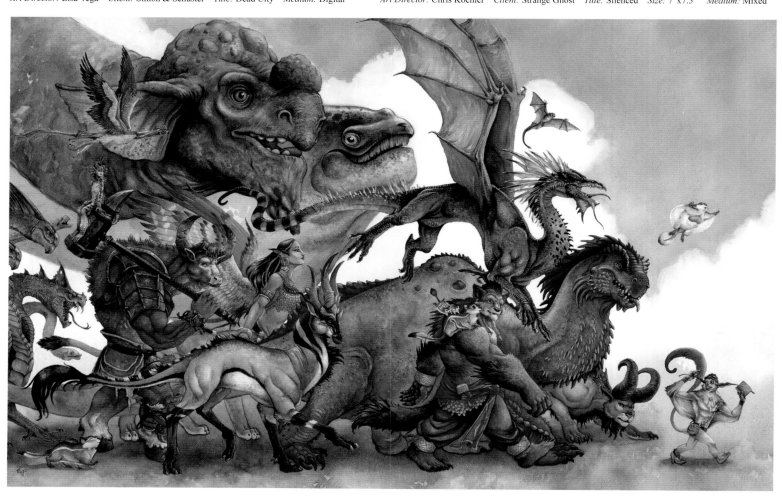

Emily Fiegenschuh

Art Director: Emily Fiegenschuh *Client:* Impact Books *Title:* The Explorer's Guide to Drawing Fantasy Creatures *Size:* 27.5"x17.5" *Medium:* Gouache, Photoshop

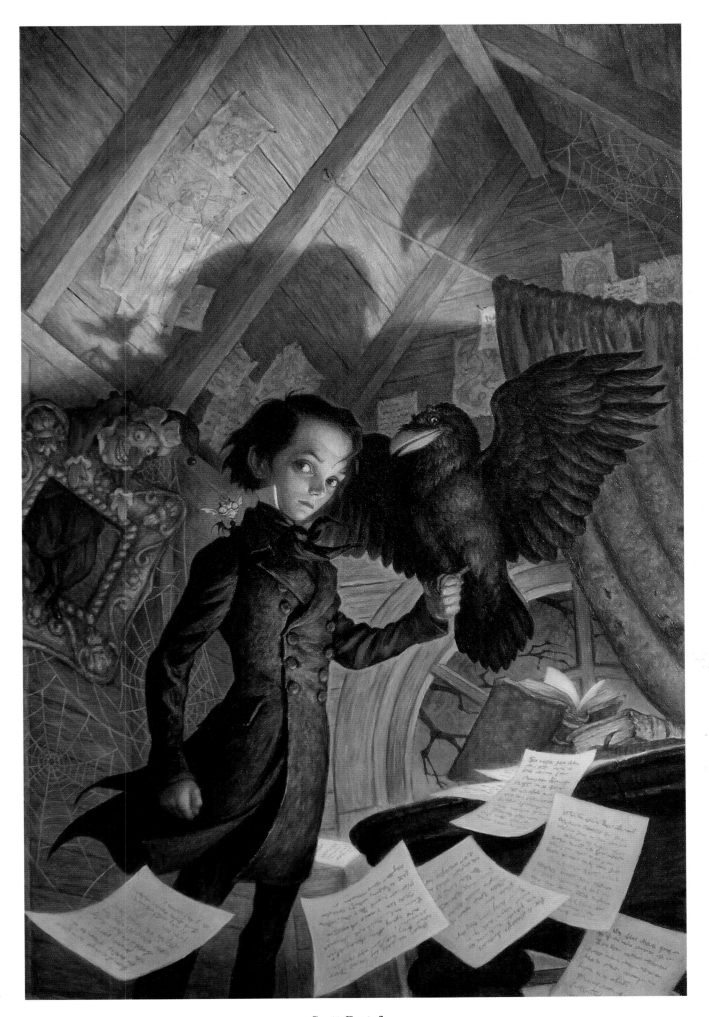

Scott Gustafson

Art Director: Laurent Linn *Client:* Simon & Schuster Books for Young Readers *Title:* Eddie: The Lost Youth of Edgar Allan Poe *Size:* 14"x21" *Medium:* Oil

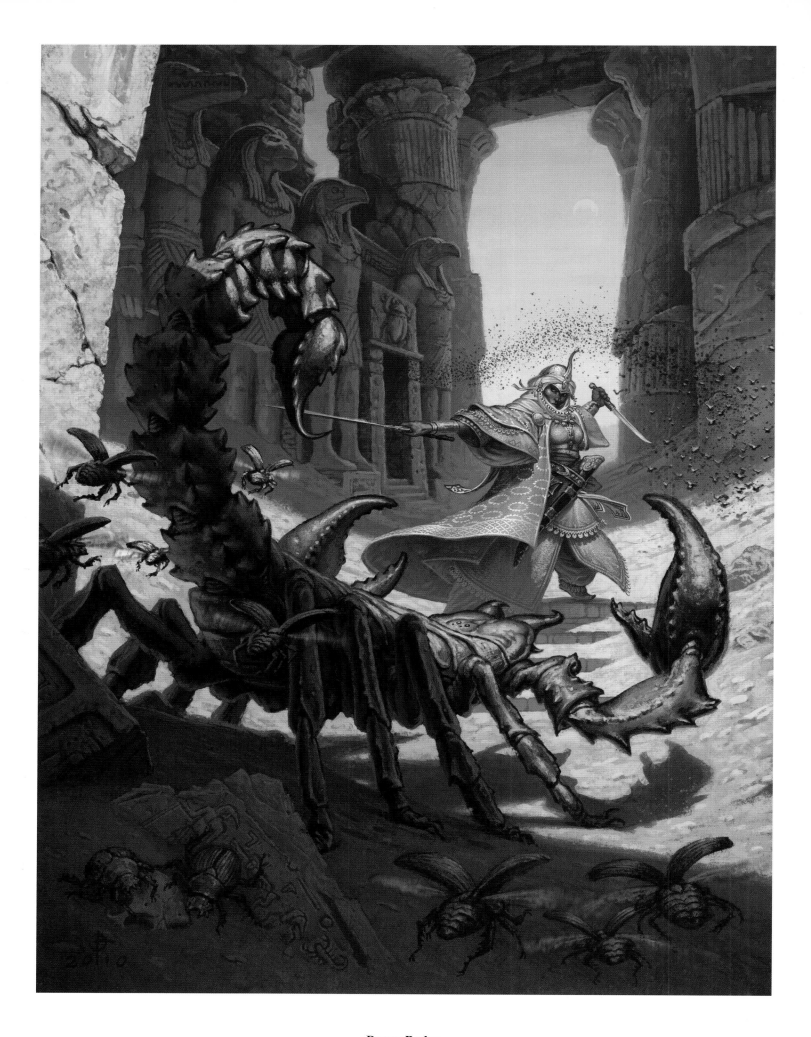

Daren Bader

Art Director: Sarah Robinson *Client:* Paizo *Title:* Lost Cities of Golarion *Size:* 8.5"x11.5" *Medium:* Digital

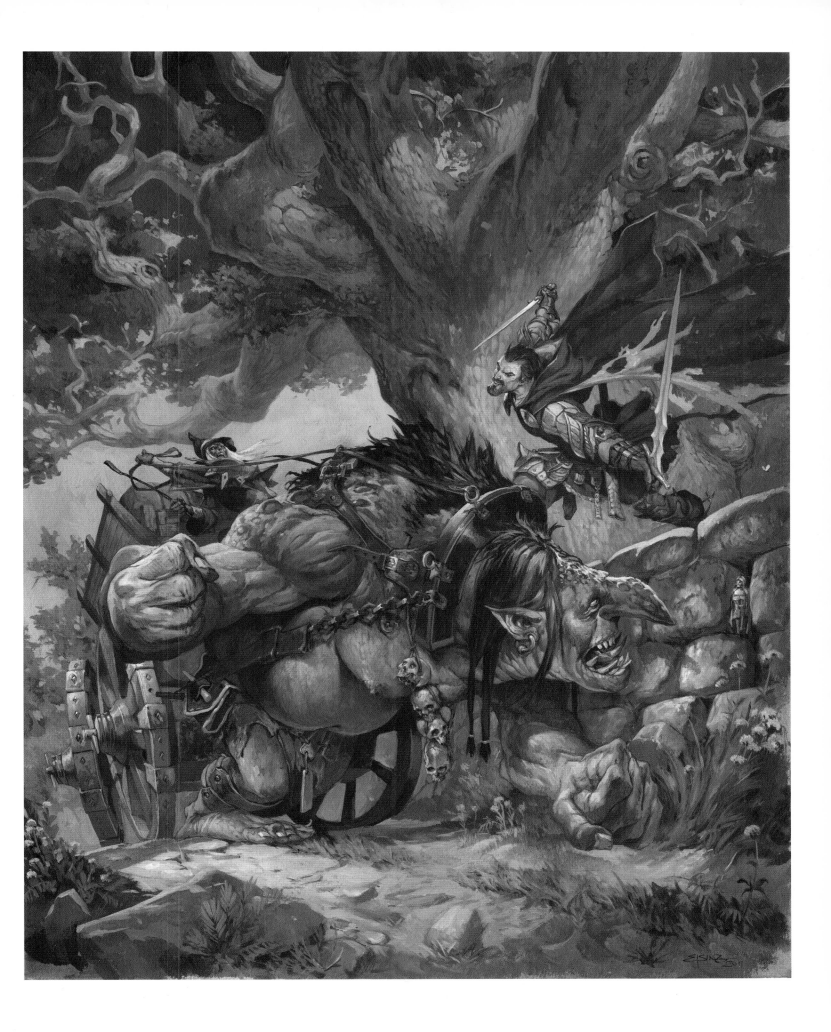

Jesper Ejsing
Art Director: Kate Irwin *Client:* Wizards of the Coast *Title:* Dale Lands *Size:* 40cm x 50cm *Medium:* Acrylic

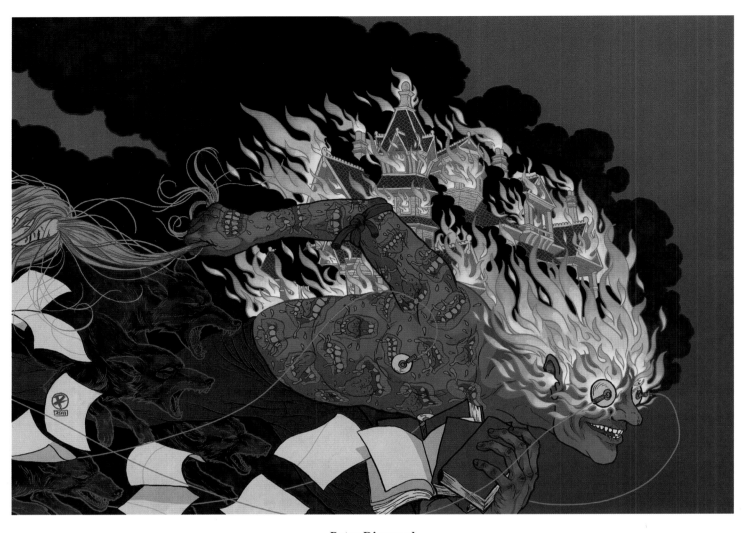

Peter Diamond
Art Director: Anil Nataly *Client:* Chômo Press *Title:* The Orphan Palace *Size:* 22"x17" *Medium:* Ink, digital

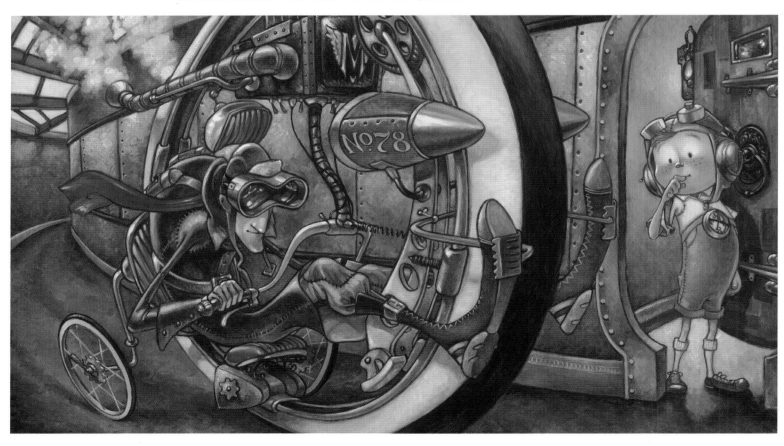

Heather Theurer
Client: Channel Photographics *Title:* Thaddeus the Boss *Size:* 20"x11.25" *Medium:* Oil

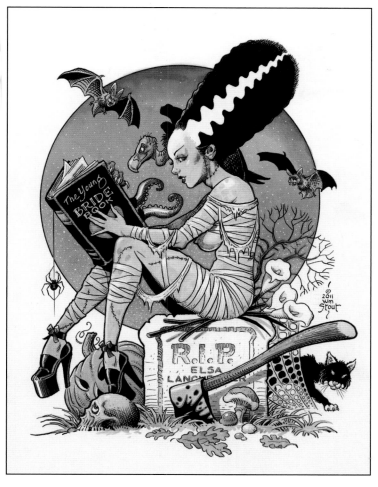

William Stout

Client: Terra Nova Press *Title:* Bridal Dreams *Size:* 9"x12" *Medium:* Ink, watercolor

Matt Dixon

Client: SQP, Inc. *Title:* Caught Changing *Medium:* Digital

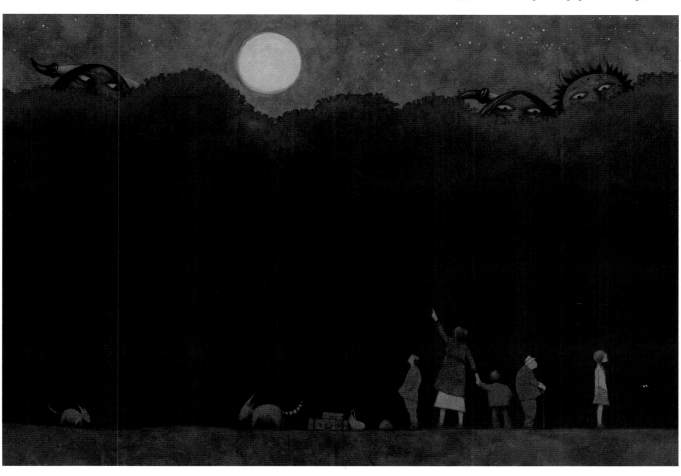

Paul Hess

Art Director: Judith Escreet *Client:* Francis Lincoln *Title:* Troll Wood *Size:* 19"x13" *Medium:* Watercolor

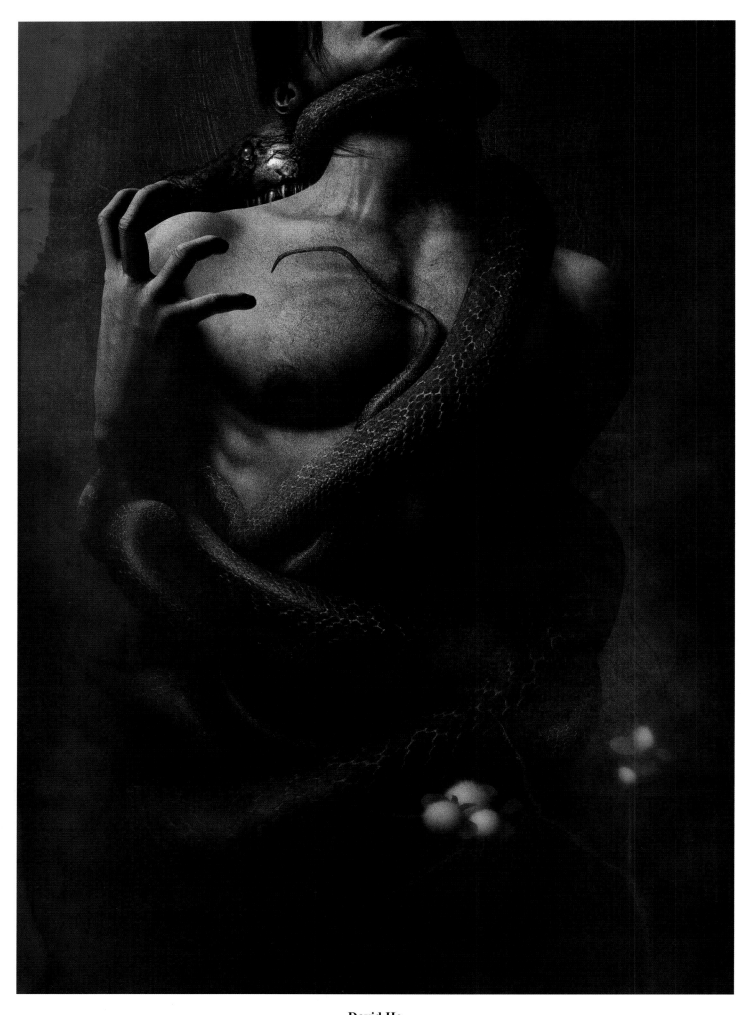

David Ho

Art Director: Jerad Walters *Client:* Centipede Press *Title:* All Heads Turn When The Hunt Goes By *Size:* 7"x10" *Medium:* Digital

Tom Kidd
Art Director: William Schafer *Client:* Subterranean Press
Title: The Inheritance Homecoming *Size:* 18"x24" *Medium:* Oil

Dragan Bilbin
Client: Orfelin Izdavastvo *Title:* Vampires and Witches
Size: 18"x22.5" *Medium:* Oil on linen

Todd Lockwood
Art Director: Betsy Wollheim *Client:* DAW Books *Title:* The Awakening *Medium:* Digital

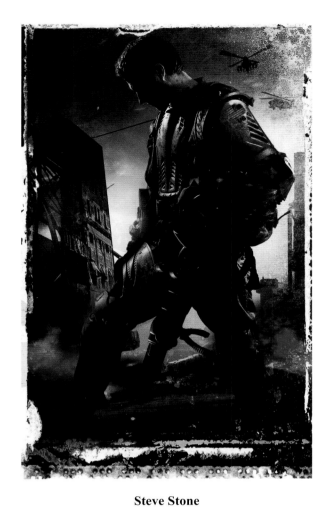

Gregory Manchess

Art Director: Irene Gallo *Client:* Tor Books *Title:* Firaxe *Medium:* Oil on linen

Steve Stone

Art Director: Lauren Panepinto *Client:* Orbit Books *Title:* Germline *Medium:* Digital

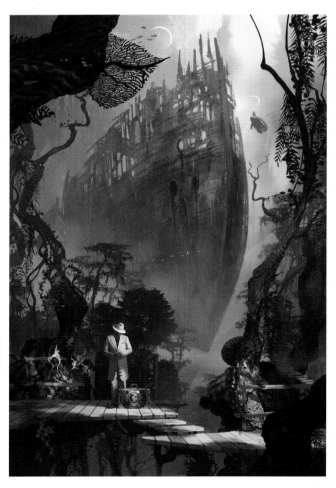

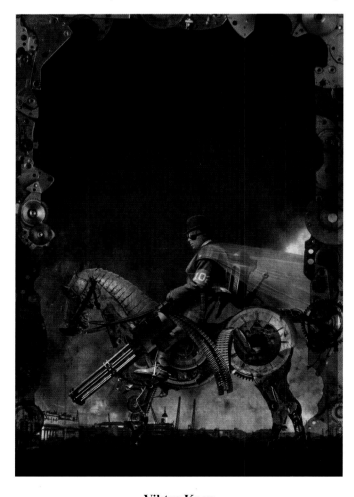

Thomas Tenery

Art Director: Irene Gallo *Client:* Tor Books *Title:* Stations of the Tide *Medium:* Digital

Viktor Koen

Art Director: Irene Gallo *Client:* Tor Books *Title:* The Immorality Engine *Medium:* Digital

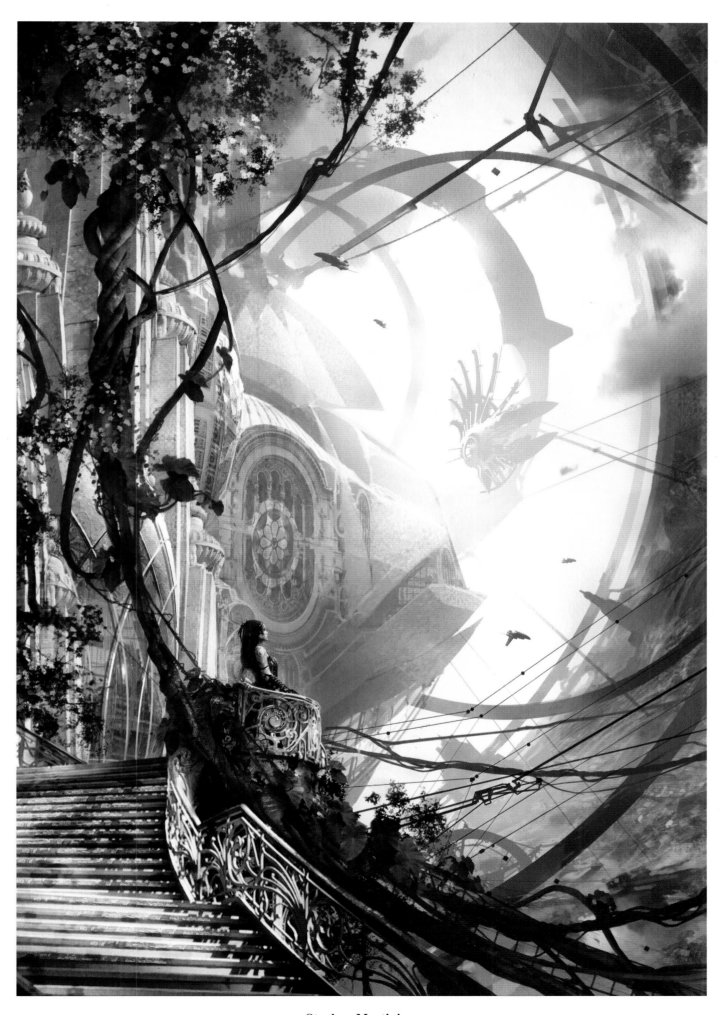

Stephan Martiniere
Art Director: Irene Gallo *Client:* Tor Books *Title:* Ashes of Candesce *Medium:* Digital

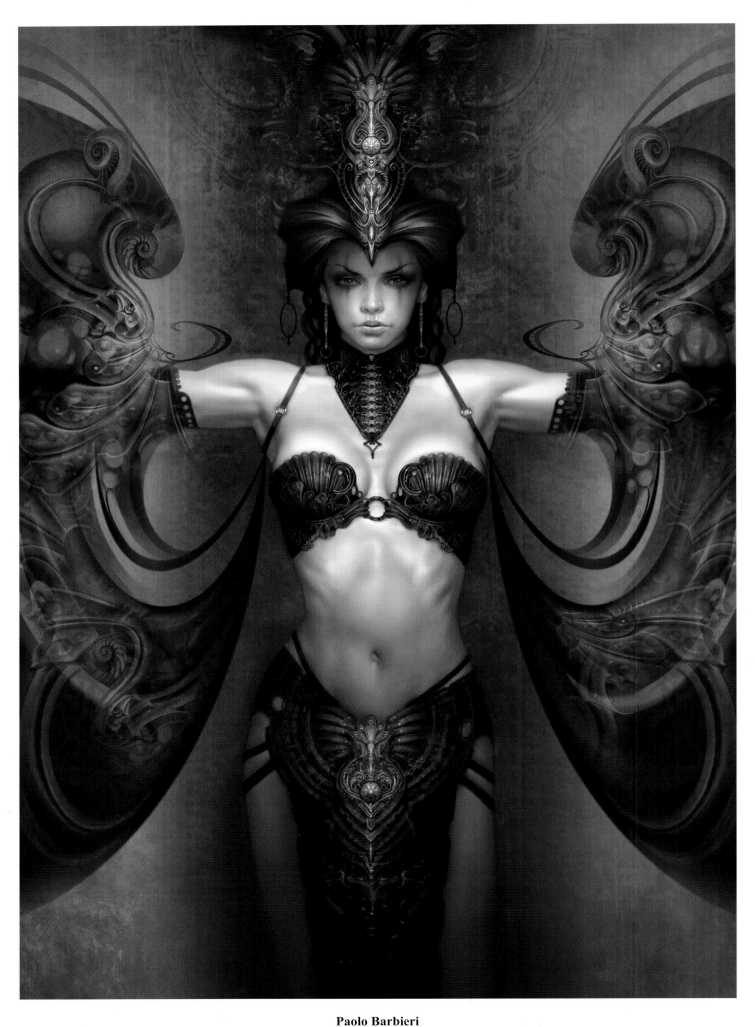

Paolo Barbieri

Art Director: Fernando Ambrosi *Client:* Arnoldo Mondadori Editore *Title:* Afrodite [from *Favole degli Dei*] *Medium:* Digital

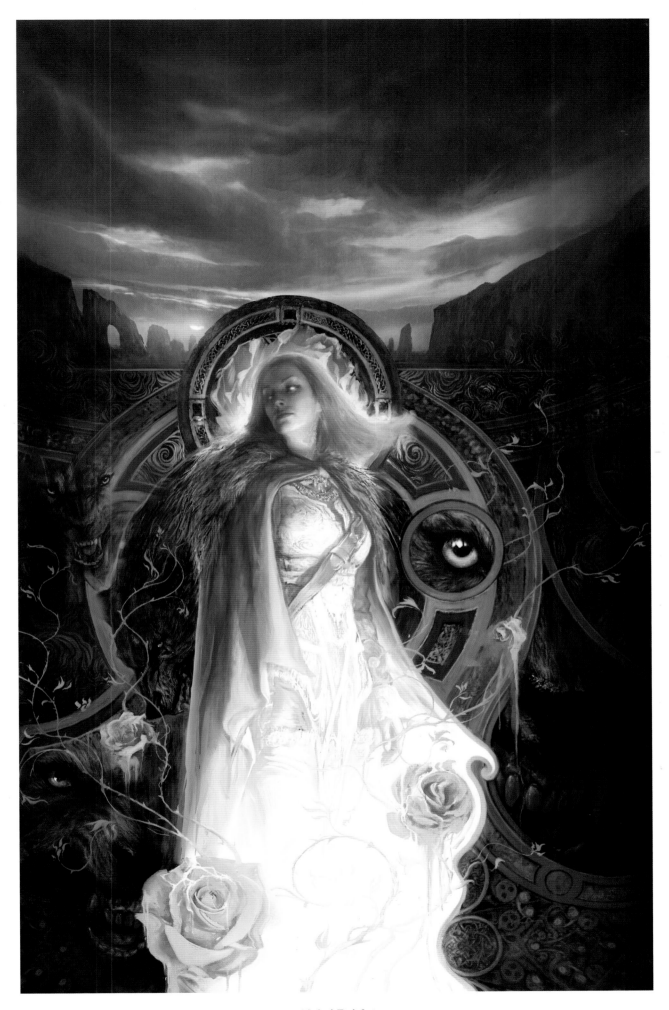

Aleksi Briclot

Art Director: Matt Adelsperger *Client:* Wizards of the Coast *Title:* The Rose of Sarifal *Medium:* Digital

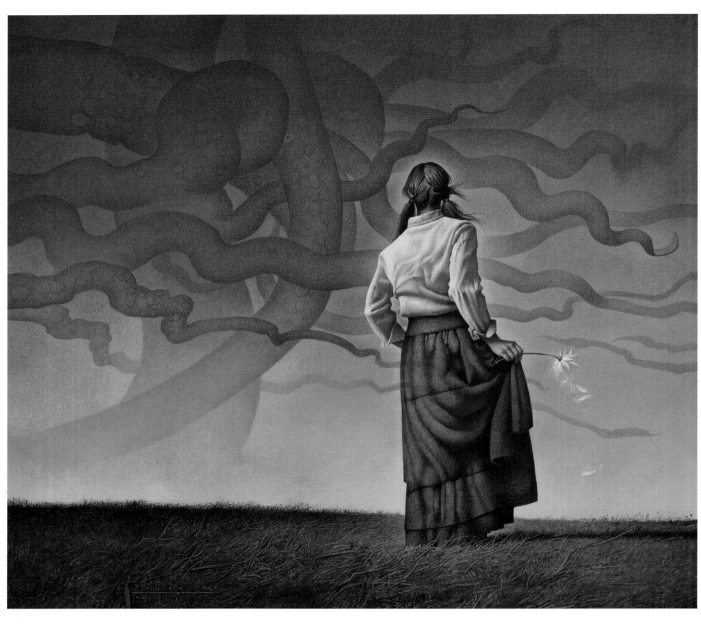

John Jude Palencar
Art Director: Irene Gallo *Client:* Tor Books *Title:* Alternate Future *Size:* 34"x32" *Medium:* Acrylic

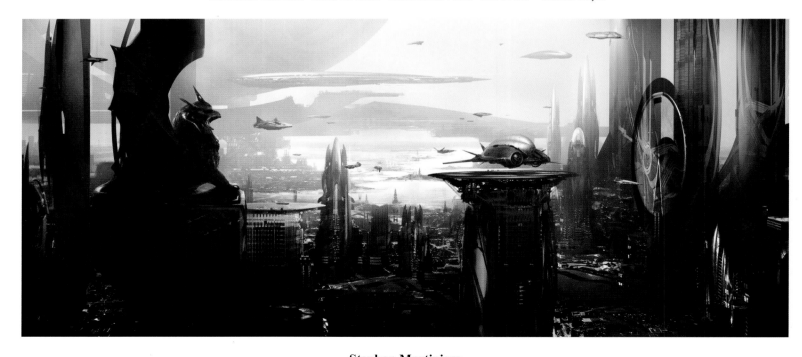

Stephan Martiniere
Client: Abrams *Title:* New Coruscant *Medium:* Digital

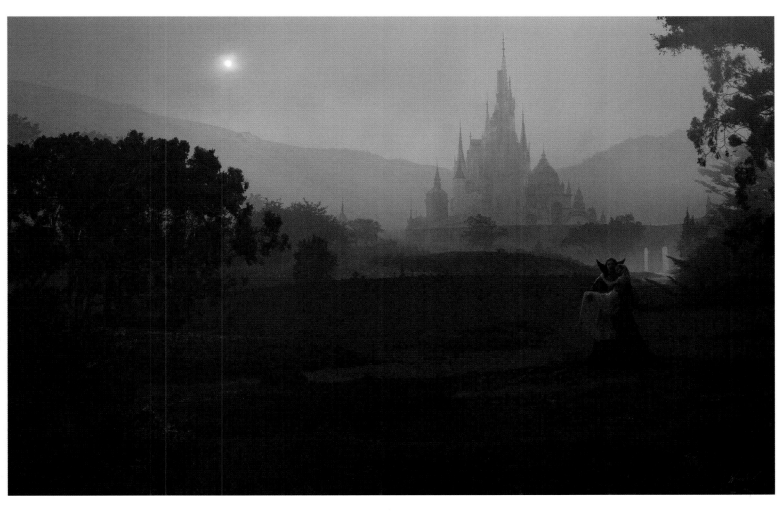

Bruno Werneck

Art Director: Jasmine Becket-Griffith *Client:* Ilex Press [UK] *Title:* Spark of Sentiment *Size:* 17"x11" *Medium:* Digital

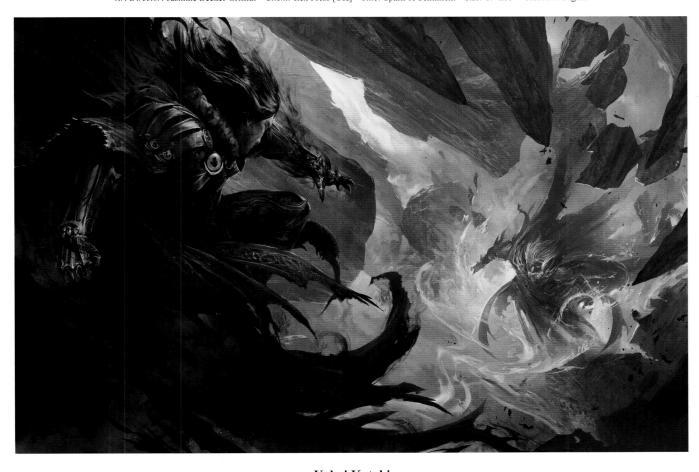

Kekai Kotaki

Art Director: Matt Adelsperger *Client:* Wizards of the Coast *Title:* Bury Elminster Deep *Medium:* Digital

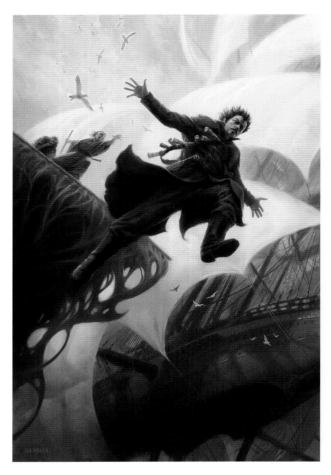

Todd Lockwood
Art Director: David Palumbo *Client:* Night Shade Books
Title: Leap *Medium:* Digital

Paul Youll
Art director: Scott Biel *Client:* Random House
Title: Yoda [*Star Wars Essential Reader's Guide*] *Medium:* Mixed

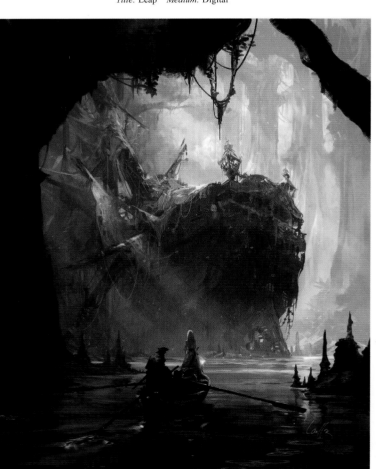

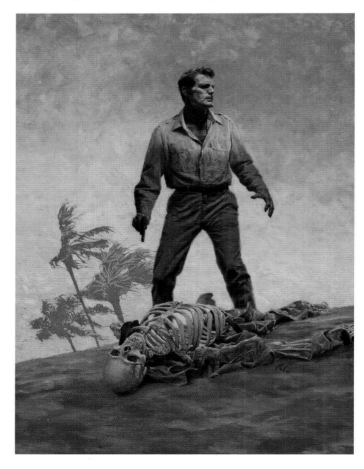

Mathieu Lauffray
Client: Dargaud *Title:* Long John Silver 3 *Medium:* Photoshop

Ken Laager
Art Director: Bill Schafer *Client:* Subterranean Press *Title:* Dangerous Ways
Size: 14.5"x20" *Medium:* Oil on canvas

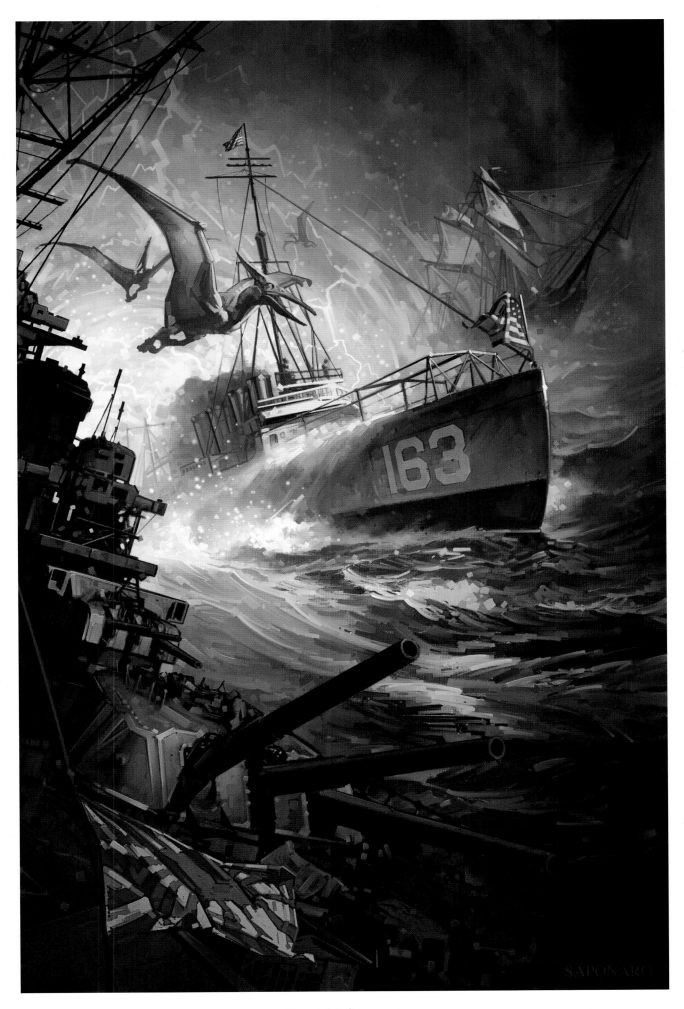

Dominick Saponaro

Art Director: Matthew Kalamidas *Client:* The Science Fiction Book Clup *Title:* Destroyermen: Unknown Seas *Size:* 13"x20" *Medium:* Mixed, digital

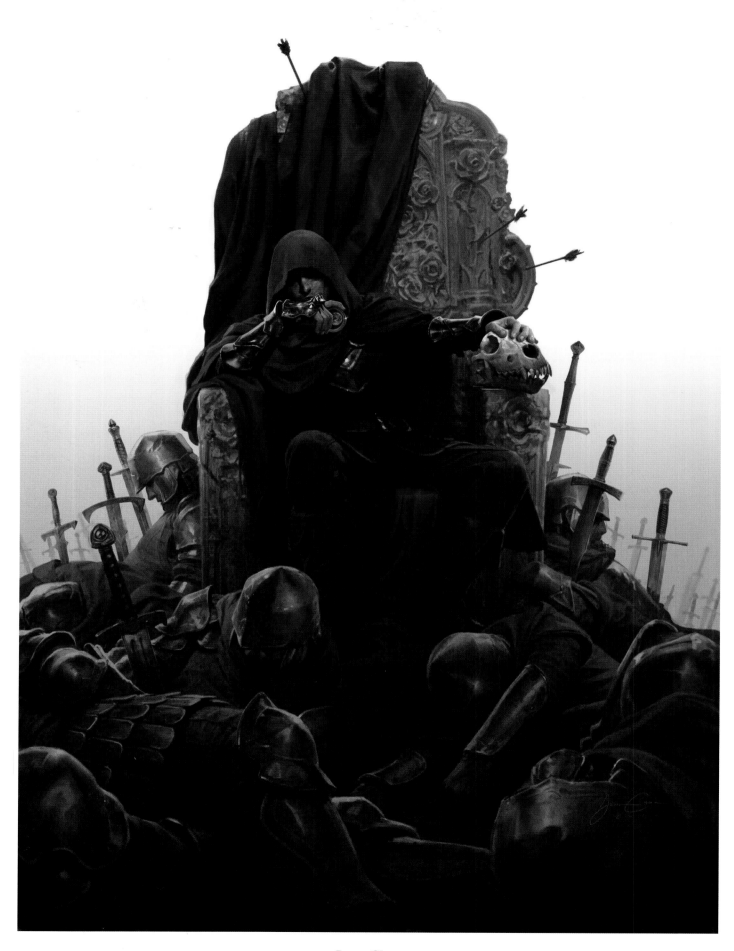

Jason Chan
Art Director: Judith Murello *Client:* Penguin Group *Title:* King of Thorns *Size:* 14"x20" *Medium:* Digital

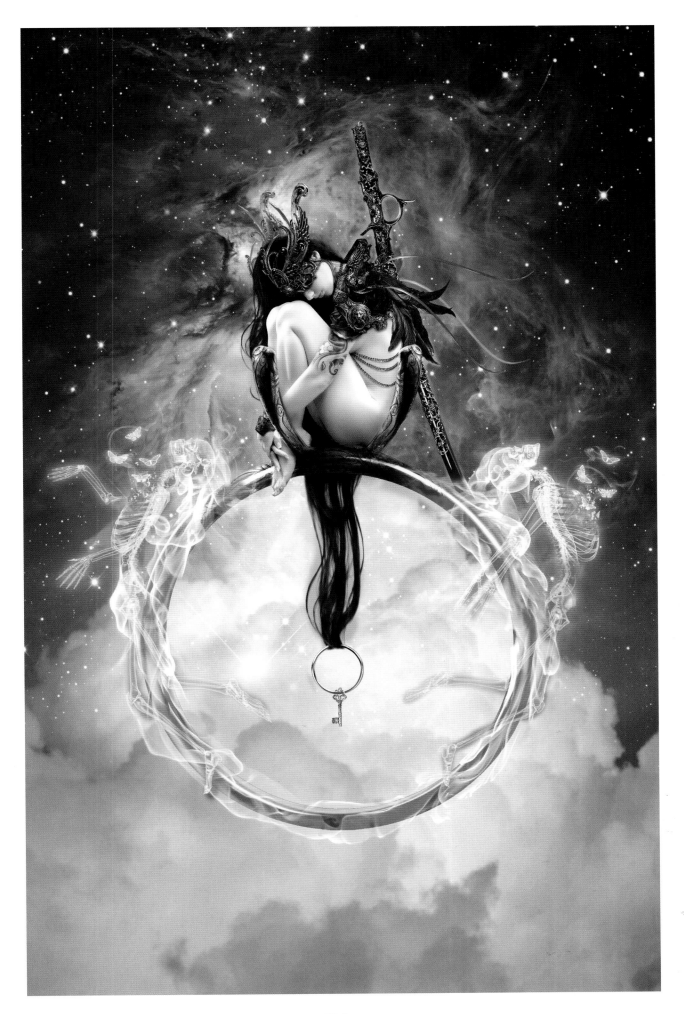

Nekro

Art Director: Nekro *Client:* Norma Editorial *Title:* Yoda: Nebular [from *Skeleton Key*] *Medium:* Digital

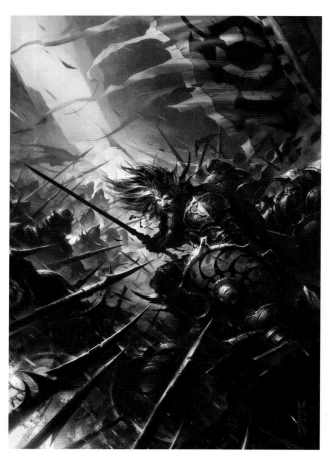

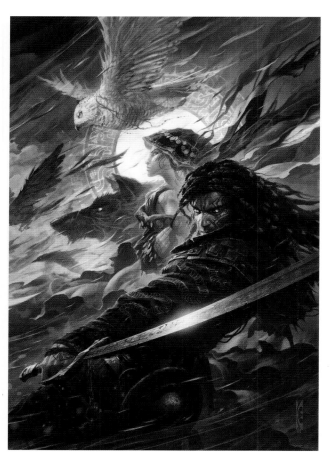

Raymond Swanland
Art Director: David Palumbo *Client:* Night Shade Books
Title: An Ill Fate Marshalling *Medium:* Digital

Raymond Swanland
Art Director: Lou Anders *Client:* Pyr Books
Title: Blackdog *Medium:* Digital

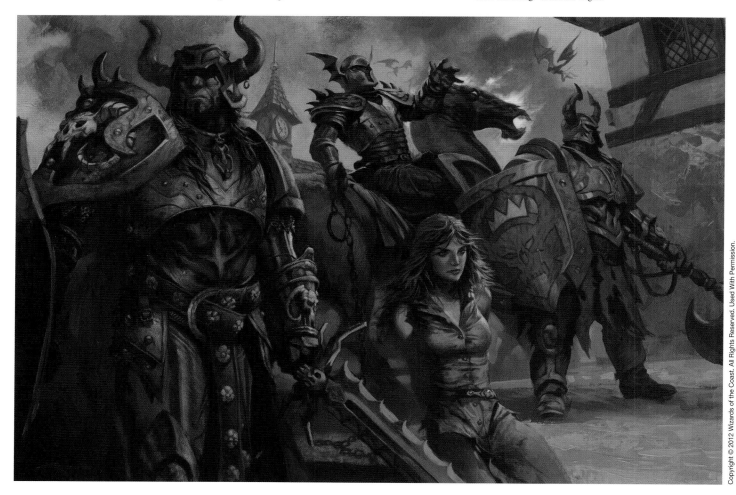

Christopher Moeller
Art Director: Mari Kolkowski *Client:* Wizards of the Coast *Title:* Brigands *Size:* 21"x14" *Medium:* Acrylic on board

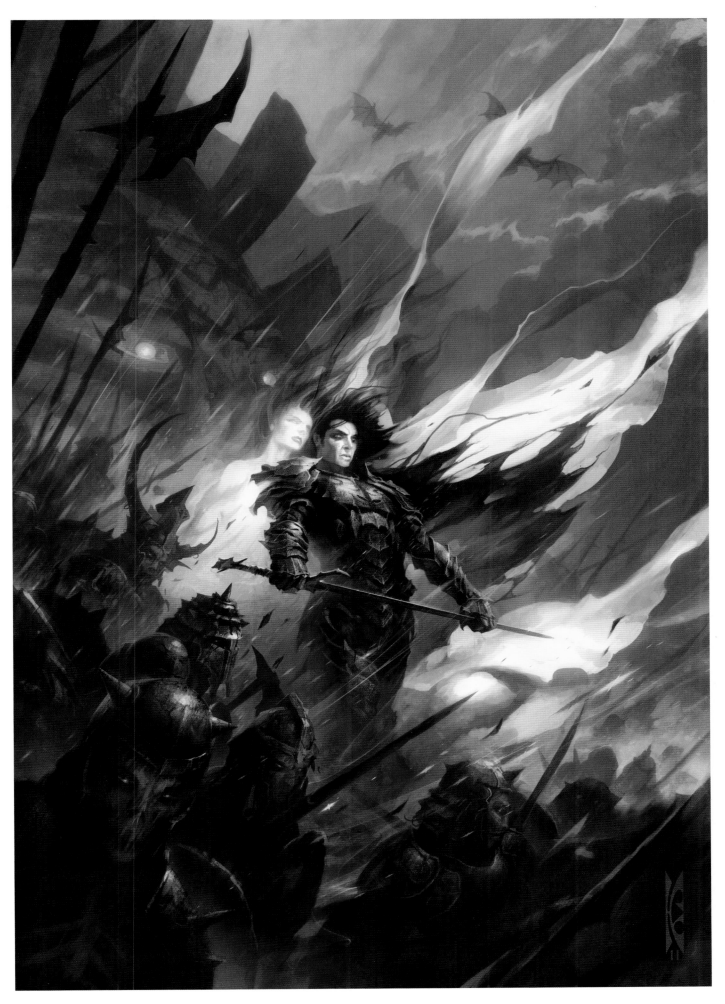

Raymond Swanland

Art Director: David Palumbo *Client:* Night Shade Books *Title:* Reap the East Wind *Medium:* Digital

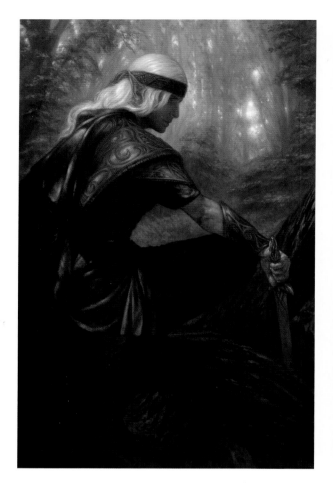

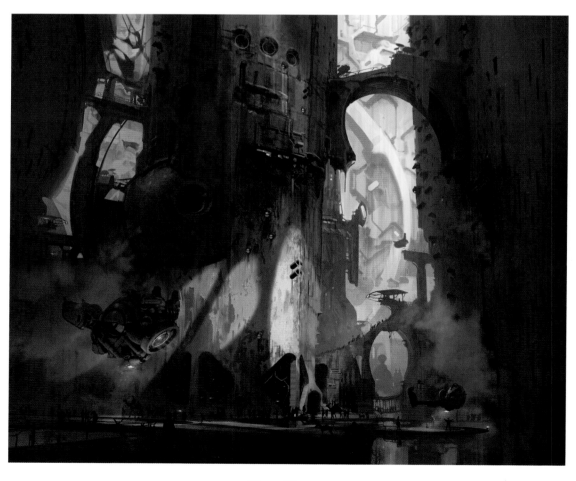

Volkan Baga

Art Director: Nele Schütz *Client:* Heyne Verlag
Title: Elf *Size:* 16.1"x14.8" *Medium:* Oil

Tyler Jacobson

Art Director: Kate Irwin *Client:* Wizards of the Coast
Title: Web of the Spider Queen *Medium:* Digital

Thom Tenery
Client: Design Studio Press *Title:* Shiva

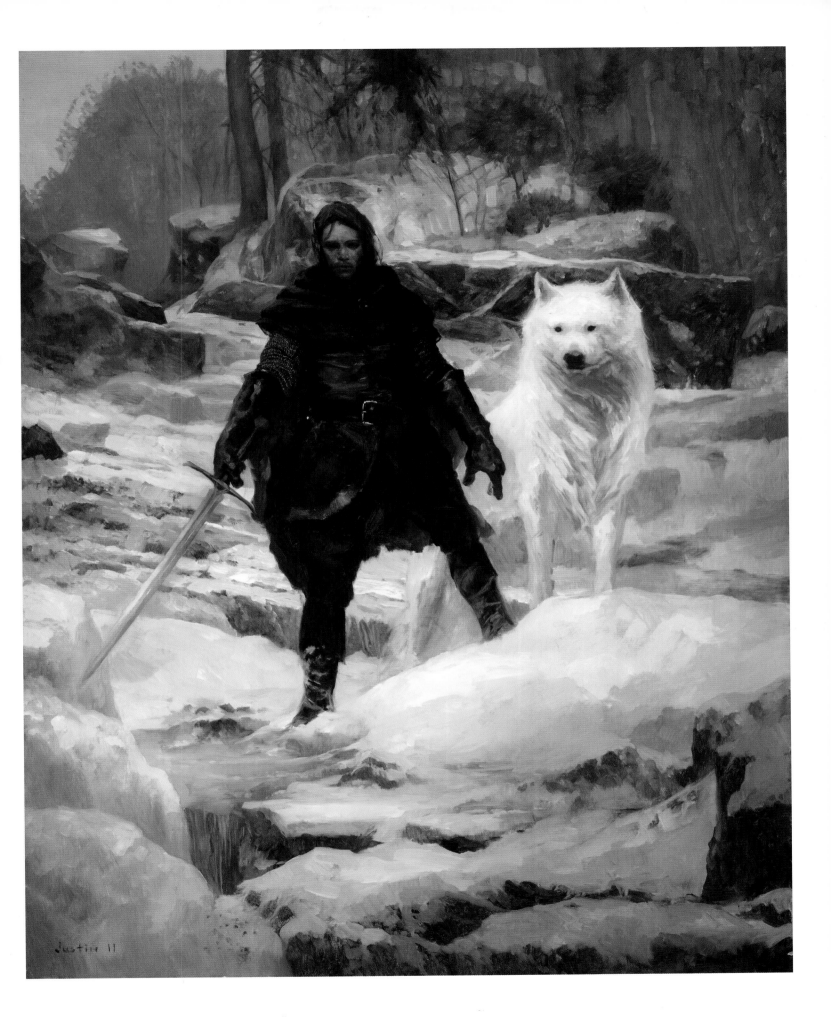

Justin Sweet

Art Director: George R.R. Martin *Client:* Random House *Title:* Jon Snow *Size:* 32"x40" *Medium:* Oil

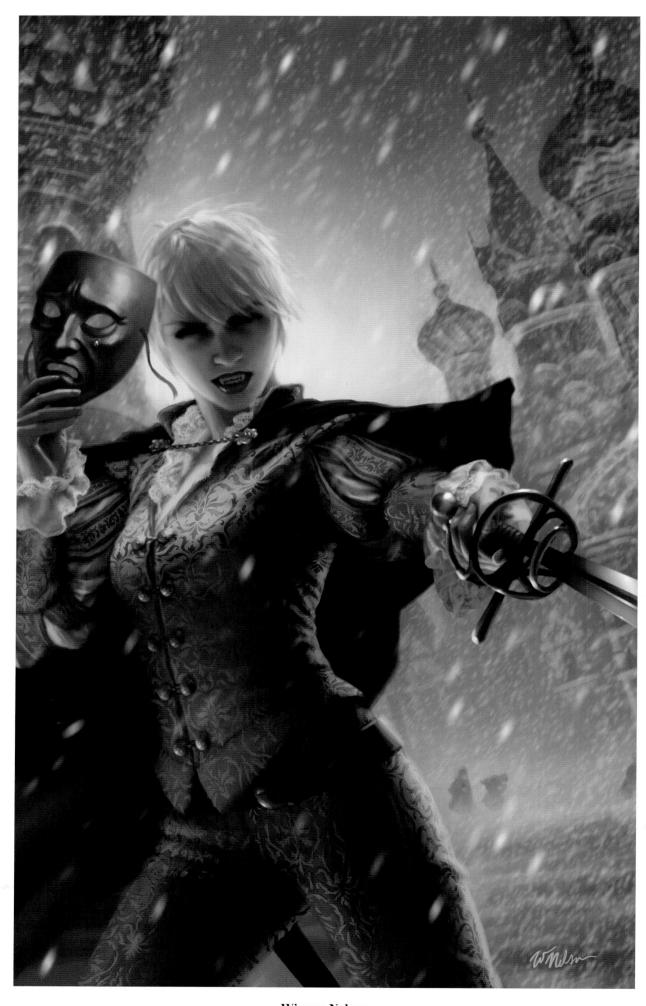

Winona Nelson
Art Director: Darius Hinks *Client:* Games Workshop *Title:* Bloodforged *Size:* 12.5"x20" *Medium:* Digital

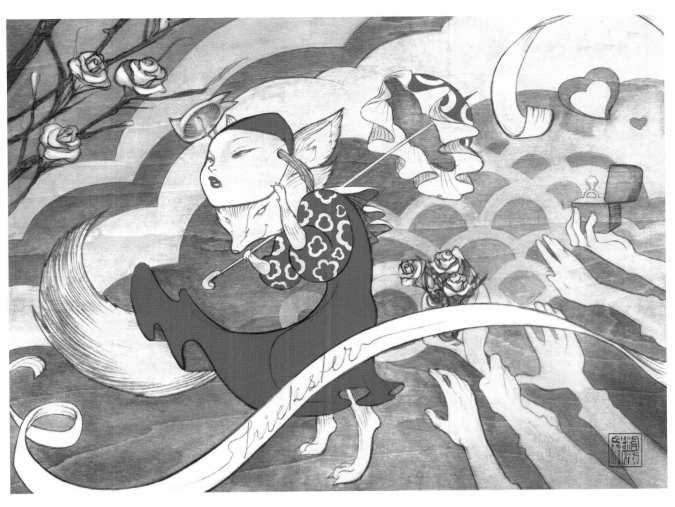

Sho Murase
Art Director: Sho Murase *Client:* Trickster Anthology *Title:* Trickster *Medium:* Gouache on wood

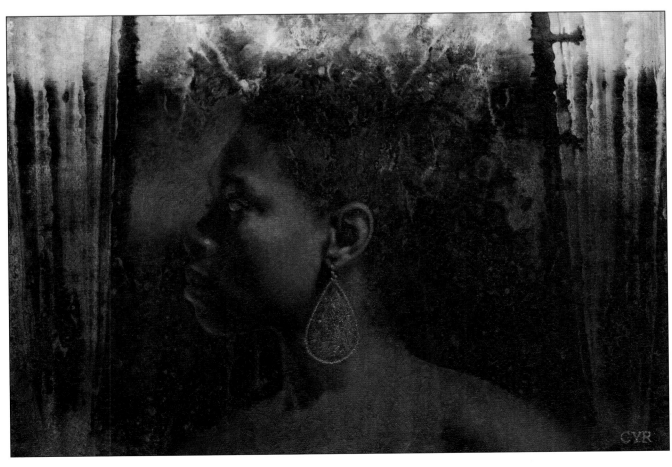

Lisa L. Cyr
Designer: Guy Kelly *Client:* North Light Books *Title:* African Dreamer *Size:* 14.75"x10.75" *Medium:* Mixed

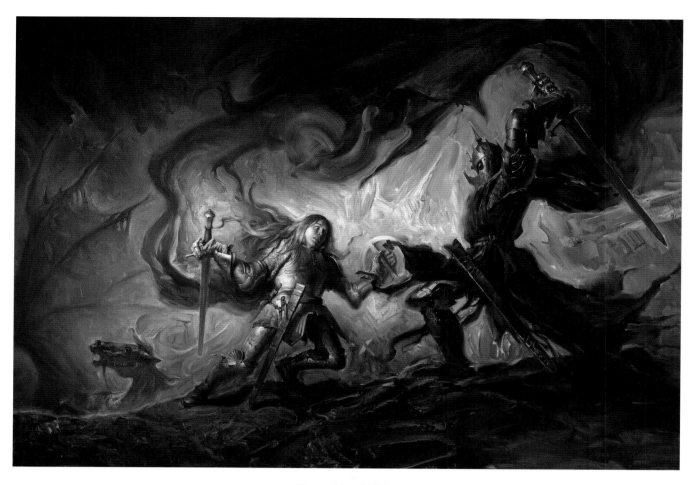

Petar Meseldžija
Client: Jim Reid *Title:* Eowyn and the Lord of the Nazgul *Size:* 39.4"x27.2" *Medium:* Oil on wood

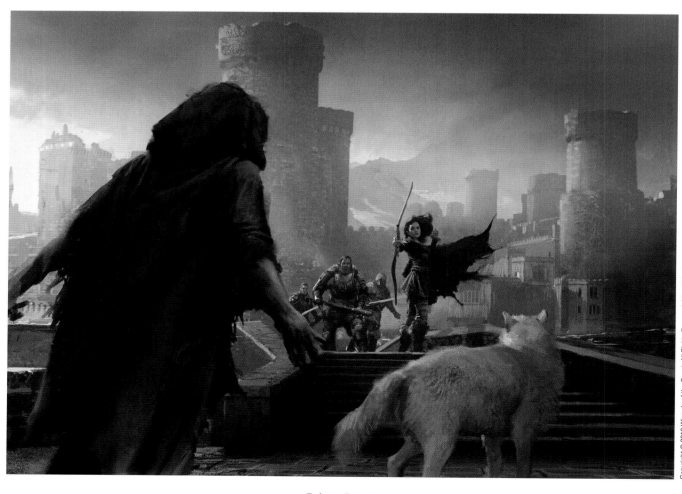

Jaime Jones
Art Director: Matt Adelsperger *Client:* Wizards of the Coast *Title:* Cry of the Ghost Wolf *Medium:* Digital

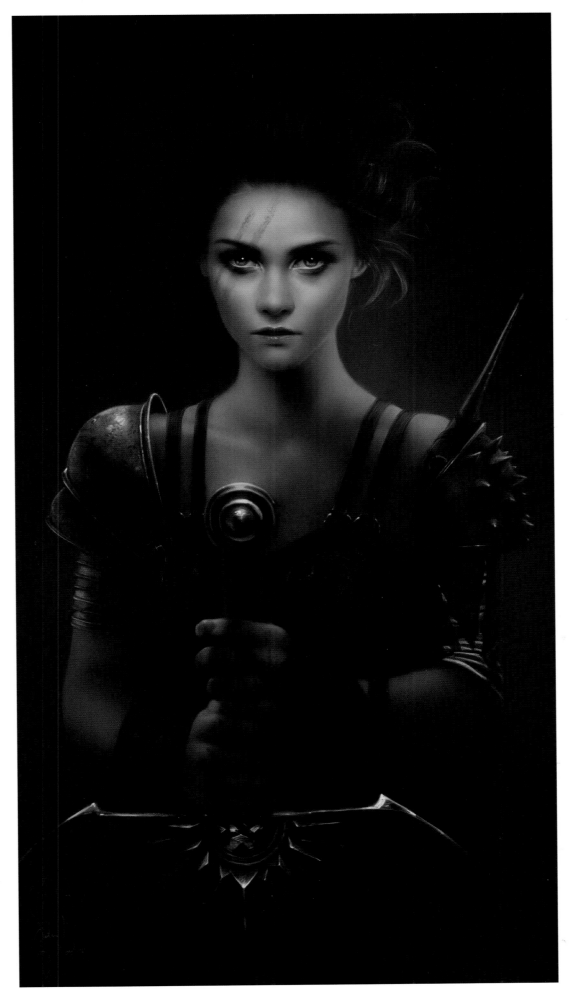

Mélanie Delon
Art Director: Mélanie Delon *Client:* Norma Editorial *Title:* War [from *Tales Vol. 1*] *Medium:* Digital

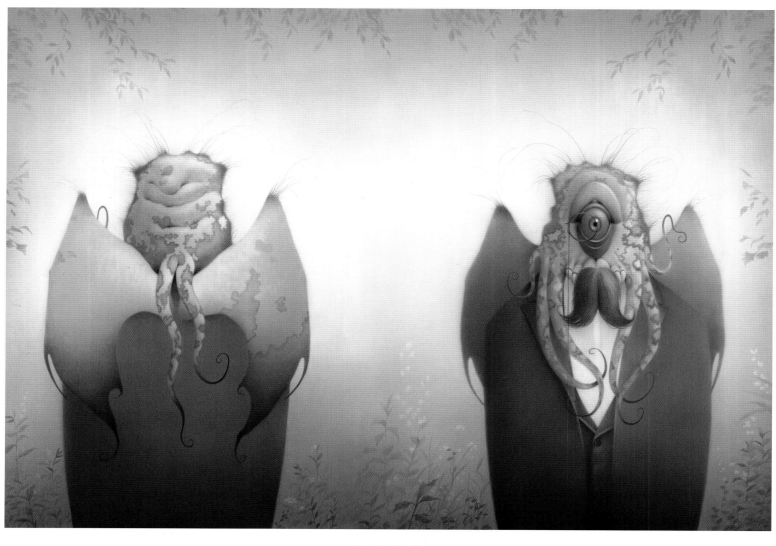

Travis Louie

Art Director: Paul Buckley *Designer:* Paul Buckley *Client:* Viking/Penguin *Title:* Call of Cthulhu and Other Weird Tales *Size:* 17"x11.25" *Medium:* Acrylic on board

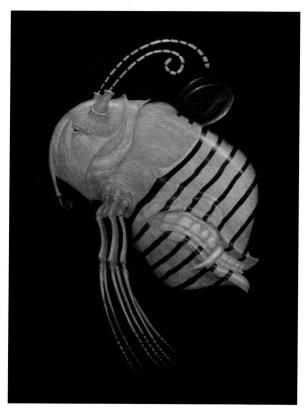

Bill Carman

Art Director: Bill Carman *Title:* Beesbite *Size:* 5"x7" *Medium:* Acrylic on copper

Jim Burns

Art Director: Pete Crowther *Client:* PS Publishing *Title:* Arkangel *Medium:* Digital

Shaun Tan

Art Director: Shaun Tan *Designer:* Phil Falco *Client:* Arthur A. Levine Books/Scholastic, Inc. *Title:* Lost & Found *Size:* 30cm x40cm *Medium:* Oil

Charles Harbour
Client: Immersion Press *Title:* The Immersion Book of Steampunk *Medium:* Digital

Erin McGuire
Art Director: Carla Weiss *Client:* Harper Collins *Title:* Breadcrumbs *Medium:* Digital

Emily Fiegenschuh
Art Director: Emily Fiegenschuh *Client:* Impact Books *Title:* Crowned Ibak *Size:* 16.25"x10.25" *Medium:* Gouache

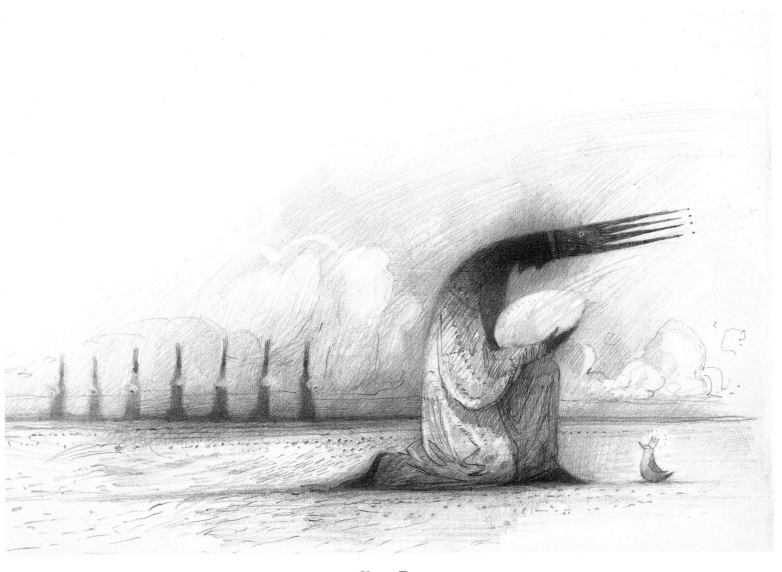

Shaun Tan

Art Director: Shawn Tan *Client:* Windy Hollow Books *Title:* The Bird King: The Eight Eggs *Size:* 30cm x 20cm *Medium:* Pencil

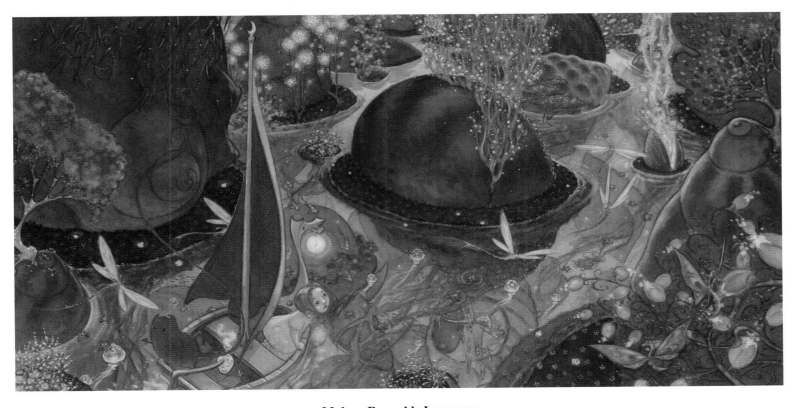

Malene Reynolds Laugesen

Client: Rosinante & Co. *Title:* Havkongens Have [The Sea King's Garden] *Medium:* Watercolor, gouache, pencil

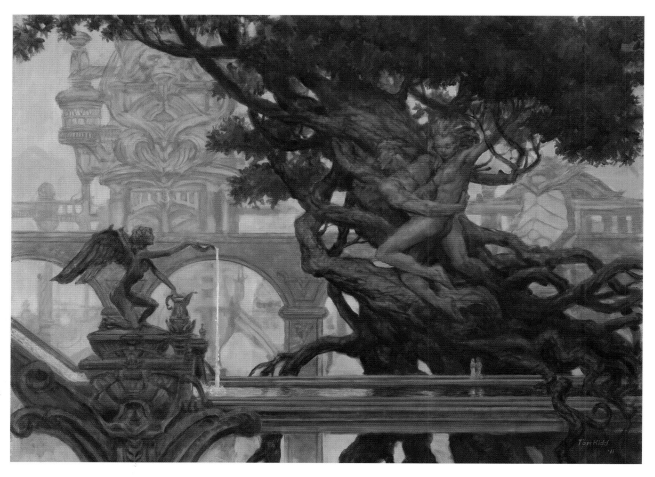

Tom Kidd

Art Director: William Schafer *Client:* Subterranean Press *Title:* Dying of the Light/Nothing So Melancholy *Size:* 18"x14" *Medium:* Oil

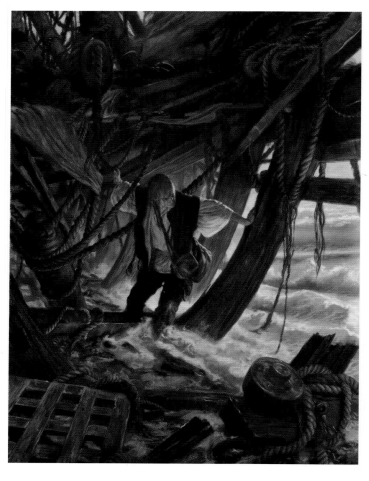

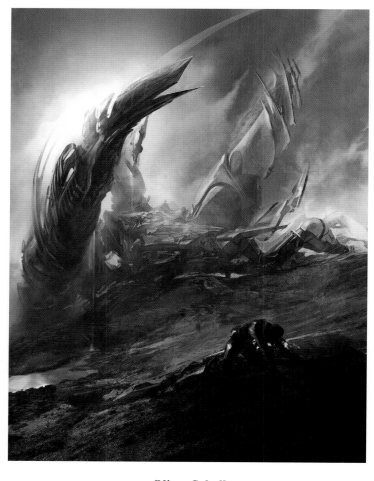

Donato Giancola

Art Director: Irene Gallo *Client:* Tor Books *Title:* Scholar—Robinson Crusoe

Size: 36"x48" *Medium:* Oil on panel

Oliver Scholl

Client: Design Studio Press *Title:* CabCake

Title: 41.9"x54.7" *Medium:* Digital

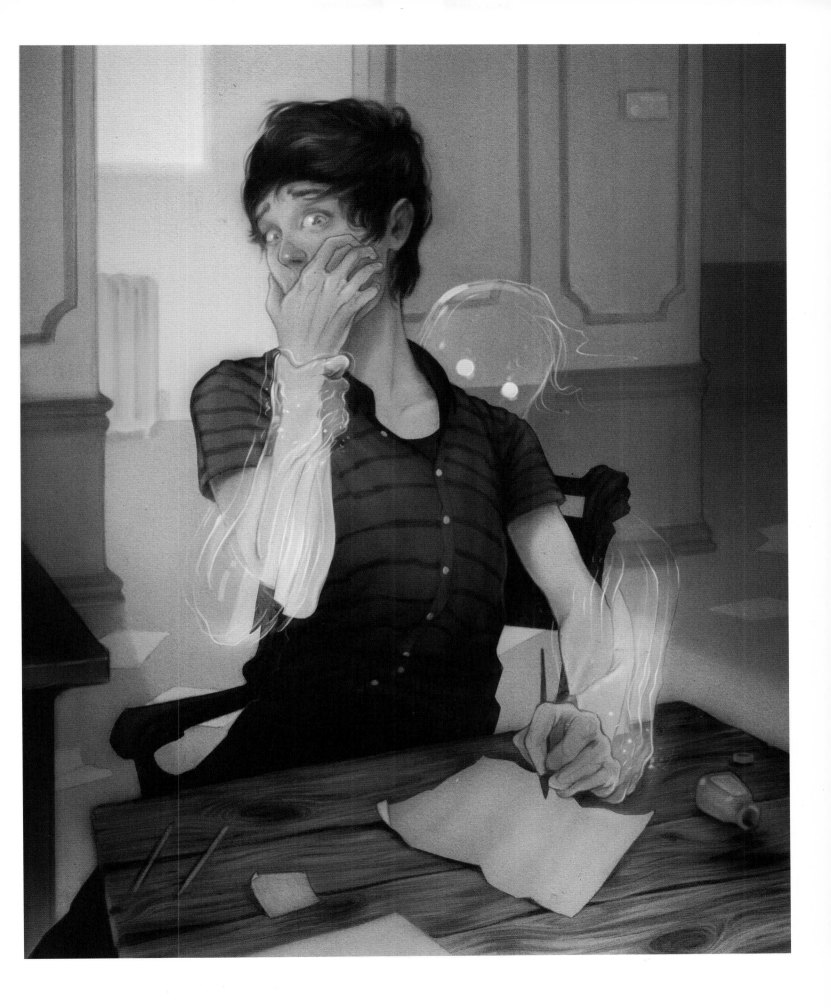

Sam Wolfe Connelly

Art Director: David Plumbo *Client:* Night Shade Books *Title:* Hitchers *Size:* 12"x15" *Medium:* Graphite, digital

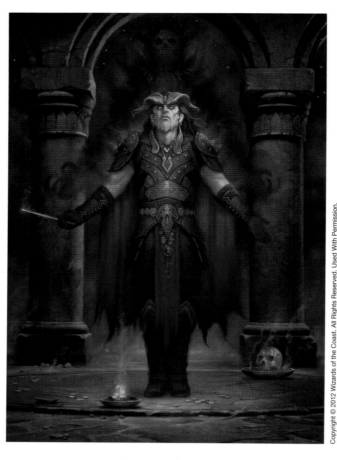

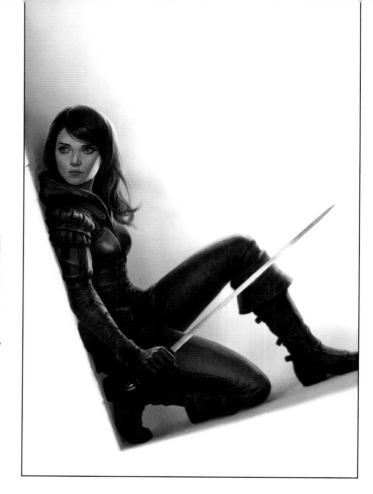

Howard Lyon

Art Director: Mari Kolkowsky *Client:* Wizards of the Coast
Title: Ravenloft—Warlock Curse *Size:* 10"x14" *Medium:* Digital

Jason Chan

Art Director: Lou Anders *Client:* Pyr Books *Title:* False Covenant
Size: 10.6"x20" *Medium:* Digital

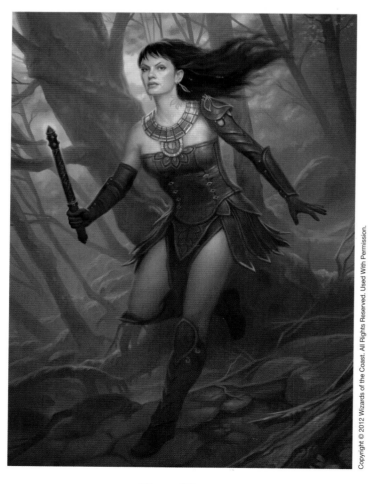

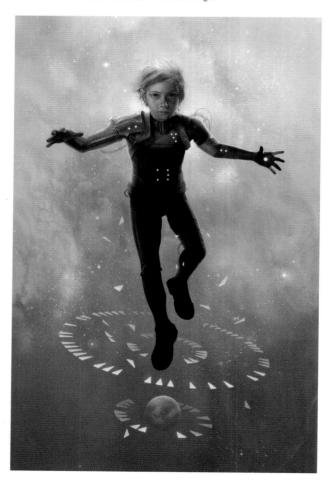

Howard Lyon

Art Director: Mari Kolkowsky *Client:* Wizards of the Coast
Title: Ravenloft—Warlock Sprint *Size:* 10"x14" *Medium:* Digital

Sam Weber

Art Director: Irene Gallo *Client:* Tor Books
Title: Ender's Game *Medium:* Oil

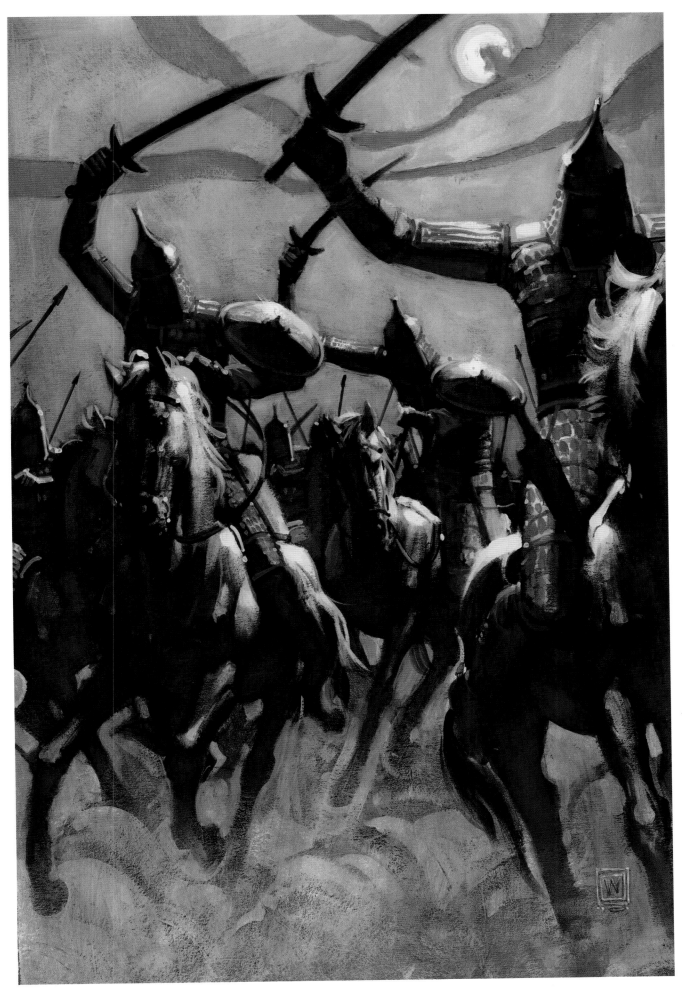

John Watkiss

Art Director: Jim and Ruth Keegan *Client:* Del Rey Books *Title:* Sowers of the Thunder *Medium:* Acrylic

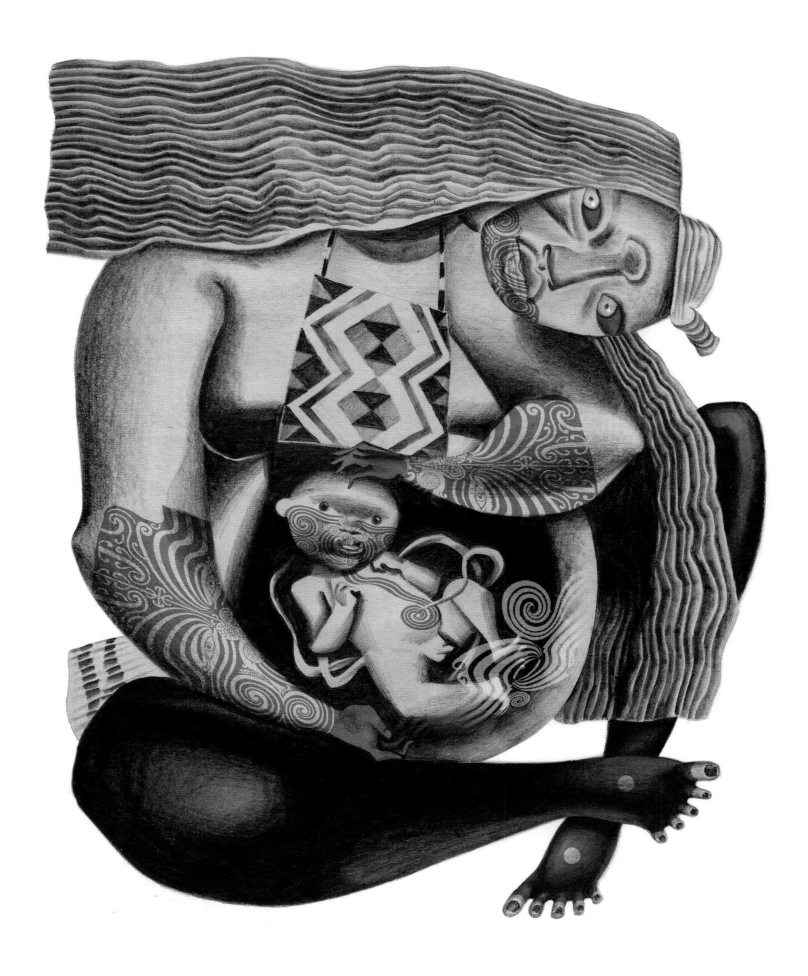

Dave McKean
Art Director: Dave McKean *Client:* Free Press/Simon & Schuster *Title:* The Magic of Reality: Mauri Creation Myth *Size:* 8"x10" *Medium:* Mixed

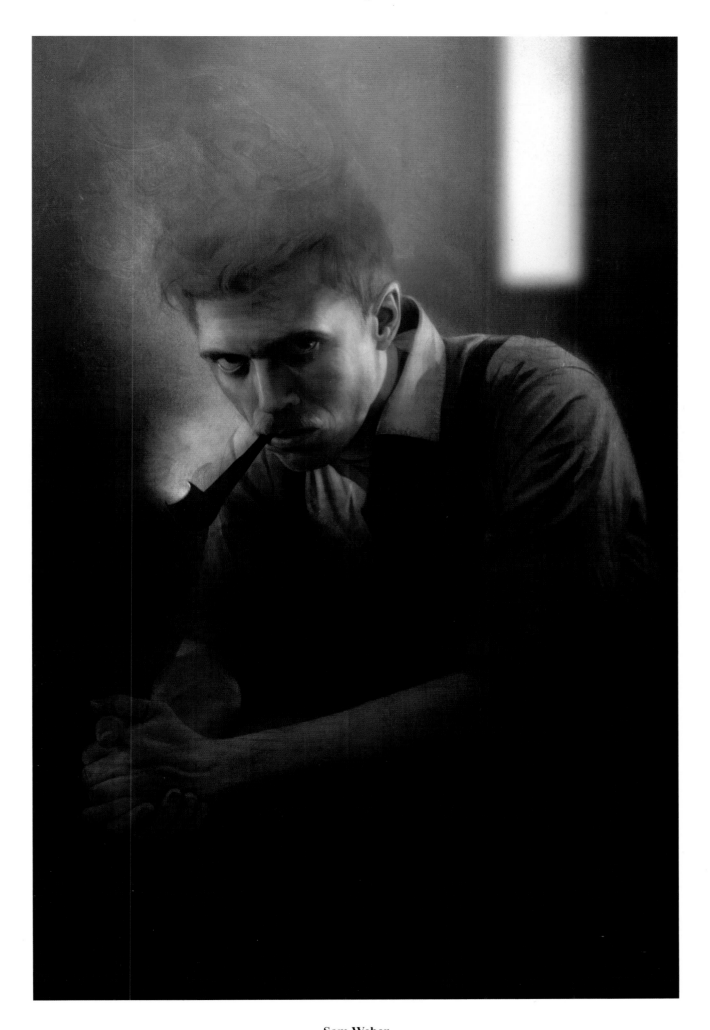

Sam Weber

Art Director: Sheri Gee *Client:* Folio Society *Title:* Fahrenheit 451 *Medium:* Acrylic, watercolor, digital

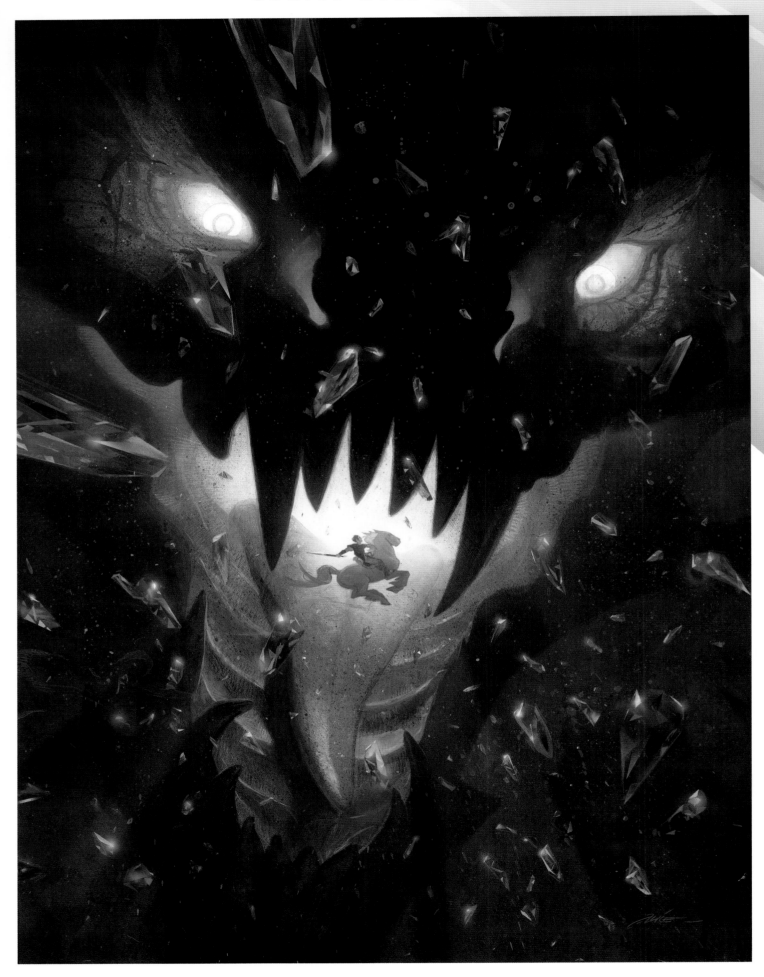

Alex Alice
Client: Dargaud *Title:* Siegfried III *Size:* 60cm x 80cm *Medium:* Acrylic

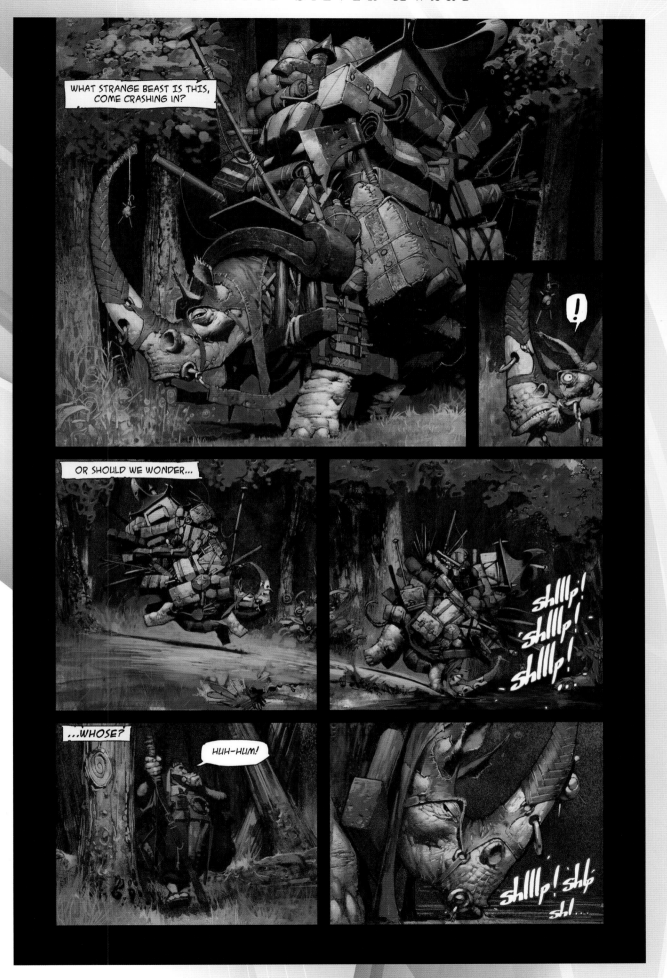

Jim Murray
Client: Valve Software *Title:* Dota 2—Tales From the Secret Shop *Size:* 11"x17" *Medium:* Acrylic, digital

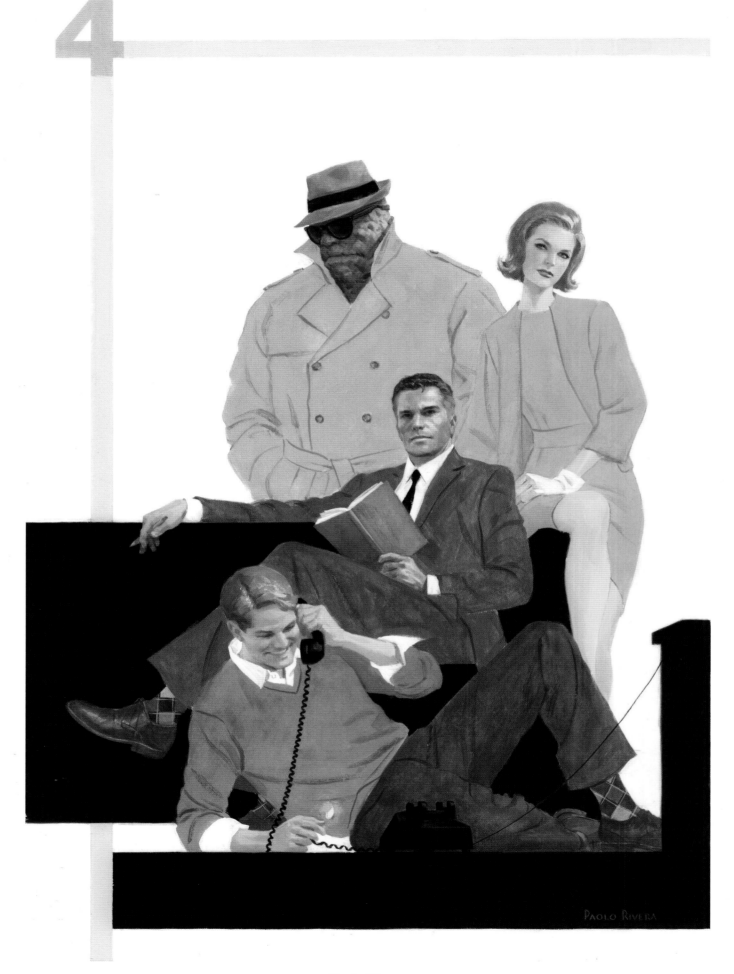

Paolo Rivera
Art Director: Tom Brevoort *Client:* Marvel Comics *Title:* Fantastic Four: '60s Cover *Size:* 11"x17" *Medium:* Gouache, acrylic

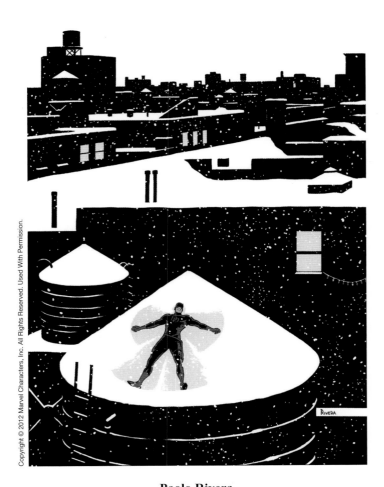

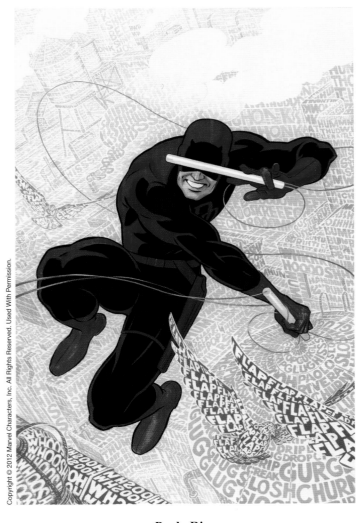

Paolo Rivera

Art Director: Steve Wacker *Client:* Marvel Comics
Title: Daredevil #7 Cover *Size:* 11"x17" *Medium:* Ink, digital

Paolo Rivera

Art Director: Steve Wacker *Client:* Marvel Comics
Title: Daredevil #1 Cover *Size:* 11"x17" *Medium:* Gouache, acrylic

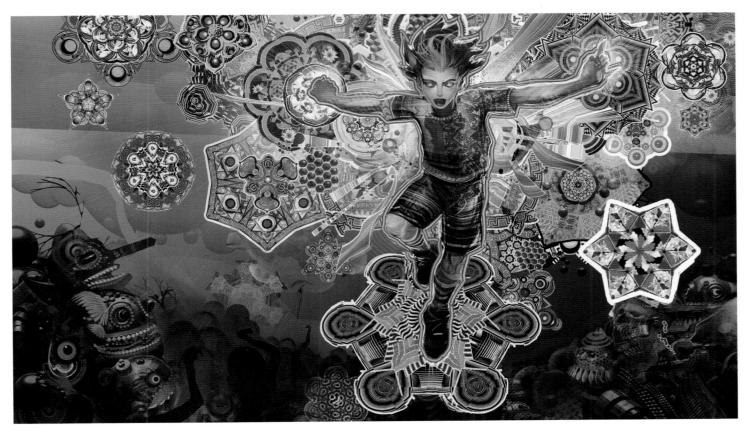

Android Jones

Art Director: Jeremy Berger *Client:* Radical Comics *Title:* Jake Full ON *Size:* 24"x14" *Medium:* Painter 12

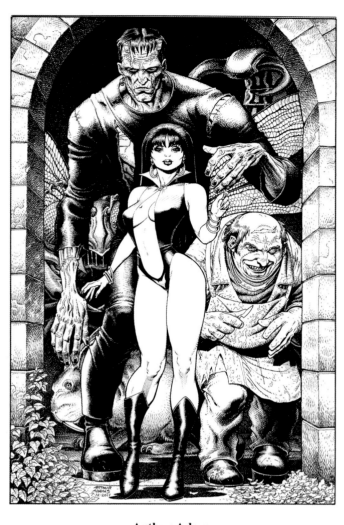

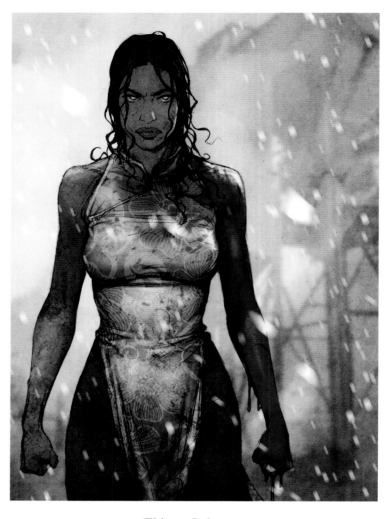

Arthur Adams
Title: Famous Monsters? *Size:* 11"x17" *Medium:* Pen & Ink

Thierry Labrosse
Client: Vents D'Ouest *Title:* Ab Irato Vol. 2 *Size:* 11"x17" *Medium:* Pencil, digital

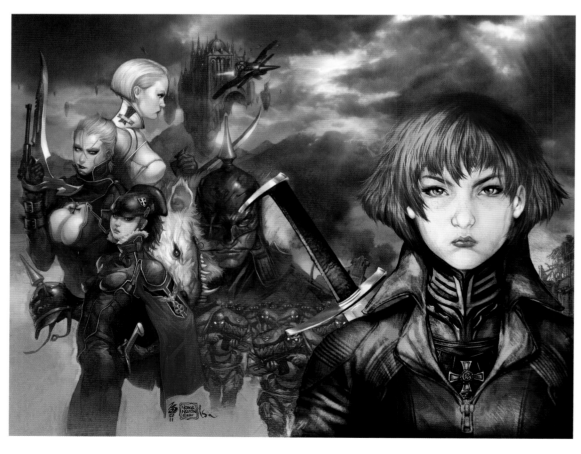

Hoang Nguyen/Khari Evans
Art Director: Hoang Nguyen *Colorist:* Kinsun Loh *Client:* Image Comics *Title:* Carbon Grey *Size:* 13.5"x10.5" *Medium:* Digital

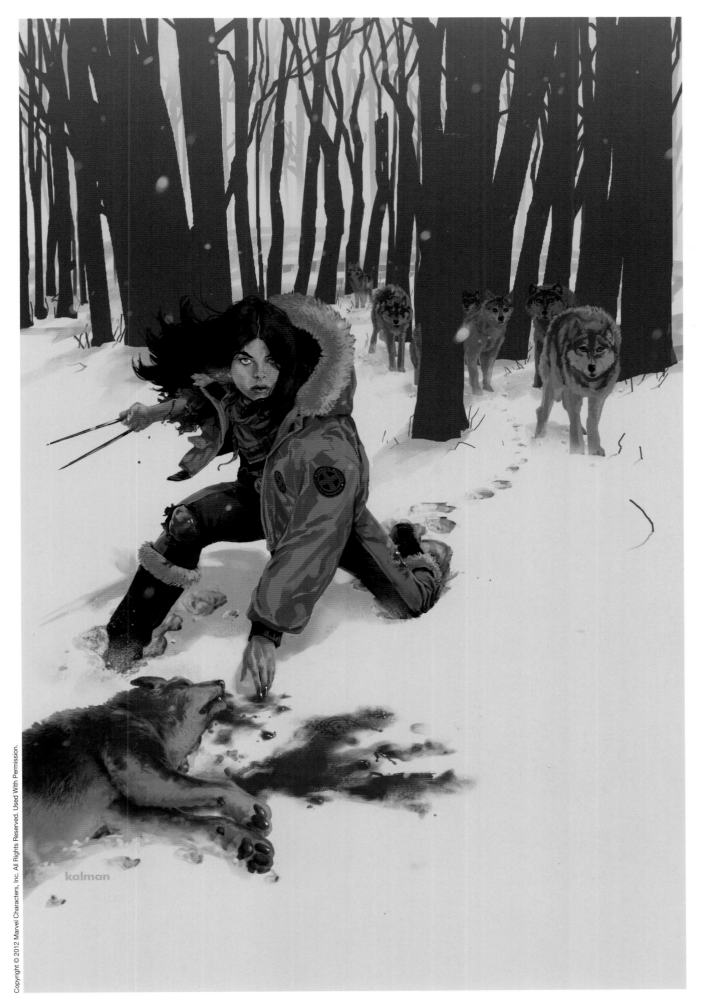

Kalman Andrasofszky

Art Director: Jeanine Schaefer & Jody Leheup *Client:* Marvel Comics *Title:* X-2J #21 *Size:* 6.88"x10.44" *Medium:* Ink, Photoshop

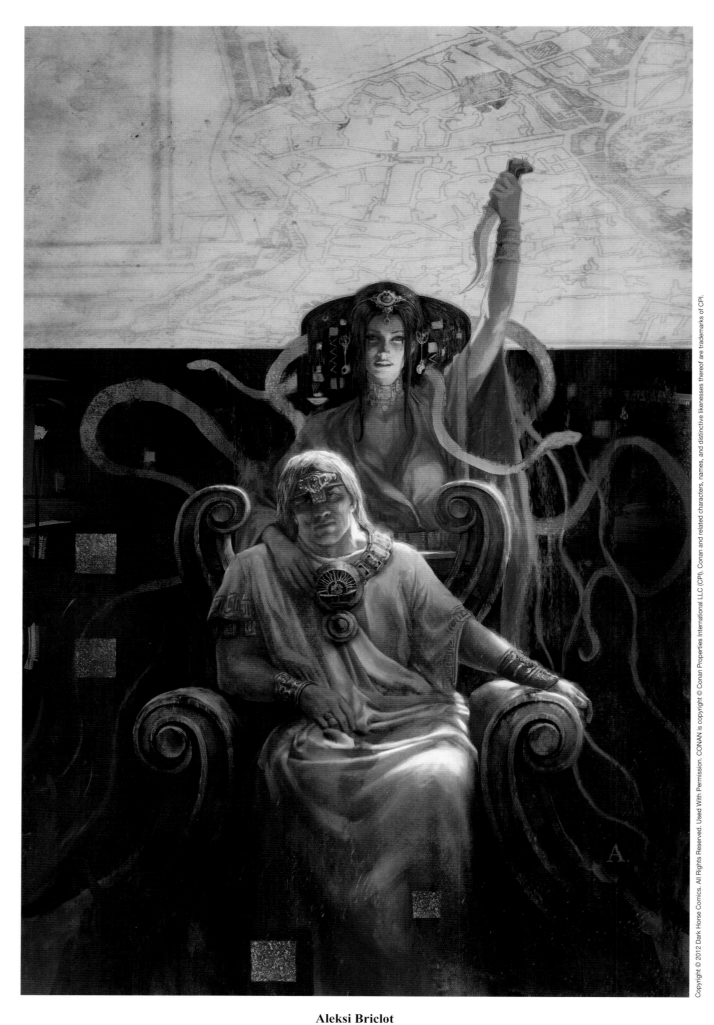

Aleksi Briclot
Art Director: Dave Land *Client:* Dark Horse Comics *Title:* Conan: Road of Kings *Size:* 22.6cm x 34cm *Medium:* Digital

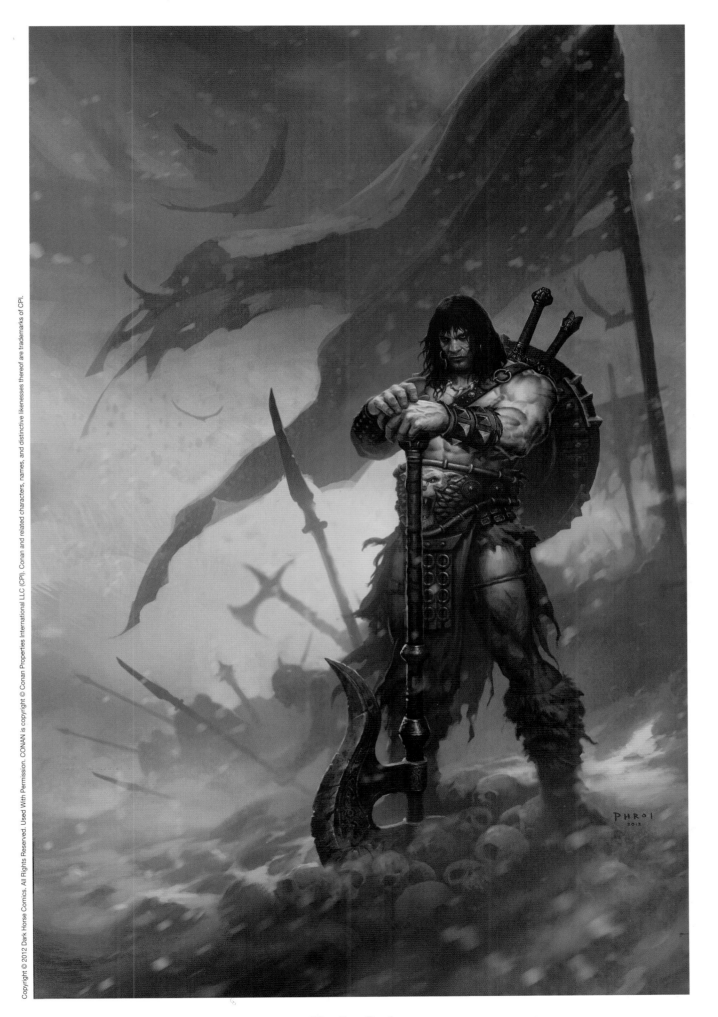

Phroilan Gardner

Client: Dark Horse Comics *Title:* The Destroyer *Size:* 17.6"x27" *Medium:* Digital

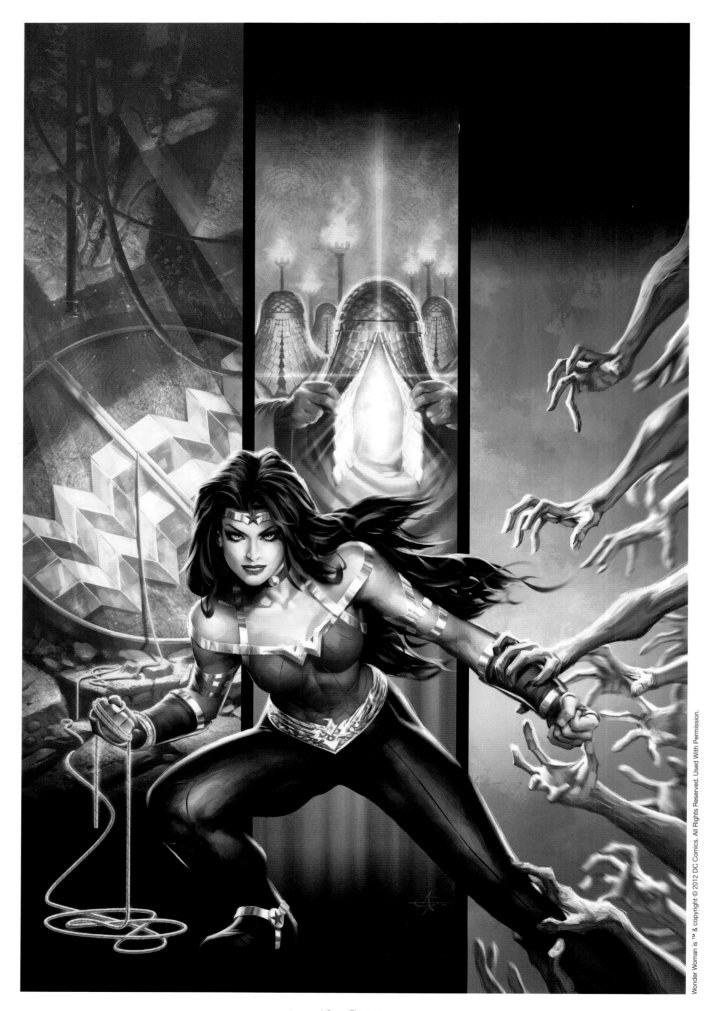

Alex Garner

Client: DC Comics *Title:* Wonder Woman #612 *Size:* 10.5"x15.8" *Medium:* Digital

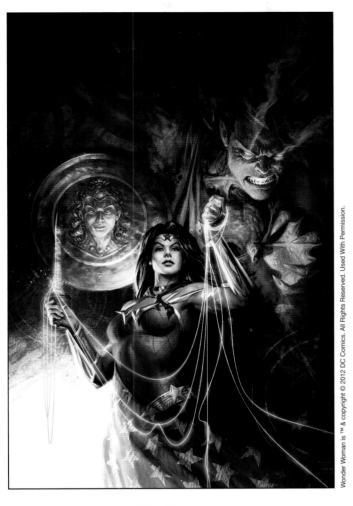

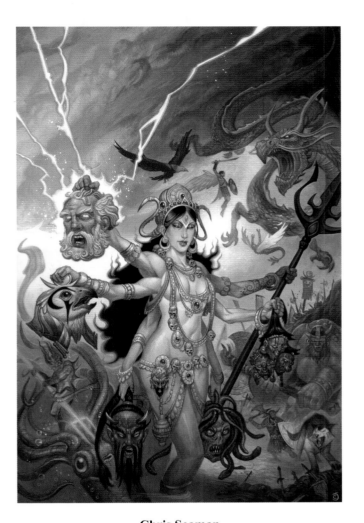

Alex Garner
Client: DC Comics *Title:* Wonder Woman #610
Size: 10.5"x15.8" *Medium:* Digital

Chris Seaman
Art Director: Sean O'Reilly *Client:* Arcana Studios
Title: Kali, Goddess of Death *Size:* 13.75"x21" *Medium:* Acrylic

Arantza Sestayo Jimenez
Title: Palmira *Medium:* 25"x19" *Medium:* Oil

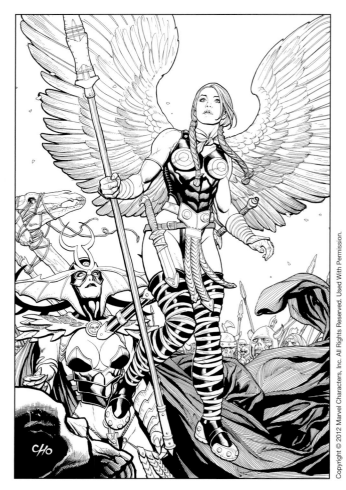

Michael Wm. Kaluta & Lee Moyer
Client: IDW *Title:* Starstruck *Size:* 8"x12" *Medium:* Digital

Frank Cho
Client: Marvel Comics *Title:* Valkyrie Reborn *Size:* 14"x21" *Medium:* Ink

Fiona Meng
Art Director: David Mack *Title:* Drown *Size:* 11"x14" *Medium:* Photoshop

Arantza Sestayo Jimenez
Title: Lactana Nocturnum *Medium:* 20"x26" *Medium:* Oil

Frank Cho
Colorist: Nikos Koutsis *Client:* Image Comics *Title:* 50 Girls 50 #3 *Size:* 14"x21" *Medium:* Pen & Ink, digital

Arthur Adams

Title: Dragon Girl *Size:* 15"x17" *Medium:* Pen & Ink

Arthur Adams
Title: Ther Mermaid *Size:* 13"x17" *Medium:* Pen & Ink

MENTON 3
Client: IDW Publishing *Title:* The Hellbound Train #3 *Medium:* Digital

Brecht Evens
Client: Top Shelf Productions *Title:* Night Animals *Size:* 13.5"x9.25" *Medium:* Ink, watercolor

Jennifer L. Meyer
Art Director: Nathan Cosby *Client:* Archaia *Title:* Jim Henson's The Storyteller p. 2 *Size:* 10.5"x15.5" *Medium:* Pencil, digital

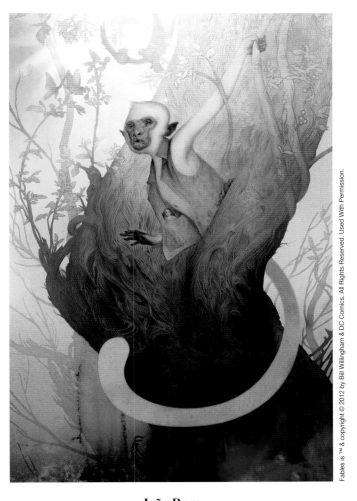

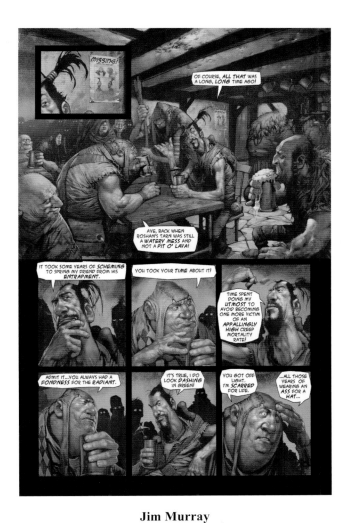

João Ruas

Art Director: Shelly Bond *Client:* DC Comics *Title:* Fables #101 *Medium:* Mixed

Jim Murray

Client: Valve Software *Title:* Dota 2: Tales From the Secret Shop *Medium:* Acrylic, digital

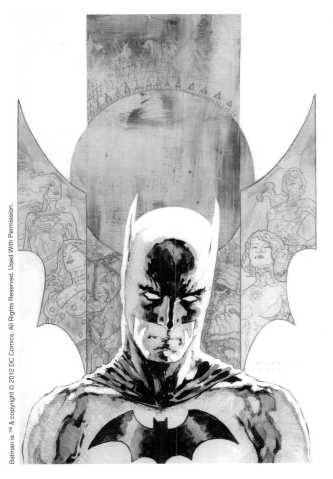

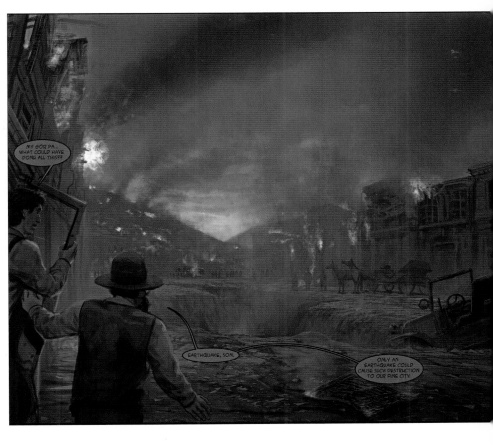

David Mack

Art Director: Eddie Berganza *Client:* DC Comics *Medium:* Mixed

Justin Coro Kaufman

Client: Massive Black *Title:* Transient Seqa.3 *Size:* 17"x14" *Medium:* Digital

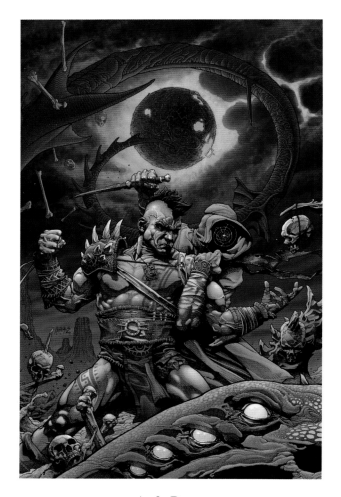

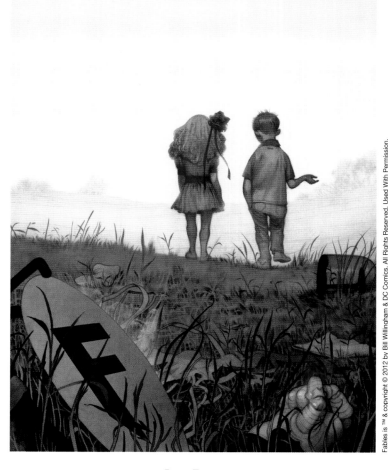

Andy Brase
Client: IDW Publishing *Title:* Dark Sun #1 *Size:* 11"x17" *Medium:* Ink, digital

João Ruas
Art Director: Shelly Bond *Client:* DC Comics *Title:* Fables #106 *Medium:* Mixed

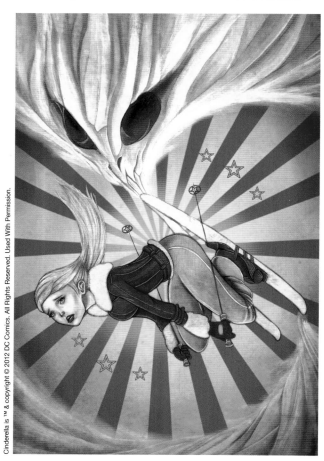

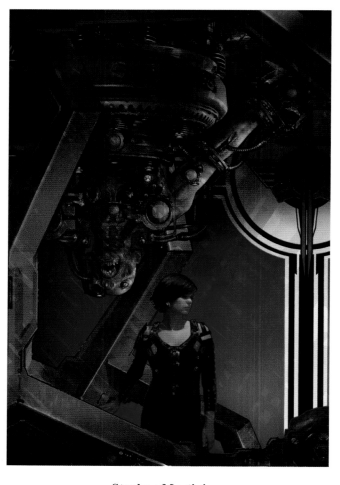

Chrissie Zulo
Art Director: Shelly Bond *Client:* DC Comics *Title:* Cinderella: Fables Are Forever 4
Size: 20"x30" *Medium:* Acrylic, Photoshop

Stephan Martiniere
Client: Dark Horse Comics *Title:* Rage 1 Limited *Medium:* Digital

Sonny Liew
Art Director: Danny Yee *Client:* Image Comics *Title:* Malinky Robot *Size:* 8"x10" *Medium:* Pencil, digital

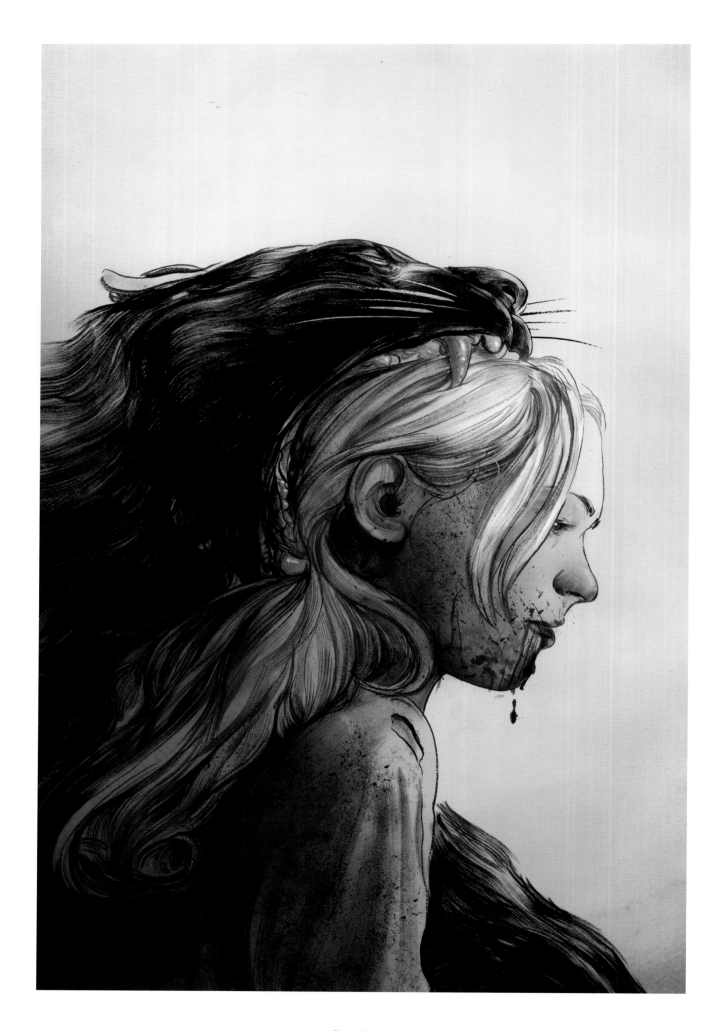

Greg Ruth
Art Director: Rachael Edidin *Client:* Dark Horse Comics *Title:* Alabaster #3 *Size:* 7"x9" *Medium:* Mixed

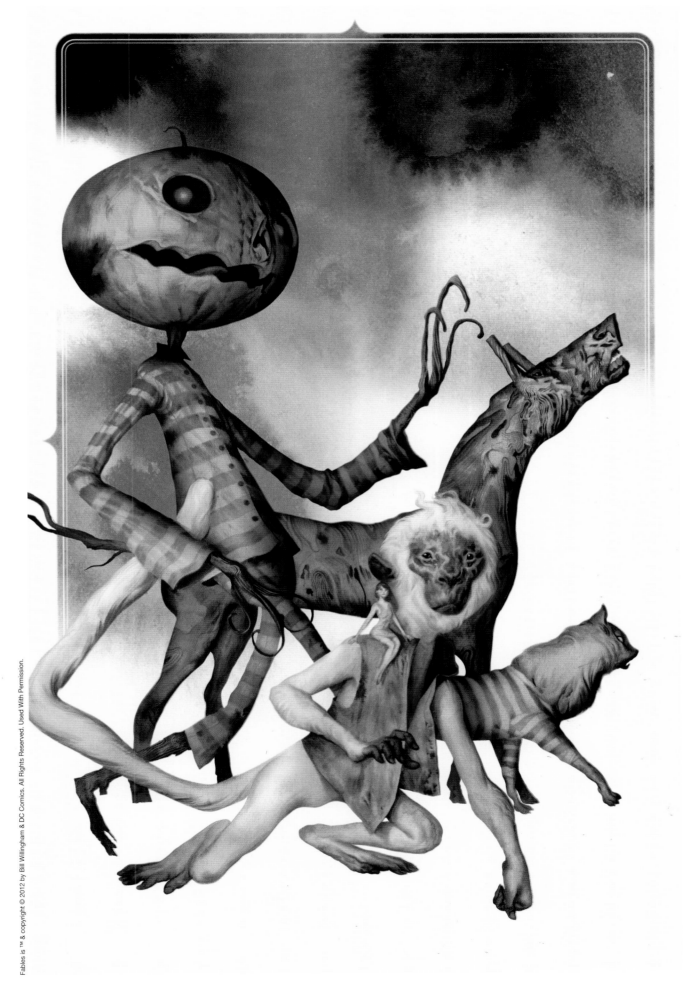

João Ruas

Art Director: Shelly Bond *Client:* DC Comics *Title:* Fables #109 *Medium:* Watercolor, gouache, digital

Jake Wyatt
Art Director: *Joy Ang*　*Client:* Lucidity Press　*Title:* Theseus 03　*Size:* 20"x10"　*Medium:* Graphite, digital

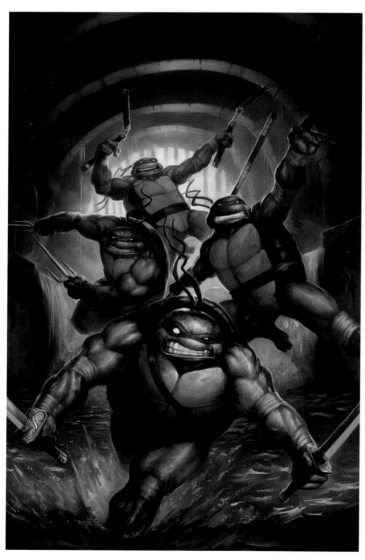

Tyler Walpole
Art Director: Bobby Cuenow　*Client:* IDW Publishing
Medium: Painter

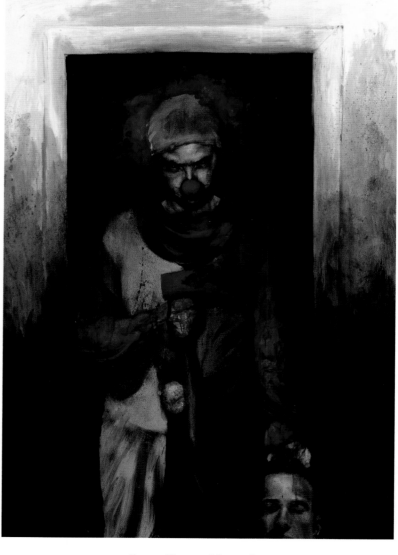

Jason Shawn Alexander
Art Director: Christopher A. Taylor　*Client:* Dark Horse Comics　*Title:* Creepy #6
Size: 36"x48"　*Medium:* Oil on canvas

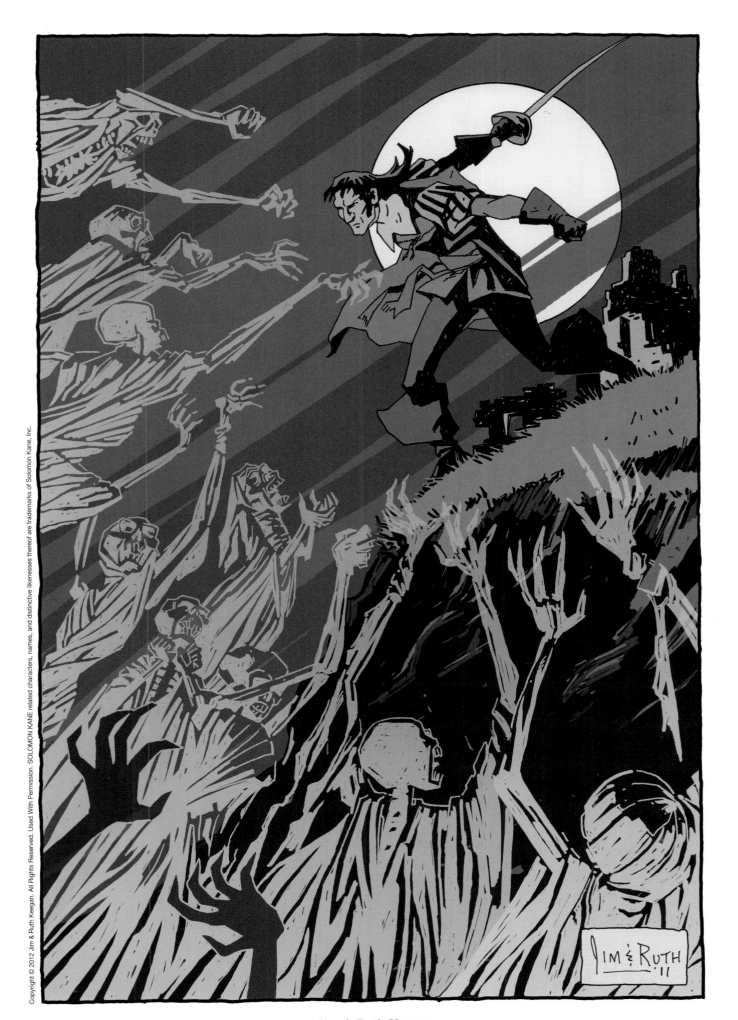

Jim & Ruth Keegan

Client: Dark Horse Comics *Title:* Solomon *Size:* 9"x13" *Medium:* Ink, digital

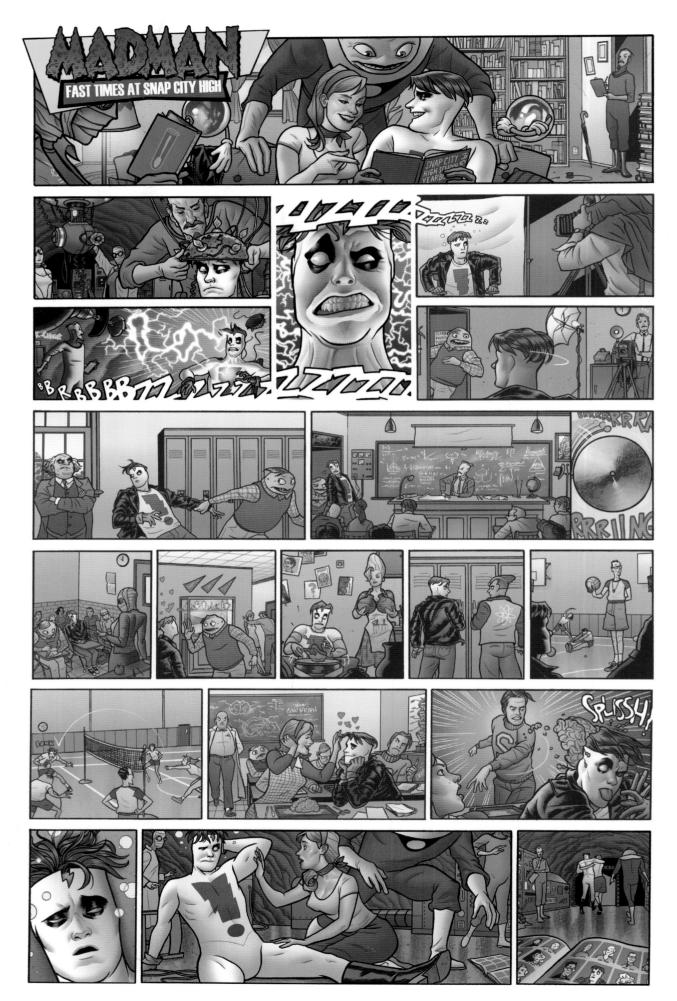

Joe Quinones
Art Director: Mike Allred *Client:* Image Comics *Title:* Mad Man: Fast Times at Snap City High *Size:* 13.75"x21.25" *Medium:* Ink, digital

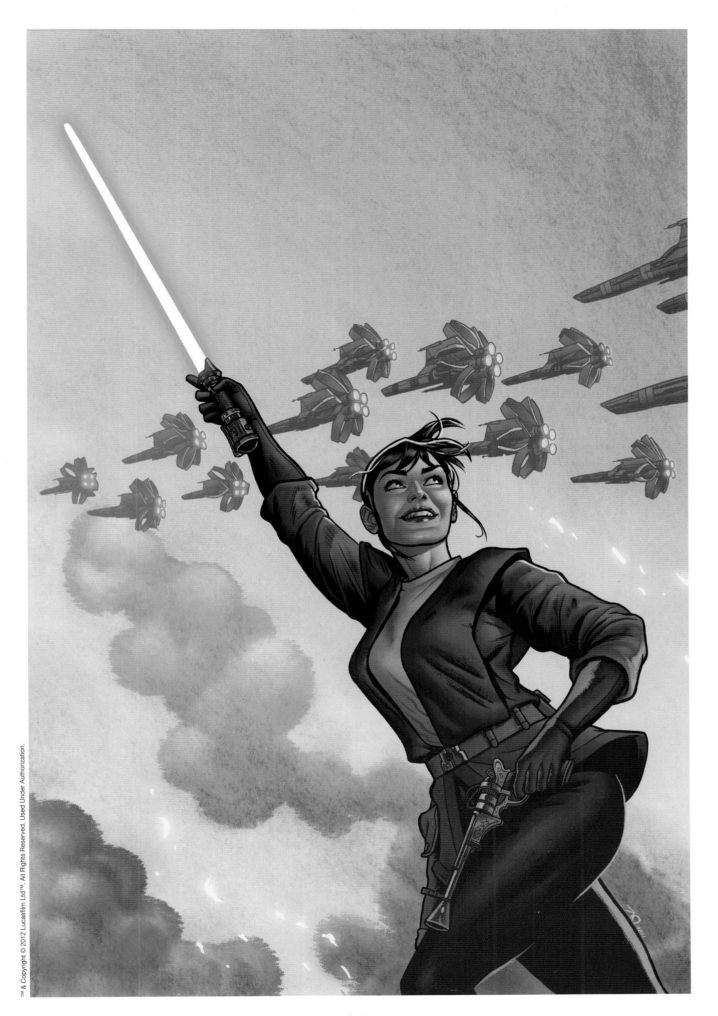

Joe Quinones

Art Director: Dave Marshall *Client:* Dark Horse Comics *Title:* Knight Errant: Deluge #1 *Size:* 10.4"x15.8" *Medium:* Ink, pastel, digital

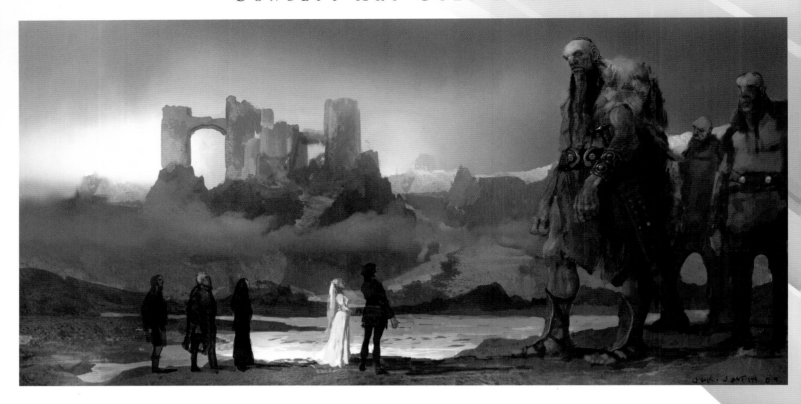

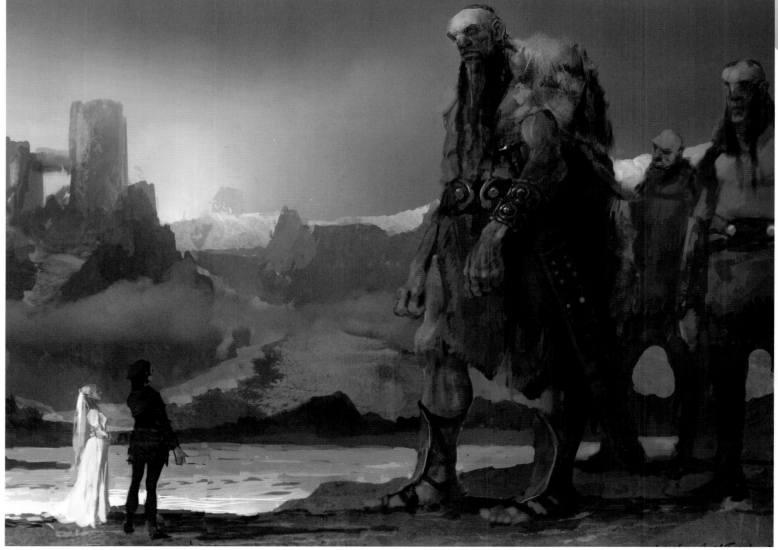

detail

Justin Sweet
Client: Warner Bros. *Title:* Jack the Giant Killer *Medium:* Digital

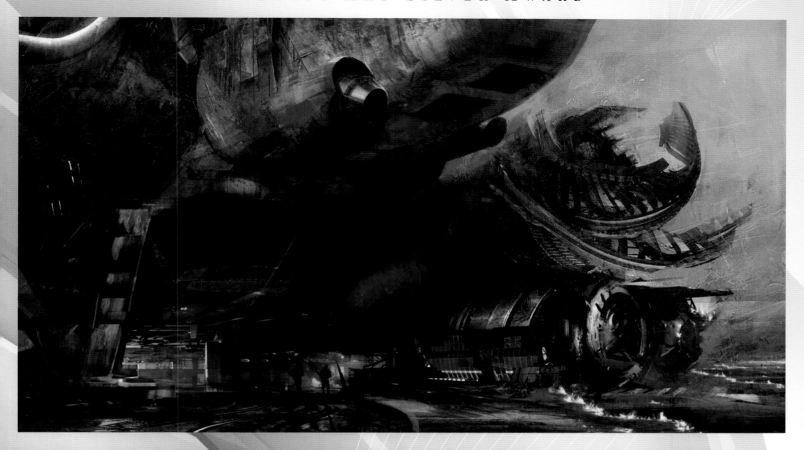

detail

Daniel Dociu

Art Director: Daniel Dociu *Client:* ArenaNet—Guild Wars 2 *Title:* Hangar *Medium:* Digital

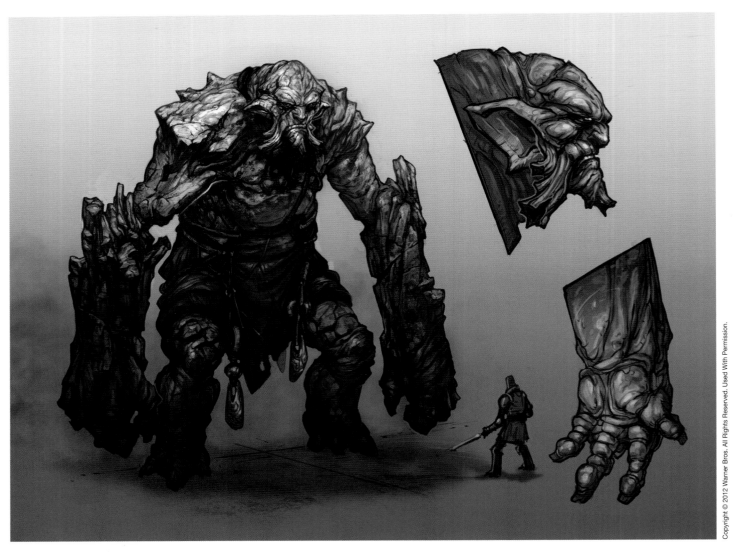

boilerplate: Copyright © 2012 Warner Bros. All Rights Reserved. Used With Permission.

Vinod Rams
Art Director: Philip Straub *Client:* Warner Bros. *Title:* Stone Giant *Size:* 9"x7" *Medium:* Digital

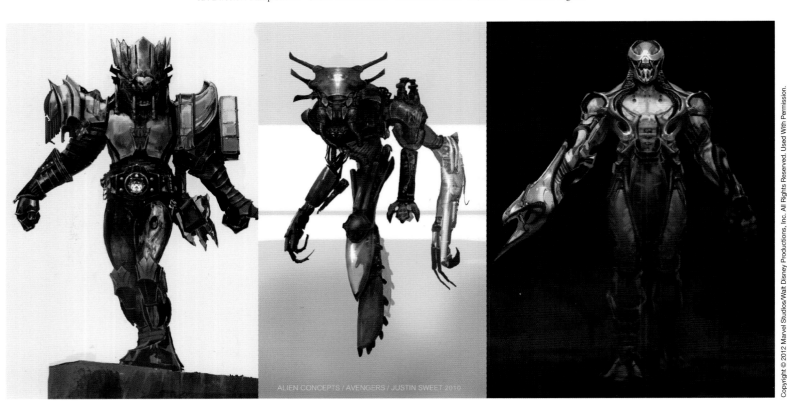

boilerplate: Copyright © 2012 Marvel Studios/Walt Disney Productions, Inc. All Rights Reserved. Used With Permission.

Justin Sweet
Art Director: Ryan Meinerding & Charlie Wen *Client:* Marvel Studios *Title:* The Avengers/Aliens *Medium:* Digital

**116 Spectrum 19**

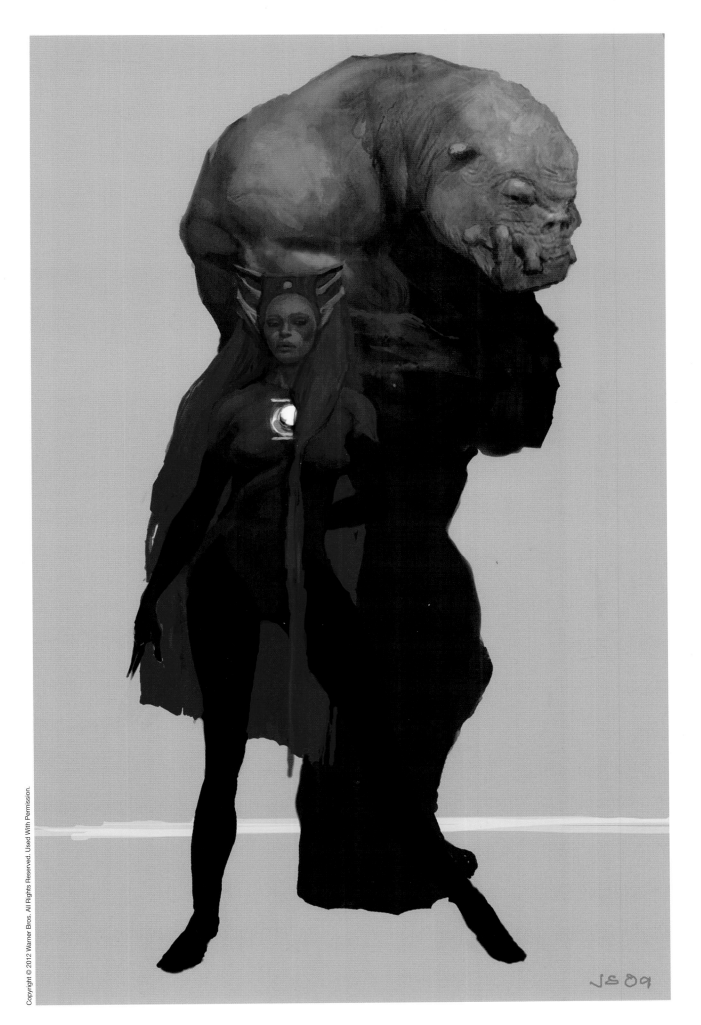

Justin Sweet

Art Director: Grant Mark *Client:* Warner Bros. *Title:* Kilowog & Boddica *Medium:* Digital

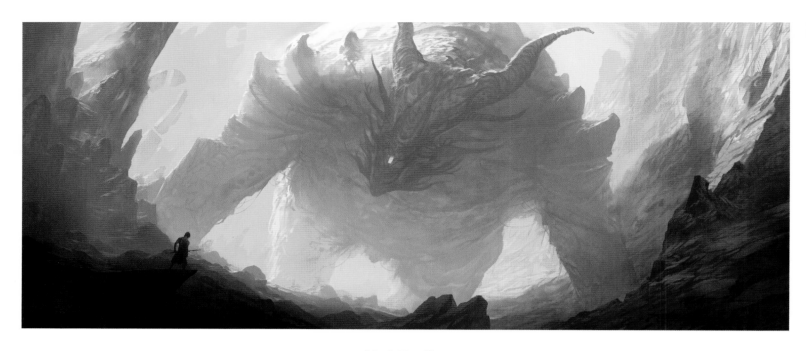

Noah Bradley
Title: Chief of the Ways *Size:* 40"x17" *Medium:* Digital

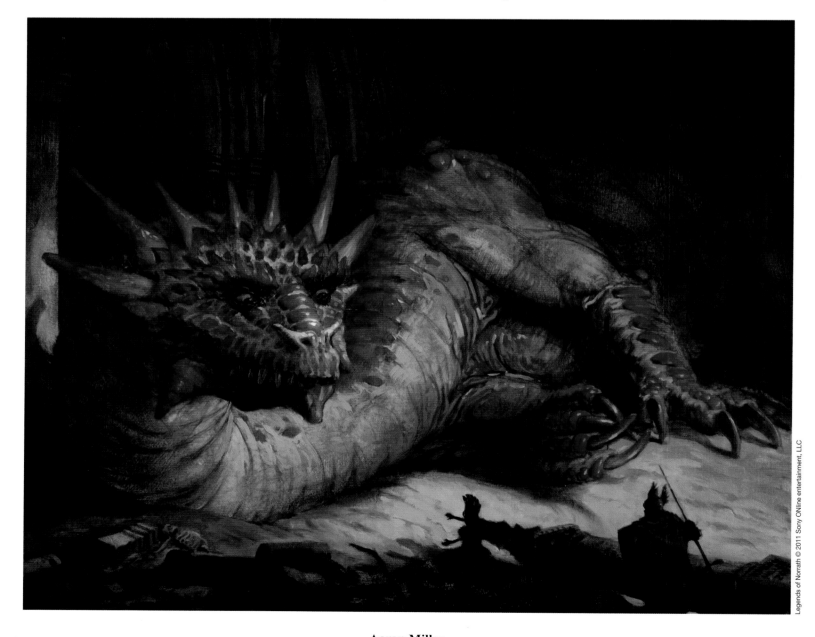

Aaron Miller
Art Director: David M. Carter *Client:* Sony Online Entertainment *Title:* Zaos the Wyrm *Medium:* Oil on panel

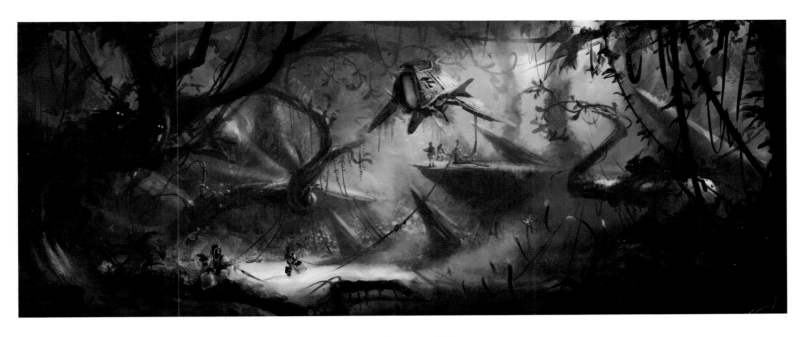

Jordan Lamarre-Wan

Title: Project NOVUS—Alien Forest *Size:* 24"x10" *Medium:* Digital

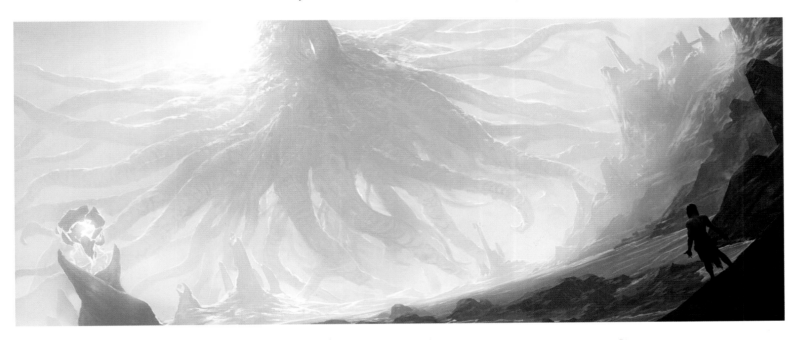

Noah Bradley

Title: King of the Proud *Size:* 40"x17" *Medium:* Digital

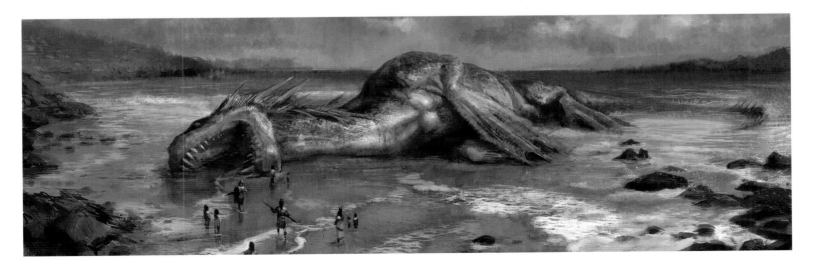

Chad Weatherford

Client: Chadweatherford.com *Title:* Washed Up *Medium:* Digital

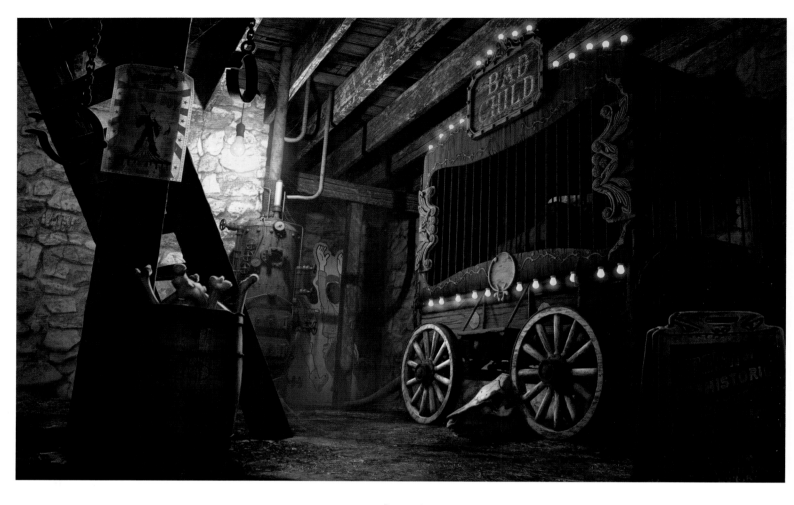

r.k. post
Art Director: Jeff Haynie *Client:* Big Fish Games *Title:* Big Boys Don't Cry *Medium:* Digital

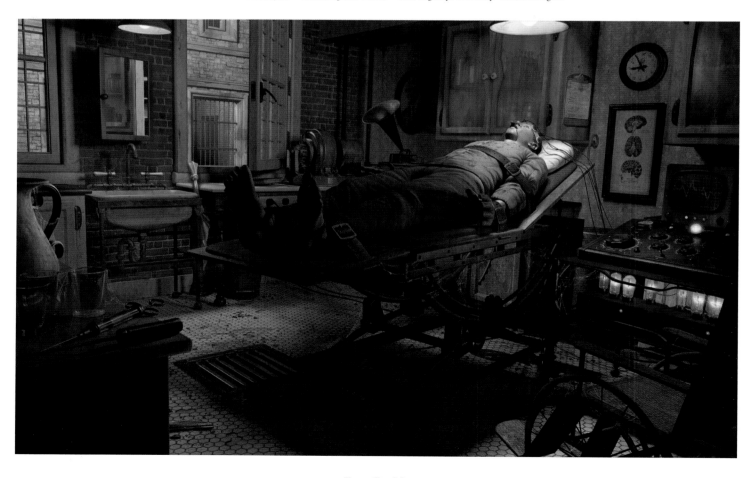

Ron Crabb
Art Director: Jeff Haynie *Designer:* Adrian Woods *Client:* Big Fish Games *Title:* Shock Therapy [Mystery Case Files] *Medium:* Digital

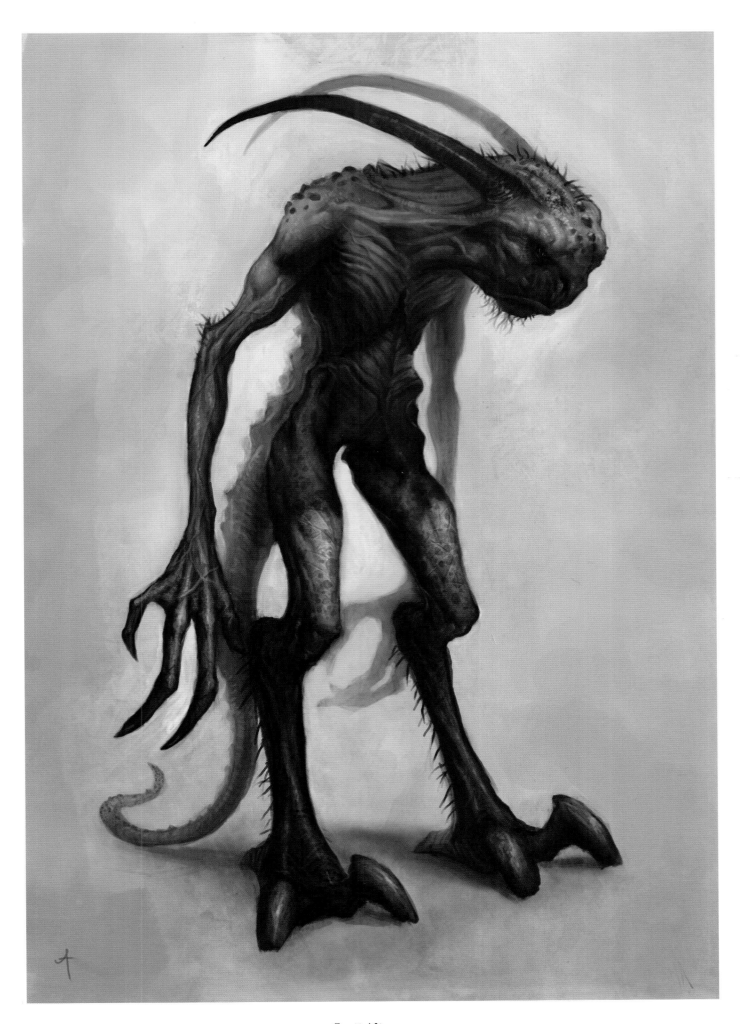

Scott Altmann

Title: Grigg *Medium:* Digital

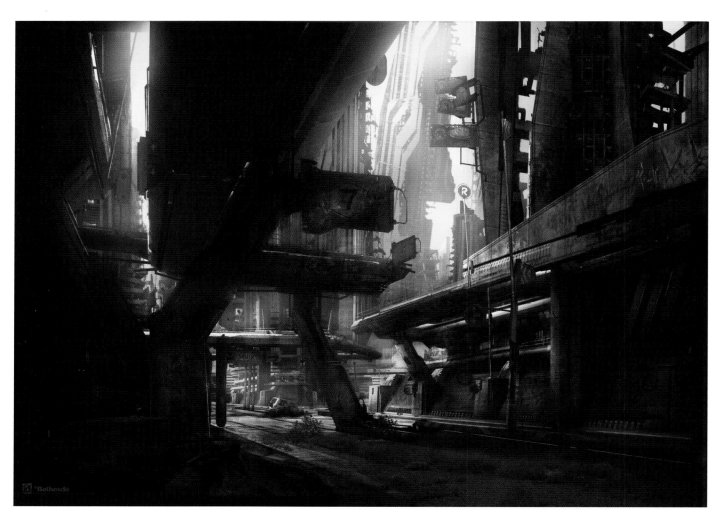

Stephan Martiniere
Client: ID Software—Bethesda *Title:* Dead City *Medium:* Digital

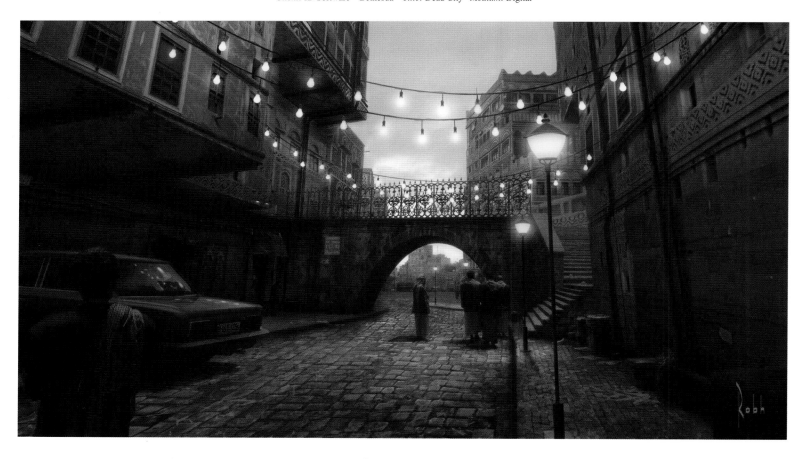

Robh Ruppel
Art Director: Robh Ruppel *Client:* Naughty Dog *Title:* Yemen *Medium:* Digital

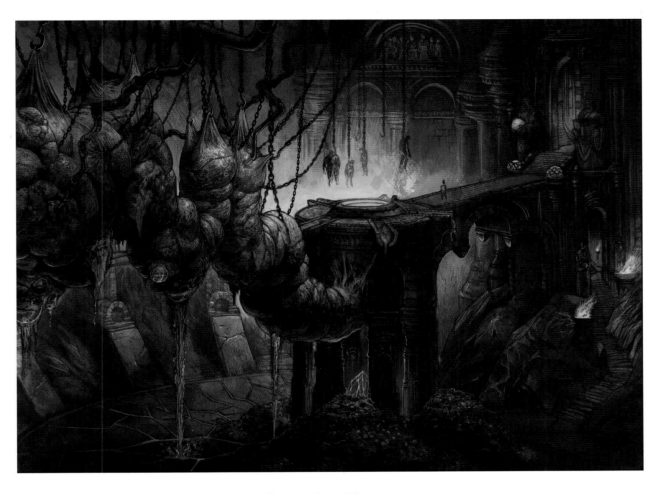

Sean Andrew Murray

Art Director: Tim Coman *Client:* 38 Studios/Big Huge Games *Title:* Reckoning: Ventrinio's Well of Souls *Medium:* Digital

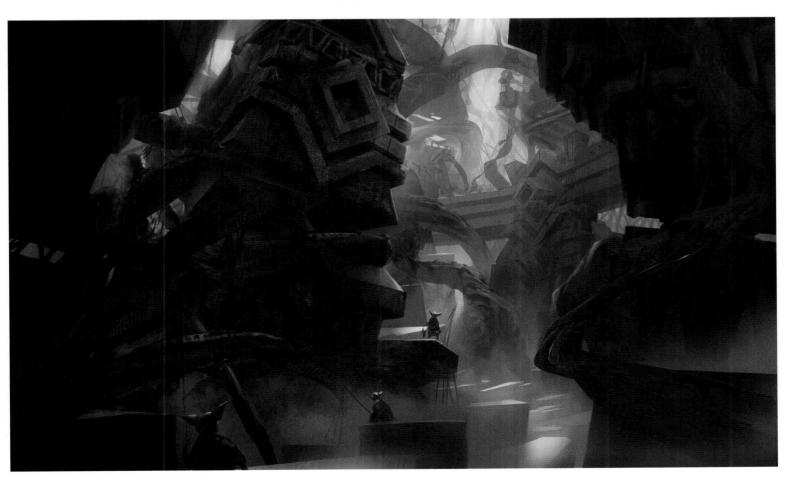

Levi Hopkins

Art Director: Daniel Dociu *Client:* ArenaNet *Title:* Asura Ruins *Medium:* Digital

Ed Bell
Art Director: Ed Bell *Designer:* Vaughn Ross *Client:* Maverix Studios LLC *Title:* Oasis Development Art *Size:* 9"x7" *Medium:* Pencil, digital

Vincent Proce
Art Director: Jeremy Jarvis *Client:* Wizards of the Coast *Title:* Where the Children Feed *Medium:* Pencil, digital

Matt Gaser
Client: Riot Games *Title:* Bilgewater *Size:* 10"x5" *Medium:* Digital

Daniel Dociu
Art Director: Daniel Dociu *Client:* ArenaNet Guild Wars 2 *Title:* Fantasy Ships *Medium:* Digital

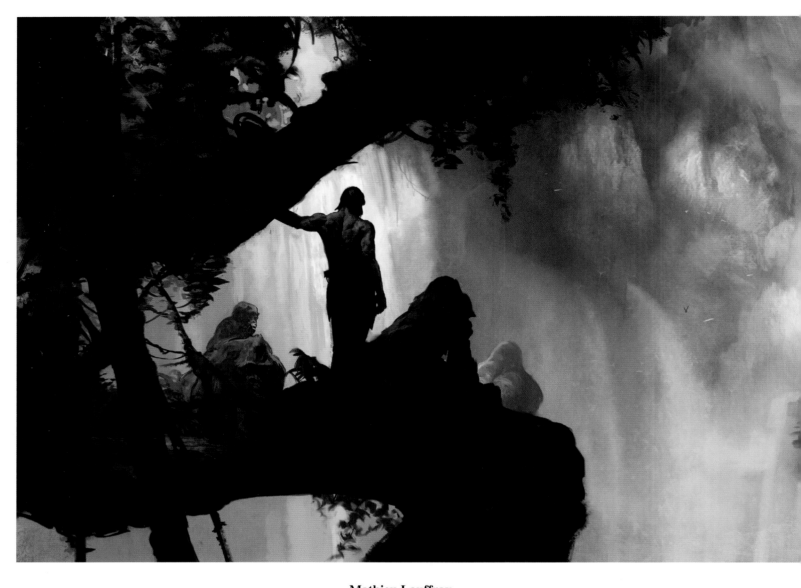

Mathieu Lauffray
Client: La Oetite Reive *Title:* Tarzan, Lord of the Apes *Medium:* Photoshop

Brian Matyas
Art Director: Josh Viers *Client:* Kabam *Title:* Spartan Victory *Size:* 12.5"x 6.75" *Medium:* Digital

Scott Altmann
Title: Poogie *Medium:* Digital

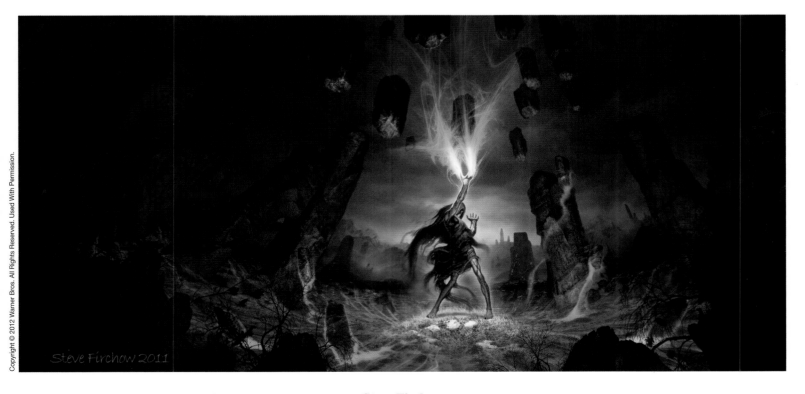

Steve Firchow
Art Director: Philip Straub *Client:* Warner Bros. *Title:* Summoner *Size:* 13.5"x6.5" *Medium:* Digital

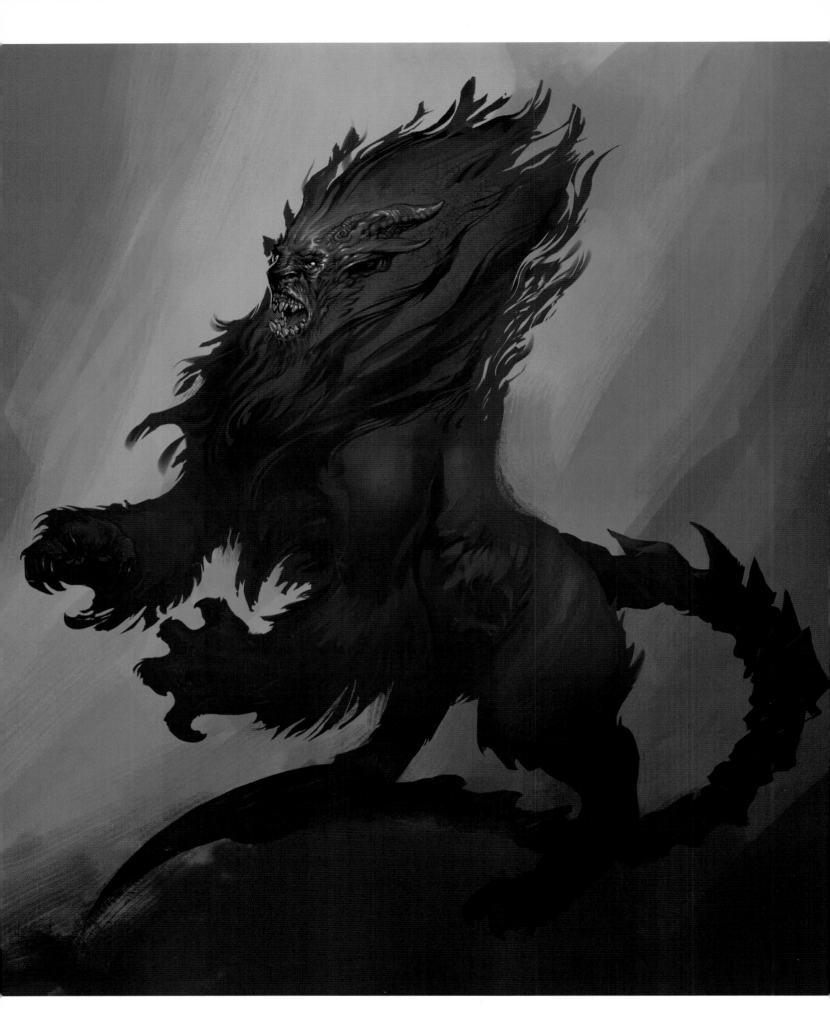

Allen Williams

Art Director: Josh Viers *Client:* Kabam *Title:* Manticore *Size:* 11"x 12.5" *Medium:* Digital

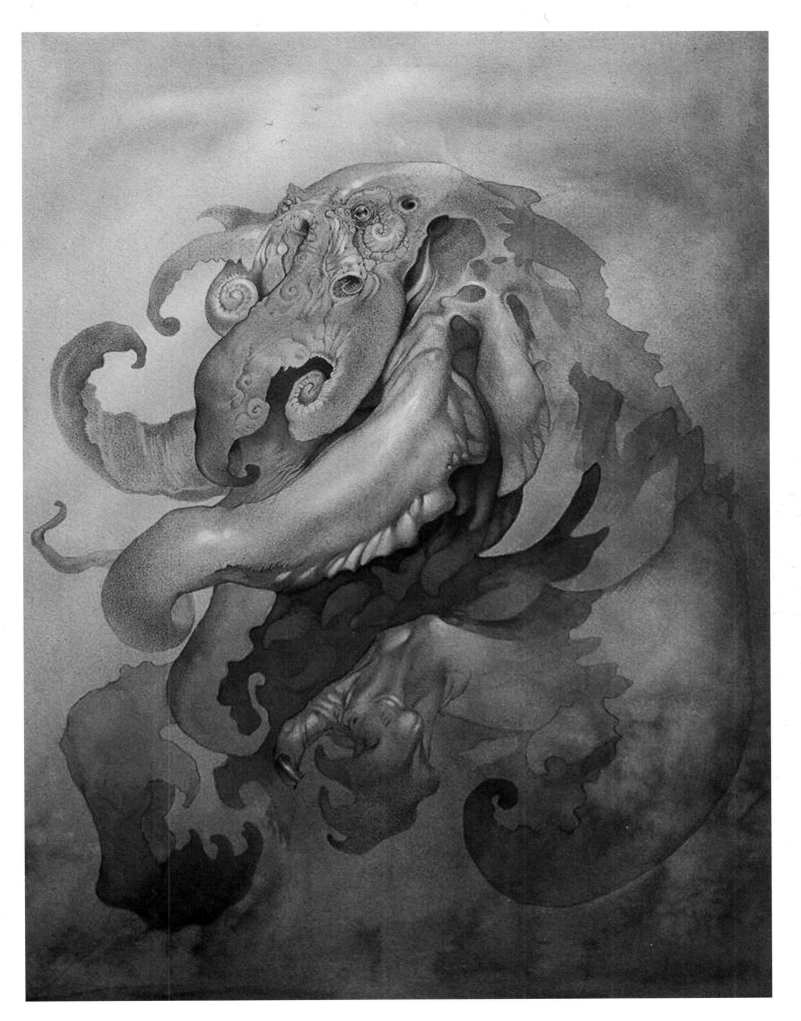

Allen Williams

Title: Unknown One *Size:* 12"x17" *Medium:* Acrylic, pencil

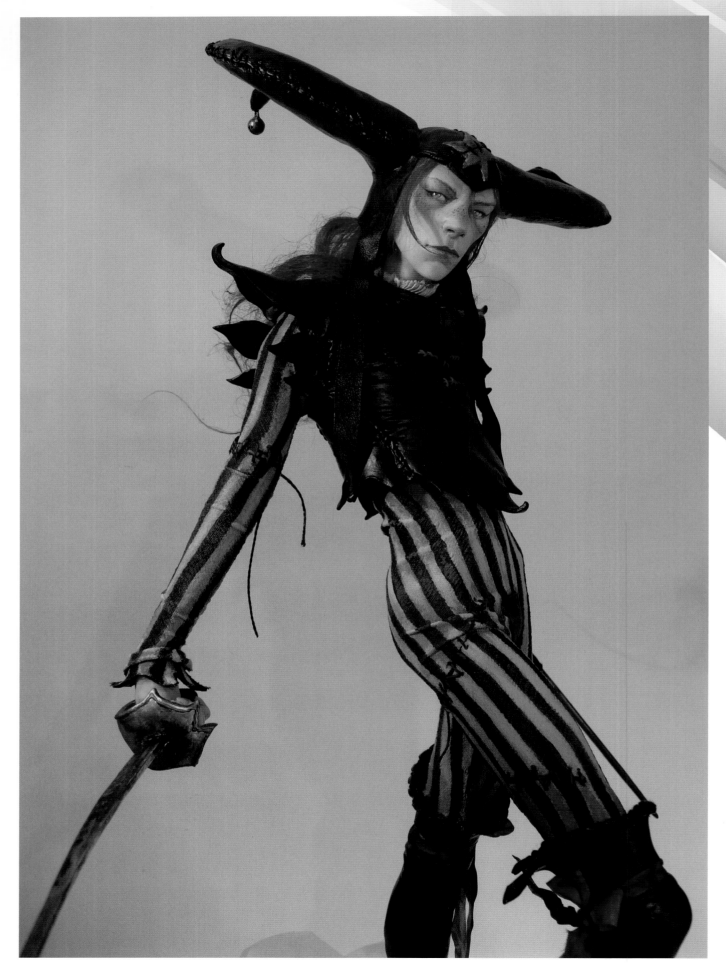

Virginie Ropars
Designer: Brom *Title:* Jack *Size:* 68cm Tall *Medium:* Polymer, mixed

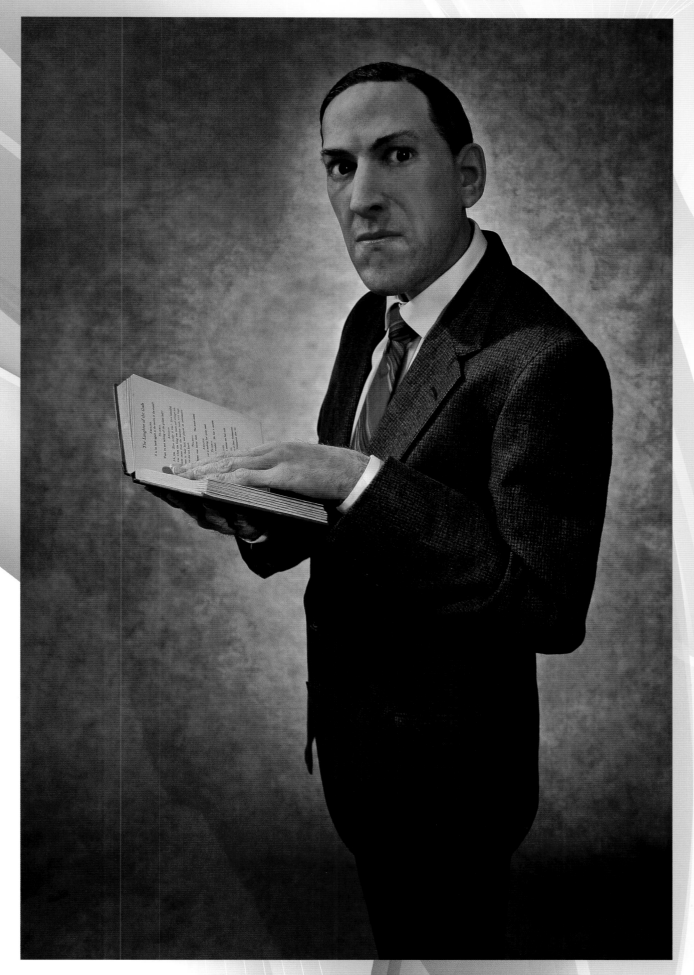

Thomas S. Kuebler

Client: Guillermo del Toro *Title:* I Am Providence *Size:* Life size *Medium:* Silicone, mixed

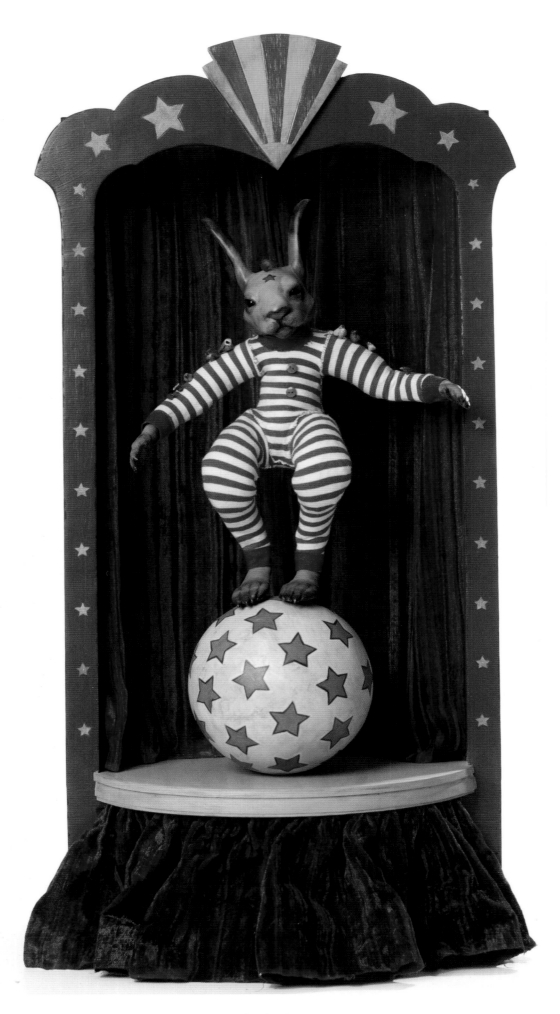

Carisa Swenson

Photographer: Steven Harrison *Title:* Keeping the Balance *Size:* 30" tall x 14" wide *Medium:* Mixed

Kathie Olivas

Designer: Kathie Olivas *Title:* Elizabeth Cold Gray *Size:* 20.5"x34"x14" *Medium:* Mixed on fiberglass

Michael Defeo
Art Director: Michael Defeo *Designer:* Bill Presing *Client:* MD3D, Inc. *Title:* Valentine
Size: 4"x1"x1" *Medium:* Resin

Julie Mansergh
Client: Faeries in the Attic *Title:* Barnacle Mermaid *Size:* 11"x10" *Medium:* Polymer

Kyla Richards
Title: Magda Seated on Xuriel *Size:* 6"x4"x11.5" *Medium:* Mixed

Julie Mansergh
Client: Faeries in the Attic *Title:* Male Faerie *Size:* 11.5"x8" *Medium:* Polymer

Jeremy Pelletier

Art Director: Jeremy Pelletier *Client:* The Brothers Bad *Title:* The Eyes of Lucifer *Size:* 12.5" Tall *Medium:* Super sculpey

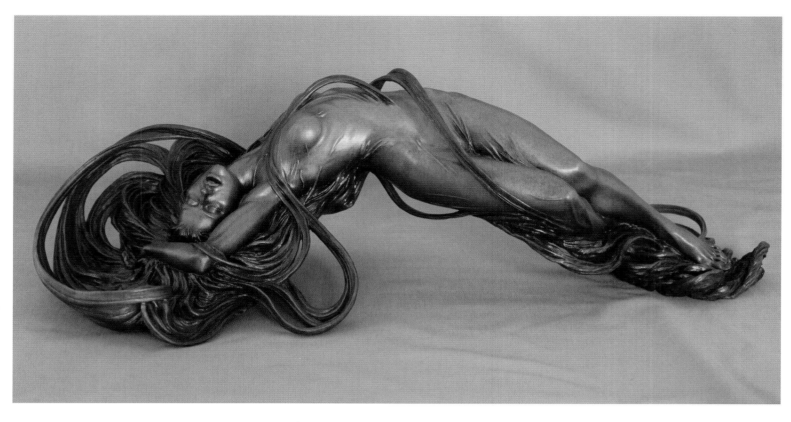

James Shoop
Client: Shoop Sculptural Design, Inc. *Title:* One *Size:* 24"x10"x8" *Medium:* Bronze

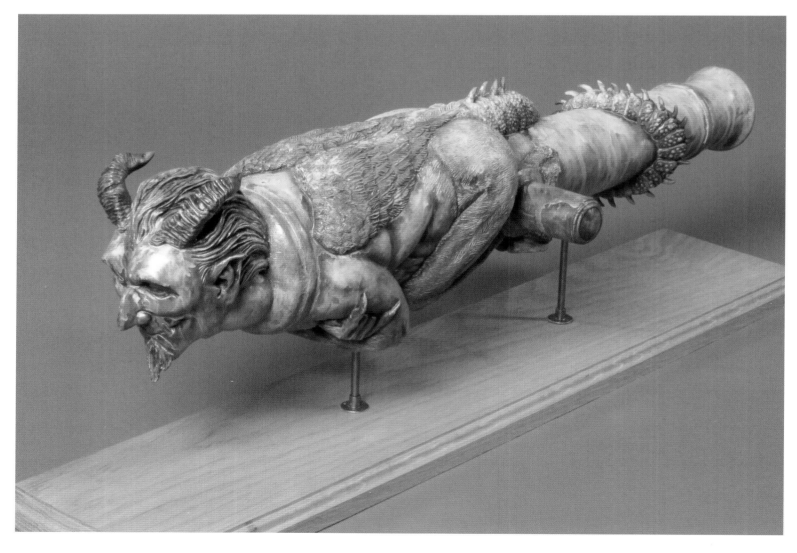

Dan Chudzinski
Photographer: Dave Casperson *Title:* Hellfire [functional cannon] *Size:* 8.5"x6"x28" *Medium:* Gun metal bronze

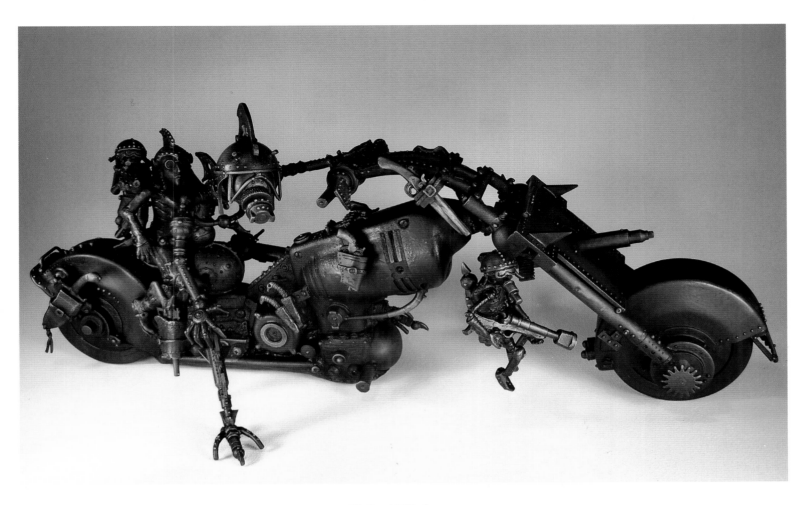

Vincent Villafranca

Art Director: Paul Lizotte *Client:* The Lizotte Collection *Title:* The Robo-Bike *Size:* 29"x10" *Medium:* Bronze

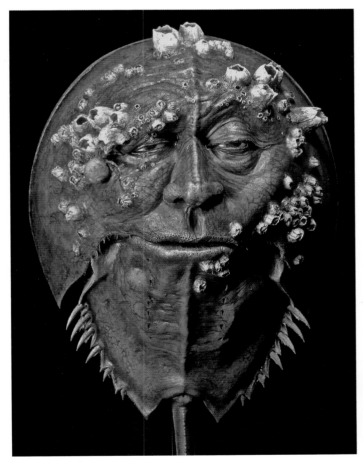

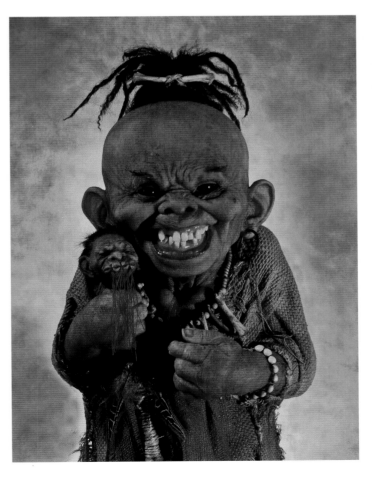

Tom Whittaker

Photographer: Mary Barah *Title:* The Bayman *Size:* 12"x26.25" *Medium:* Mixed

Thomas S. Kuebler

Title: Papa Boogedy *Size:* 26" Tall *Medium:* Silicone, mixed

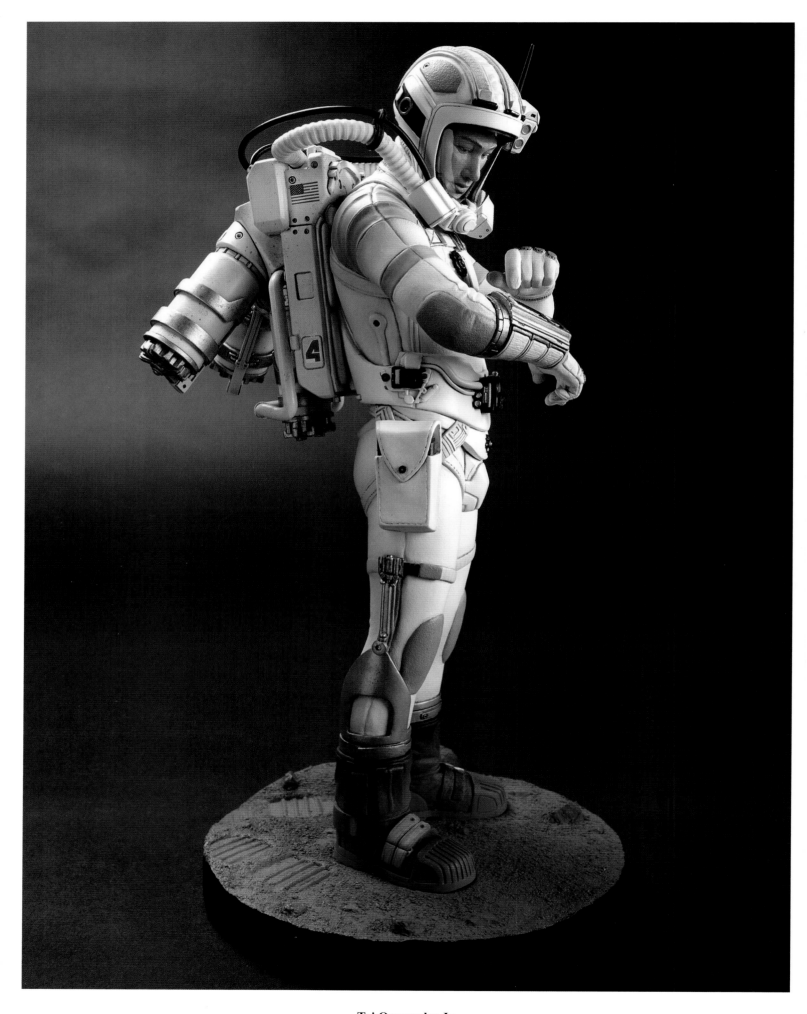

Toi Ogunyoku Jr
Designer: Kemp Remmillard *Title:* Astronaut *Size:* 1/6th scale *Medium:* Super sculpey, styrene

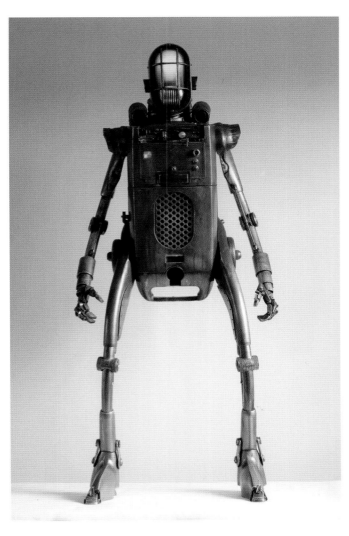

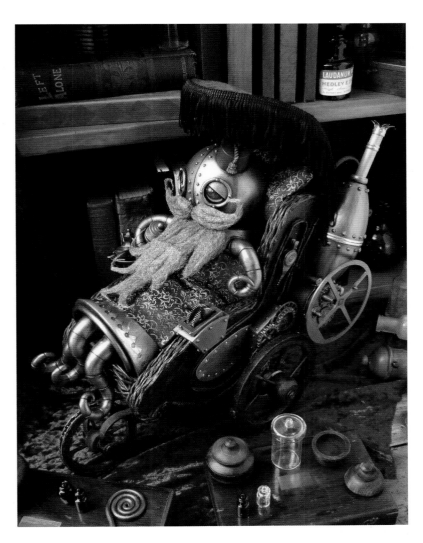

Jesse Gee

Title: Ampli-Fryer *Size:* 55"x20"x15" *Medium:* Mixed [found objects]

Bruce Whistlecraft aka Doktor A.

Title: Montague Grimshaw (The Elder) *Size:* 14" Tall *Medium:* Mixed

Ted Terranova

Client: Rivetwars.com *Title:* Vert Tank *Size:* 55mm Tall *Medium:* Resin

Tim Bruckner
Client: The Art Farm *Title:* Mr. B's Bookkeeper *Size:* 11" Tall *Medium:* Resin

Shaun Gentry
Title: A Clockwork Cthulhu *Size:* 17" Tall *Medium:* Super sculpey

Randy Hand
Title: Vishy Vishy *Size:* 8.5"x8"x14" *Medium:* Clay [preliminary to bronze casting]

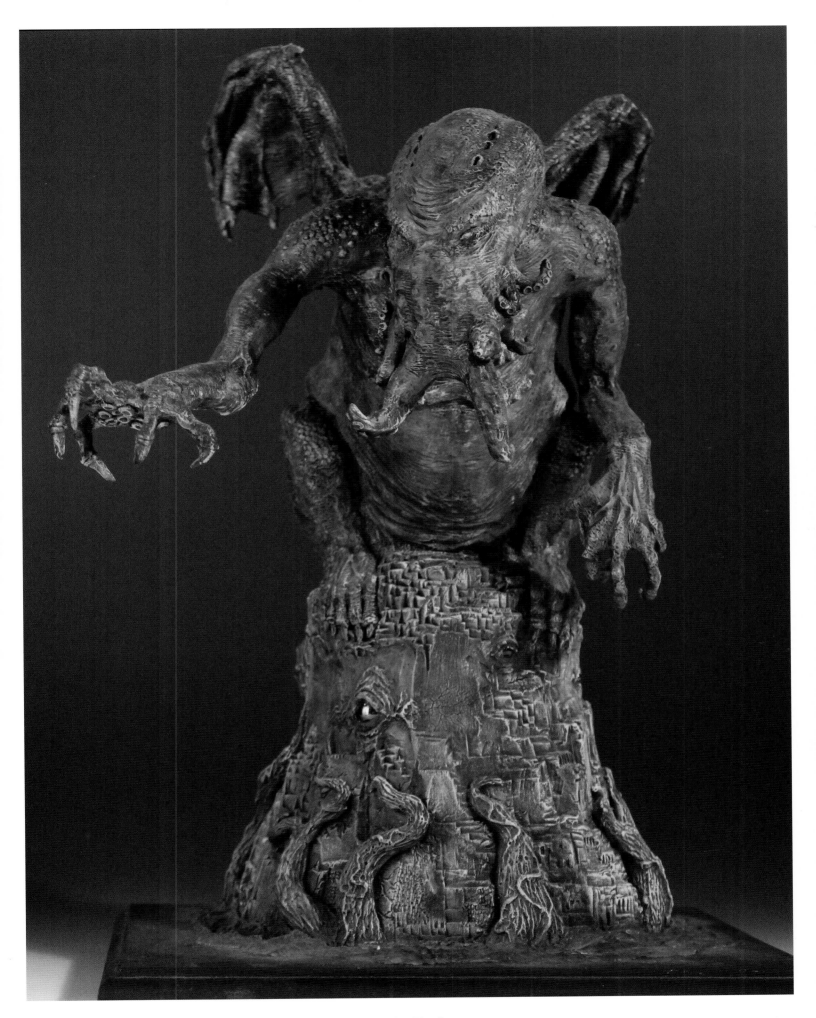

Brian Ford
Title: Mr. C *Size:* 10"x14" *Medium:* Polymer clay

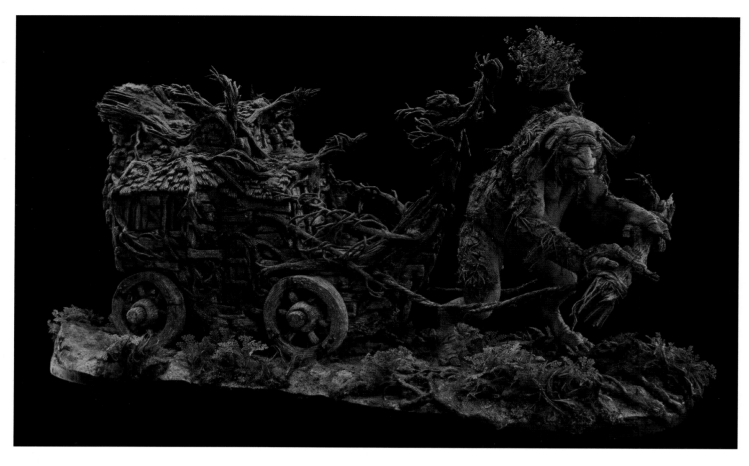

Johnny Fraser-Allen
Title: Troll Wagon *Medium:* Mixed

Michael Defeo
Photographer: Olivier Tossan *Client:* MD3D, Inc. *Title:* Octopus
Size: 5"x3"x3" *Medium:* Resin

Johnny Fraser-Allen
Title: The Troubadour *Medium:* Mixed

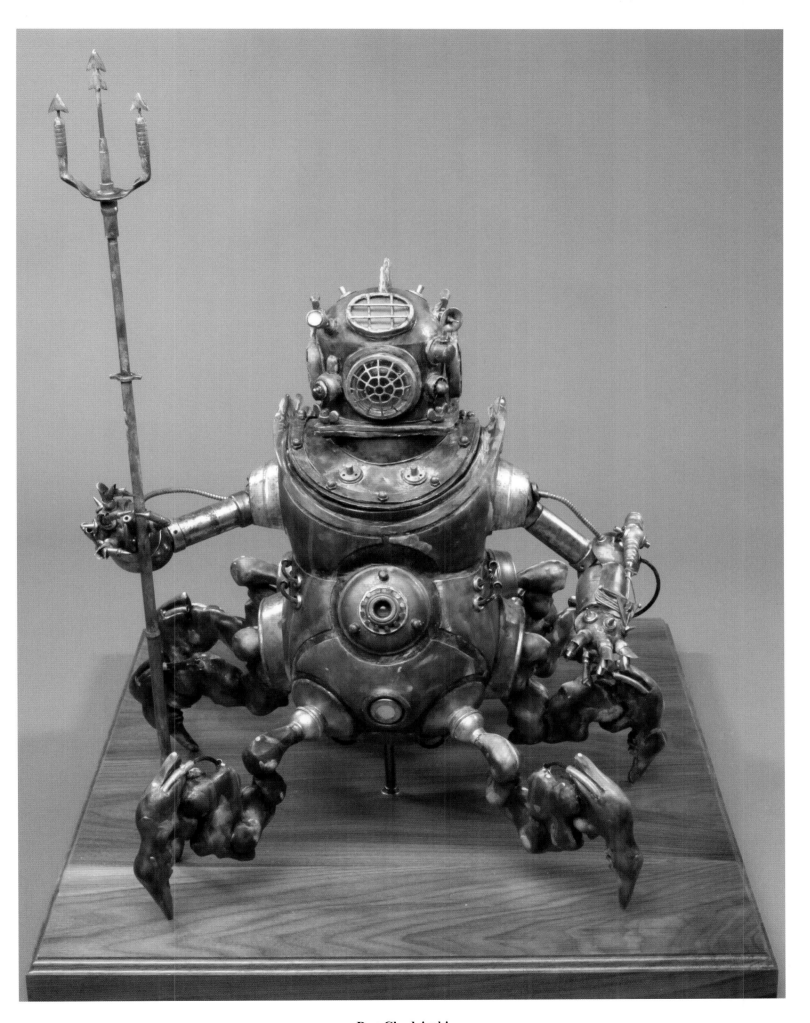

Dan Chudzinski

Photographer: Dave Casperson *Title:* The Grindylow *Size:* 24"x22.5"x26" *Medium:* Mixed

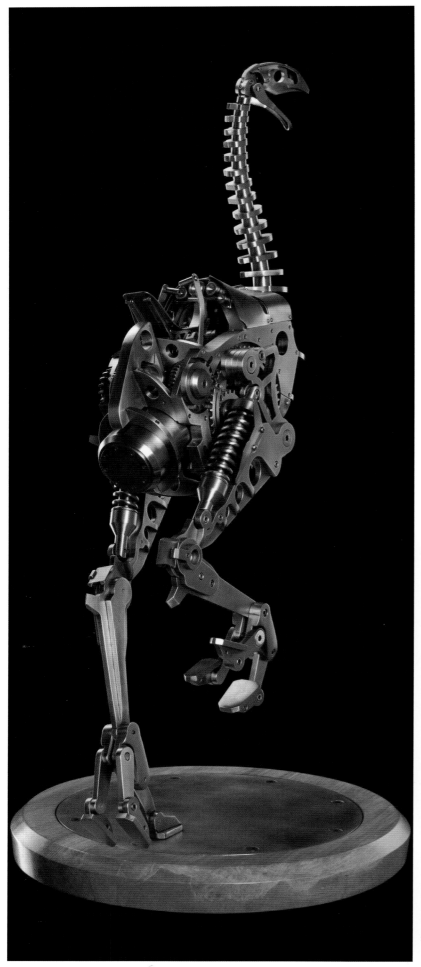

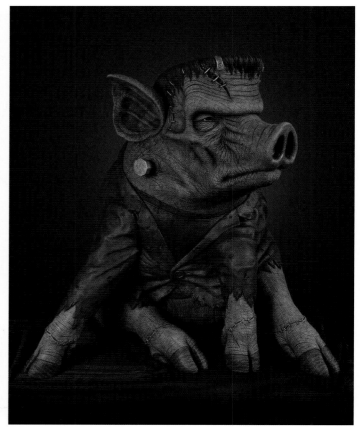

Mike Rivamonte
Title: Tank *Size:* 33" Tall *Medium:* Mixed

Stephen Lambert
Photographer: Steve Unwin *Title:* M.O.A.BOT *Size:* 400mm x 800mm *Medium:* Steel

J. Anthony Kosar
Photographer: Bear McGivney *Title:* Boaris Frankenswine
Size: 30"x30.5"x32" *Medium:* Mixed

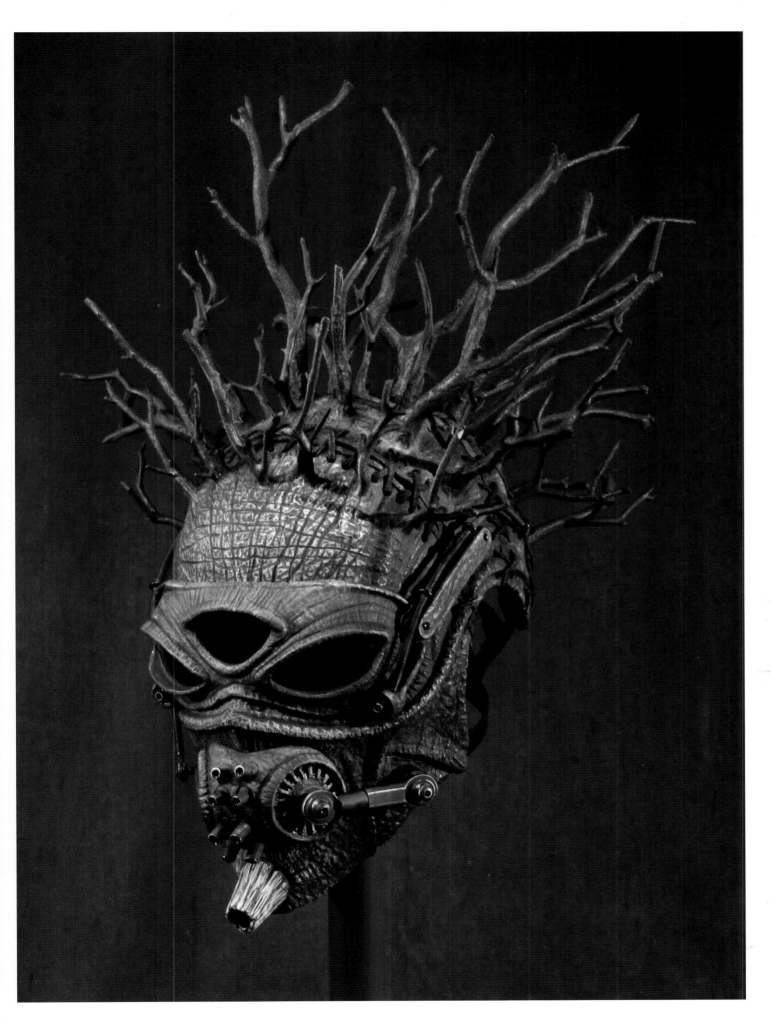

Bruce D. Mitchell

Photographer: Lola Mitchell *Title:* The Thicket *Size:* 17"x14"x16" *Medium:* Mixed

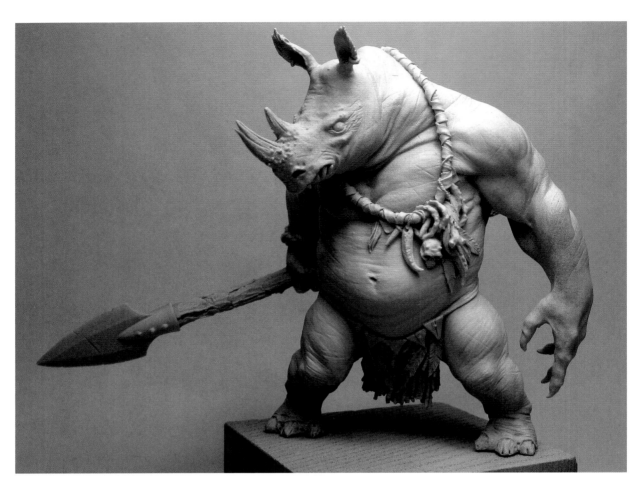

Allan Carrasco
Title: Rhinotaur *Medium:* Polymer clay

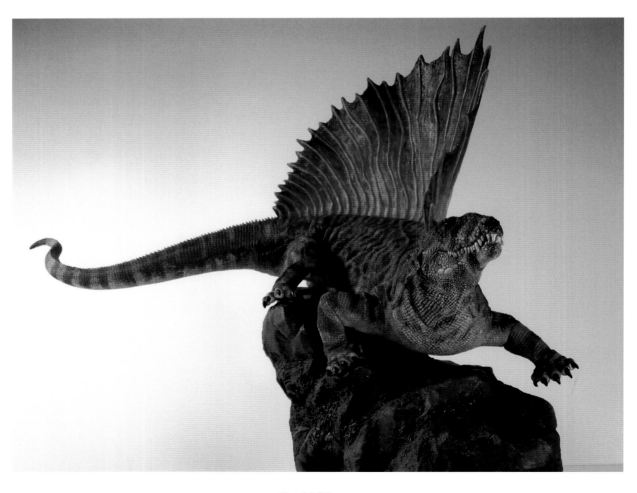

David Silva
Client: Creative Beast Studio *Title:* Permian Predator *Size:* 15"x11" *Medium:* Painted resin

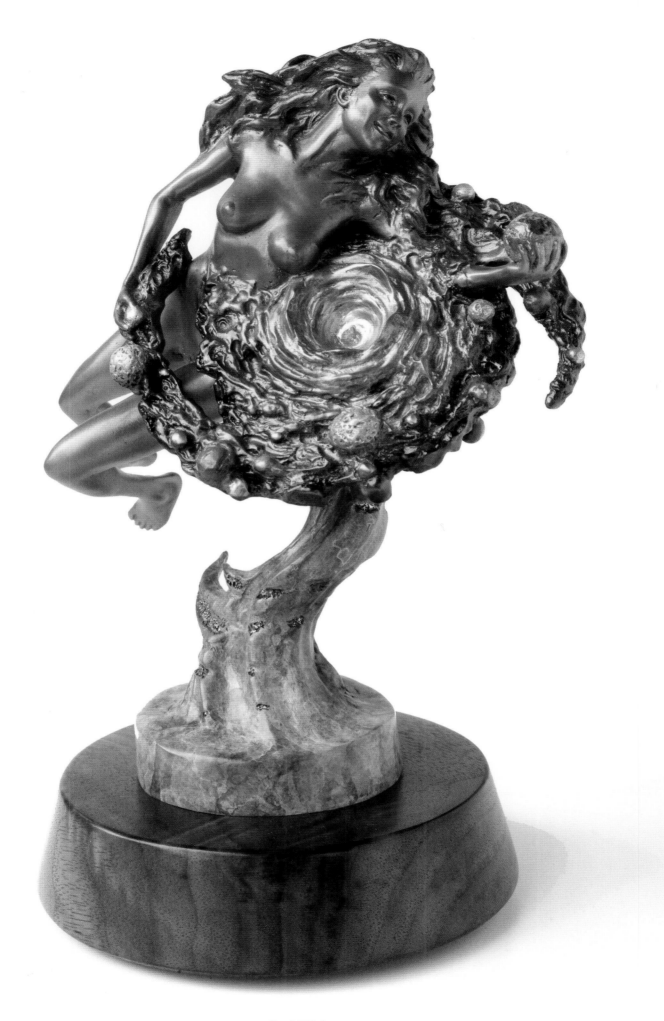

Levi Fitch

Photographer: Brent Jones *Title:* Feminine Presence *Size:* 9"x8" *Medium:* Bronze

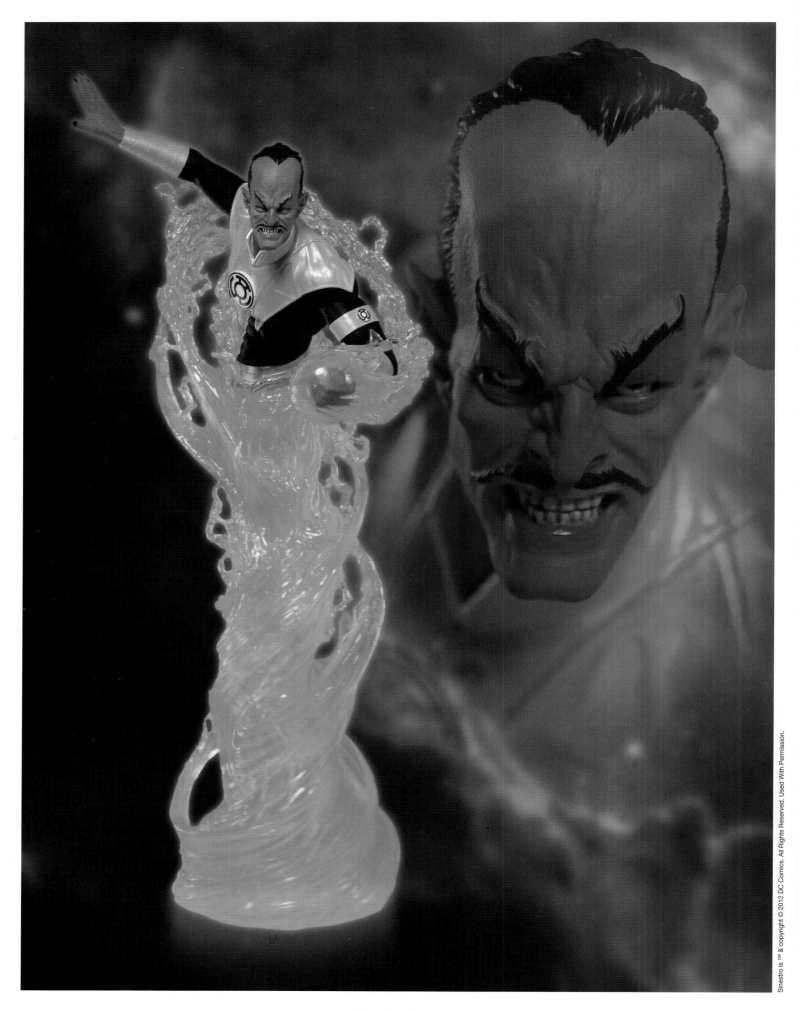

Tim Bruckner

Art Director: Tim Bruckner/Georg Brewer *Designer:* Tim Bruckner *Client:* DC Direct *Title:* DC Dynamics: Sinestro *Size:* 13.25" Tall *Medium:* Resin

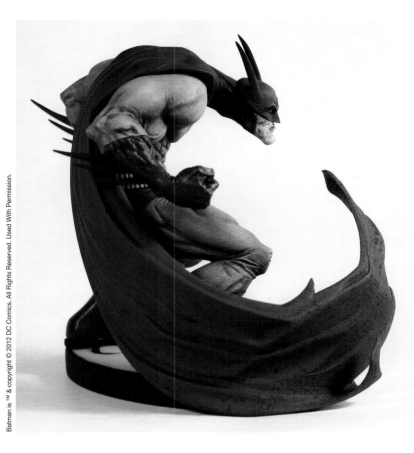

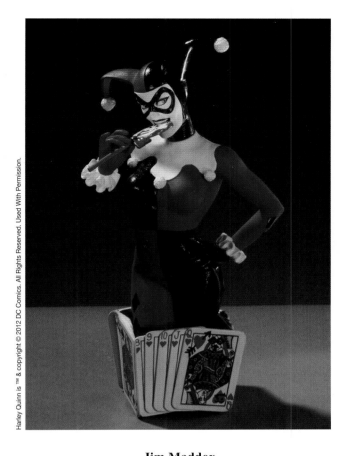

Jonathan Matthews

Art Director: Shawn Knapp *Designer:* Sam Keith
Client: DC Direct *Title:* Batman Black and White
Size: 7" Tall *Medium:* Painted resin

Jim Maddox

Art Director: John Santagada *Designer:* Amanda Conner
Painter: Brandy Anderson *Client:* DC Direct
Title: Women of the DCU: Harley Quinn *Size:* 6.5" Tall *Medium:* Resin

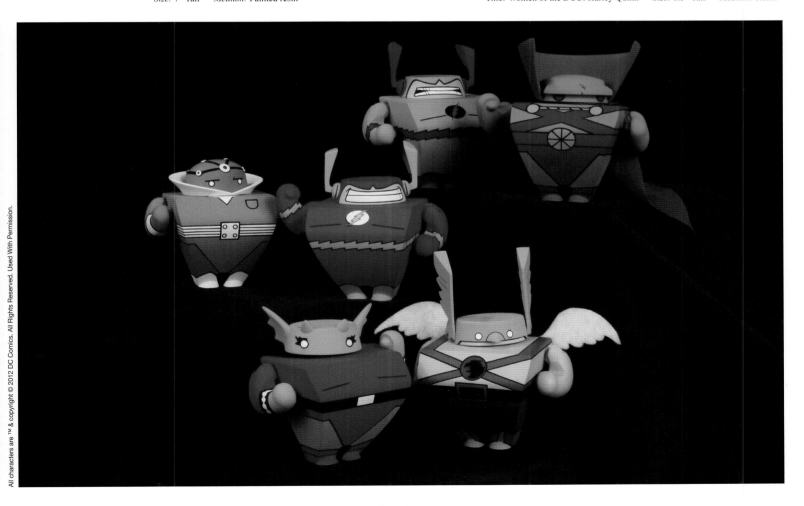

Joshua Sutton

Art Director: John Santagada *Designer:* John Santagada *Client:* DC Direct *Title:* Blammoids! Series 4 *Size:* 3" Tall *Medium:* Resin

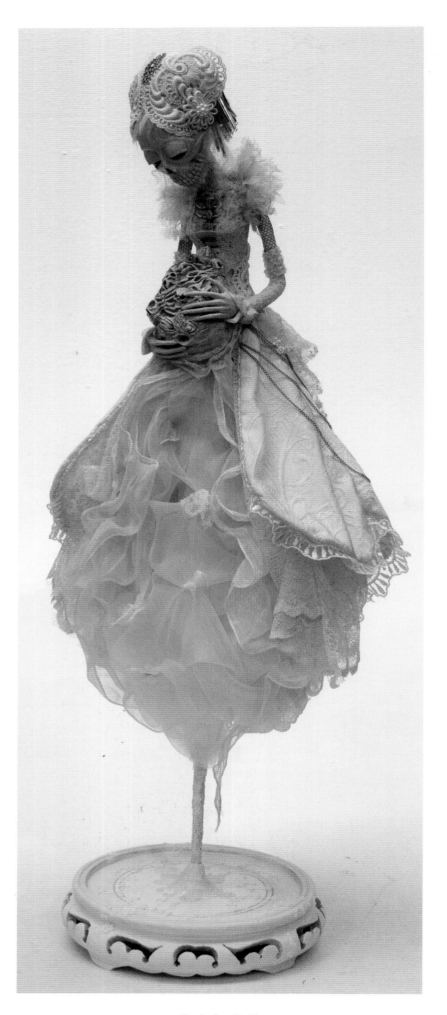

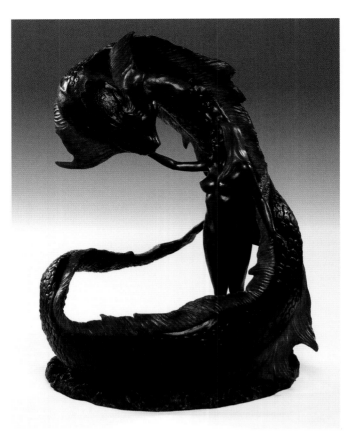

Yongkiat Karnchanapayap

Designer: Onuma Chintana Sathit *Client:* Himmapan *Title:* Lady of Naga *Size:* 20"x20"x24" *Medium:* Bronze

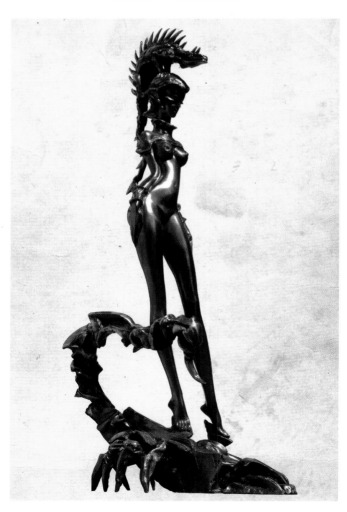

Christine Polis

Title: Expecting *Size:* 65cm *Medium:* Mixed

Igor Grechanyk

Title: Time of Scorpio *Size:* 51.2" Tall *Medium:* Bronze

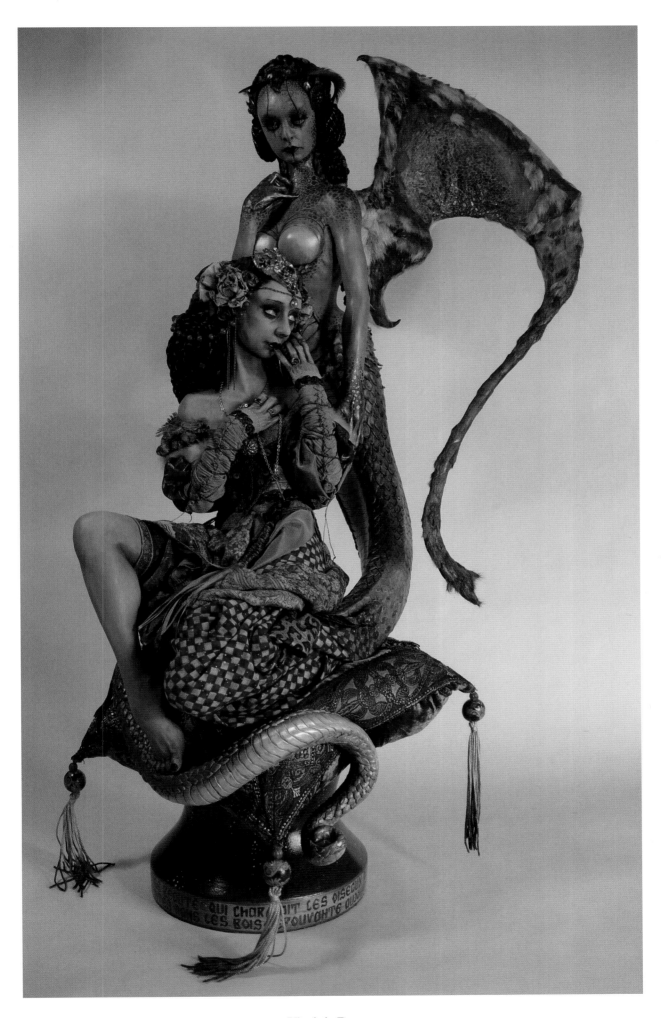

Virginie Ropars

Title: Legend of Melusine *Size:* 62cm Tall *Medium:* Polymer clay, mixed

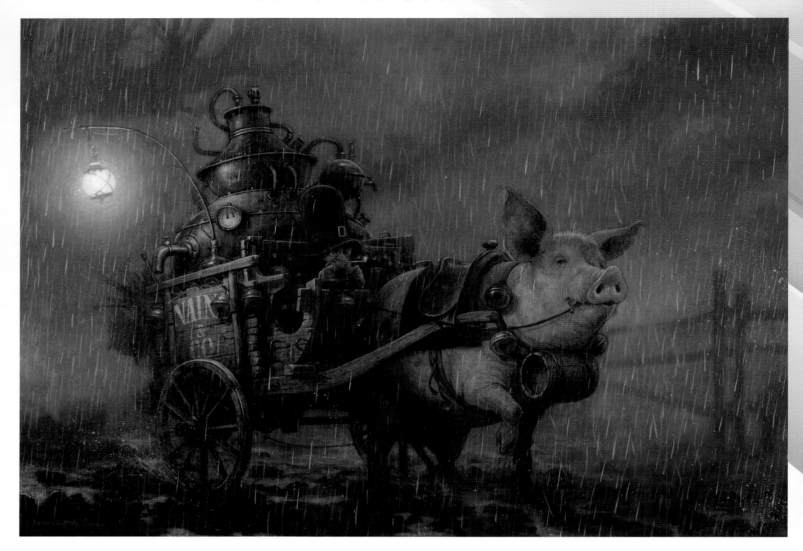

detail

Jean-Baptiste Monge
Client: International Artist Magazine *Title:* Mic Mac Cormac *Size:* 27.5"x19.75" *Medium:* Oil on canvas board

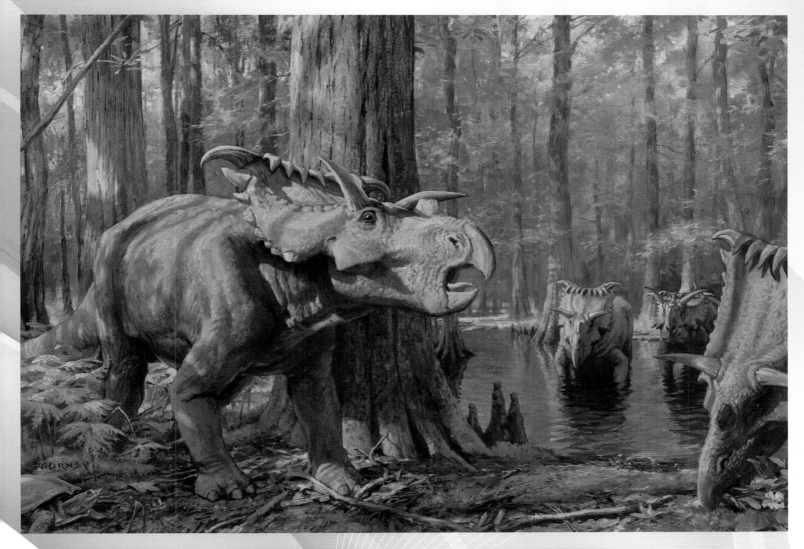

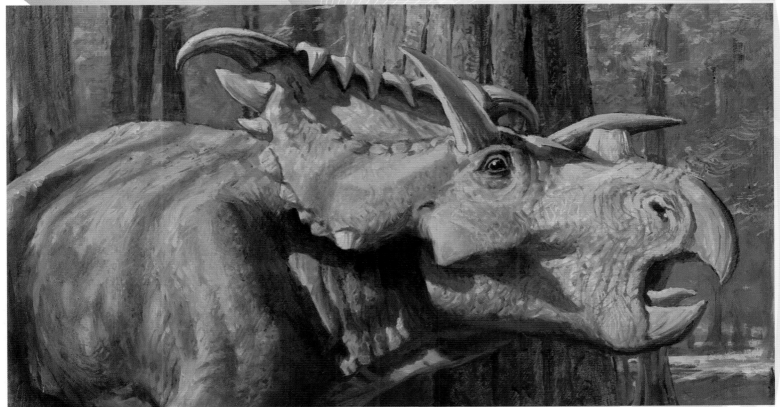

detail

James Gurney

Art Director: Michael R. Mrak *Designer:* Michael R. Mrak *Client:* Scientific American *Title:* Kosmoceratops *Size:* 18.75"x12.75" *Medium:* Oil

Chris Beatrice
Art Director: John Warley *Client:* John Warley *Title:* Lady Justice
Size: 8"x12" *Medium:* Mixed

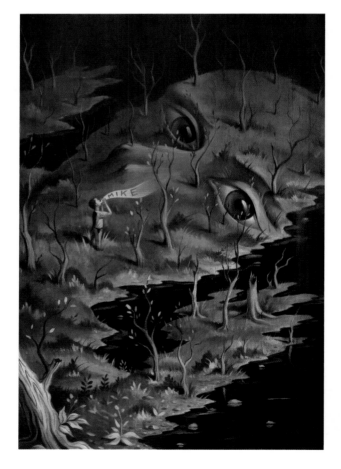

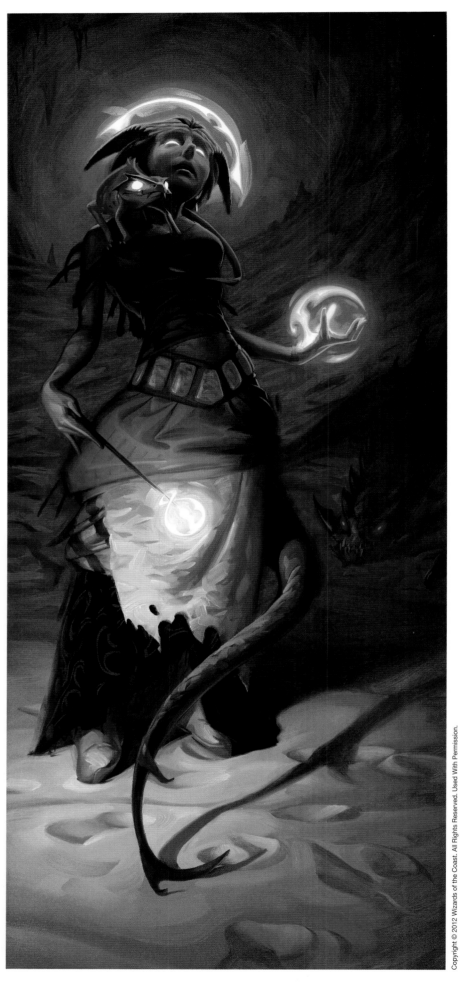

Chris Buzelli
Art Director: David Ross *Client:* Reader's Digest Asia
Title: Kidnapped and Buried Alive *Size:* 14"x20" *Medium:* Oil on paper

Rob Rey
Art Director: Jon Schindehette *Client:* Wizards of the Coast
Title: Athasian Familiars *Size:* 10"x24" *Medium:* Oil

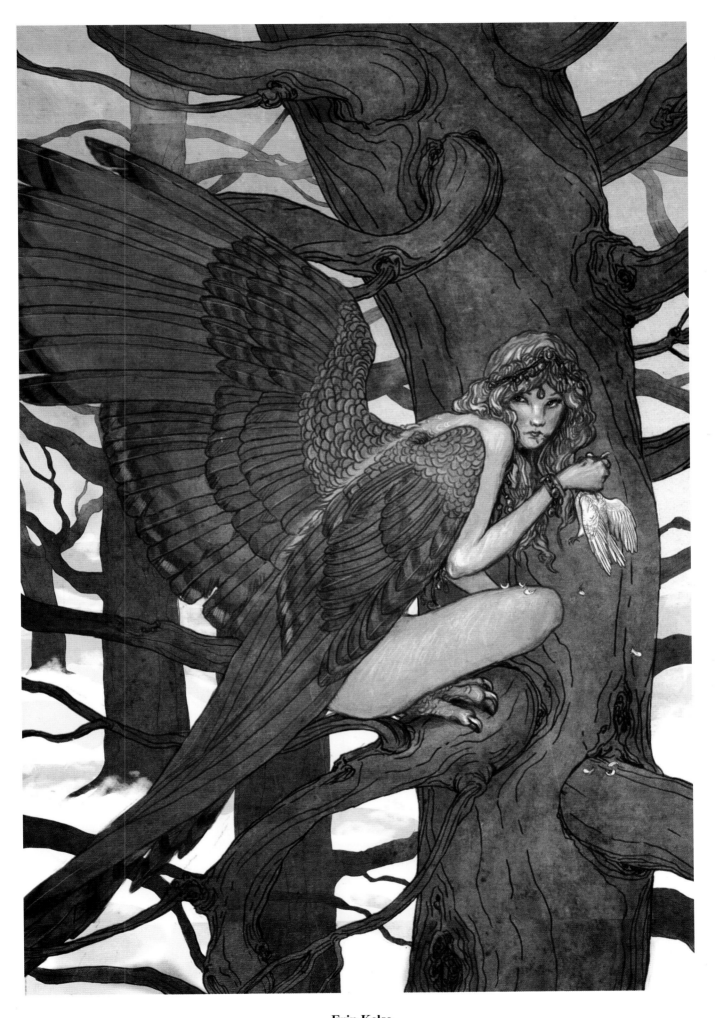

Erin Kelso

Art Director: Claire Howlett *Client:* ImagineFX Magazine *Title:* Harpy *Medium:* Digital

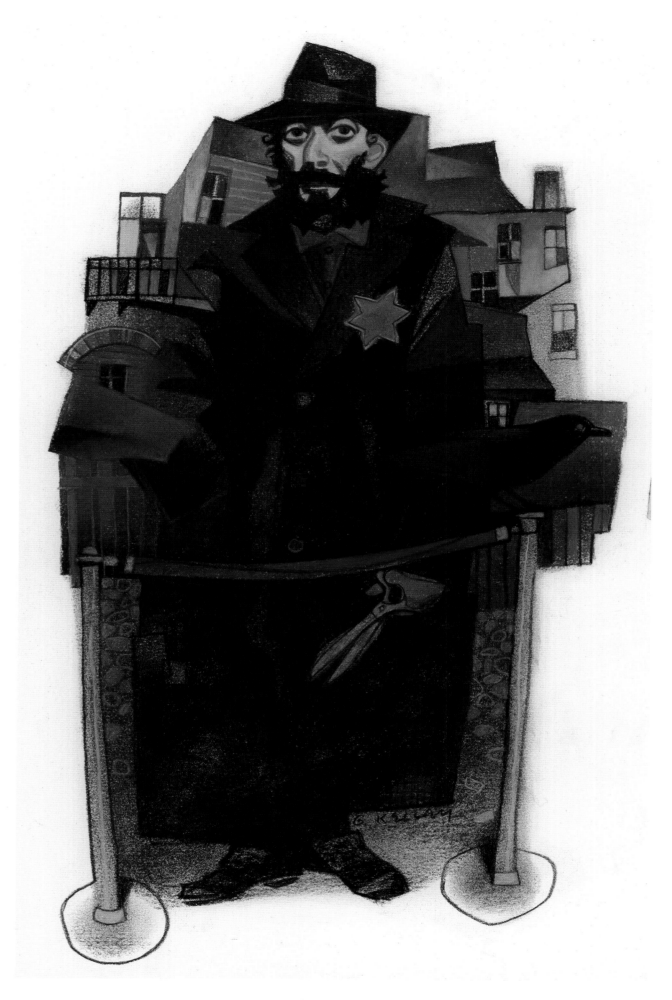

Gary Kelley
Art Director: Irene Gallo *Client:* Tor.com *Title:* Shtetl Days *Size:* 27.5"x19.75" *Medium:* Pastel

Sam Weber

Art Director: Irene Gallo *Client:* Tor.com *Title:* Rotten Beast *Medium:* Acrylic, watercolor, digital

Ture Ekroos

Client: Stylus Blue Magazine *Title:* Beneath *Medium:* Digital

Jeff Preston

Client: Monsterpalooza Magazine *Title:* Pumpkinmaster *Size:* 13"x17" *Medium:* Marker

Kalman Andrasofszky

Client: Silver Snail Comics *Title:* 35th Anniversary *Size:* 16.7"x11.2" *Medium:* Ink, Photoshop

Bobby Chiu
Art Director: Paul Tysall *Client:* ImagineFX Magazine *Title:* Early Bloom *Size:* 9"x12" *Medium:* Digital

Scott Brundage
Art Director: Irene Gallo *Client:* Tor.com
Title: Ch-Ch-Ch-Changes *Medium:* Watercolor

Filip Burburan
Art Director: Jon Schindehette *Client:* ArtOrder
Title: ArtOrder Challenge *Medium:* Digital

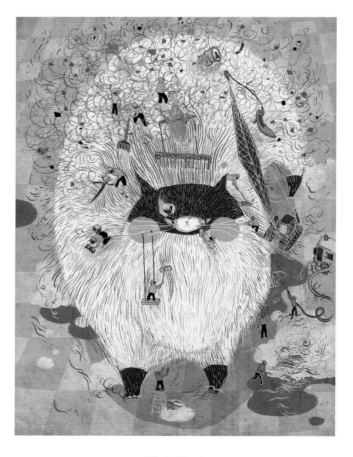

David Leri
Art Director: Douglas Cohen *Client:* Realms of Fantasy
Title: Wreathed in Westeria, Draped in Ivy *Size:* 8.5"x11.5" *Medium:* Oil

Victo Ngai
Art Director: SooJin Chun Buzelli *Client:* Asset International, Inc.
Title: Grooming Day *Size:* 7.4"x 12" *Medium:* Mixed

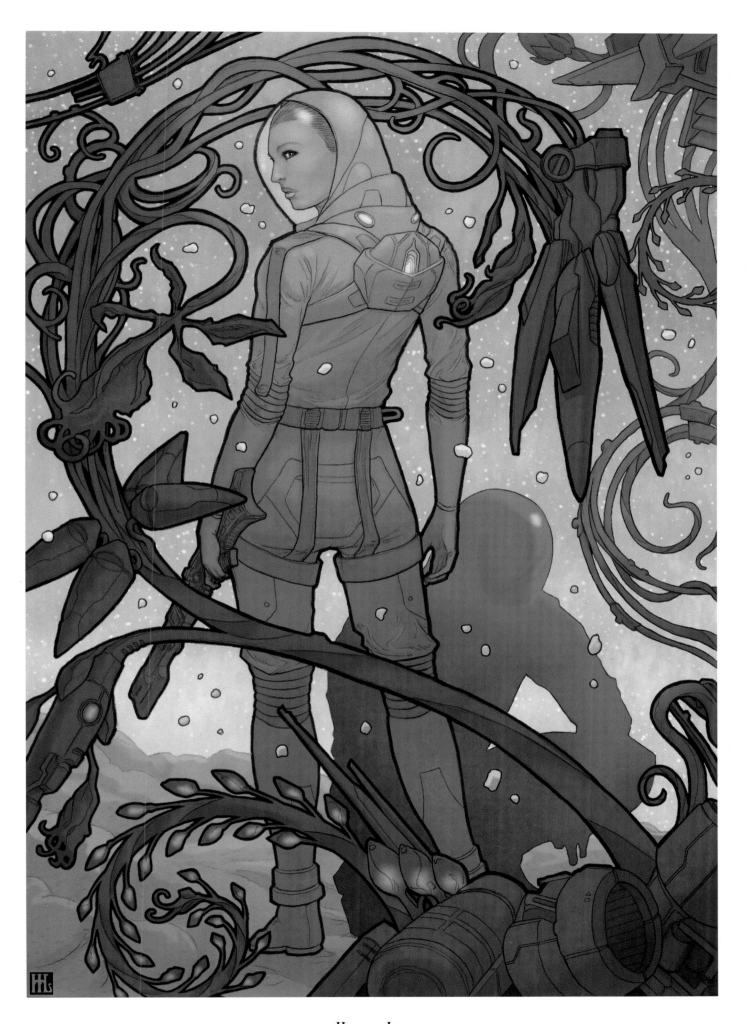

Herman Lau

Art Director: Jon Schindehette *Client:* ArtOrder *Title:* ArtOrder Challenge *Medium:* Digital

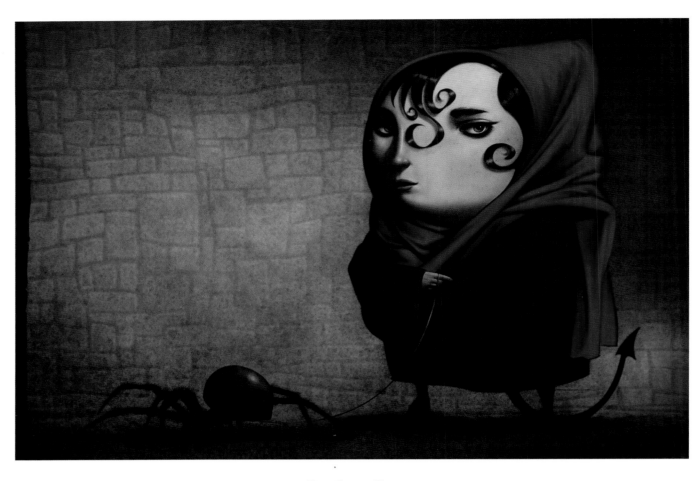

Don Seegmiller
Art Director: Don Seegmiller *Client:* ImagineFX Magazine *Title:* Girl Walking Her Pet Spider *Size:* 17"x11" *Medium:* Digital

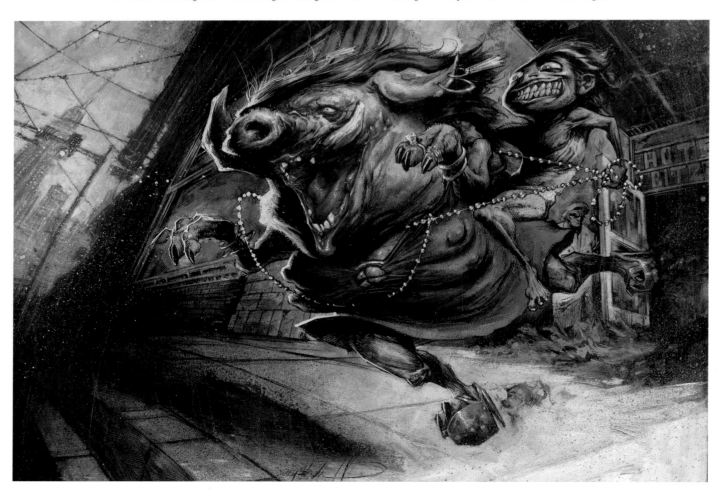

Jonathan Wayshak
Art Director: Stephen Lpshiavo *Client:* Magna Publishing *Title:* Pigface *Medium:* Mixed

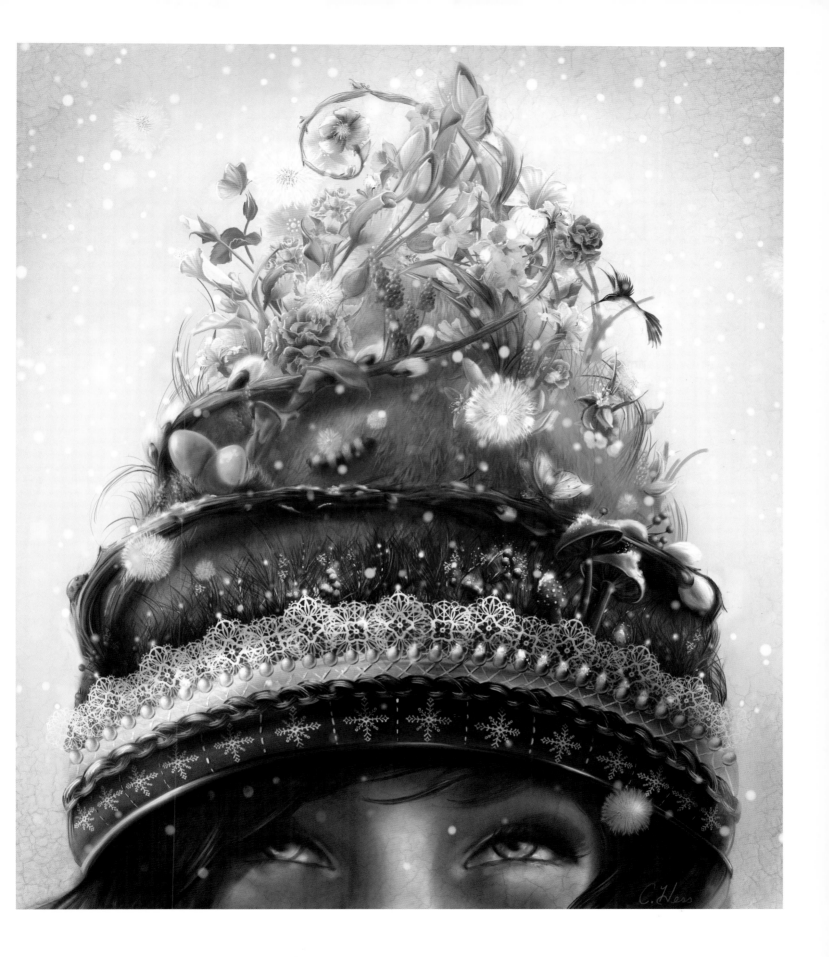

Christina Hess

Art Director: Pat Stone *Client:* Green Prints Magazine *Title:* Next Season *Size:* 9"x10.5" *Medium:* Digital

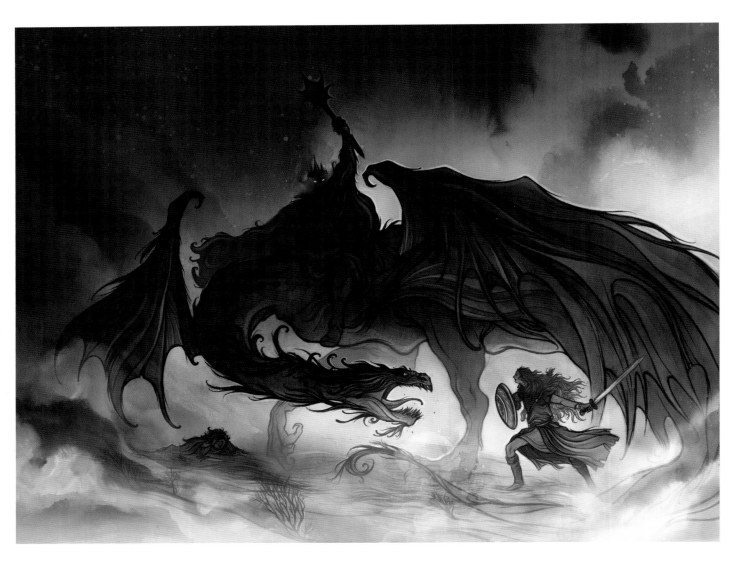

Cory Godbey
Art Director: Jon Schindehette *Client:* ArtOrder *Title:* ArtOrder Challenge *Medium:* Digital

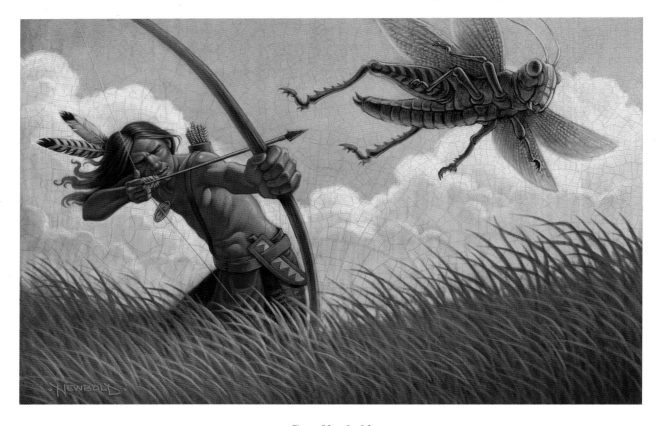

Greg Newbold
Art Director: Scott Feaster *Client:* Boy's Life Magazine *Title:* Grass Hopper Hunter *Size:* 11"x17" *Medium:* Digital

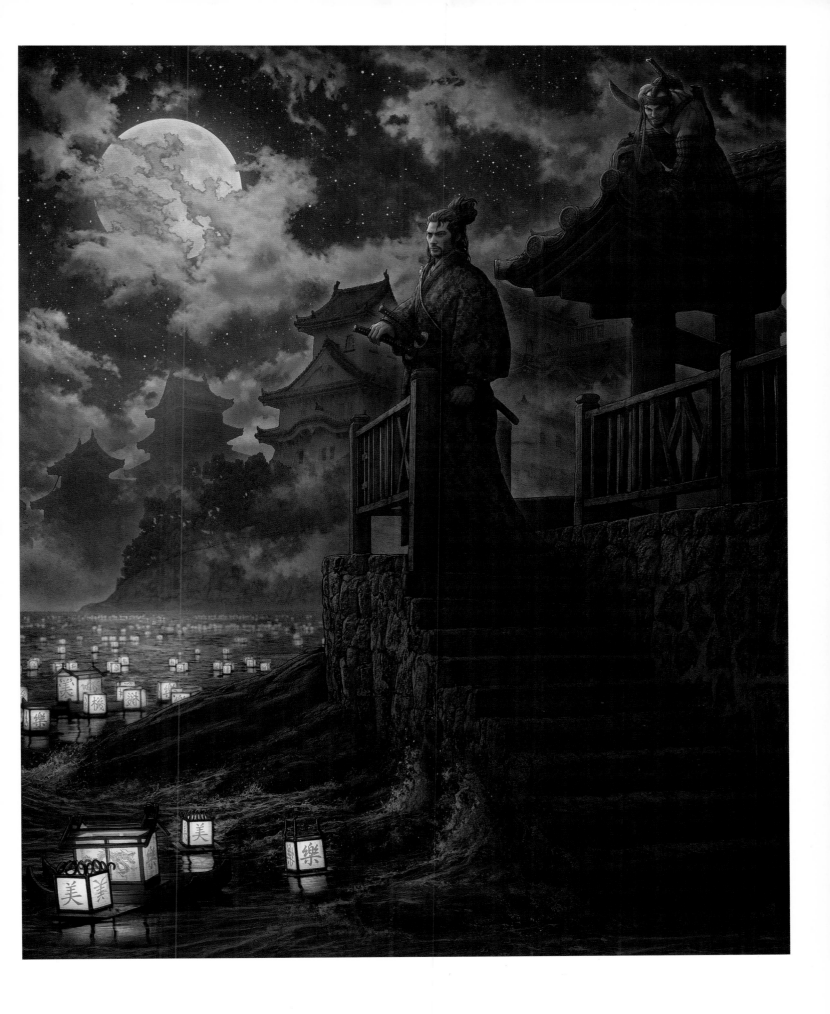

Kerem Beyit

Art Director: Kate Irwin *Client:* Wizards of the Coast *Title:* Honor System *Medium:* Digital

Winona Nelson
Art Director: Jon Schindehette *Client:* Wizards of the Coast
Title: Primal Elk *Sice:* 22"x22" *Medium:* Digital

William Stout
Art Director: Mike Fredericks *Designer:* William Stout *Client:* Prehistoric Times
Title: Gastonia Takes Shelter *Sice:* 9"x13" *Medium:* Digital

Julie Dillon
Art Director: Irene Gallo *Client:* Tor.com *Title:* Uncle Flower *Medium:* Digital

Chris Buzelli

Art Director: SooJin Buzelli *Client:* Plansponsor Magazine *Title:* Strength in Numbers *Size:* 15"x19.5" *Medium:* Oil on board

Tim O'Brien

Art Director: D.W. Pine *Client:* Time Magazine *Title:* Gadaffi *Medium:* Oil

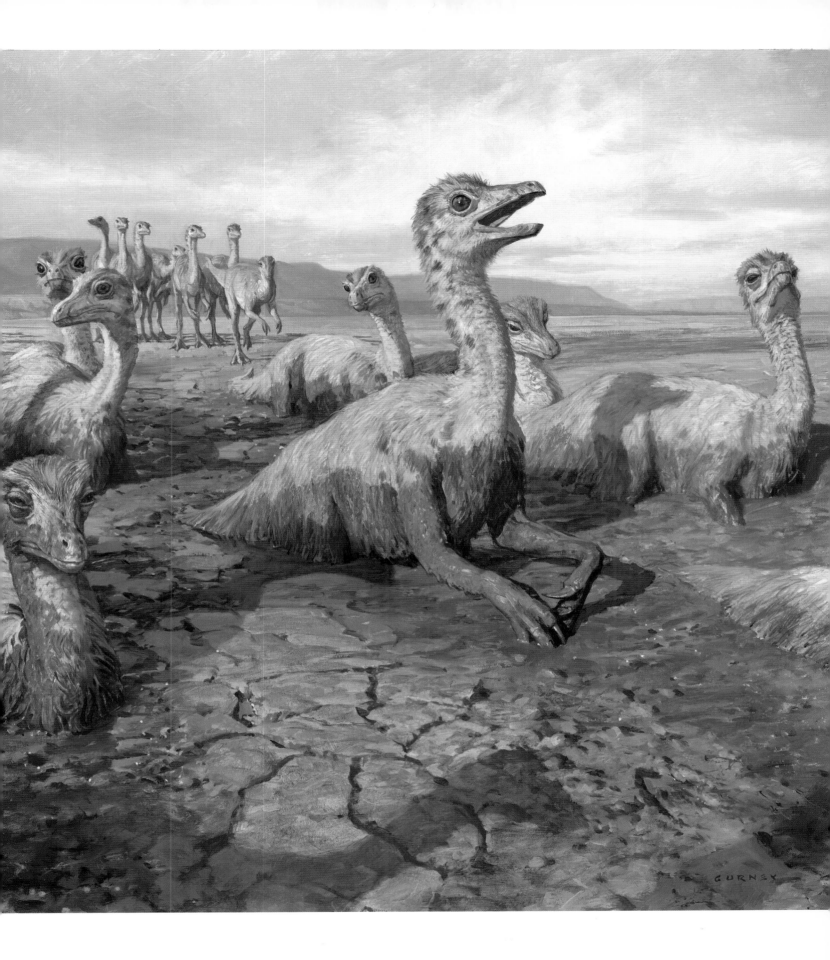

James Gurney

Art Director: Michael Mrak *Client:* Scientific American *Title:* Mud Trap *Size:* 17.5"x17" *Medium:* Oil

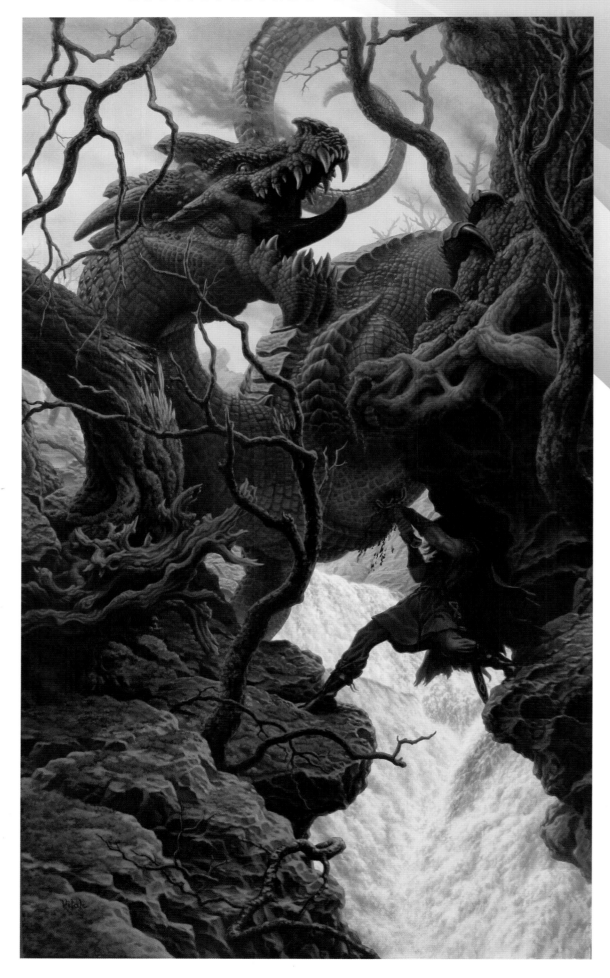

Raoul Vitale
Title: Turin and Glaurung *Size:* 17"x30.5" *Medium:* Oil on masonite

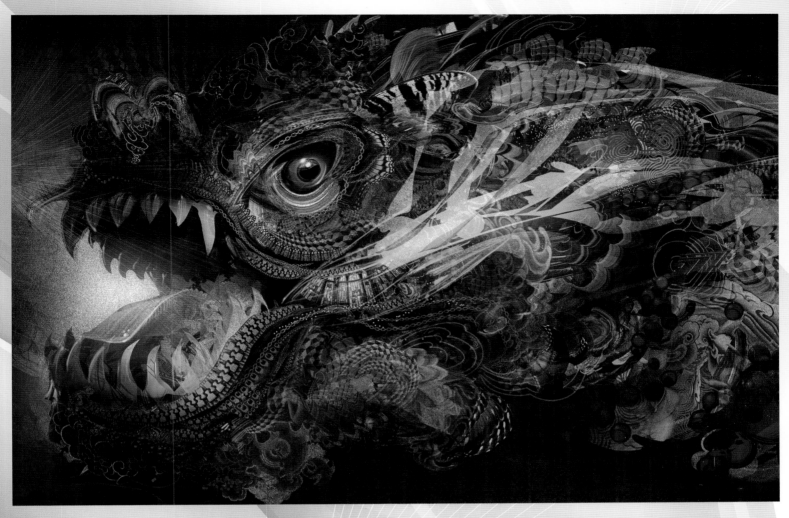

detail

Android Jones
Title: Water Dragon 2012 *Medium:* Painter 12

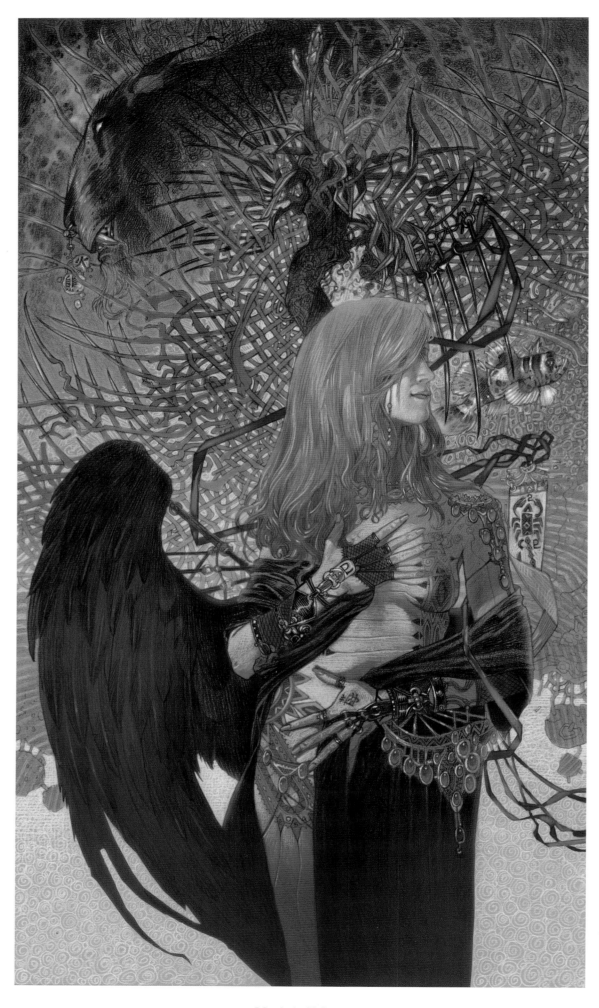

Mark A. Nelson

Art Director: Mark A. Nelson *Client:* Grazing Dinosaur Press *Title:* AGR: Persevere *Size:* 11"x18.25" *Medium:* Pencil, digital

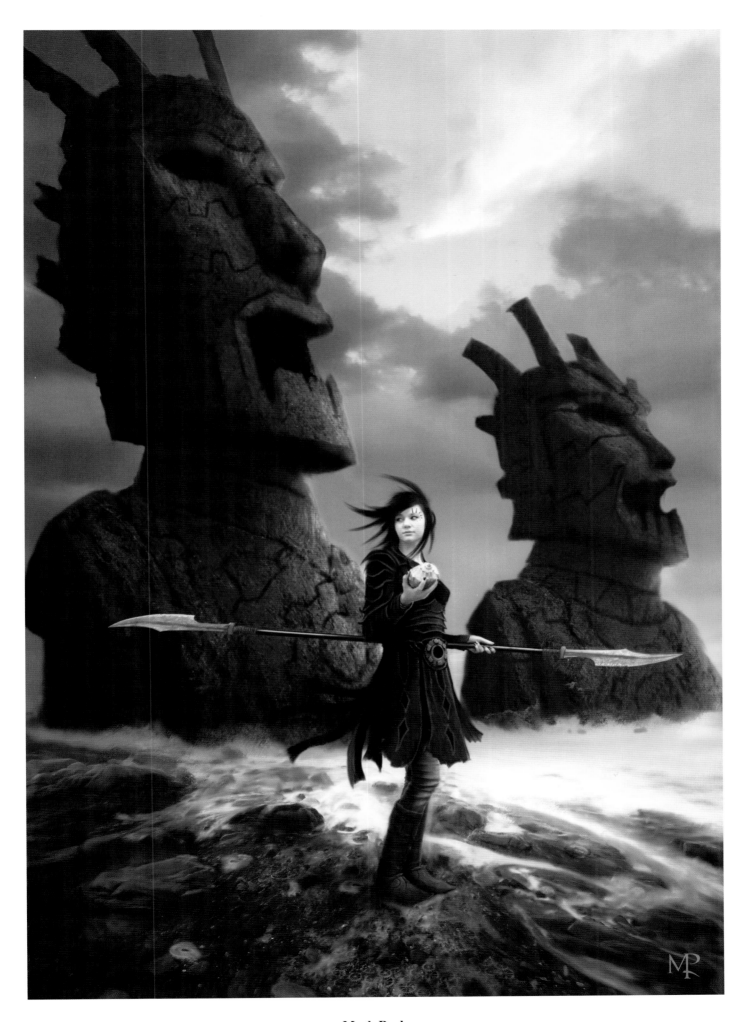

Mark Poole

Client: Mind Poole, Inc. *Title:* Sentinels *Size:* 24"x36" *Medium:* Oil

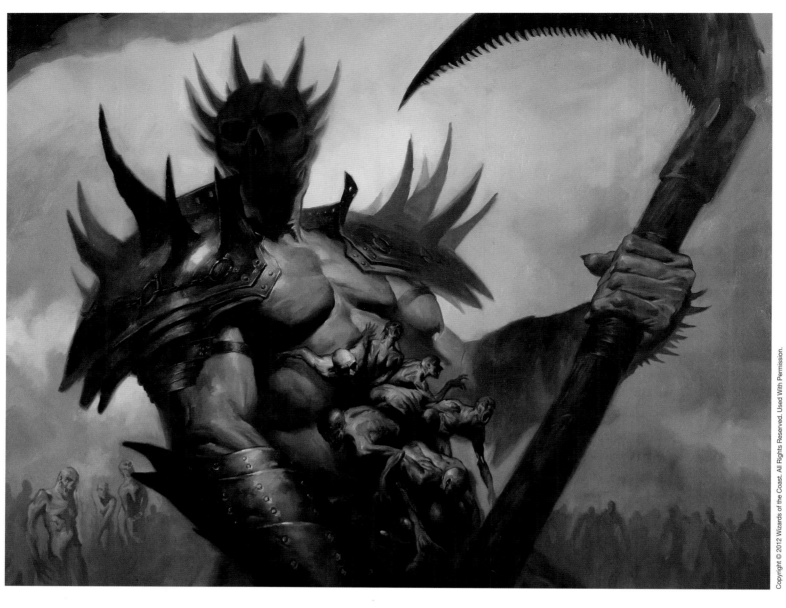

Lucas Graciano
Art Director: Jeremy Jarvis *Client:* Wizards of the Coast *Title:* Grave Titan *Size:* 20"x16" *Medium:* Oil

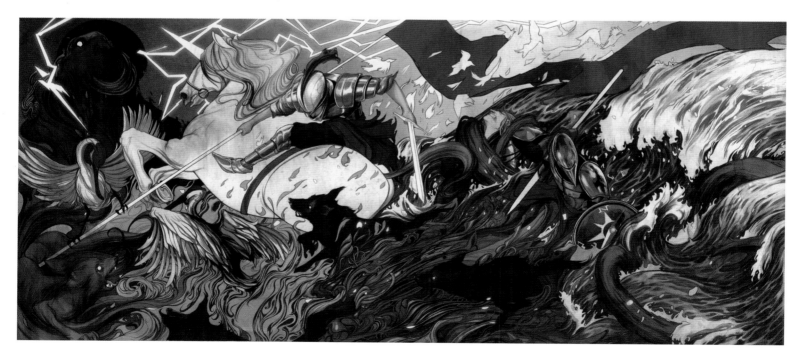

Nimit Malavia
Art Director: Daniel Weinand *Client:* Shopify *Title:* Better To Be the Storm Than the Sea *Size:* 38"x19" *Medium:* Mixed, digital

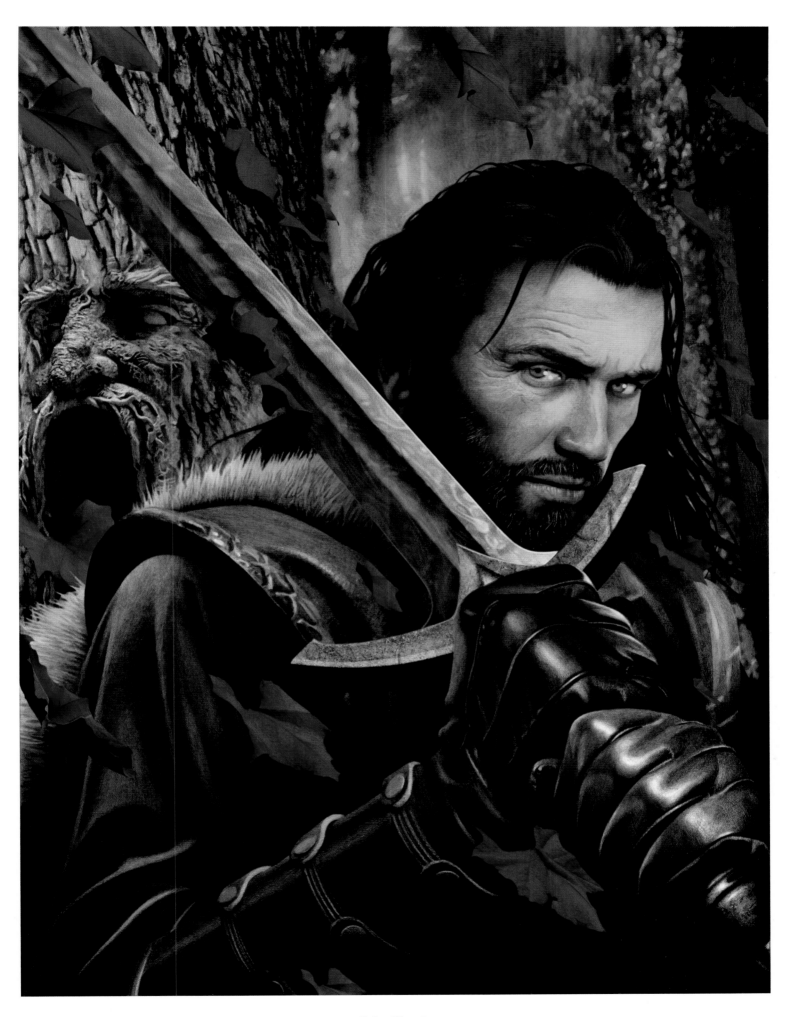

John Picacio

Art Director: David Stevenson *Client:* Bantam Books *Title:* Eddard Stark *Size:* 13.5"x18" *Medium:* Pencil, acrylic, digital

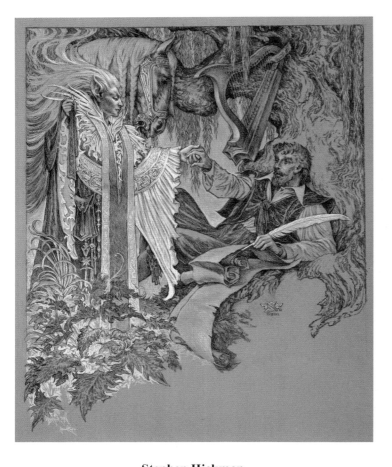

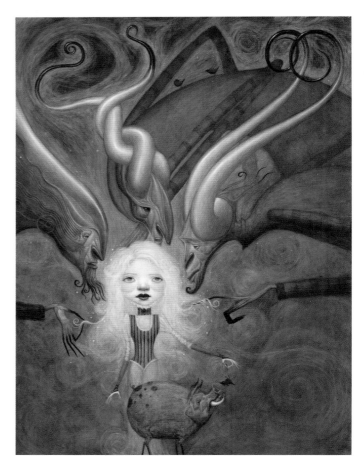

Stephen Hickman
Title: Thomas the Rhymer & The Queen of Elfland
Size: 18"x21" *Medium:* Pencil, charcoal, gouache

Bill Carman
Title: 3 Wishes *Size:* 9"x 10" *Medium:* Acrylic on copper

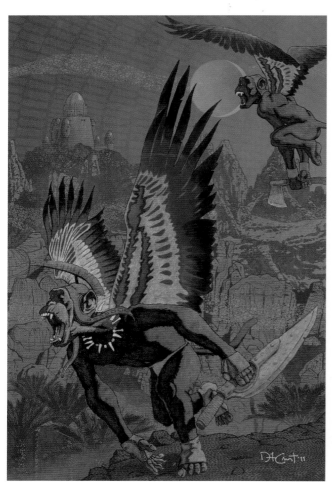

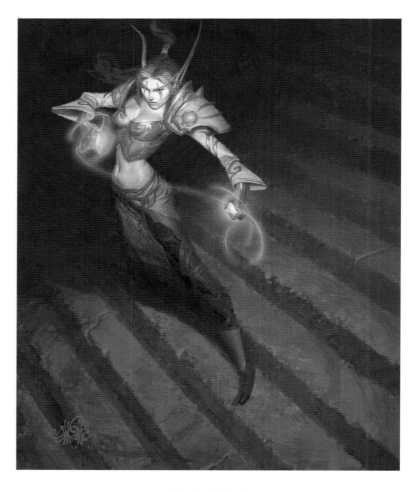

David Crust
Title: Flying Monkeys *Size:* 12"x18" *Medium:* Mixed

Craig Elliott
Art Director: Doug Alexander/Jeremy Cranford *Client:* Blizzard Entertainment
Title: Holy Nuke *Size:* 11"x 14" *Medium:* Photoshop

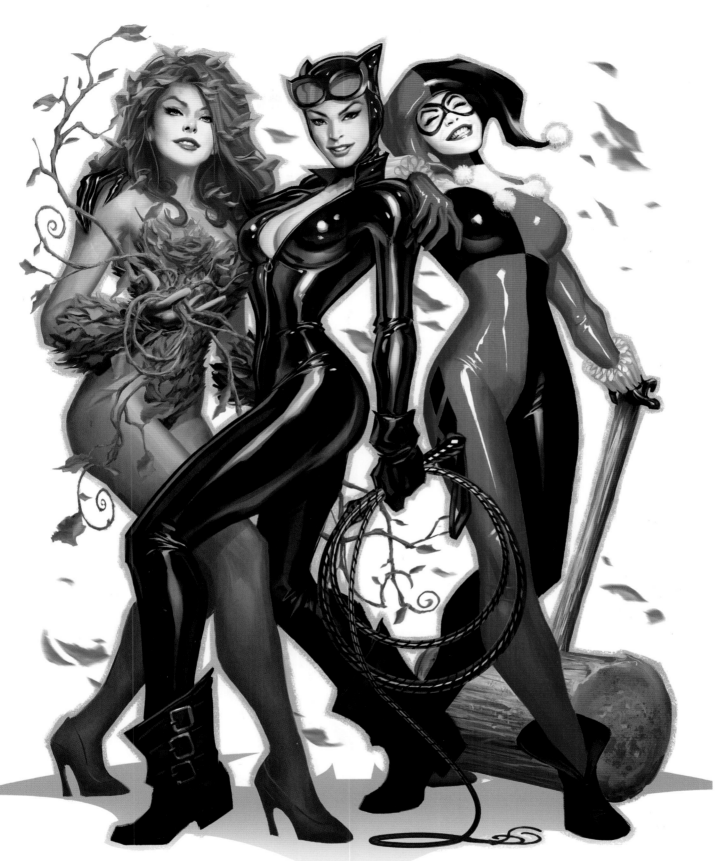

Alex Garner
Client: DC Comics Title: Gotham City Sirens Size: 12.5"x18.5" Medium: Digital

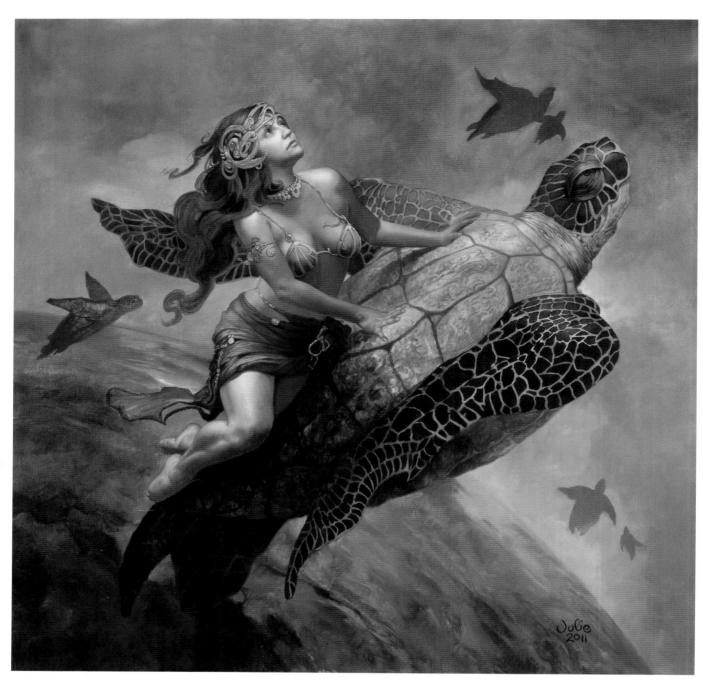

Julie Bell
Art Director: Julie Bell *Client:* Workman Publishing *Title:* The Day We Left *Size:* 18"x18" *Medium:* Oil on board

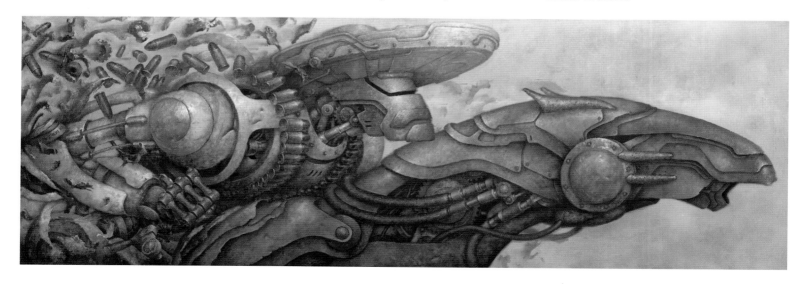

Raul Cruz
Title: Tricentenary *Size:* 180cm x 60cm *Medium:* Acrylic on canvas

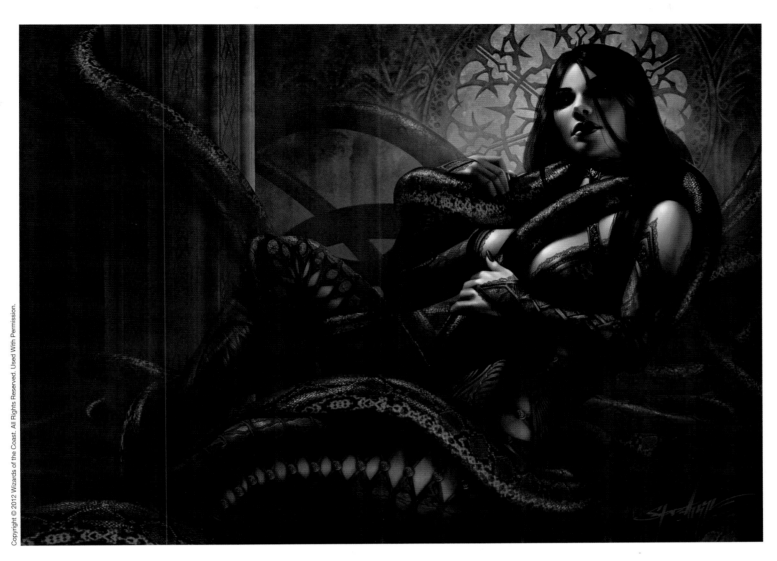

Steve Argyle
Art Director: Jeremy Jarvis *Client:* Wizards of the Coast *Title:* Deadly Allure *Medium:* Digital

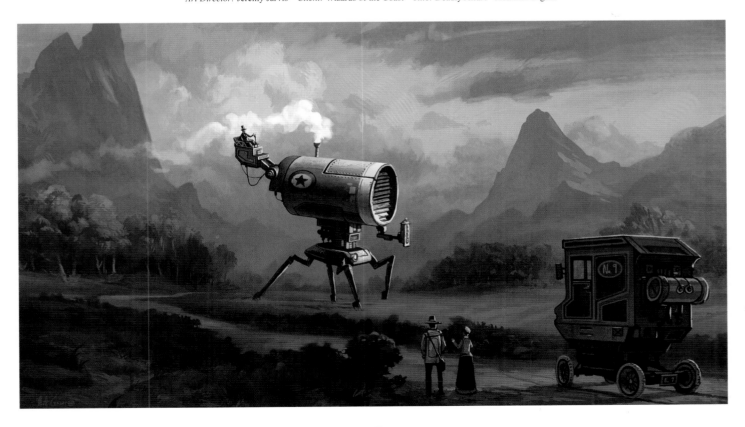

Matt Gaser
Title: Morton's Crawl *Size:* 22"x12" *Medium:* Digital

Christina Hess
Client: Lancaster Domestic Violence Shelter *Title:* Patchwork Girl
Size: 6.5"x12" *Medium:* Digital

Alexandra Manukyan
Title: Fawn *Size:* 18"x 36" *Medium:* Oil on canvas

Kan Muftic
Client: Gorillaarfare *Title:* Her Scent *Medium:* Digital

Alexandra Manukyan

Title: Guardian's Gaze *Size:* 36"x 36" *Medium:* Oil on canvas

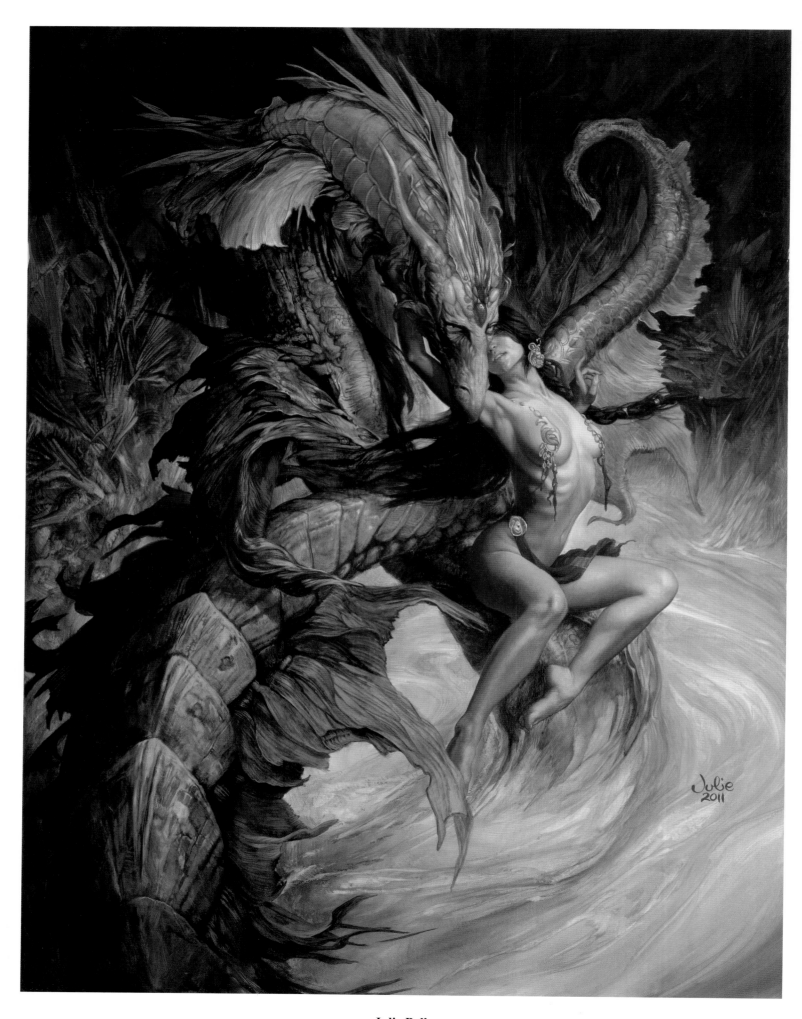

Julie Bell
Art Director: Julie Bell *Client:* Workman Publishing *Title:* Through the Mist *Size:* 18"x24" *Medium:* Oil on board

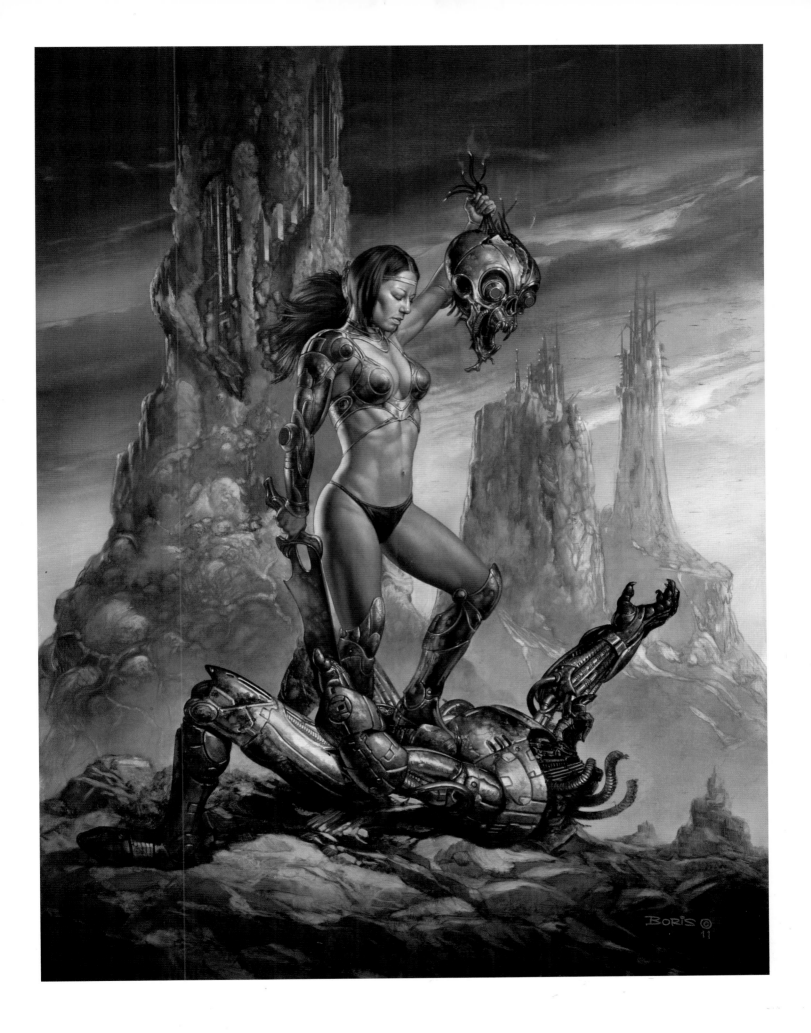

Boris Vallejo

Art Director: Boris Vallejo *Client:* Workman Publishing *Title:* Rules of the Game *Size:* 18"x24" *Medium:* Oil

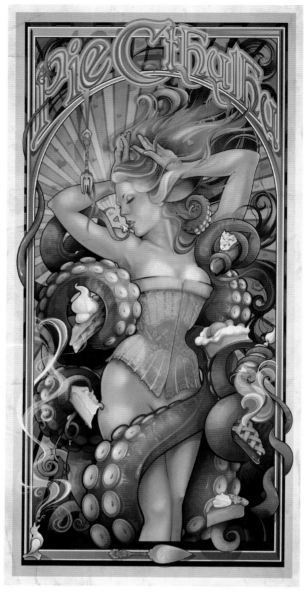

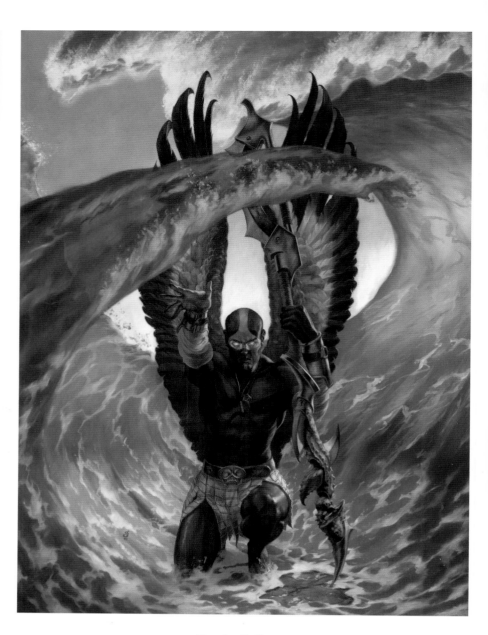

Echo Chernik

Title: Pie Cthulhu *Size:* 24"x48" *Medium:* Digital

Randy Gallegos

Art Director: Julien Di Maria *Client:* Imagine, Ltd. *Title:* Semhyr *Size:* 18"x 24" *Medium:* Oil

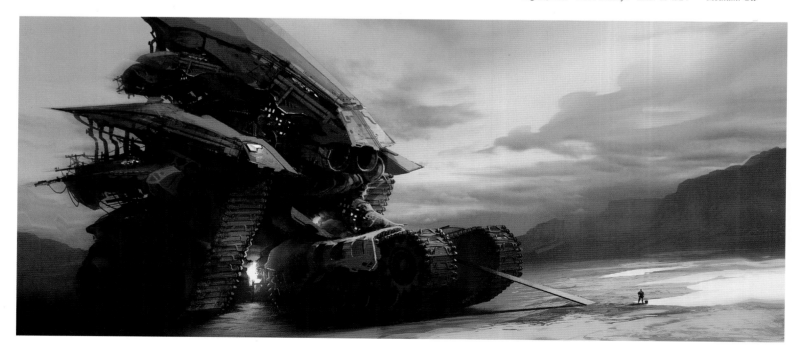

Jason Stokes

Client: Futurepoly *Title:* Thirsty Tank *Medium:* Digital

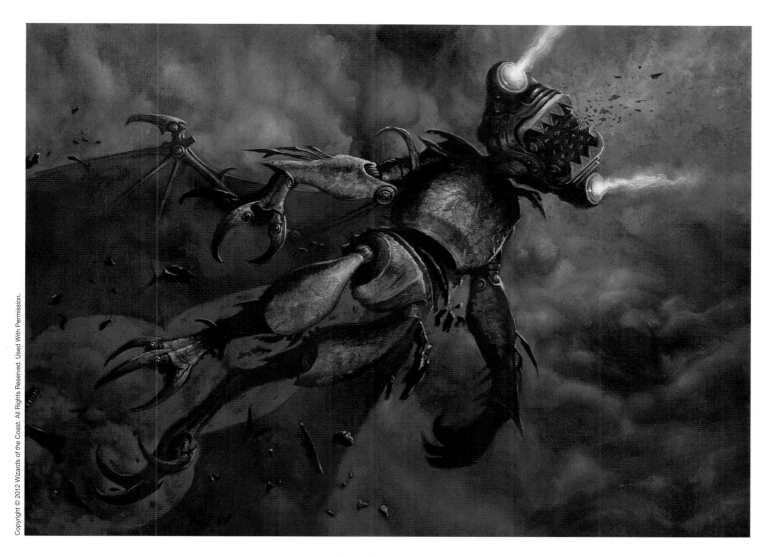

Lars Grant-West
Art Director: Jeremy Jarvis *Client:* Wizards of the Coast *Title:* Vault Skirge *Size:* 14"x11" *Medium:* Oil on masonite

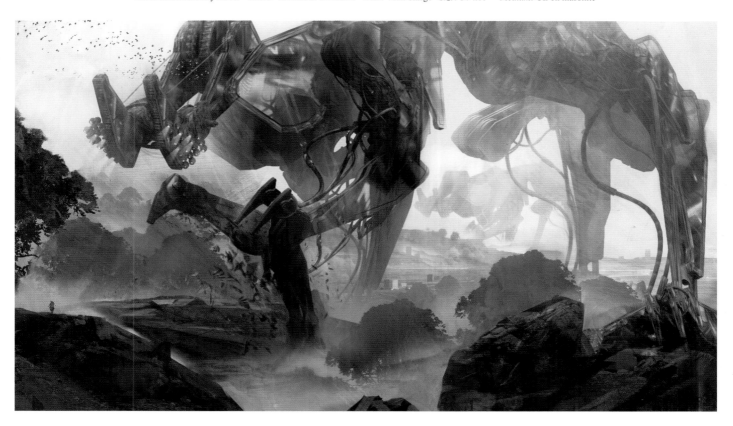

Levi Hopkins
Client: Futurepoly *Title:* H.H. Mech *Medium:* Digital

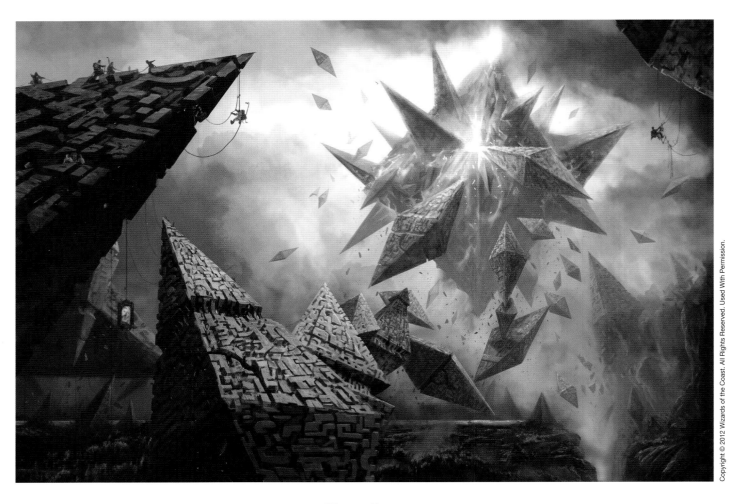

Vincent Proce
Art Director: Jeremy Jarvis *Client:* Wizards of the Coast *Title:* Zendikar *Medium:* Pencil, digital

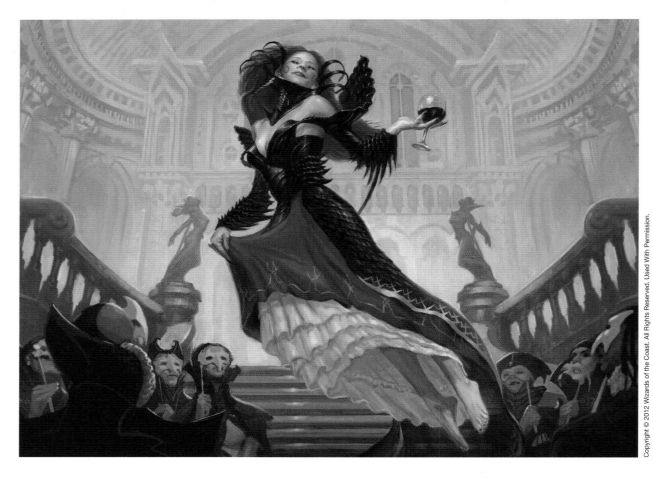

Eric Deschamps
Art Director: Jeremy Jarvis *Client:* Wizards of the Coast *Title:* Olivia Voldaren *Size:* 15"x11" *Medium:* Digital

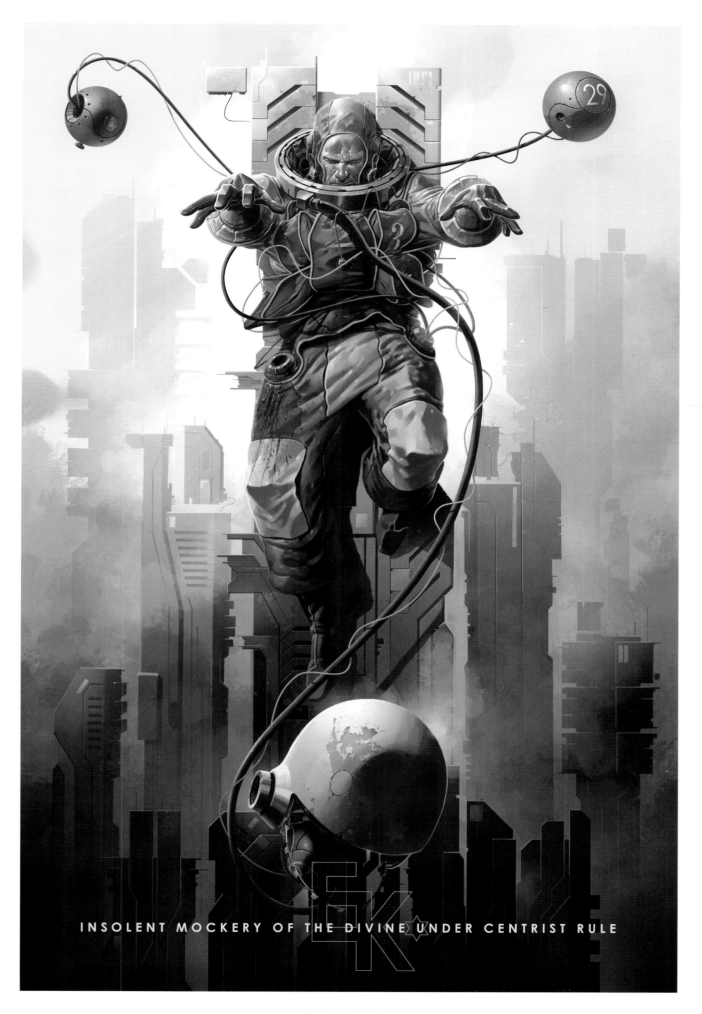

INSOLENT MOCKERY OF THE DIVINE UNDER CENTRIST RULE

Derek Stenning

Client: Born in Concrete *Title:* Insolent Mockery of the Divine Under Centrist Rule *Size:* 23"x25" *Medium:* Mixed, digital

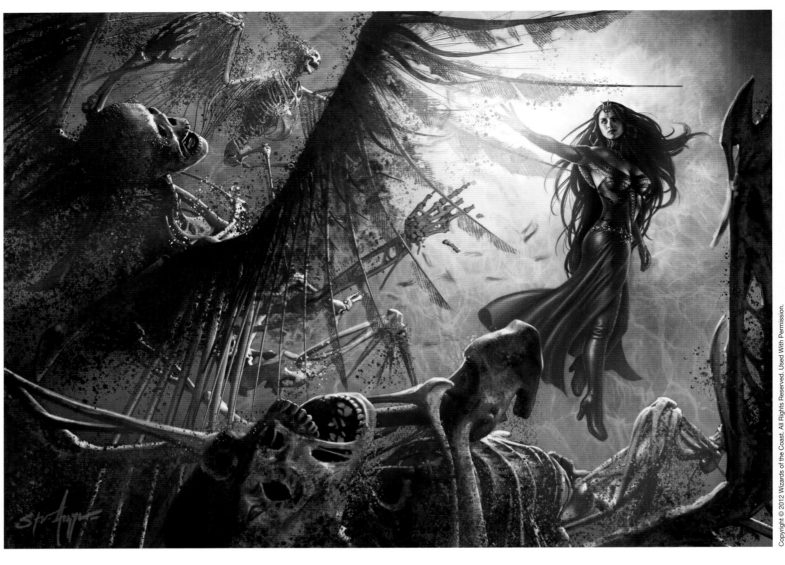

Steve Argyle

Art Director: Jeremy Jarvis *Client:* Wizards of the Coast *Title:* Death Waves *Medium:* Digital

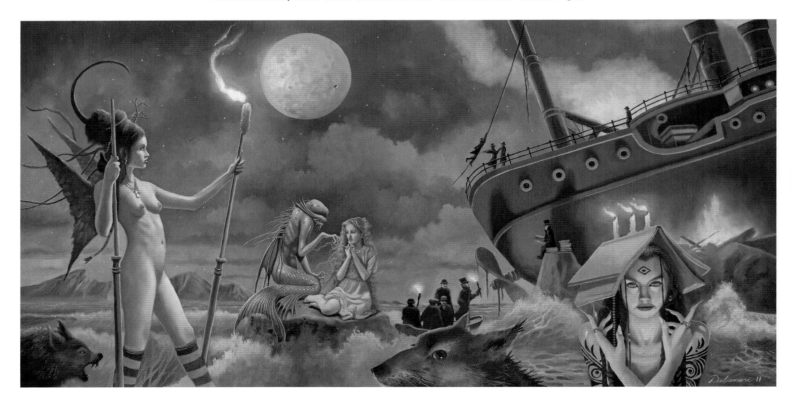

David Delamare

Art Director: Wendy Ice *Client:* Bad Monkey Productions *Title:* The Tempest *Size:* 48"x24" *Medium:* Oil on canvas

Steven Belledin

Art Director: Jeremy Jarvis *Client:* Wizards of the Coast *Title:* Narstad Scrapper *Size:* 19"x12" *Medium:* Oil

Clint Cearley

Art Director: Jeremy Jarvis *Client:* Wizards of the Coast *Title:* Censuring Stroke *Medium:* Digital

Jim Murray
Client: Valve Software *Title:* The Shopkeeper *Size:* 11"x17"

Moby Franke
Client: Valve Software *Title:* The Heavy *Size:* 24"x32" *Medium:* Oil

Brian Despain
Title: Courting Zephyrs *Size:* 11"x14" *Medium:* Oil on wood

Chris Buzelli
Art Director: John Hendrix *Client:* Icon: The Illustration Conference
Title: Drawn Together *Size:* 24"x36" *Medium:* Oil on board

Brian Despain

Title: Ghost In The Shell *Size:* 11"x14" *Medium:* Oil on wood

Seb McKinnon

Art Director: Jeremy Jarvis *Client:* Wizards of the Coast *Title:* Knight and Squire *Medium:* Digital

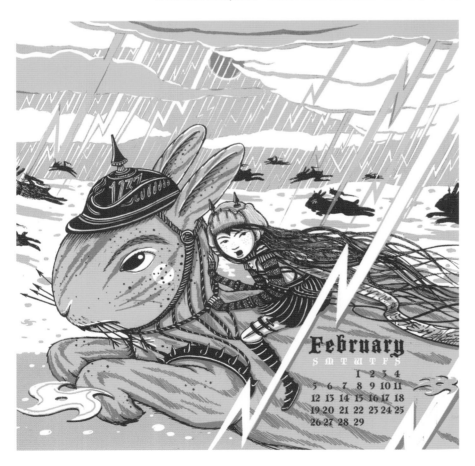

Jaime Zollars

Art Director: David Hyuck *Client:* Cloudy Co. *Title:* February Apocalypse *Size:* 6"x 6"

Donato Giancola
Client: Pijjen Media *Title:* Joan of Arc *Size:* 42"x24" *Medium:* Oil on panel

Bruno Werneck
Art Director: Bruno Werneck *Client:* Red Engine School of Design *Title:* Transient *Size:* 22"x9.4" *Medium:* Digital

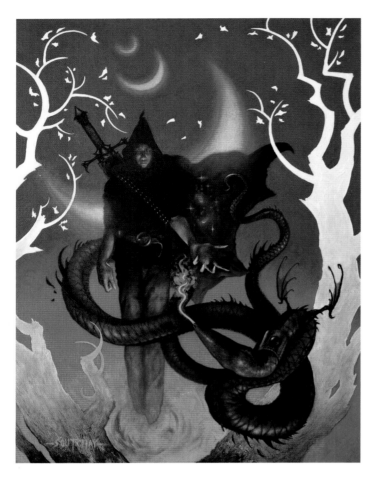

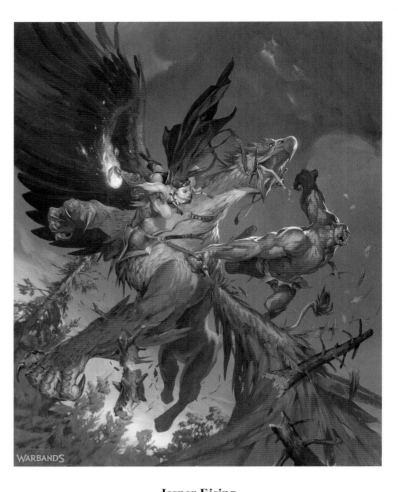

Soutchay Soungpradith

Title: Morlock *Size:* 12"x16" *Medium:* Acrylic, oil

Jesper Ejsing

Art Director: Peter Banks *Client:* Atari *Title:* Blood Demon vs. Griffen *Medium:* Acrylic

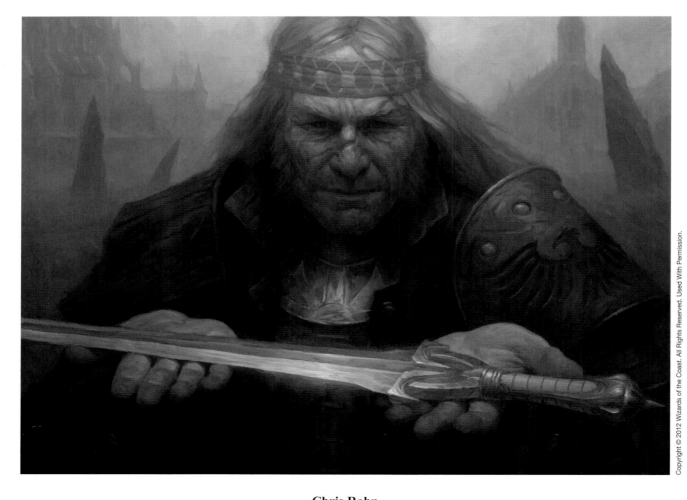

Copyright © 2012 Wizards of the Coast. All Rights Reserved. Used With Permission.

Chris Rahn

Art Director: Jeremy Jarvis *Client:* Wizards of the Coast *Title:* Elder Cathar *Size:* 16"x12" *Medium:* Oil

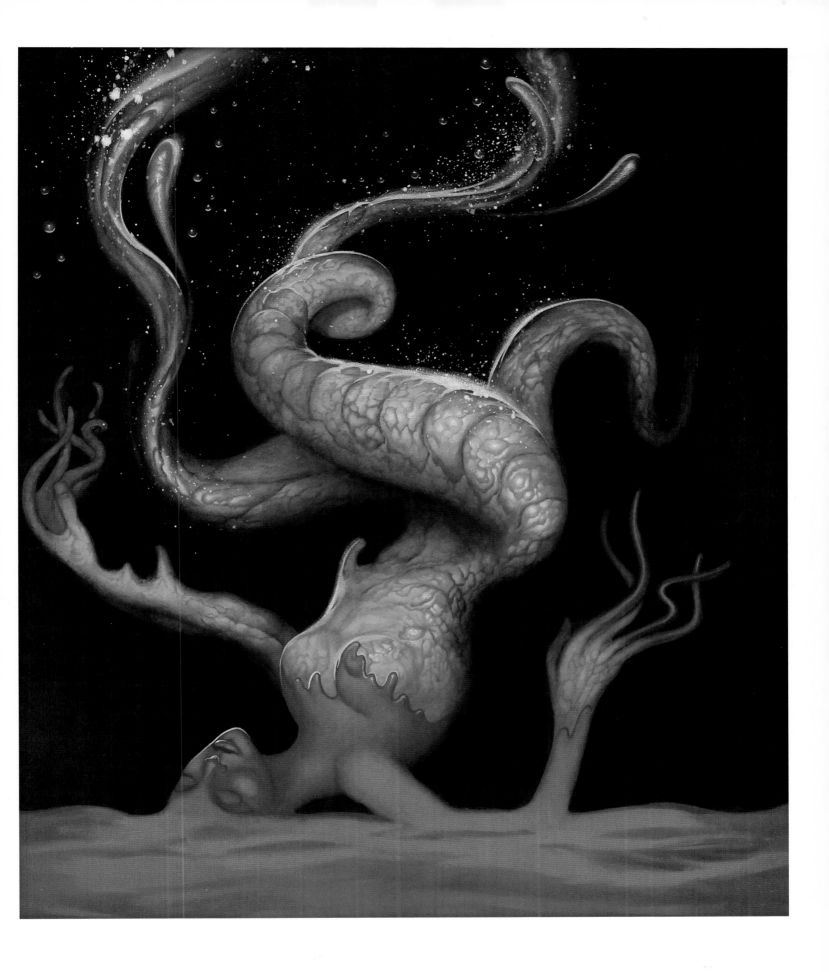

Jeff Miracola

Title: Mermaid *Size:* 20"x24" *Medium:* Oil on board

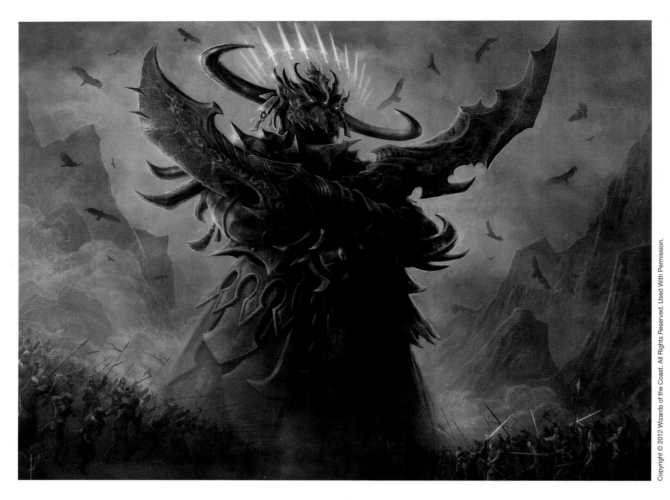

Jason Engle
Art Director: Jeremy Jarvis *Client:* Wizards of the Coast *Title:* Avatar of Slaughter *Size:* 24"x18" *Medium:* Digital

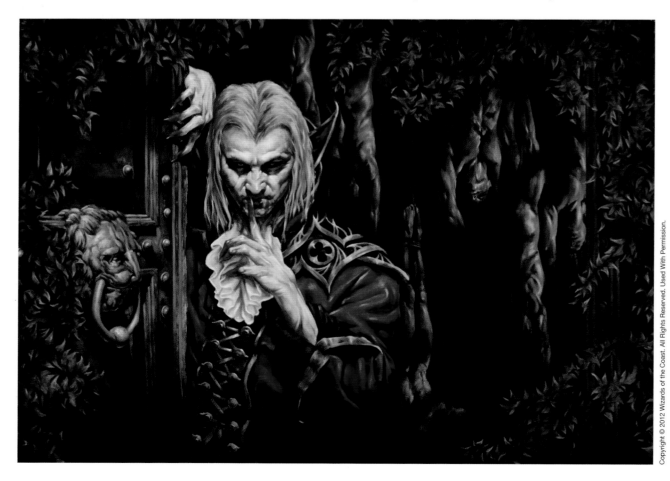

Michael C. Hayes
Art Director: Jeremy Jarvis *Client:* Wizards of the Coast *Title:* Nearheath Stalker *Medium:* Oil

Philip Straub

Art Director: Jeremy Jarvis *Client:* Magic: The Gathering/Wizards of the Coast *Size:* 17"x12" *Medium:* Digital

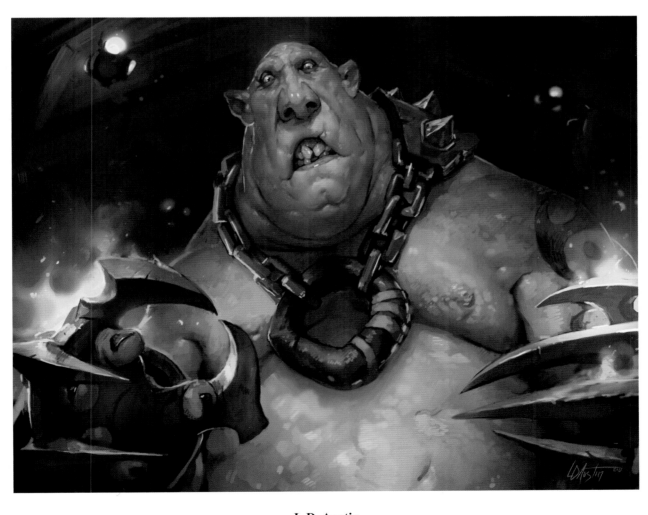

L.D. Austin

Art Director: Doug Gregory *Client:* Blizzard Entertainment *Title:* Lumbering Oaf *Size:* 10"x8" *Medium:* Digital

Brad Parker
Client: Tiki Shark Hawaii *Title:* Hawaiian Eye *Size:* 24"x30" *Medium:* Acrylic on canvas

Yukari Masuike
Title: Surge of Fur *Medium:* Photoshop

Marc Scheff
Art Director: Rebecca Guay *Title:* Another Day *Medium:* Digital

Brandt Peters
Title: Fate Series #3 *Size:* 18"x36" *Medium:* Oil on canvas

Bill Carman
Client: Gregg & Yvette Spatz *Title:* Batgirl and Batsquid Ride Batpug with Batbat In the Lead *Size:* 8"x10" *Medium:* Acrylic

Jasmine Becket-Griffith
Client: Cloudspace Gallery *Title:* Microcosm: Fawn *Size:* 16"x20" *Medium:* Acrylic on panel

Bob Eggleton

Art Director: Toni Weisskopf *Client:* Baen Books *Title:* Winter's Reign *Size:* 28"x22" *Medium:* Oil

Jerry LoFaro

Art Director: Michael McGloin *Client:* The Mountain *Title:* Mammoth *Size:* 16"x16" *Medium:* Digital

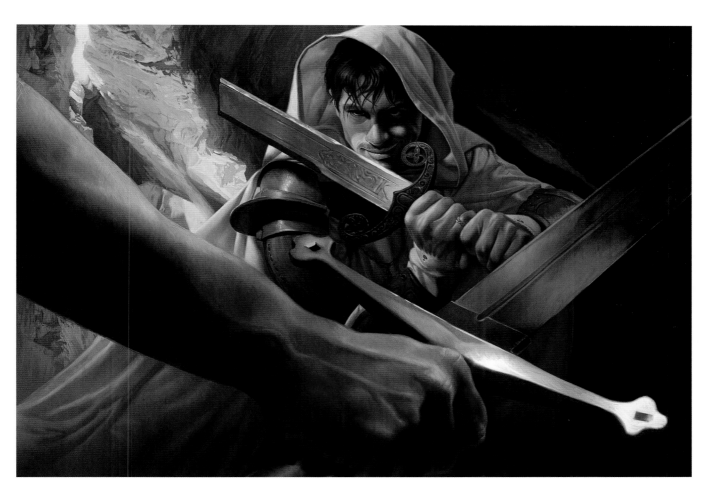

John Stanko
Art Director: Irene Gallo *Client:* Tor.com *Title:* Desecrator *Size:* 24"x18" *Medium:* Oil over giclee

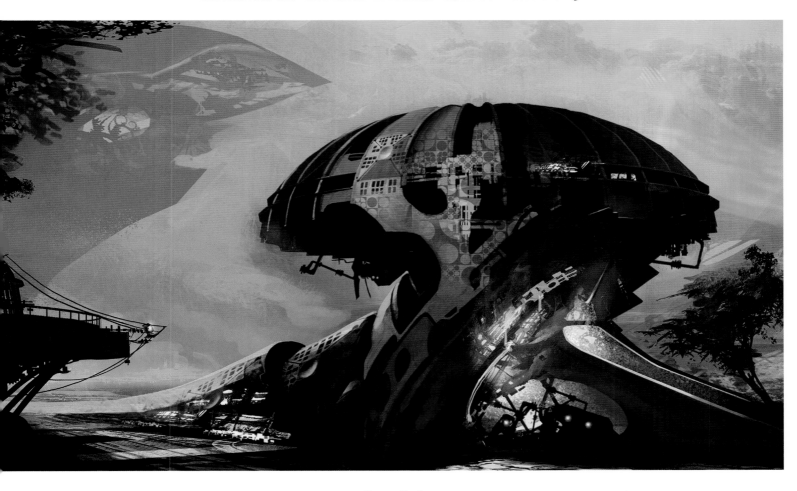

Jason Stokes
Client: FuturePoly *Title:* Hemisphere *Medium:* Digital

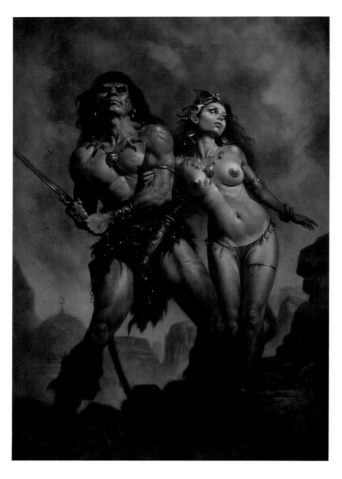

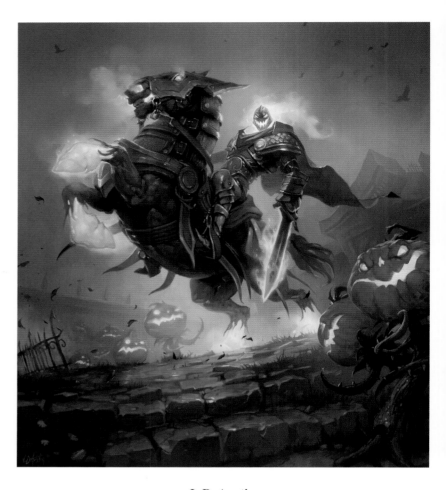

Patrick J. Jones
Art Director: Neil & Leigh Mechem *Client:* Garasol Collectibles
Title: The Forbidden Kingdom *Size:* 24"x36" *Medium:* Oil on canvas

L.D. Austin
Art Director: Doug Gregory *Client:* Blizzard Entertainment *Title:* Headless Horseman
Size: 10"x8" *Medium:* Digital

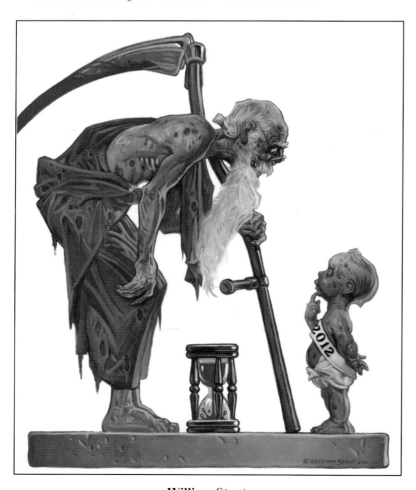

William Stout
Art Director: Arnie Fenner *Client:* Andrews McMeel Publishing *Title:* New Year *Medium:* Oil

Antoine Revoy
Title: Trick *Size:* 7"x10.5" *Medium:* Graphite, digital

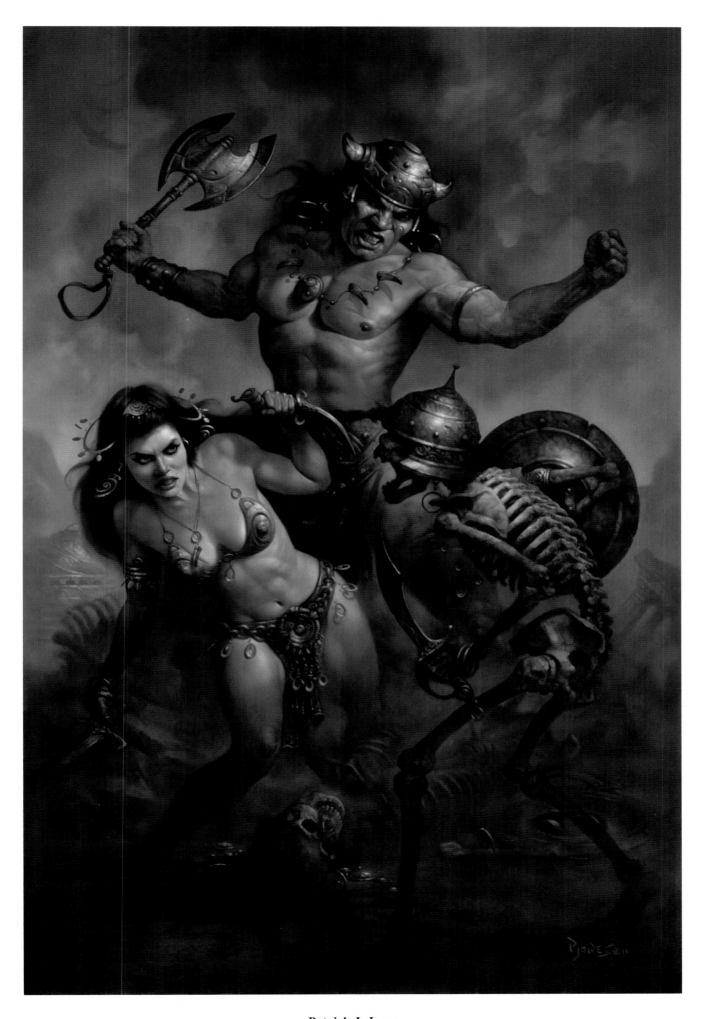

Patrick J. Jones

Art Director: Neil & Leigh Mechem *Client:* Garasol Collectibles *Title:* Army of the Damned *Size:* 24"x36" *Medium:* Oil on canvas

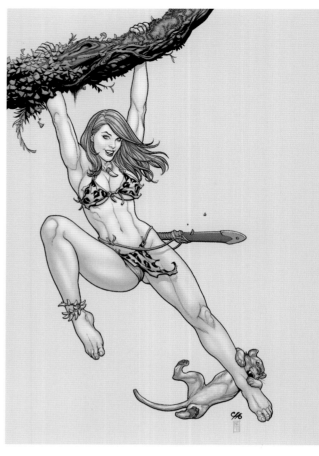

Christopher Moeller

Art Director: Jeremy Cranford *Client:* Blizzard Entertainment *Title:* Fair Play
Size: 12"x10" *Medium:* Acrylic on board

Frank Cho

Colorist: Jason Keith *Client:* Monkey Boy Press *Title:* Jenny Blade & Kitty
Size: 14"x21" *Medium:* Pen & ink, digital

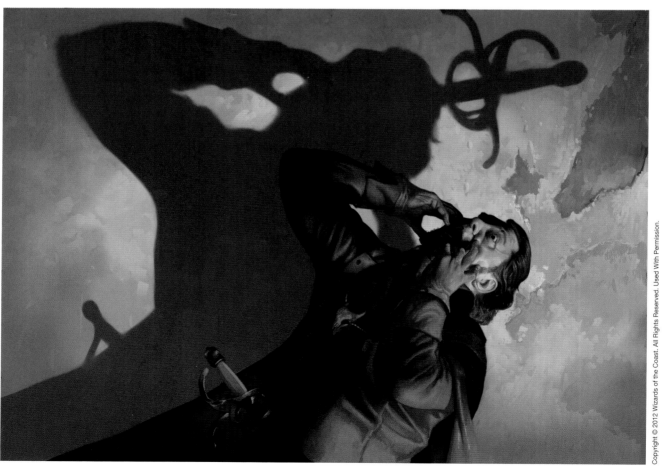

John Stanko

Art Director: Jeremy Jarvis *Client:* Wizards of the Coast *Title:* Spiteful Shadows *Medium:* Digital

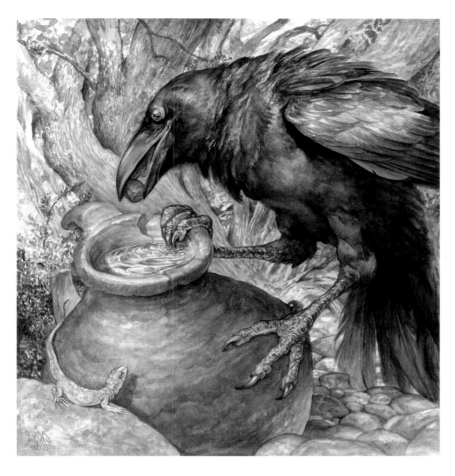

Omar Rayyan
Art Director: Dennis Benoit *Client:* Enterey
Title: Crow & Pitcher *Size:* 10.5"x11" *Medium:* Watercolor

Anthony Palumbo
Art Director: Jeremy Jarvis *Client:* Wizards of the Coast
Title: Angel *Size:* 20"x30" *Medium:* Oil, digital

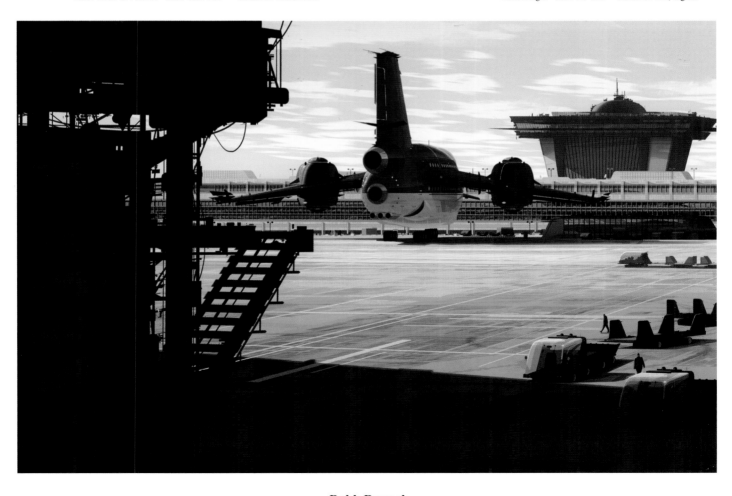

Robh Ruppel
Client: Broadview Graphics *Title:* Dulles 2050 *Medium:* Digital

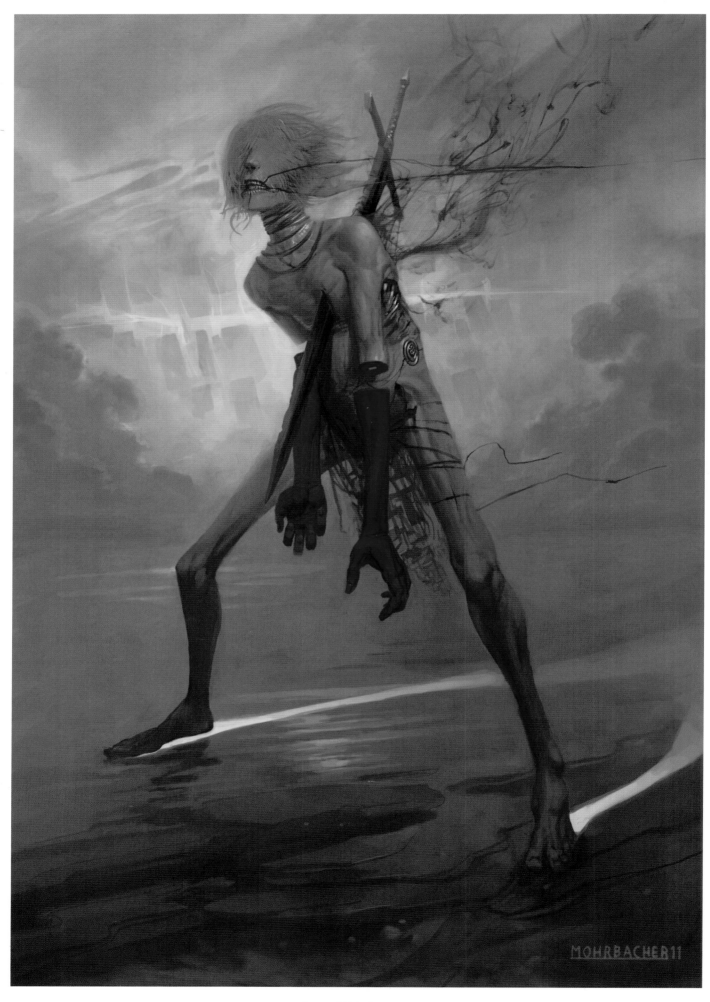

Peter Mohrbacher
Title: AF *Medium:* Photoshop

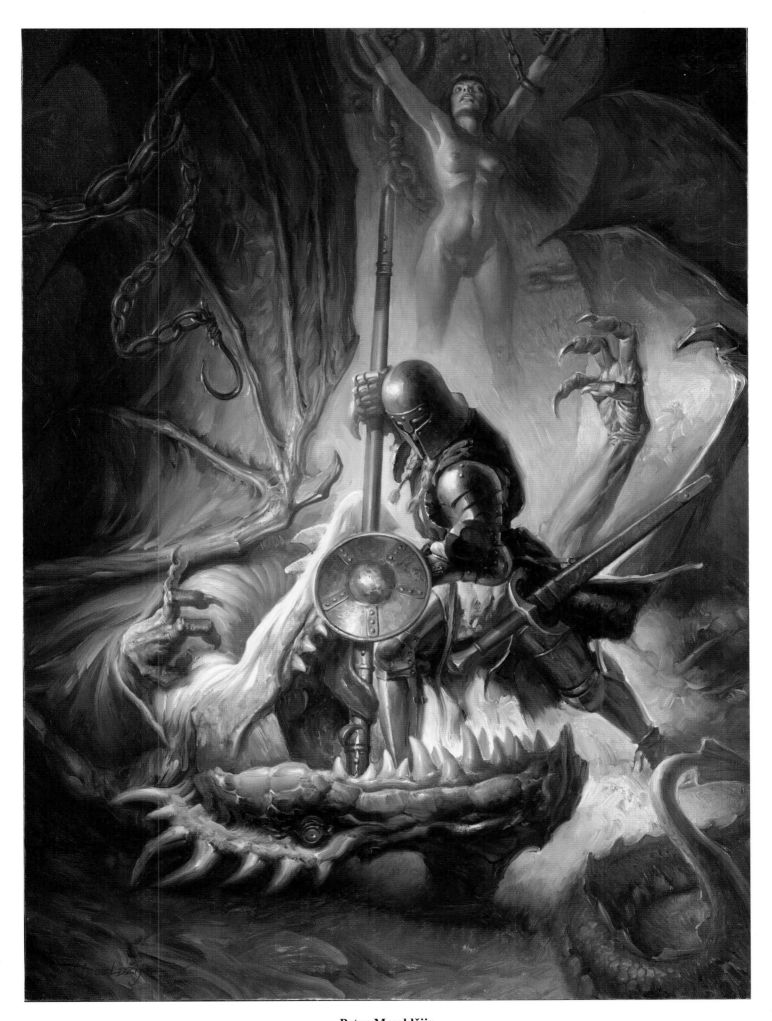

Petar Meseldžija

Client: Illuxcon 4 *Title:* The Rescuer *Size:* 16.9"x23.6" *Medium:* Oil on wood

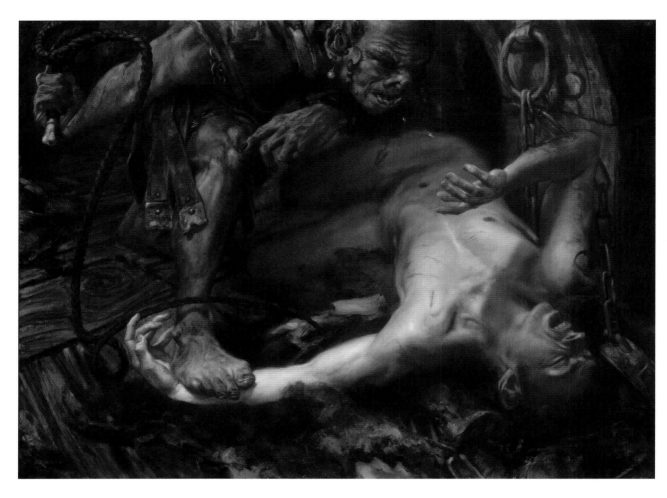

Donato Giancola
Title: The Tower of Cirth Ungo *Size:* 48"x36" *Medium:* Oil on panel

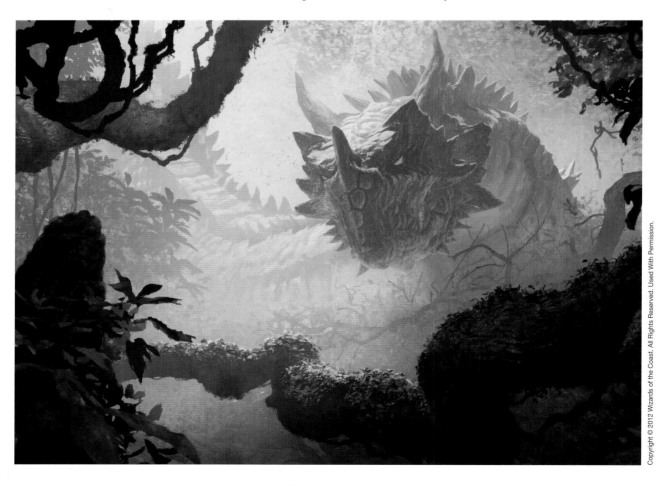

Richard Wright
Art Director: Jeremy Jarvis *Client:* Wizards of the Coast *Title:* Rendering Wurm *Medium:* Digital

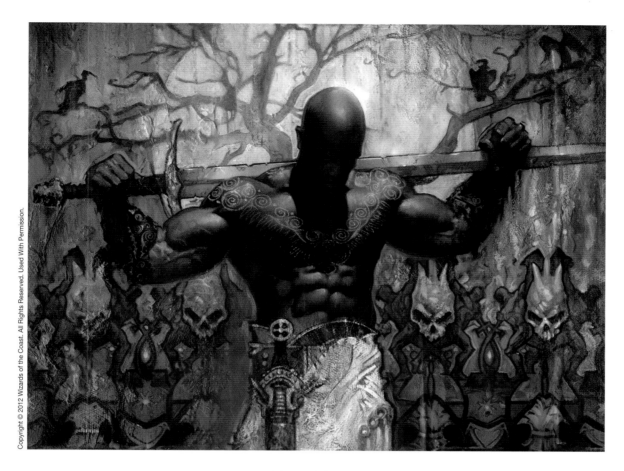

Terese Nielsen

Art Director: Jeremy Jarvis *Client:* Magic: Wizards of the Coast *Size:* 12"x9" *Medium:* Mixed

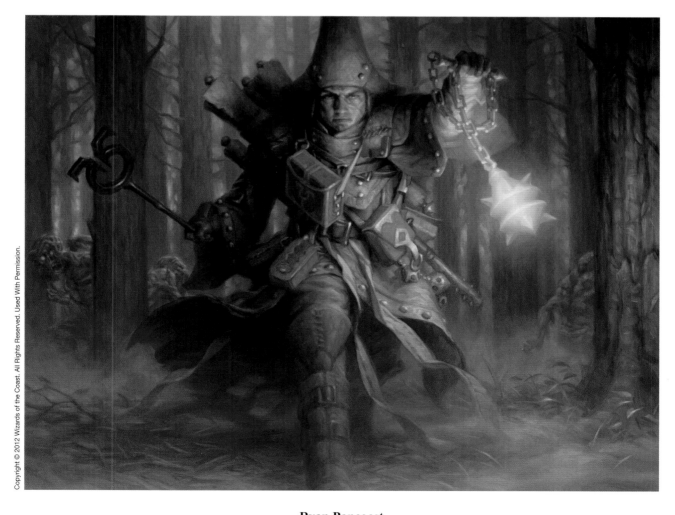

Ryan Pancoast

Art Director: Jeremy Jarvis *Client:* Wizards of the Coast *Title:* Ghoulwood Escort *Size:* 14"x11" *Medium:* Oil on canvas

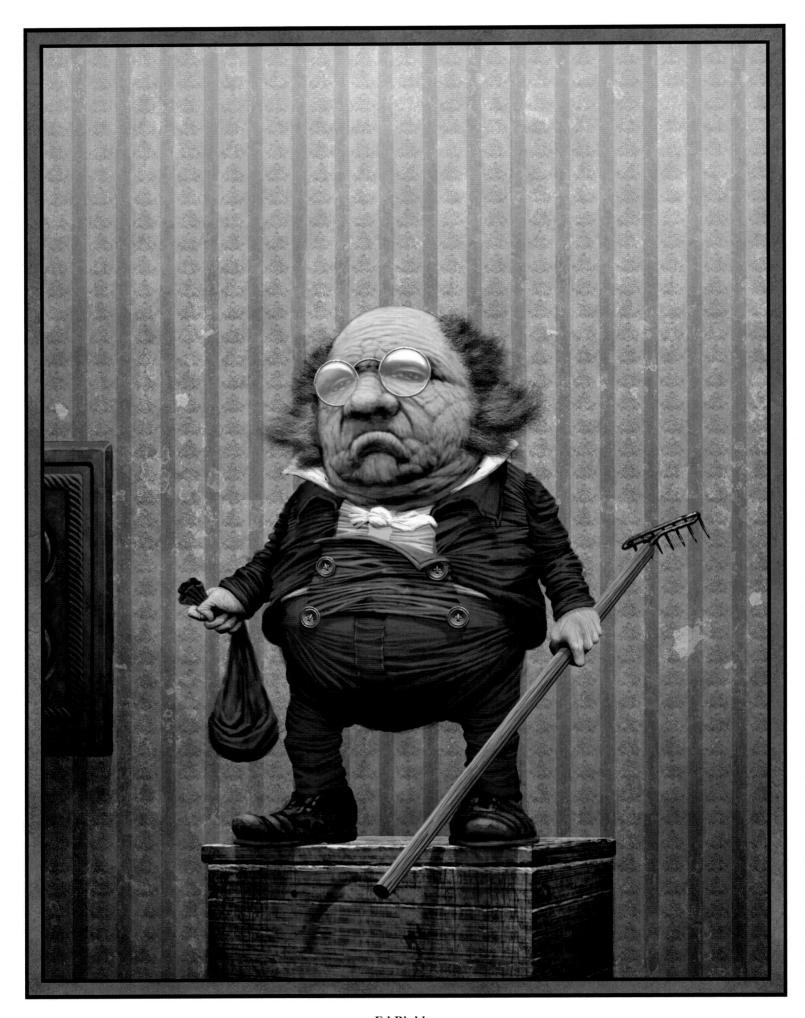

Ed Binkley
Title: Leprechaun, Kilarney *Size:* 9"x12" *Medium:* Digital

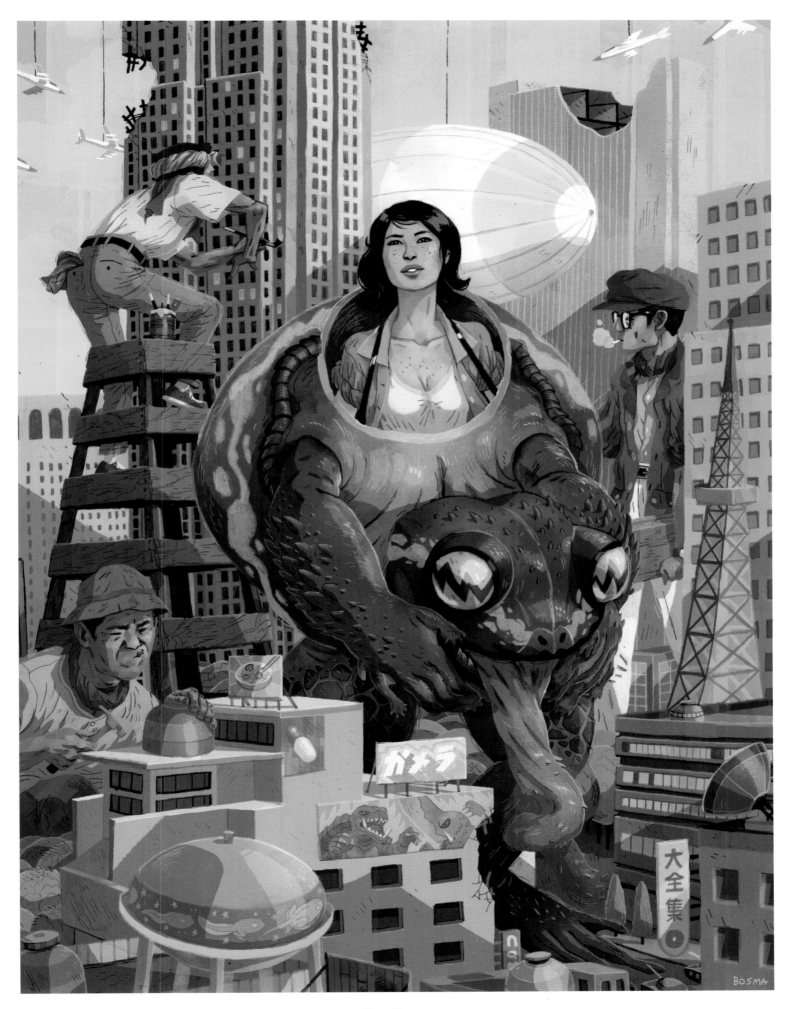

Sam Bosma

Art Director: Jim Burke *Client:* Dellas Graphics *Title:* Frog Kaiso *Size:* 12"x16" *Medium:* Digital

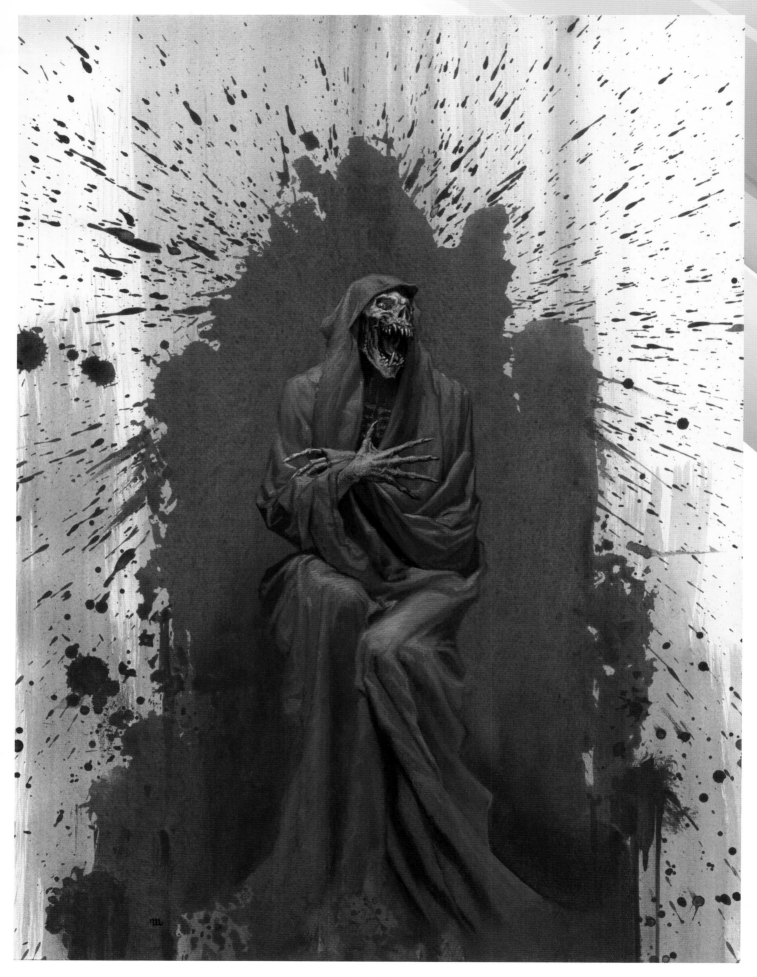

Michael Whelan
Title: CK Unmasked *Size:* 11"x15" *Medium:* Acrylic on watercolor paper

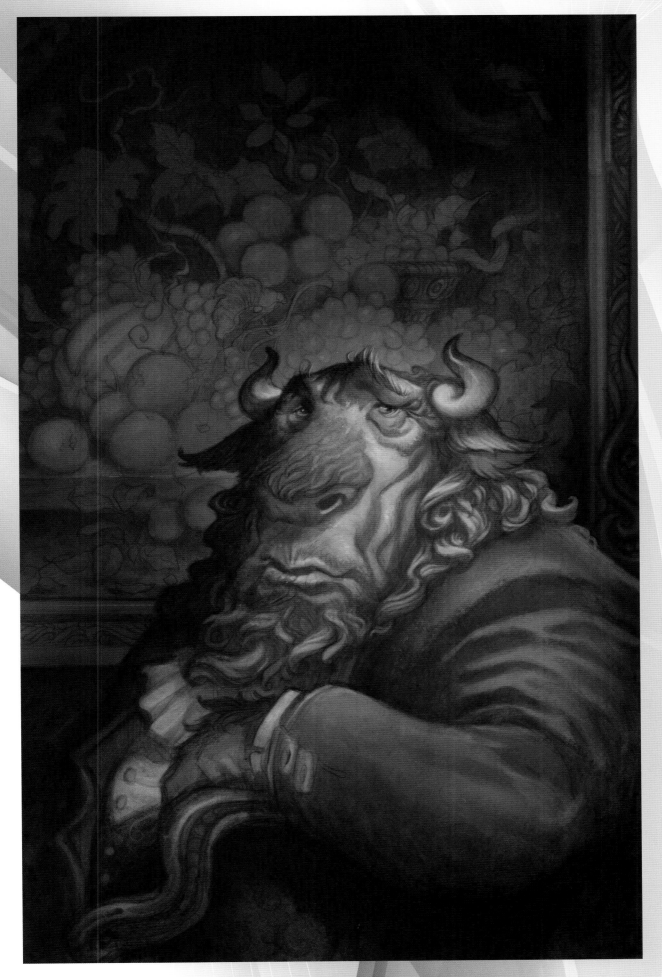

Justin Gerard
Title: Portrait of a Monster #3 *Size:* 9"x12" *Medium:* Watercolor, digital

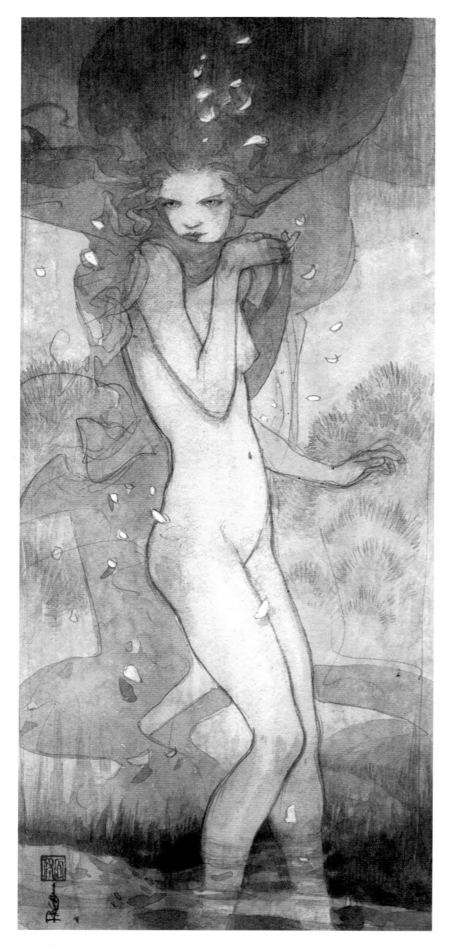

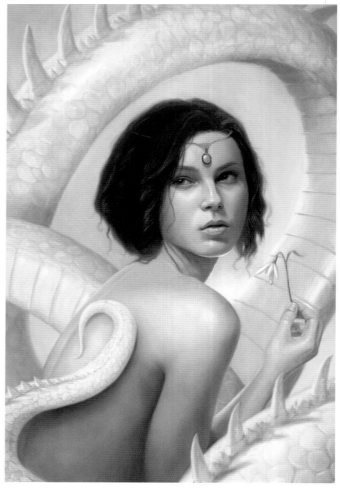

Joe Kovach
Title: Crystal Fire *Size:* 18"x25" *Medium:* Watercolor

Rebecca Guay
Title: Snow *Size:* 4"x7" *Medium:* Watercolor

Lindsey Look
Title: Mairin *Size:* 15.5"x22.5" *Medium:* Oil on board

Laurielee Brom
Title: La Fee Verte *Size:* 20"x26" *Medium:* Oil

Logan Faerber
Art Director: Fred Lynch *Client:* Montserrat College of Art
Title: Wicked Witch of the East *Size:* 12"x16" *Medium:* Ink, digital

Omar Rayyan
Title: The Dragon and the Nightingale *Size:* 16"x20" *Medium:* Oil

Alejandro Dini
Title: Alice in Nukeland *Size:* 23"x32" *Medium:* Photoshop

Juri H. Chinchilla
Title: Bless the Girl *Size:* 8"x10" *Medium:* Pencil, watercolor

Omar Rayyan
Title: Contessa With Squid *Size:* 18"x24" *Medium:* Oil

Milivoj Ćeran

Client: The ArtOrder *Title:* Eowyn and the Witch King *Size:* 60cm x 40cm *Medium:* Ecoline and gouache on paper

Petar Meseldžija

Client: Bill Johnson *Title:* Dragon Chase *Size:* 39.4"x21.3" *Medium:* Oil on wood

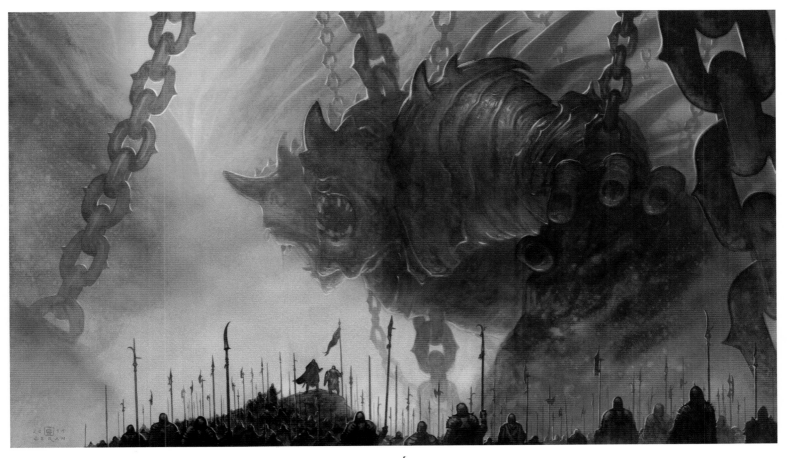

Milivoj Ćeran

Title: Awakening *Size:* 68cm x 40cm *Medium:* Ecoline and gouache on paper

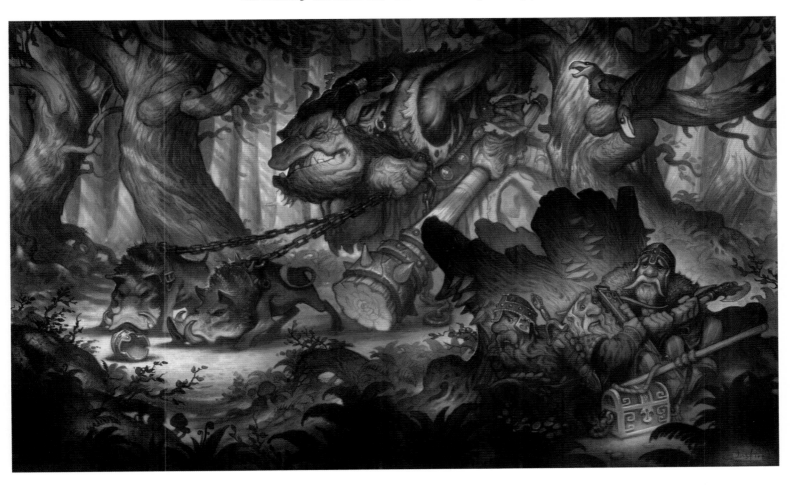

Justin Gerard

Title: The Forest Troll *Size:* 21"x13" *Medium:* Watercolor, digital

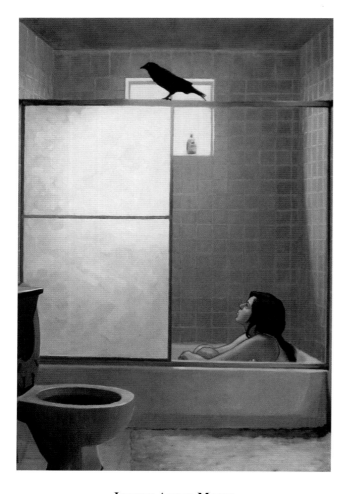

Jeremy Aaron Moore
Title: Lauren's Sanctuary *Size:* 16"x24" *Medium:* Oil, digital

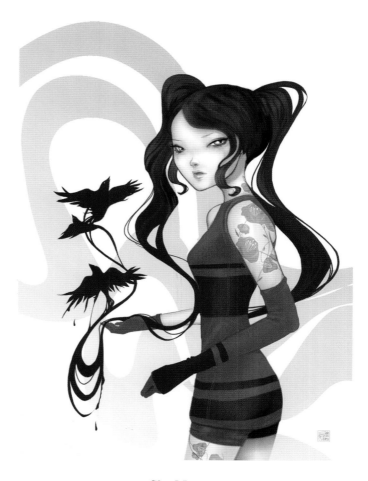

Sho Murase
Title: Black Birds *Size:* 13"x19" *Medium:* Pencil, digital

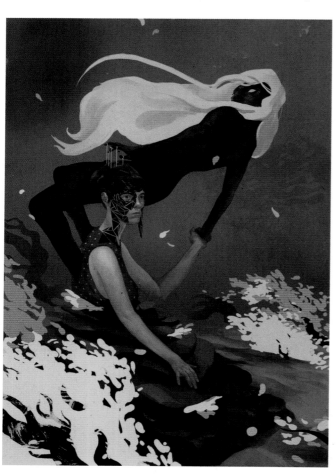

Zach Montoya
Title: Digital Identity *Size:* 11"x17" *Medium:* Digital

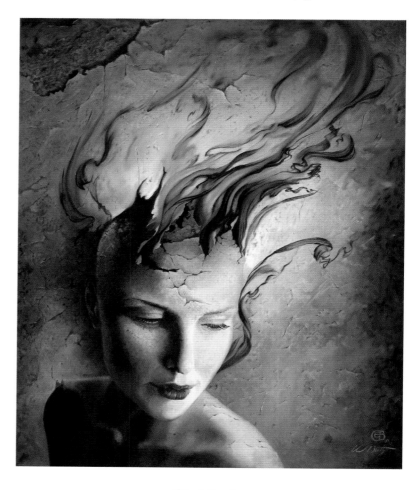

Chad Beatty
Title: Necromancer's Dream *Size:* 20"x24" *Medium:* Oil

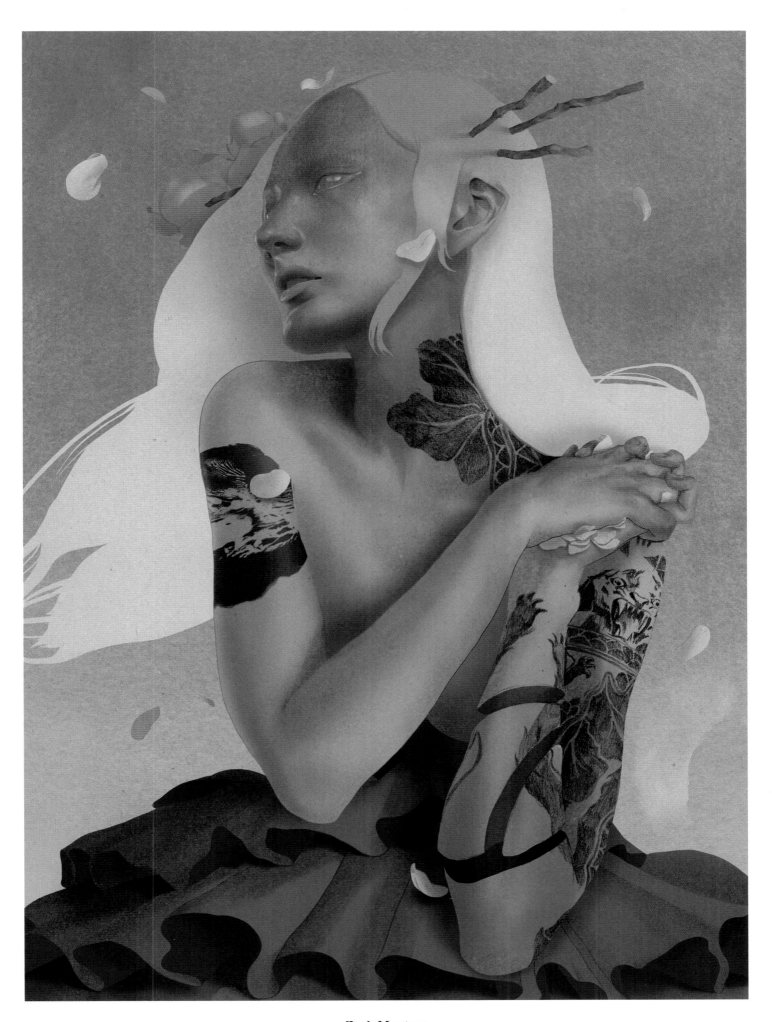

Zach Montoya

Title: Nurture Over Nature *Size:* 15"x20" *Medium:* Digital

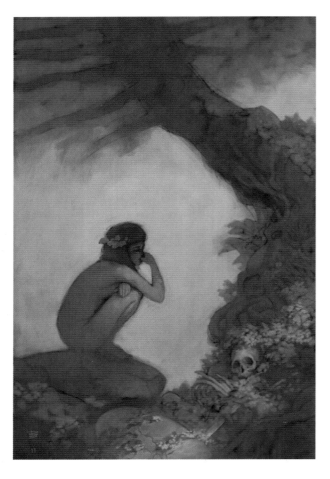

David Brasgalla
Title: Idyl (for Jeffrey Jones) *Size:* 8.25"x11" *Medium:* Mixed

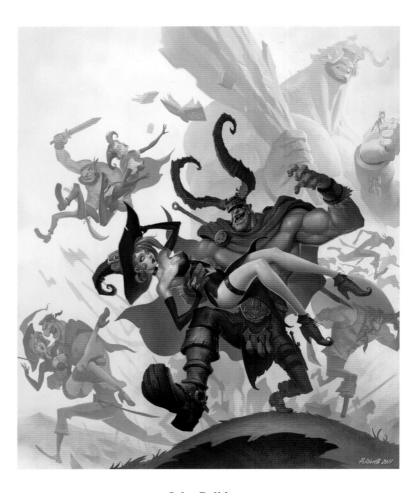

John Polidora
Title: Miscreants and Thieves *Size:* 39"x46" *Medium:* Photoshop

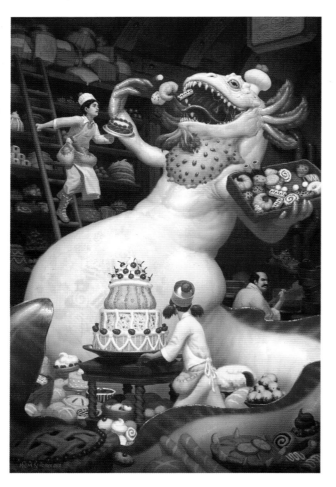

McLean Kendree
Art Director: Karla Ortiz *Title:* Sweet Tooth *Medium:* Digital

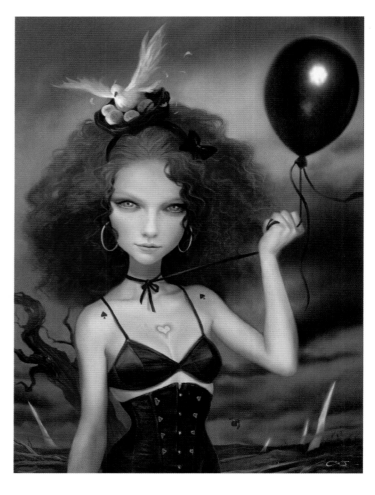

Jiansong Chain
Title: The Egg *Medium:* Digital

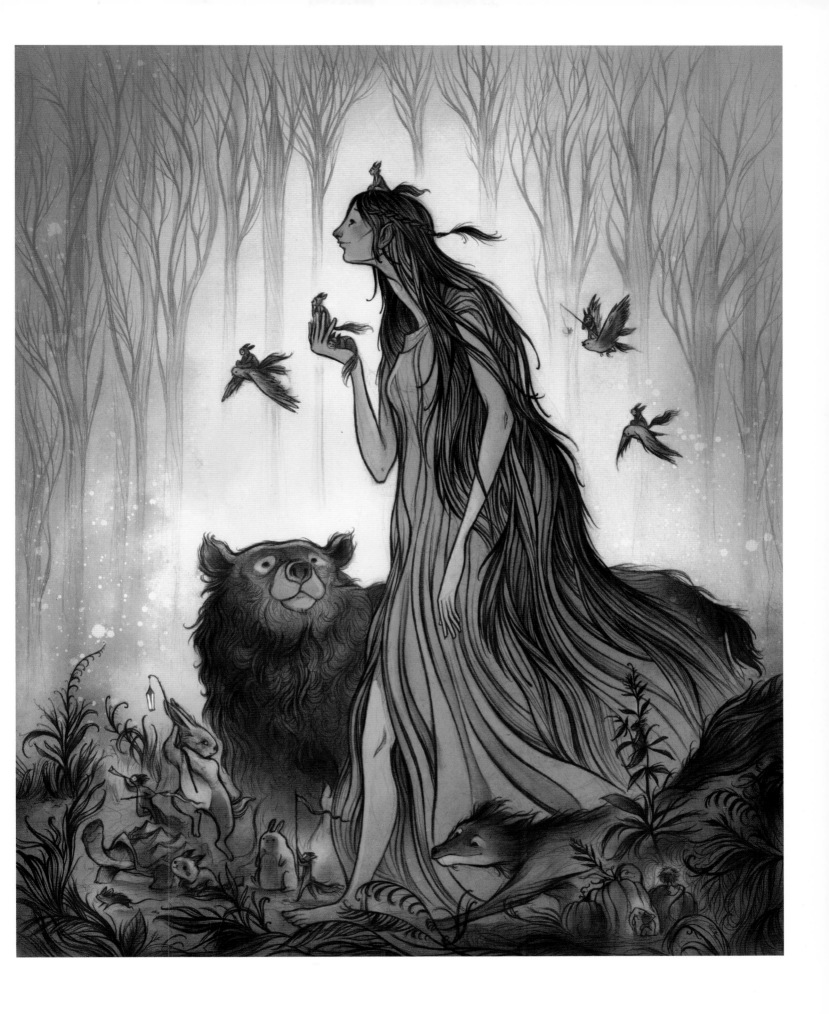

Cory Godbey
Title: The Elf Mother *Size:* 16"x20" *Medium:* Watercolor, digital

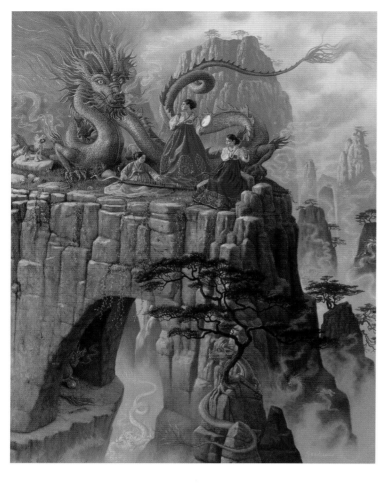

Ruth Sanderson
Title: Dragon Serenade *Size:* 30"x40" *Medium:* Oil

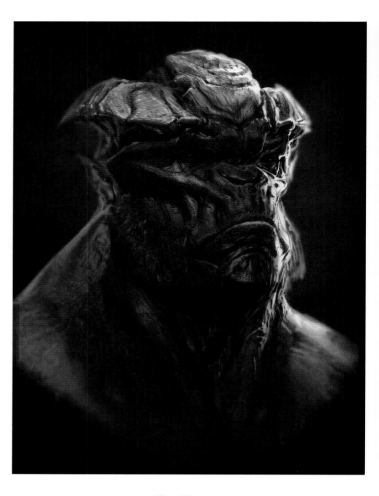

Ben Mauro
Title: Horned Gorilla *Size:* 12"x16" *Medium:* ZBrush, Photoshop

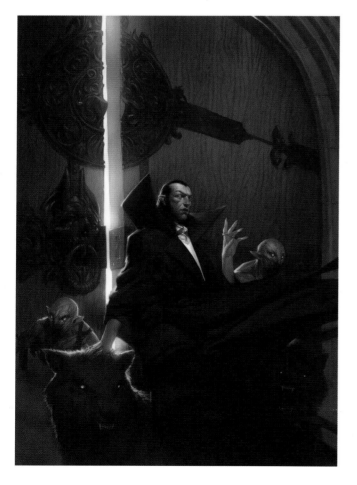

Tyler Jacobson
Art Director: Mari Kolkowsky *Client:* Wizards of the Coast *Medium:* Digital

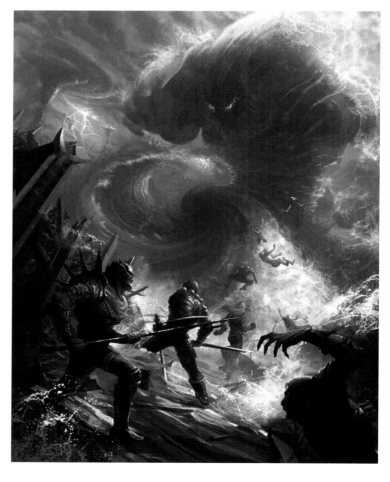

Chao Peng
Title: The Tempest of Whirlpool *Medium:* Digital

David Thiérrée
Art Director: Paolo Parente *Client:* Dust Studio Ltd. *Title:* Anastyr *Size:* 35cm x 25cm *Medium:* Pencil, digital

Andrew Ryan
Art Director: Jon Schindehette *Title:* Eowyn and the Nazgul *Size:* 40"x19" *Medium:* Pencil

Eric Velhagen
Title: Antagonists *Size:* 30"x15" *Medium:* Oil on linen

Paul Bonner
Client: Riotminds *Title:* Hrimox *Size:* 63cm x 44cm *Medium:* Watercolor

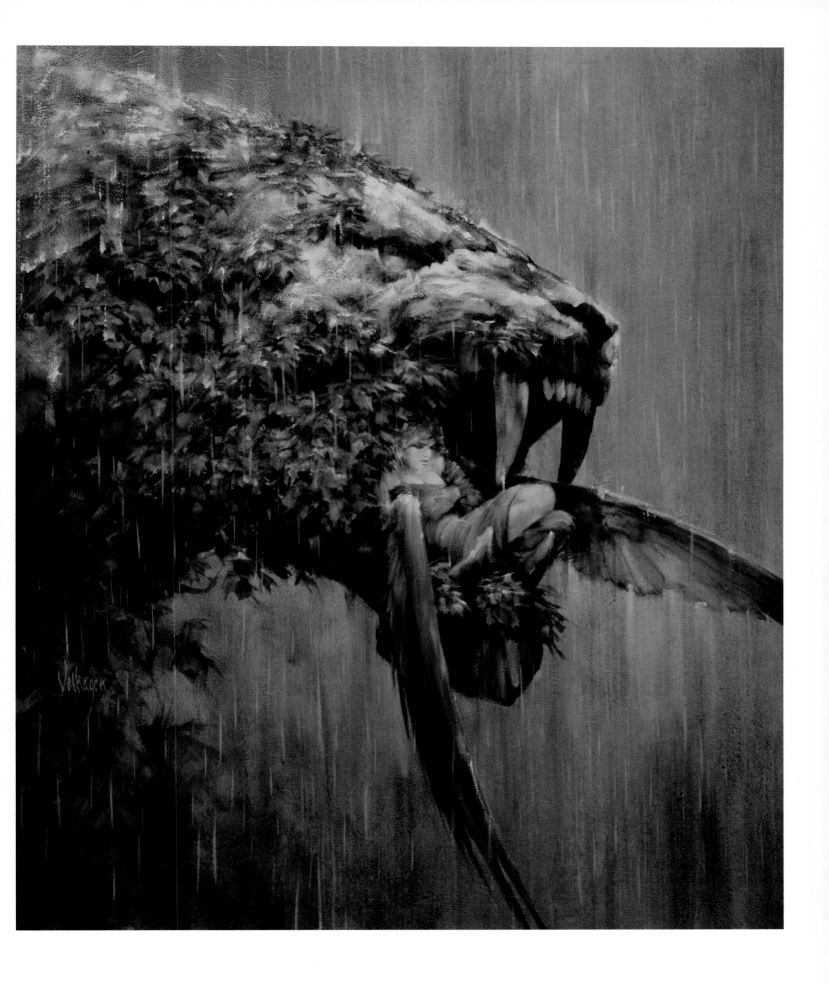

Eric Velhagen

Title: Shelter *Size:* 21"x25" *Medium:* Oil on linen

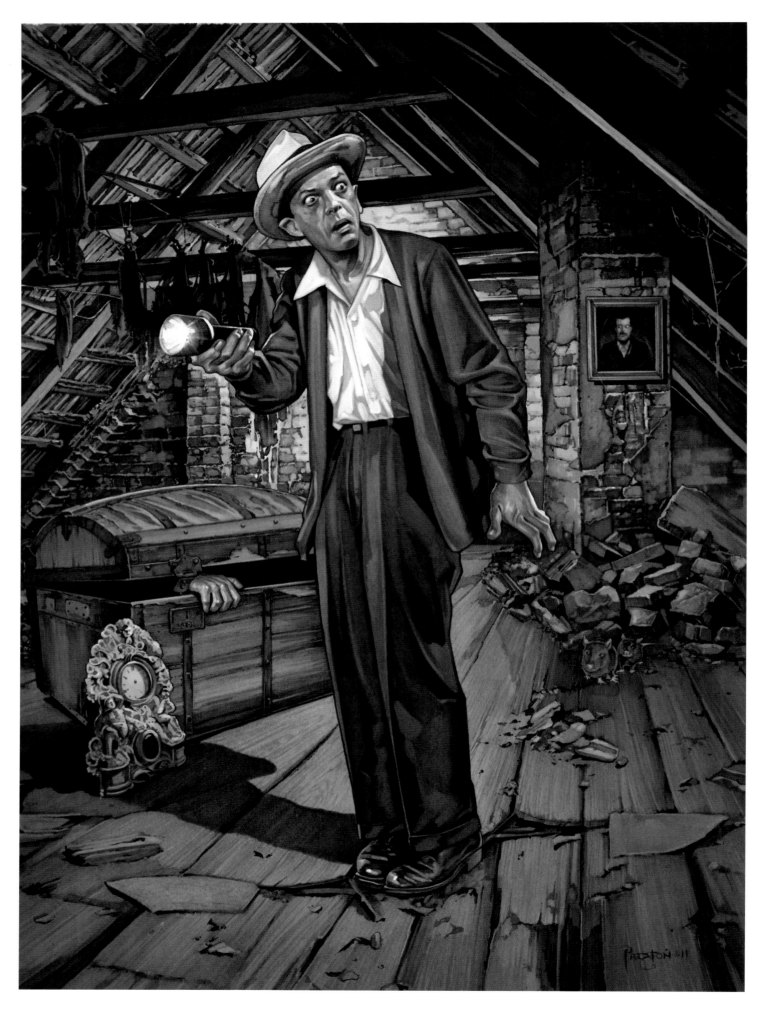

Jeff Preston
Client: Society of Illustrators 2011 Members' Show: "Fear" *Title:* Any Old Tramps Down There?" *Size:* 12"x16" *Medium:* Marker

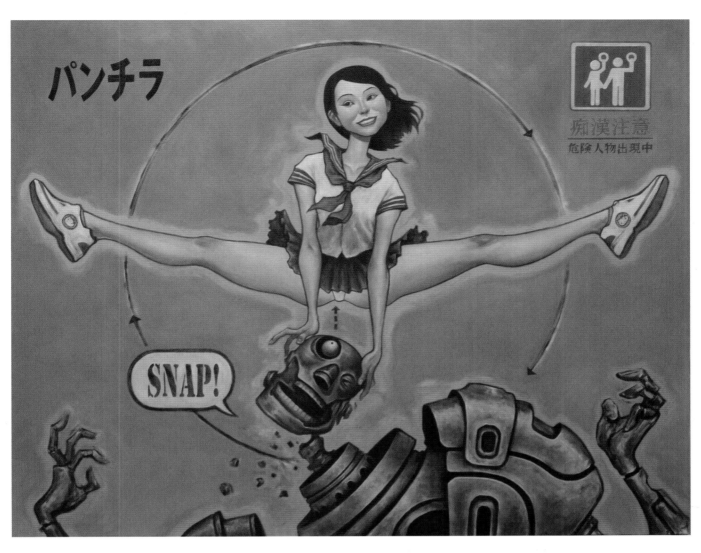

Sonny Liew
Client: Asia Society *Title:* Sailor's Moon *Size:* 63"x40" *Medium:* Oil on canvas

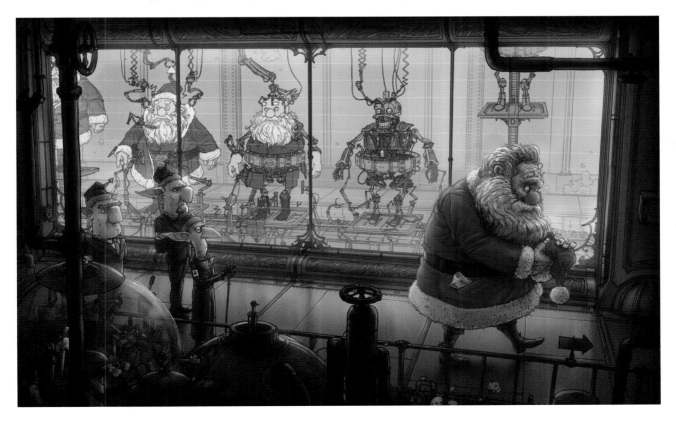

Michael Dziekan
Title: Industrial Elfolution *Size:* 15.2"x10" *Medium:* Digital

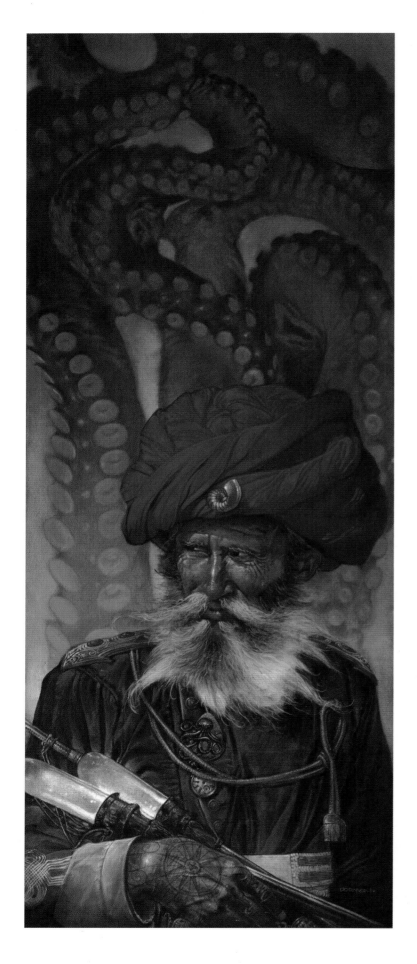

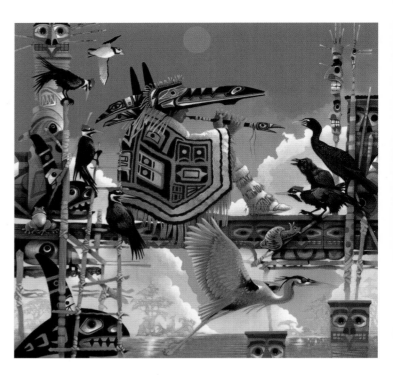

Val Paul Taylor
Title: Harmony In the Ruins *Size:* 18"x18" *Medium:* Acrylic

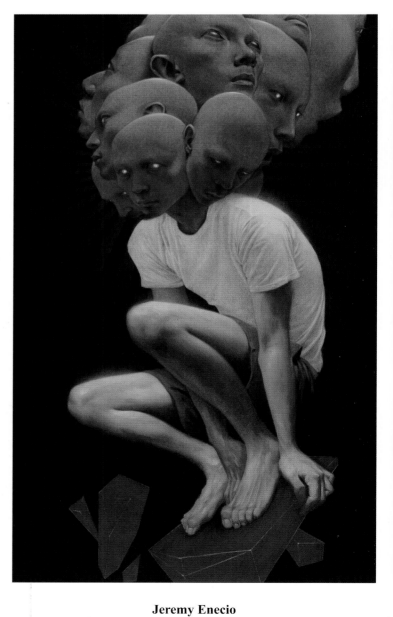

Dave Dorman
Title: Nemo *Size:* 18"x40" *Medium:* Oil, acrylic

Jeremy Enecio
Client: Gallery Nucleus *Title:* Technology *Size:* 11.5"x18.5" *Medium:* Acrylic, oil

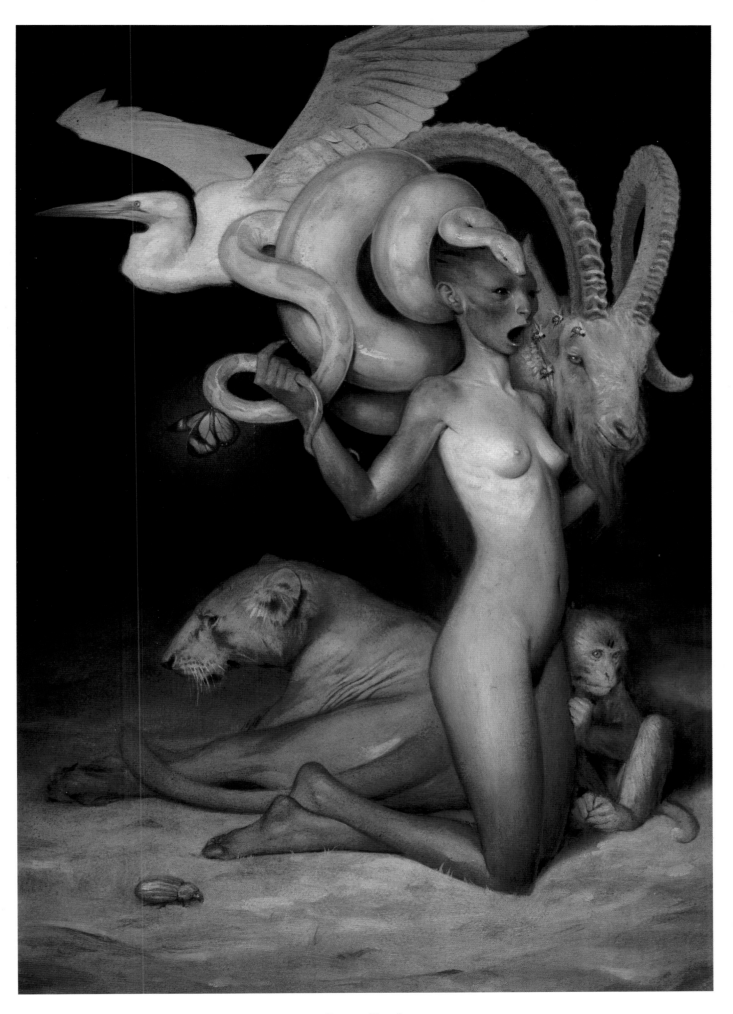

Jeremy Enecio

Client: Gallery Nucleus *Title:* Fauna *Size:* 13.5"x20" *Medium:* Acrylic, oil on paper

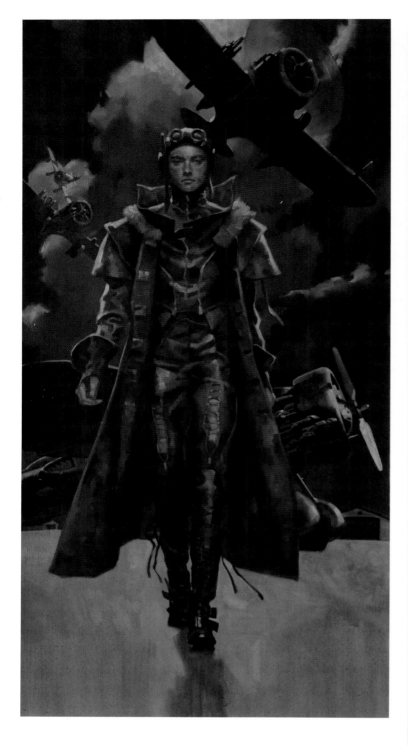

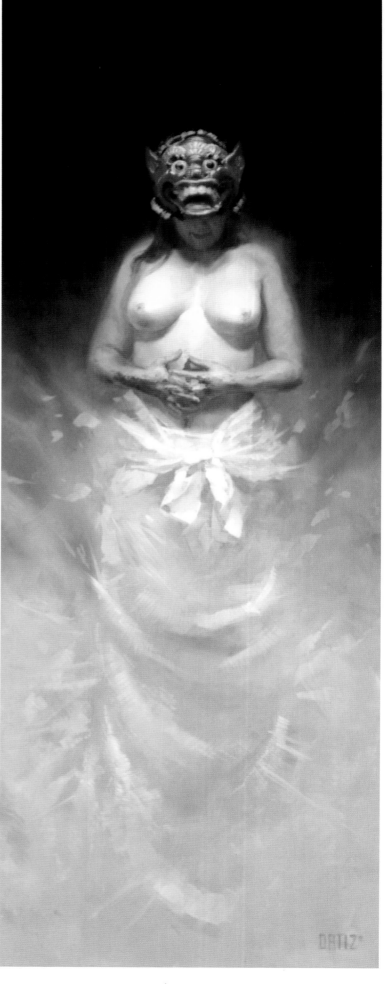

Gregory Manchess

Title: Amelia *Size:* 19"x38" *Medium:* Oil on linen

Carla Ortiz

Title: The Ghost Witch *Size:* 6"x14" *Medium:* Oil

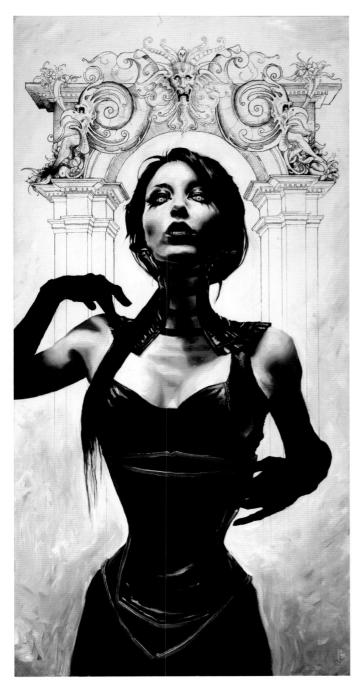

menton3

Client: Gregg & Yvette Spatz *Title:* Anima Penumbra 1 *Size:* 18"x26" *Medium:* Oil

Andrew Theophilopoulos

Title: Princess of the Pleiadians *Medium:* Photoshop

Geoffrey Aaron Harris

Title: Robot Racer *Size:* 36"x12" *Medium:* Digital

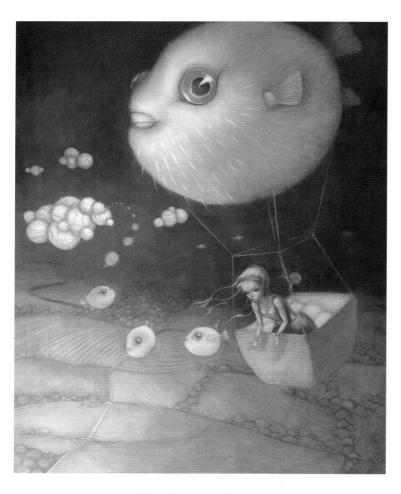

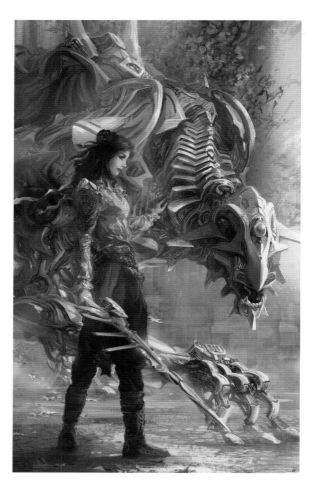

Erika Taguchi-Newton
Title: Blowfish Dream *Size:* 16"x20" *Medium:* Acrylic

Jason Cheng
Medium: Digital

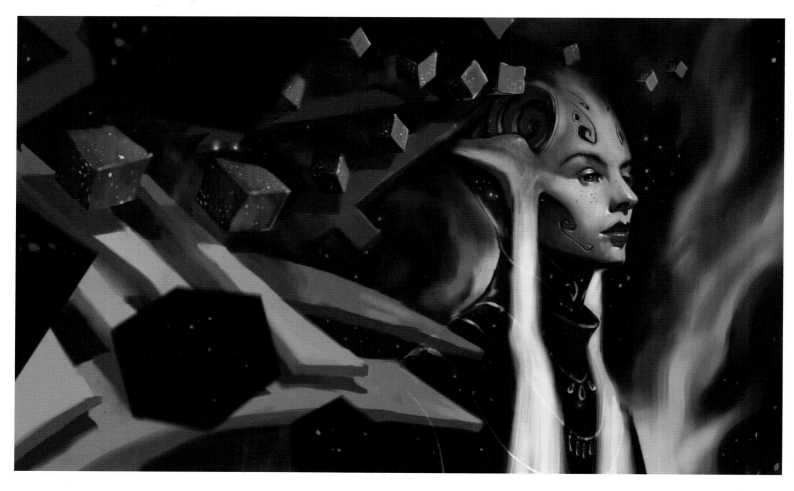

Michal Milkowski
Title: Entity of Geometry *Size:* 17"x11" *Medium:* Digital

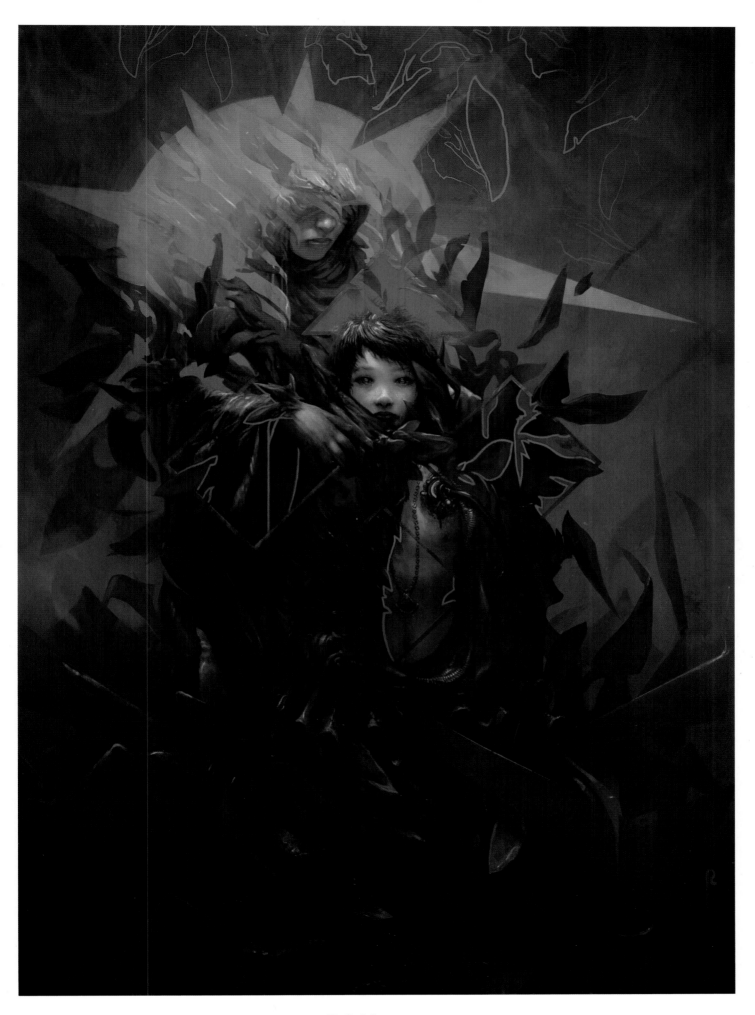

Rafael Sarmento
Title: Prodigy *Size:* 10"x14" *Medium:* Digital

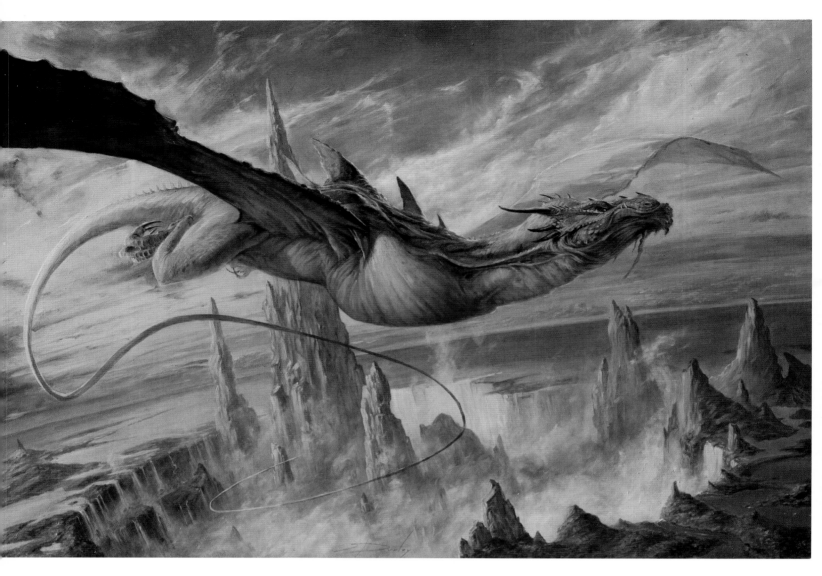

Sam Burley
Title: Keeper of Cascade *Size:* 36"x24" *Medium:* Oil

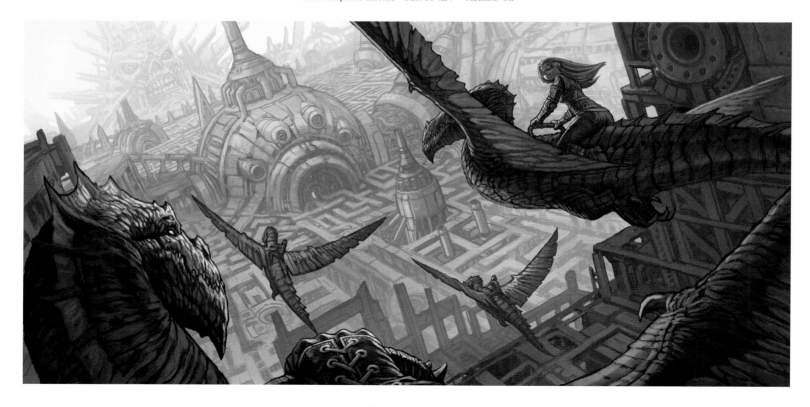

Nick Southam
Title: Machine Maze *Medium:* Digital

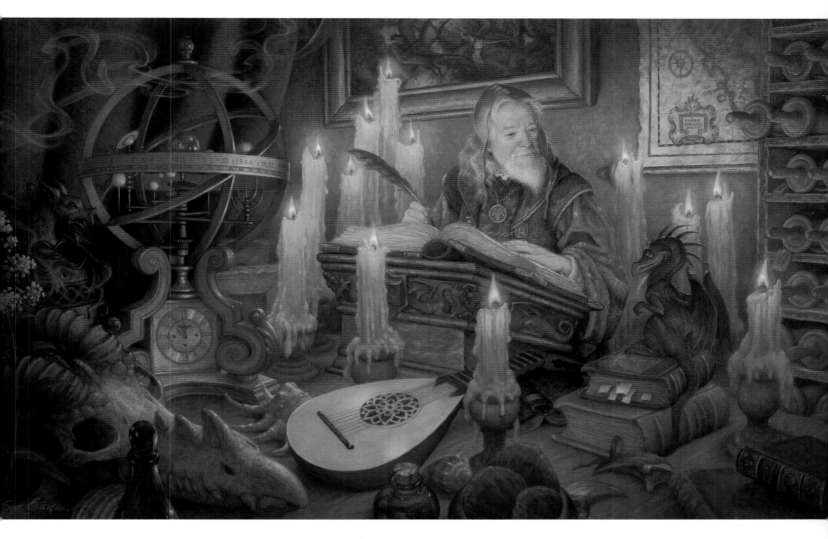

Scott Gustafson
Client: Bill Johnson *Title:* Dragon and Scribe *Size:* 40"x24" *Medium:* Oil

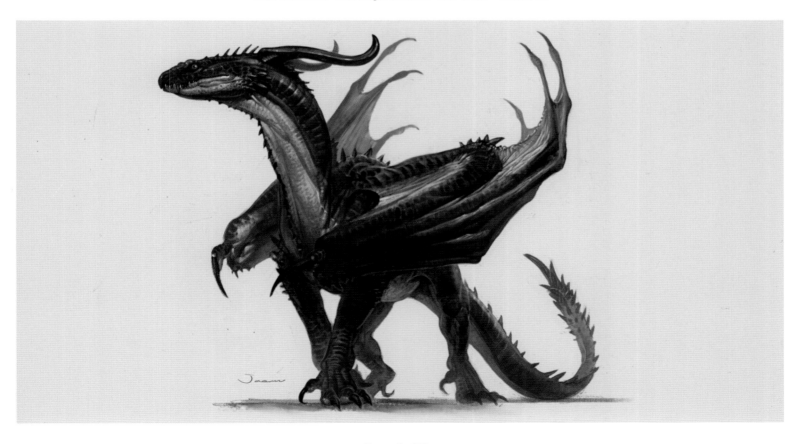

Jae min Kim
Title: Walking Dragon *Size:* 20"x14" *Medium:* Digital

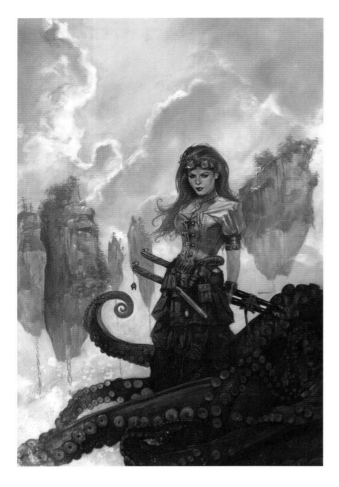

Dave Dorman
Title: PI *Size:* 24"x36" *Medium:* Oil, acrylic

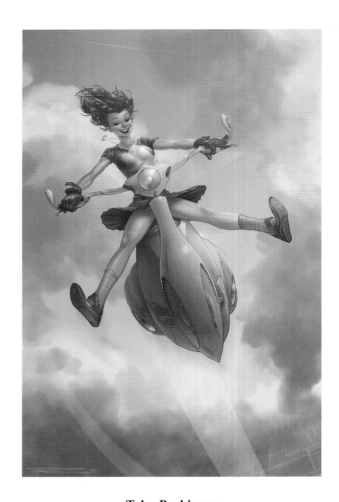

Tyler Parkinson
Title: Vespa *Size:* 11"x17" *Medium:* Digital

Vanja Todoric
Title: Little Red Riding Hood *Medium:* Digital

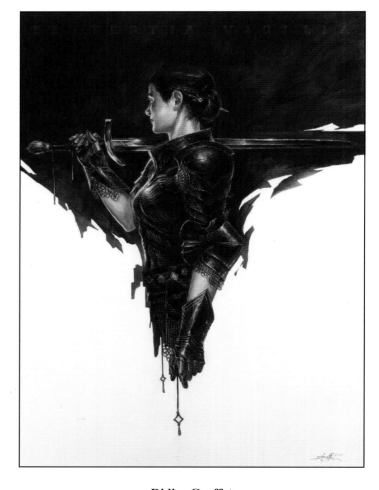

Didier Graffet
Title: De Tertia Vigilia *Size:* 29"x39" *Medium:* Acrylic on canvas

Victo Ngai
Art Director: Ryan Gattis *Client:* Meltdown Comics Gallery *Title:* Wing Chun *Size:* 16"x20" *Medium:* Mixed

Richard Corben

Art Director: Sean O'Leary *Client:* Lore Digest *Title:* Procession *Size:* 22"x17" *Medium:* Pen & brush

Justin Albers

Title: Westbound *Size:* 40"x16" *Medium:* Digital

Matt Rota
Client: Copra Nason Gallery *Title:* Belly's Ocean *Size:* 14.25"x11.5" *Medium:* Ink, watercolor, acrylic

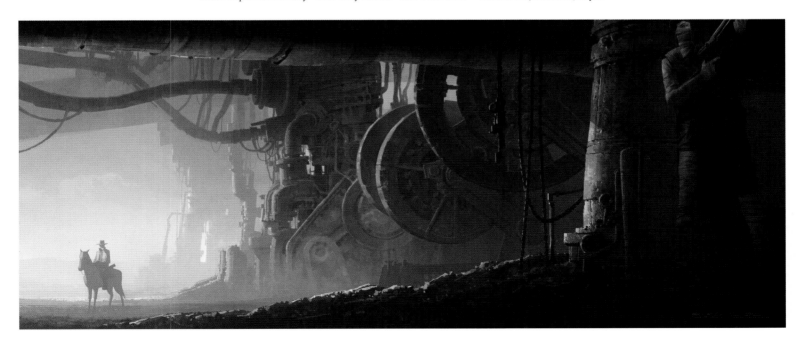

Ritche Sacilioc
Title: Uncertain *Medium:* Digital

Joe Vaux
Title: Two Weeks *Size:* 24"x36" *Medium:* Acrylic on wood panel

Kirk Reinert

Client: Animazing Gallery *Title:* Bug *Size:* 20"x30" *Medium:* Acrylic

Alex Beck

Art Director: George Pratt *Title:* Bandit Carpenters *Size:* 11"x14" *Medium:* Mixed

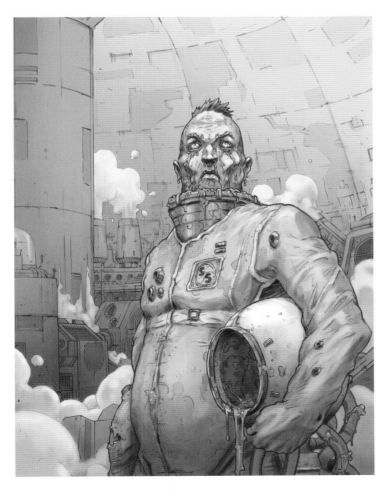

Gus Storms

Title: Void Breakers Vol. 0 *Size:* 12"x16" *Medium:* Pencil, digital

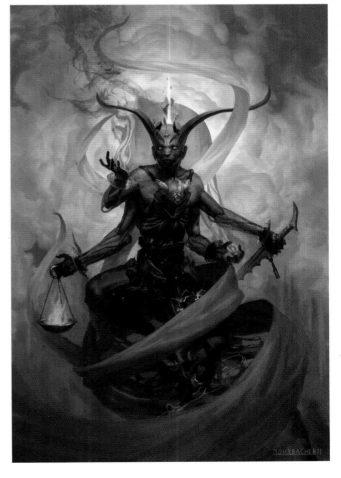

Peter Mohrbacher

Title: Mercy *Medium:* Photoshop

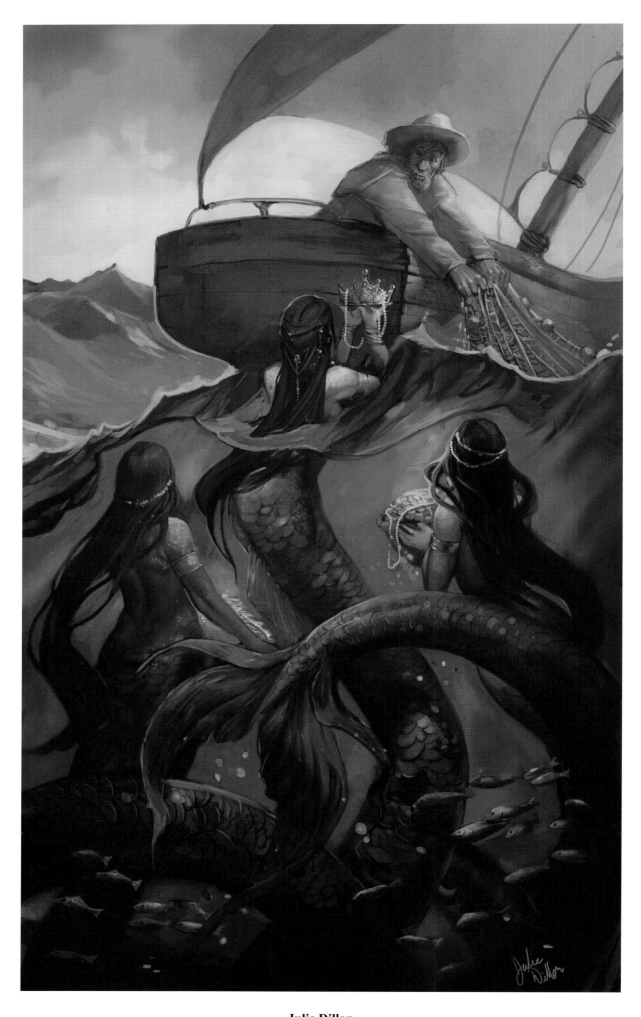

Julie Dillon
Title: Treasure from the Deep *Medium:* Digital

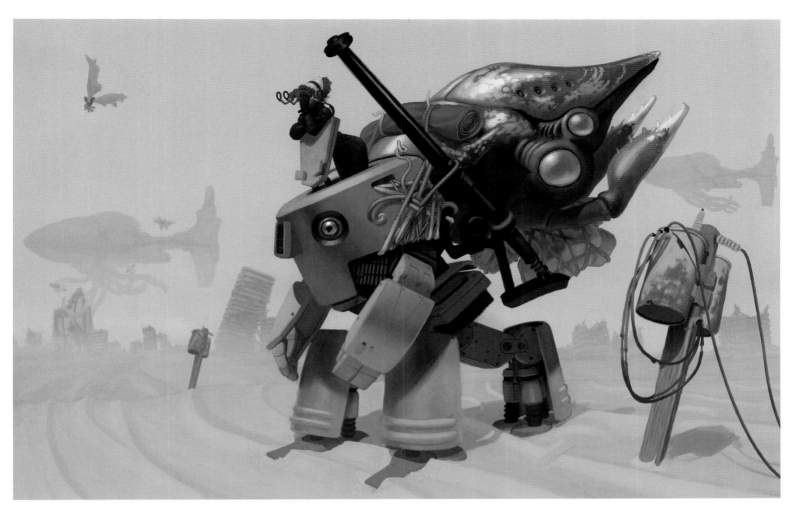

Steven Sanders
Title: Biowalker *Size:* 17"x11" *Medium:* Digital

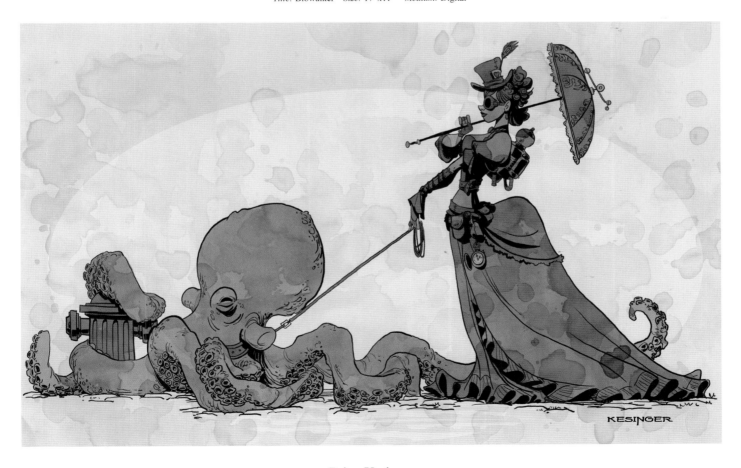

Brian Kesinger
Title: Walkies for Otto *Size:* 17"x11" *Medium:* Digital

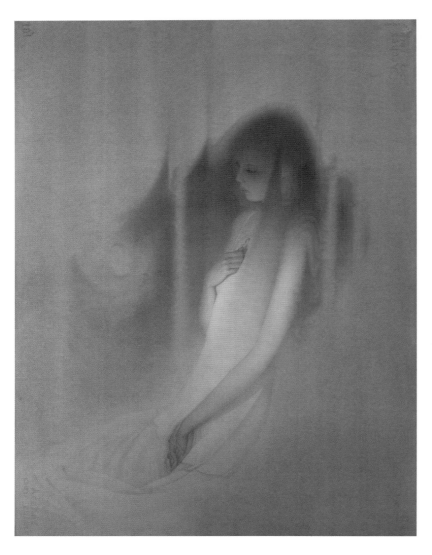

Eric Fortune
Title: Lilith *Size:* 22"x30" *Medium:* Acrylic

Sara K. Diesel
Title: Ruination *Size:* 17"x27" *Medium:* Digital

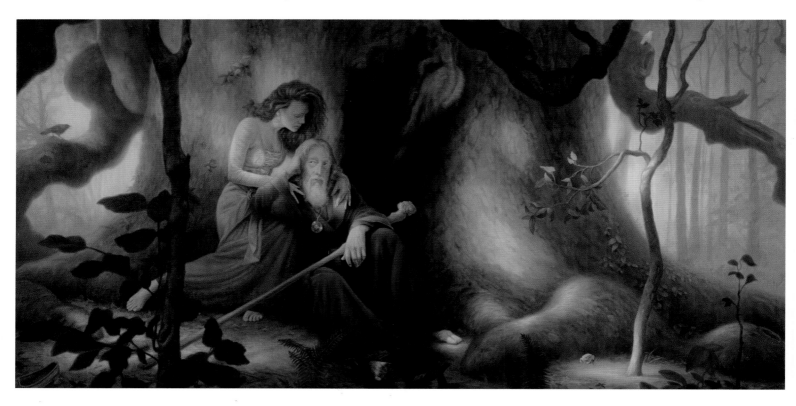

Allen Douglas
Title: Merlin and Vivien *Size:* 52"x26" *Medium:* Oil on panel

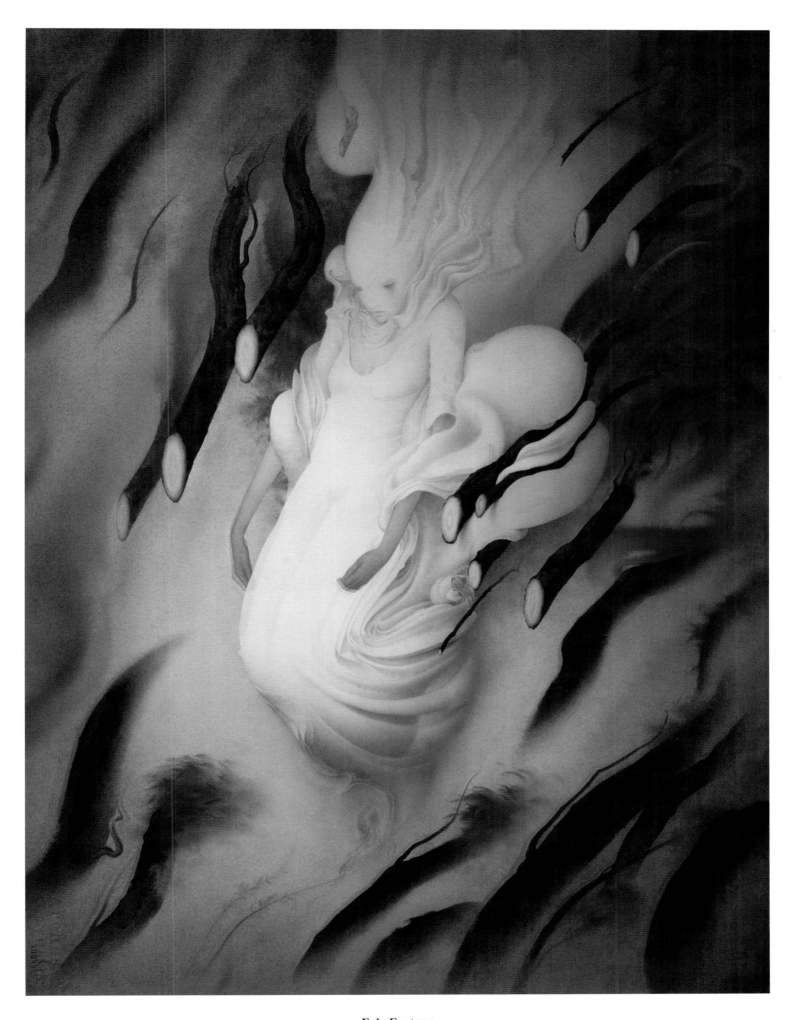

Eric Fortune

Title: Last Embrace *Size:* 22"x30" *Medium:* Acrylic

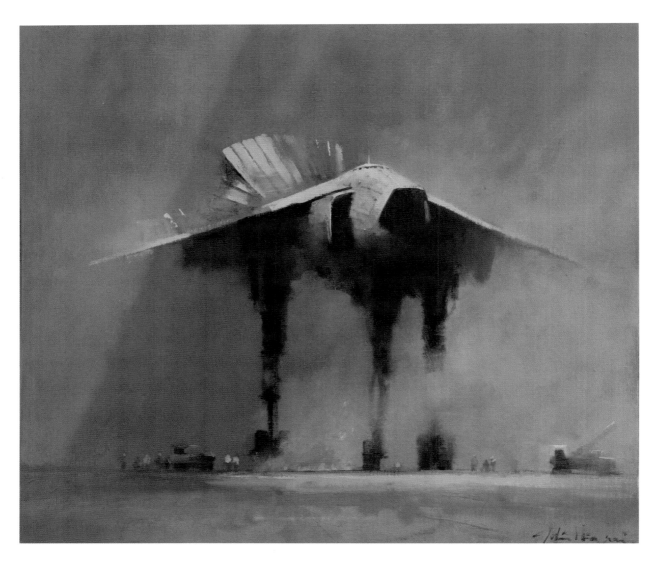

John Harris
Title: A Minor Incident *Size:* 16"x15" *Medium:* Oil on board

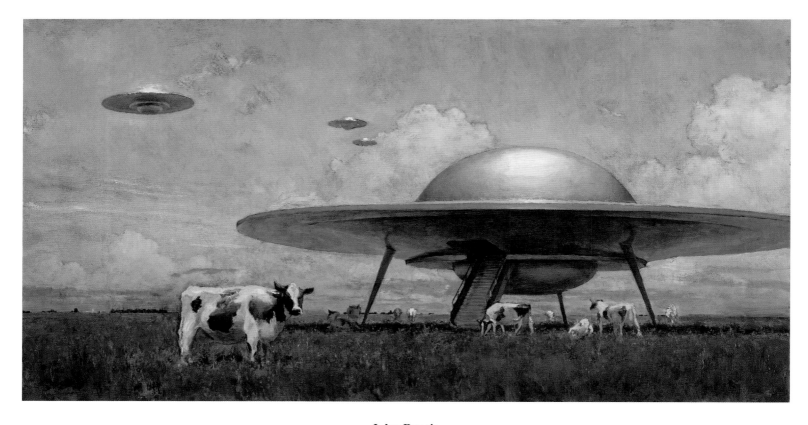

John Brosio
Title: Whole Foods *Size:* 46"x24" *Medium:* Oil on canvas

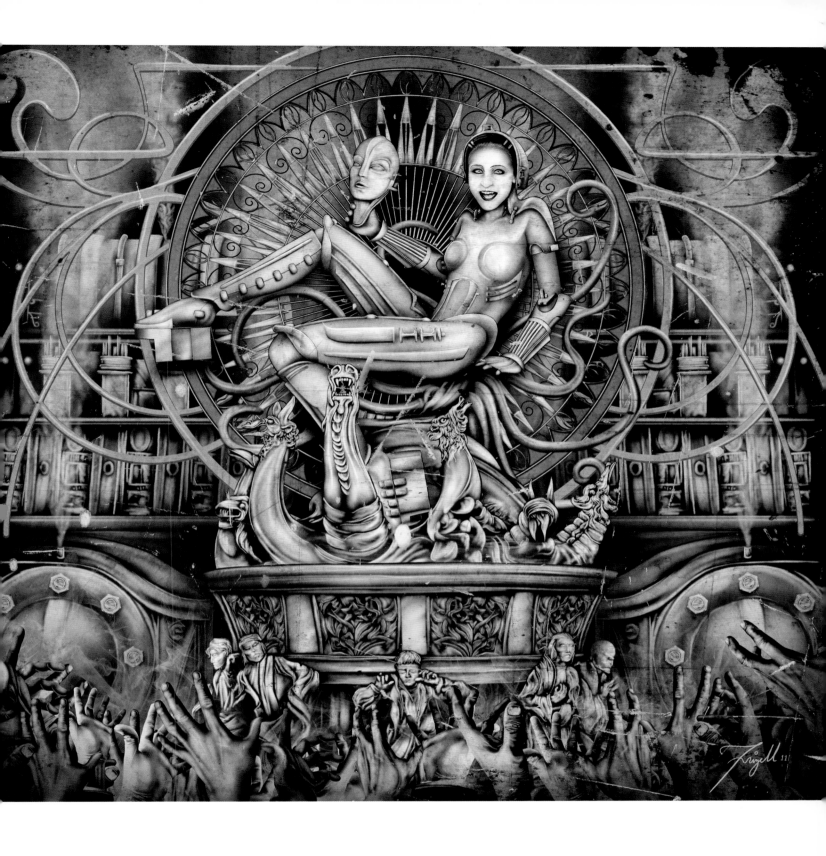

D.A. Frizell
Title: Futura *Size:* 45"x40" *Medium:* Digital

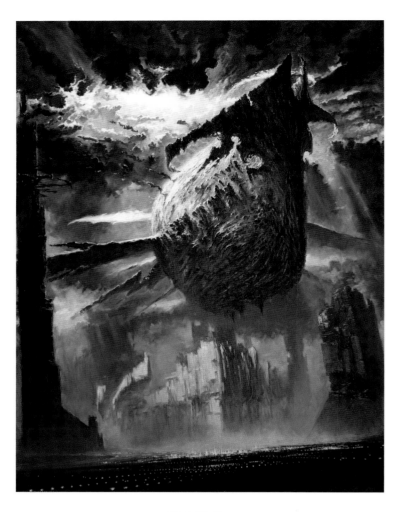

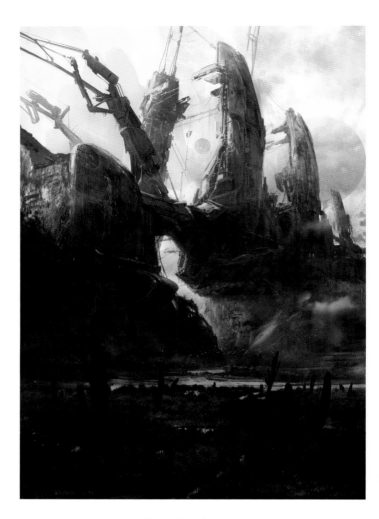

Nick Keller
Title: The Descent *Size:* 30"x40" *Medium:* Oil on canvas

Joan Dumitrescu
Title: Discovery *Size:* 11.6"x22"

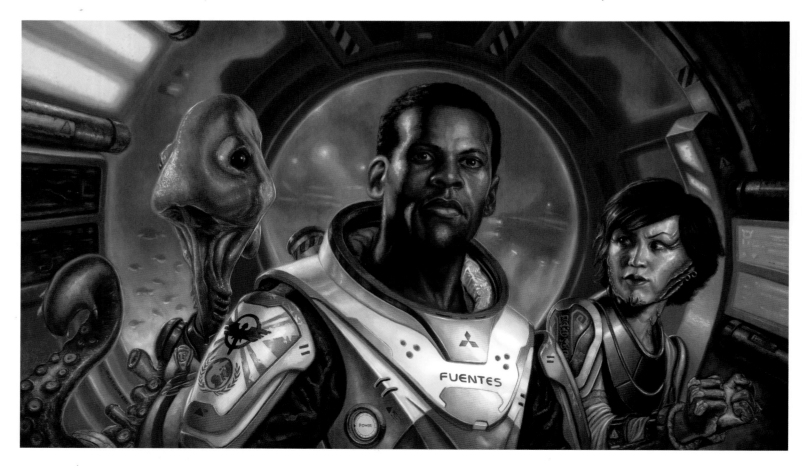

Eric Wilkerson
Title: Aquanauts: Distant Origins *Size:* 40"x24" *Medium:* Oil

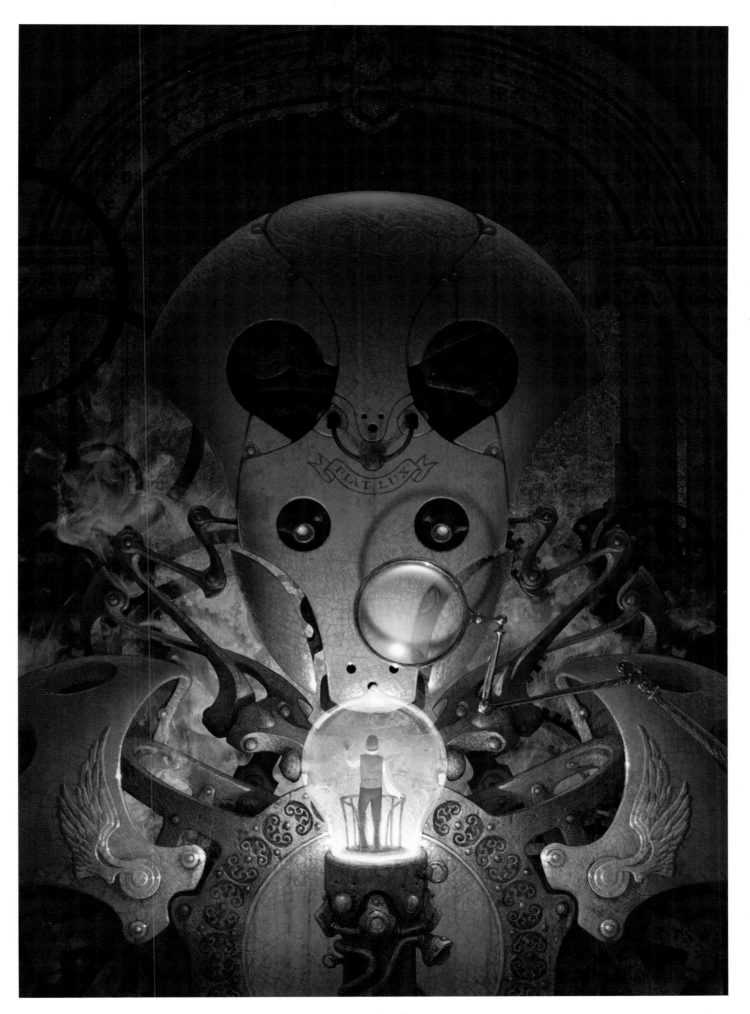

Antonio Javier Caparo

Title: Access the Oracle *Size:* 13.1"x18.5" *Medium:* Digital

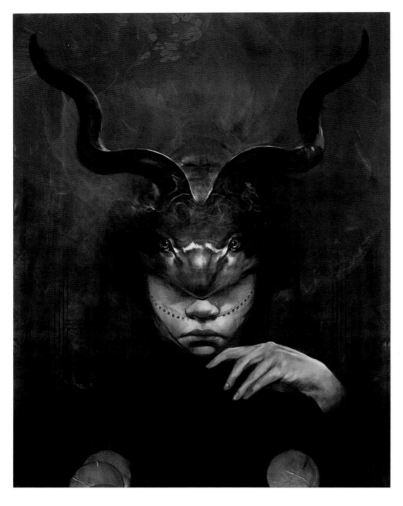

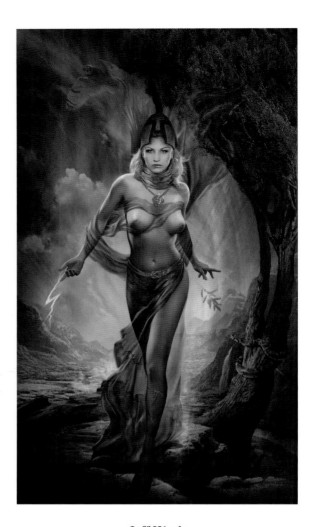

Jeff Simpson

Title: Kudu Guard *Size:* 11"x14" *Medium:* Photoshop

Jeff Wack

Client: James Franco *Title:* Athena *Size:* 32"x56" *Medium:* Mixed

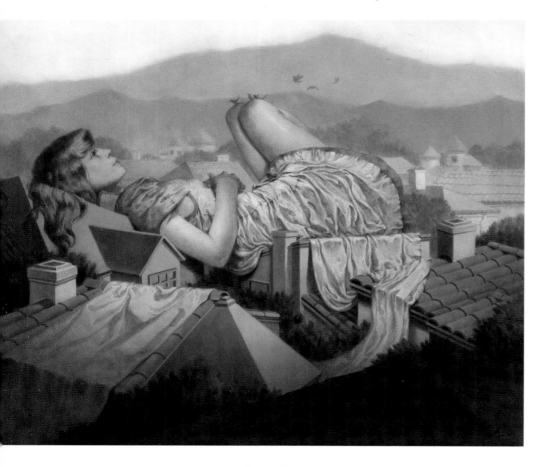

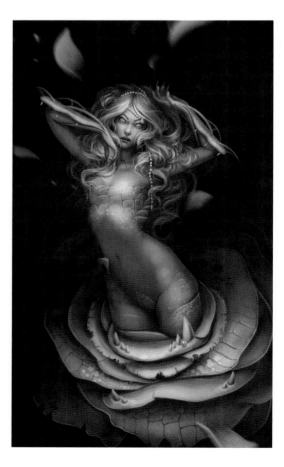

Tran Nguyen

Title: Trading Through An Untrimmed Memory *Size:* 24"x18" *Medium:* Acrylic, color pencil

Jennifer Healy

Title: Beauty In the Beast *Size:* 7"x10" *Medium:* Digital

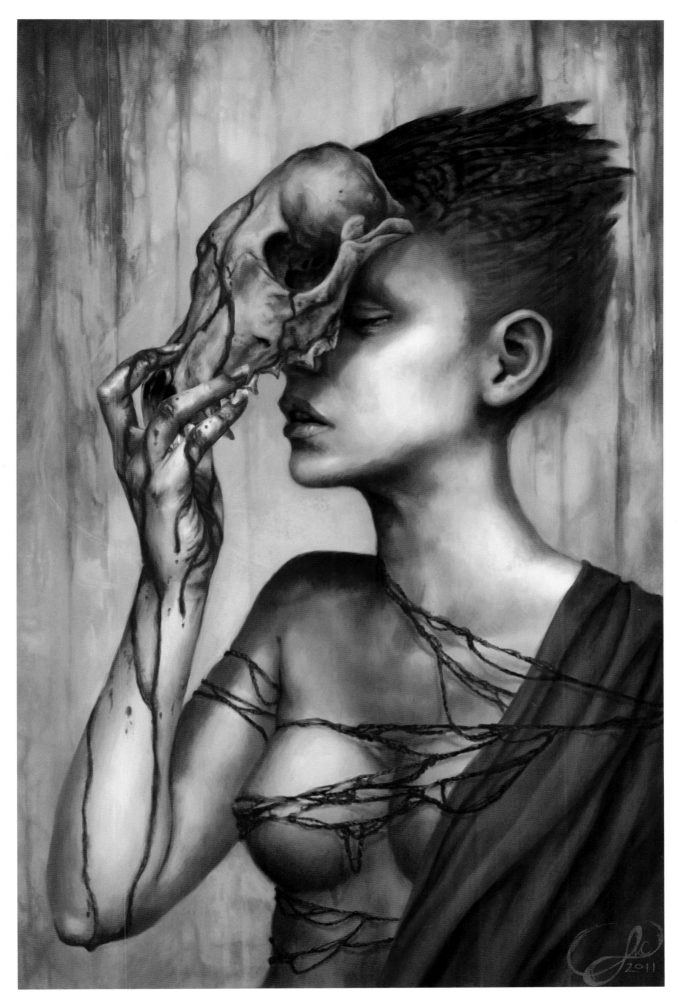

Lauren K. Cannon

Title: Mortal Coil *Medium:* Digital

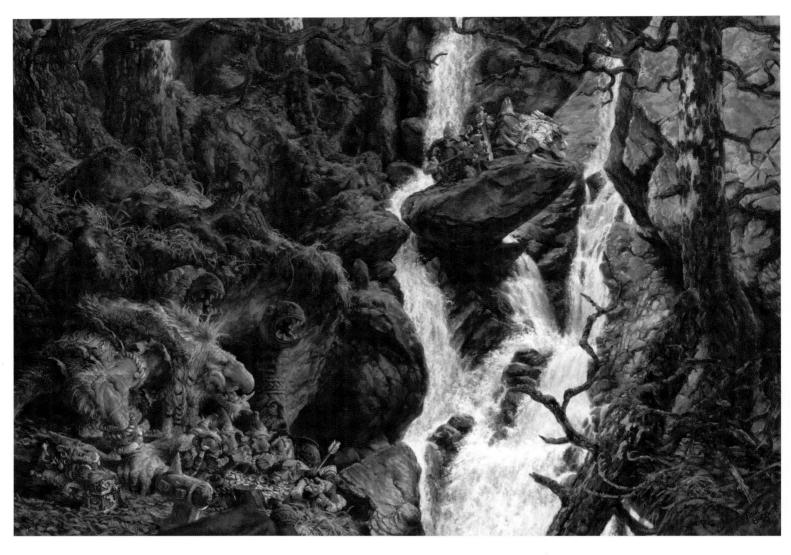

Paul Bonner
Title: Beowulf Project *Size:* 70cm x 49cm *Medium:* Watercolor

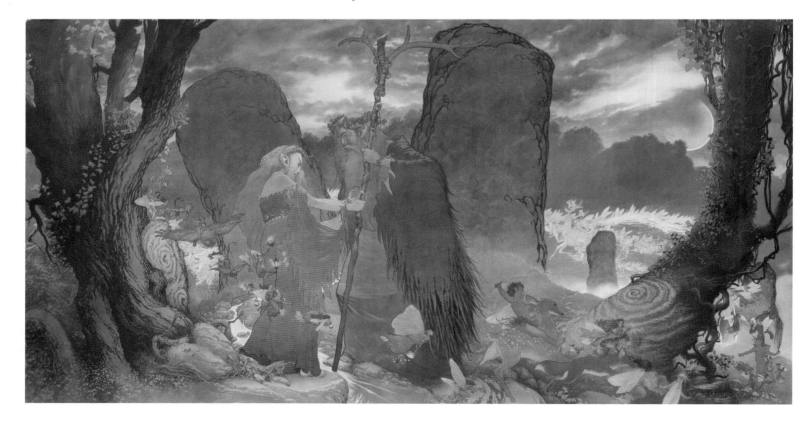

Charles Vess
Title: The Reconcilliation of the Sun and the Moon *Size:* 8'x4' *Medium:* Colored inks

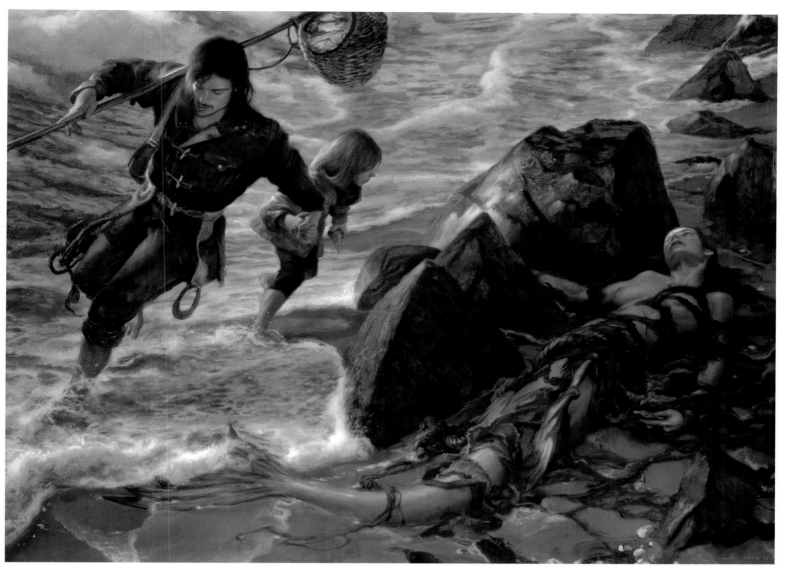

Donato Giancola

Client: Richard Demato Fine Arts Gallery *Title:* Search: For Mother *Size:* 48"x36" *Medium:* Oil on panel

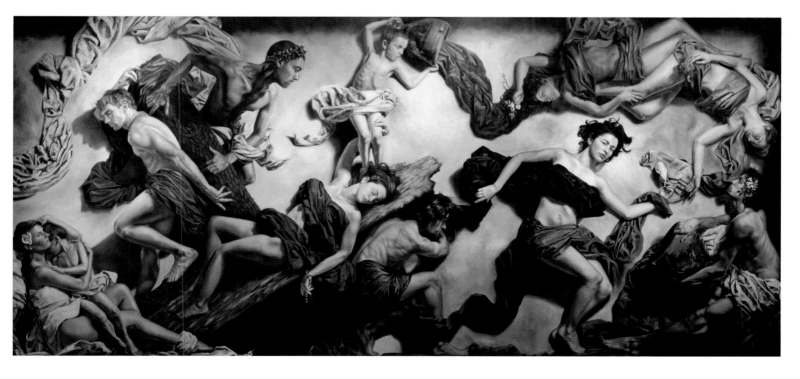

Nicholas Napoletano

Title: Fraternal Codependence *Size:* 16'x7.5' *Medium:* Oil

Jeff Wack
Client: James Franco *Title:* NYX *Size:* 32"x56" *Medium:* Mixed on canvas

Sam Weber

Title: The Pearl Fisher *Medium:* Acrylic, watercolor, digital

Edward F. Howard
Title: The Search Begins *Size:* 18"x24" *Medium:* Oil on on board

Hala Wittwer
Title: Watchfrog *Size:* 7"x10" *Medium:* Acrylic, oil

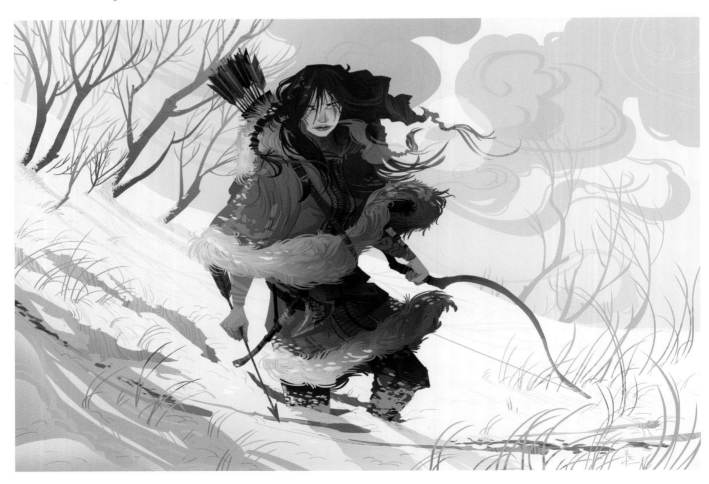

Hannah Christenson
Title: Winter Hunt *Size:* 20"x30" *Medium:* Digital

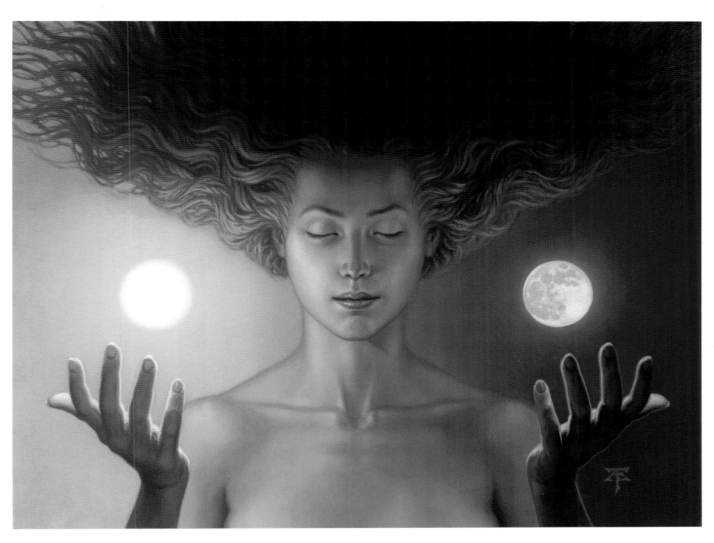

Tristan Elwell
Title: Night and Day *Size:* 14"x10.25" *Medium:* Oil on board

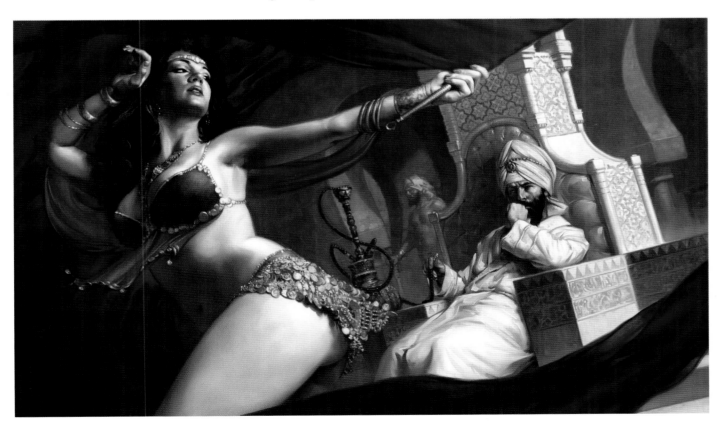

David Palumbo
Client: Neil and Leigh Mechem *Title:* Through a Blood Red Veil *Size:* 16"x27" *Medium:* Oil

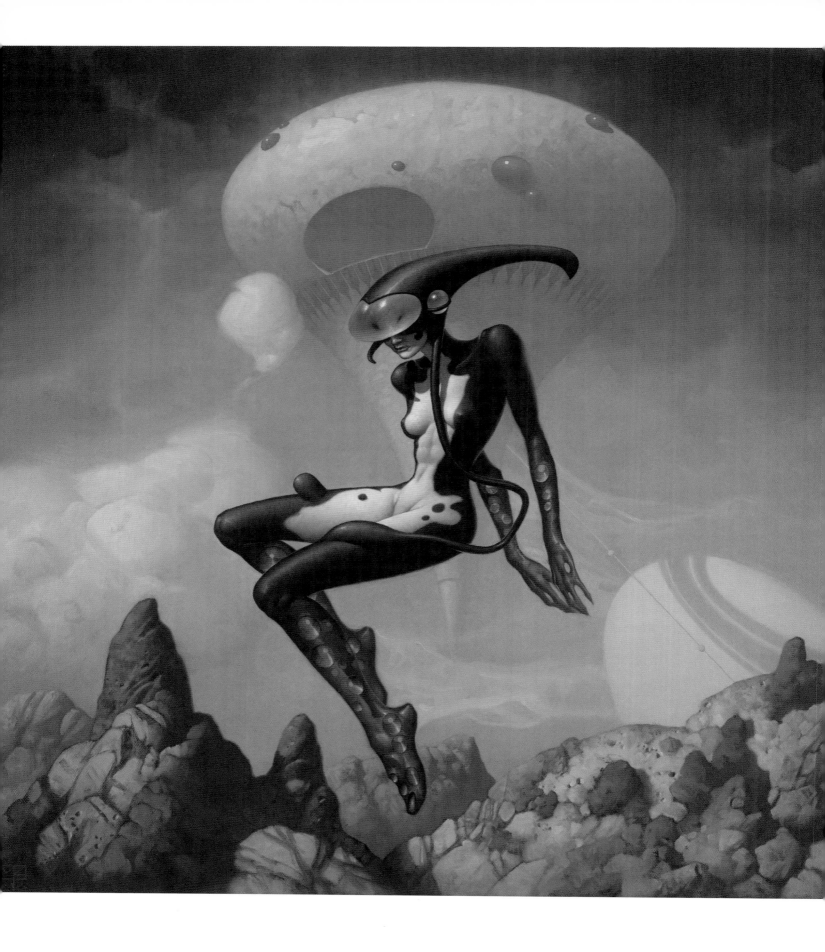

Mark Zug
Title: Xenon *Size:* 24"x24" *Medium:* Oil

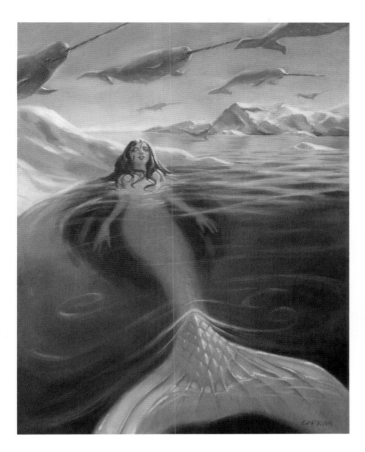

John Larriva
Title: Narwhal Sky *Size:* 14"x18" *Medium:* Oil

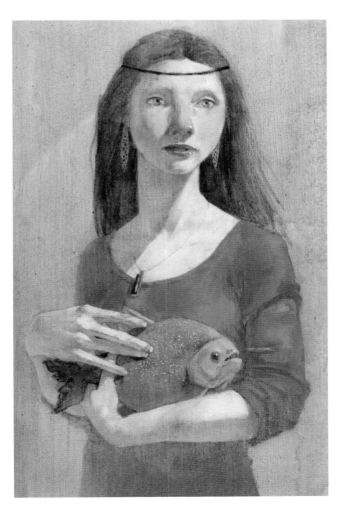

Erika Steiskal
Title: He Worried His Friends Only Liked Him For His Golden Scales
Size: 6"x10" *Medium:* Mixed

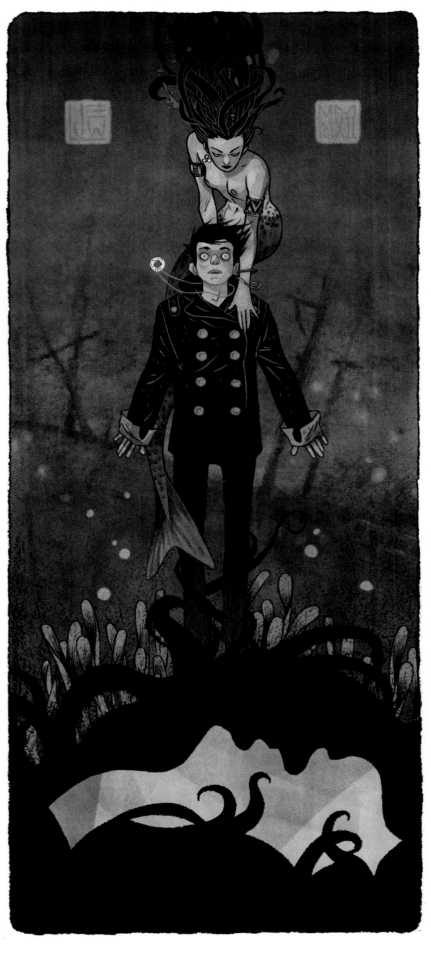

Jake Wyatt
Title: Sailor Twain *Size:* 9"x21" *Medium:* Graphite, digital

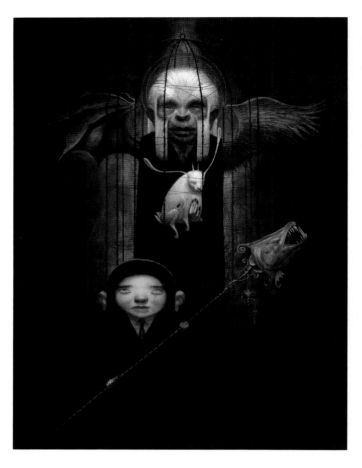

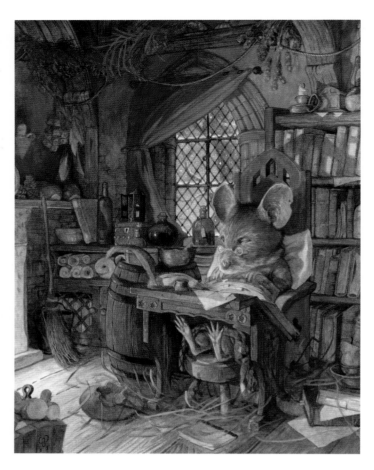

Bill Carman
Title: I Could Escape If I Wanted *Size:* 9"x12" *Medium:* Acrylic on copper

Chris Dunn
Title: Jacques' Rest *Size:* 24cm x 31cm *Medium:* Watercolor

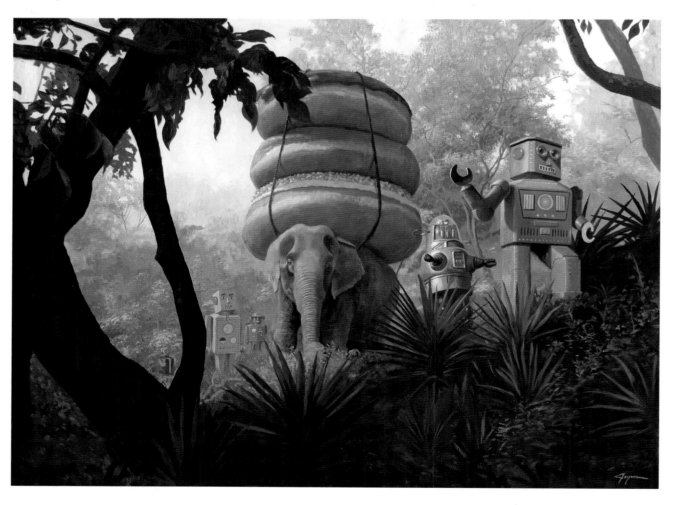

Eric Joyner
Client: Corey Helford Gallery *Title:* On Tiger Mountain *Size:* 64"x48" *Medium:* Oil on board

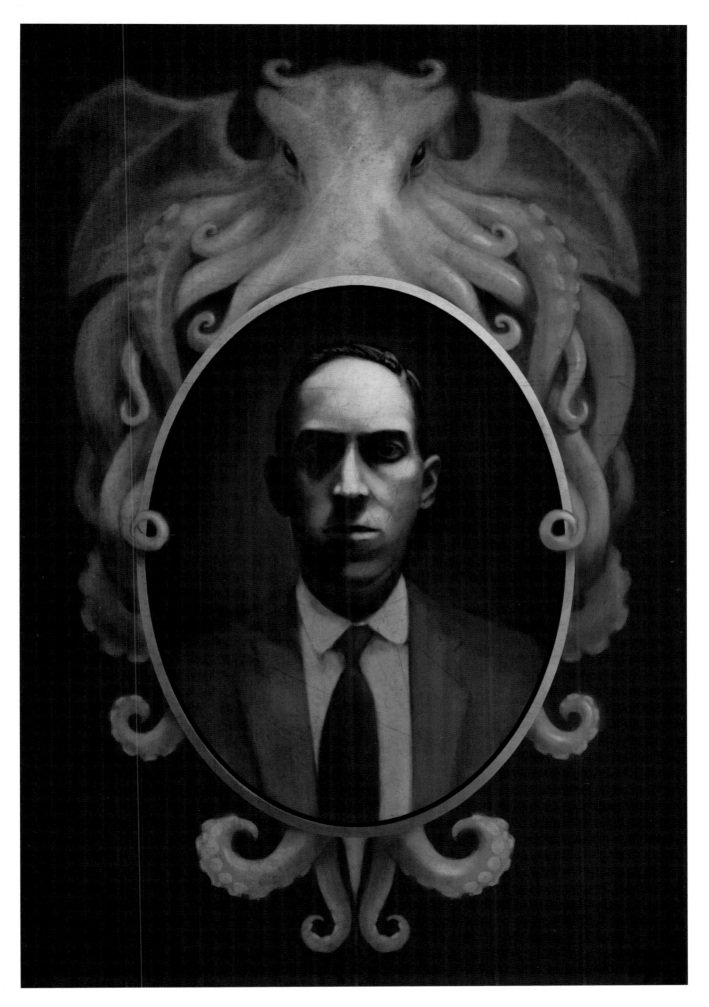

Travis Lewis
Title: H.P. Lovecraft *Size:* 16"x24" *Medium:* Oil, digital

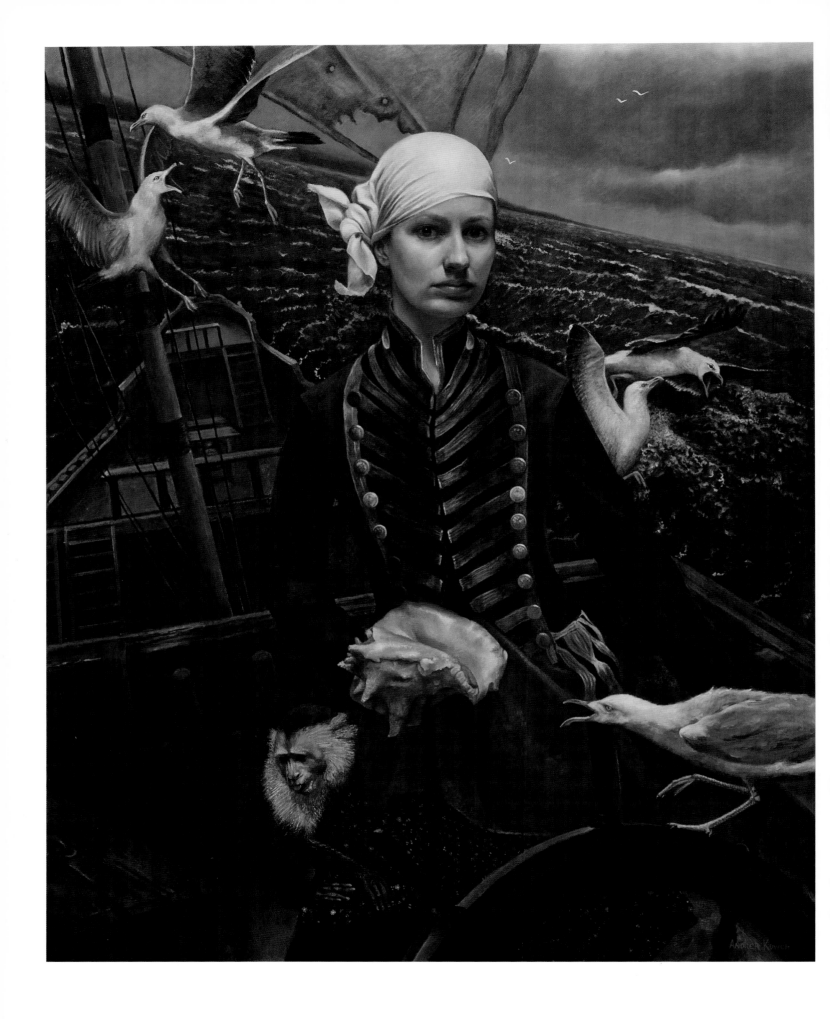

Andrea Kowch
Title: Tempest *Size:* 24"x30" *Medium:* Acrylic on canvas

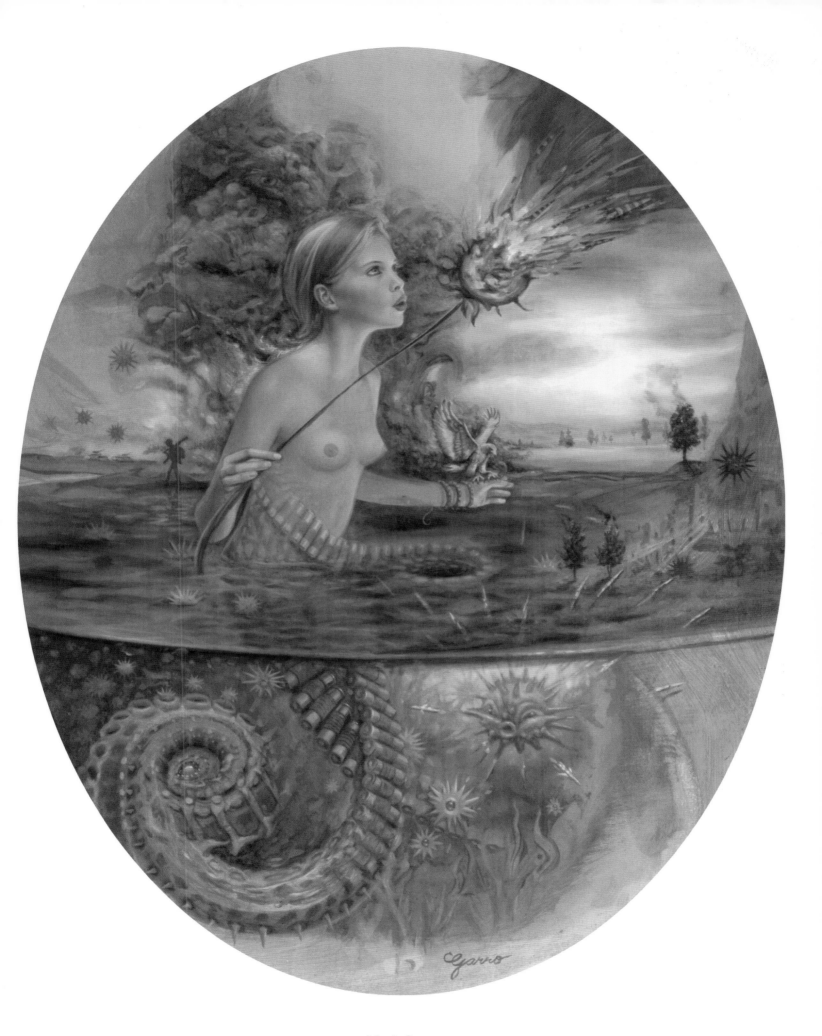

Mark Garro

Client: Copro Gallery *Title:* Warchild *Size:* 14"x20" *Medium:* Oil on panel

Fabio Listrani
Title: Lemegeton Clavicula SalomONIs *Medium:* Digital

Dave Laub
Title: Runs Amok *Size:* 8"x10" *Medium:* Digital

Scott Bakal
Client: William–Scott Gallery *Title:* Explosion #2 *Size:* 11"x14" *Medium:* Acrylic, ink

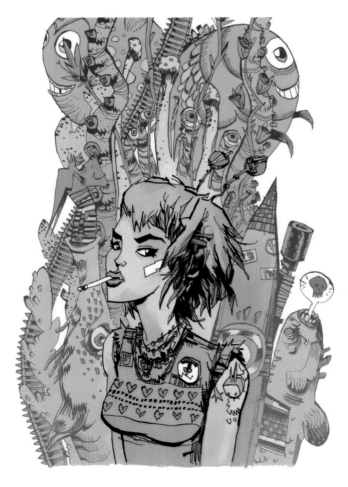

Jim Mahfood
Art Director: Steve White *Colorist:* Anne Masse *Client:* Titan Books
Title: Everyone Loves Tank Girl #2 *Size:* 6"x9" *Medium:* Ink, digital

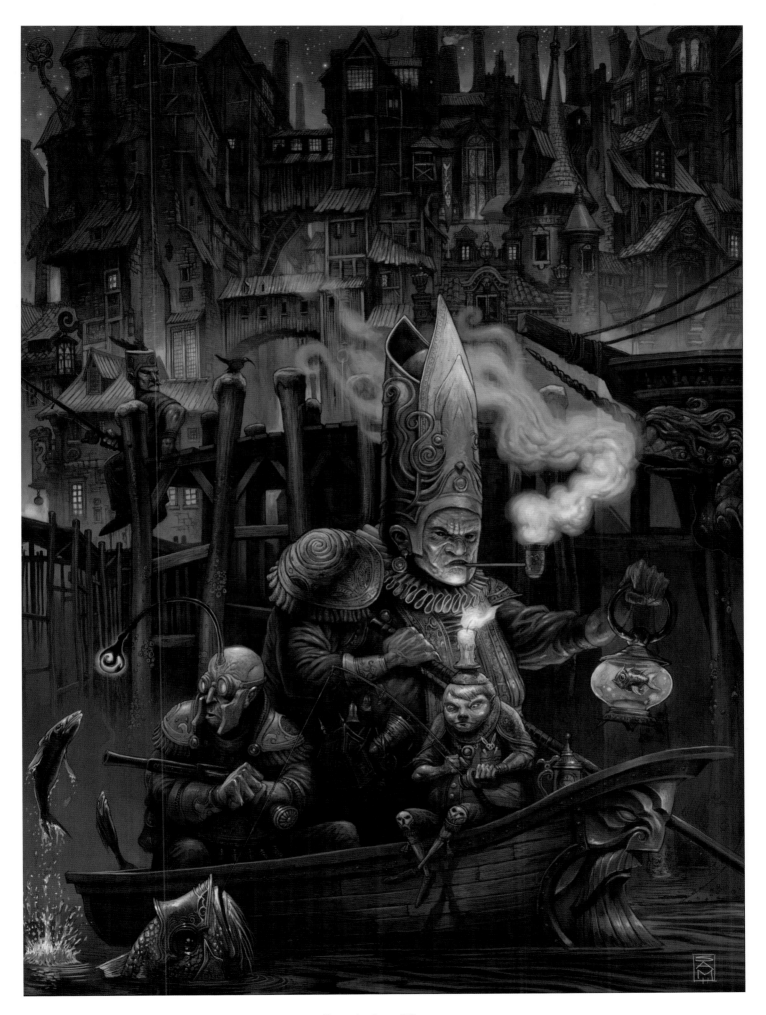

Sean Andrew Murray
Title: Night Fishermen *Medium:* Pencil, digital

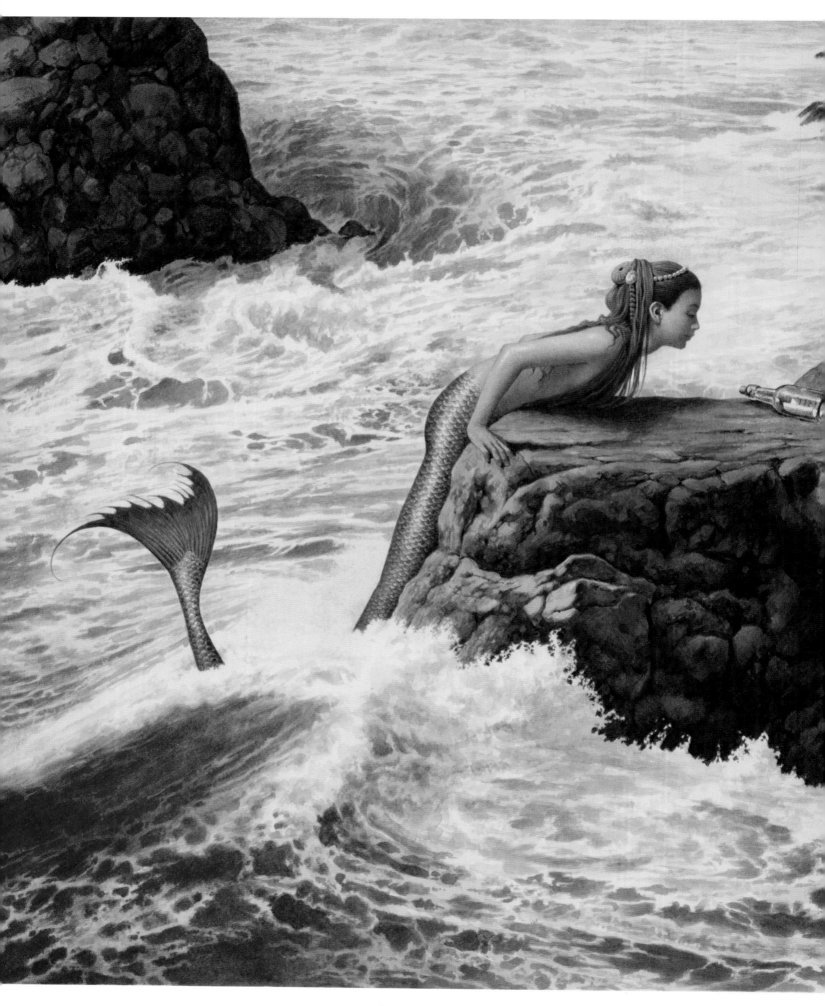

Dennis Nolan
Title: Message In a Bottle *Size:* 19.5"x15.5" *Medium:* Watercolor

William O'Connor

Title: Ride to Gondor *Size:* 21"x48" *Medium:* Oil

Kei Acedera
Client: Imaginism Studios *Title:* Bear Interrupted *Size:* 11"x14" *Medium:* Gouache

B.R. Guthrie
Title: Tigerpede *Size:* 7.25"x10" *Medium:* Mixed

Heather Watts
Client: La Luz de Jesus Gallery *Title:* The Weary Shepherd *Size:* 14"x11" *Medium:* Acrylic on panel

Kei Acedera

Client: Imaginism Studios *Title:* Morning Chill *Size:* 18"x24" *Medium:* Gouache

Andrea Kowch
Title: Knell's Edge *Size:* 30"x30" *Medium:* Acrylic on canvas

Erika Taguchi-Newton
Title: We Hide In the Forest *Size:* 6"x12" *Medium:* Acrylic

Jai Kamat
Title: Forest Dweller *Size:* 20"x15.5" *Medium:* Digital

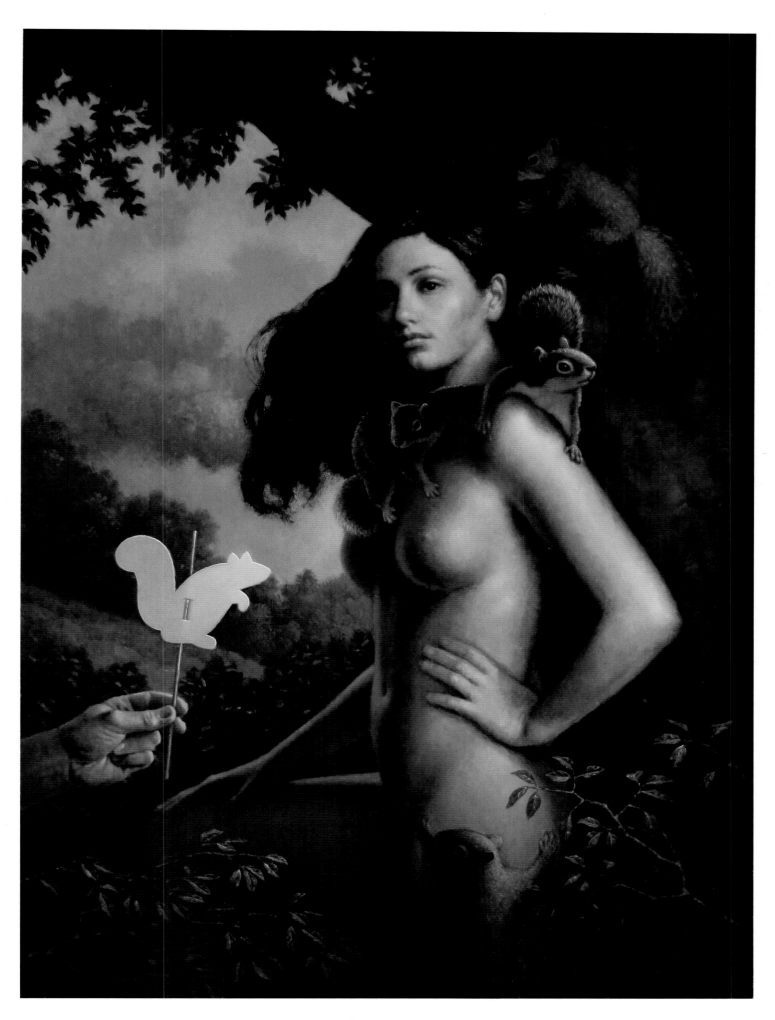

Steven Kenny
Title: The Imposter *Size:* 22"x30" *Medium:* Oil on linen

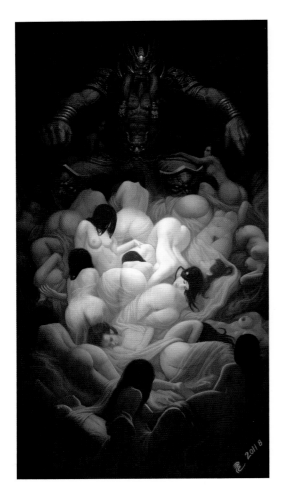

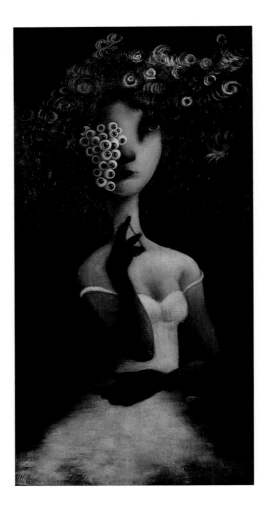

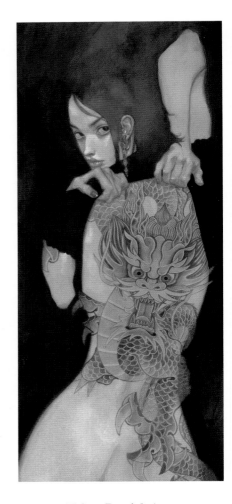

ZhongHua You
Title: King of Evil *Medium:* Digital

P. Tepper
Title: The Black Rose Bride *Size:* 20"x40" *Medium:* Oil

Tohru Patrick Awa
Title: Draken Flicka *Medium:* Watercolor

Heather Theurer
Title: The Rescue *Size:* 48"x36" *Medium:* Oil

Kali Ciesemier
Title: Conqueror and Catbeast *Size:* 19"x13" *Medium:* Digital

Renae Taylor
Title: Mother of Pearl Faerie *Size:* 14"x11" *Medium:* Pencil, Photoshop

Dvid Palumbo

Title: Coral Demon *Size:* 12"x15" *Medium:* Oil

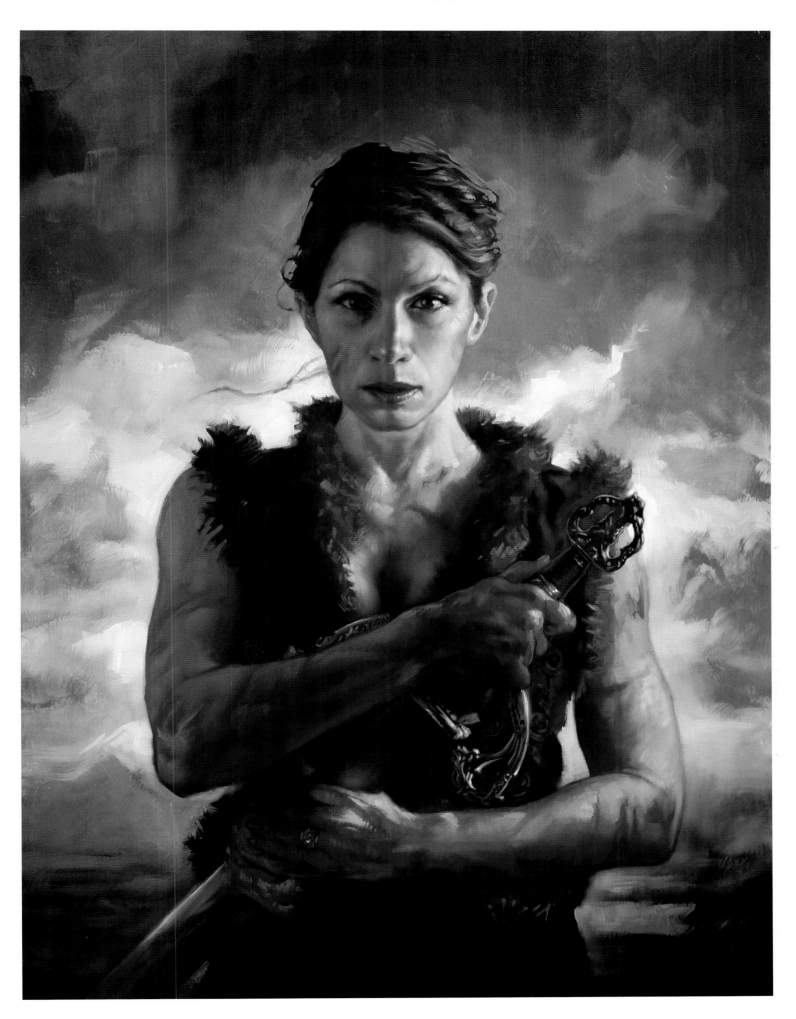

Anthony Palumbo
Title: Bloodied, Not Beaten *Size:* 18"x24" *Medium:* Oil, digital

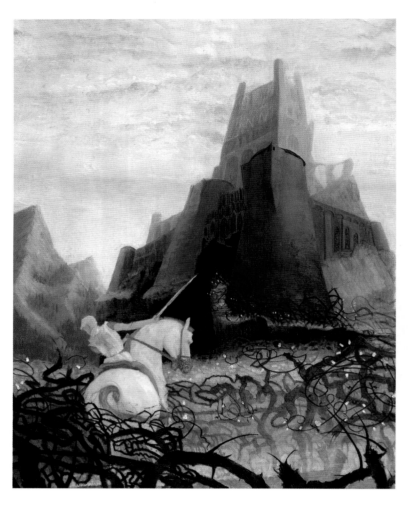

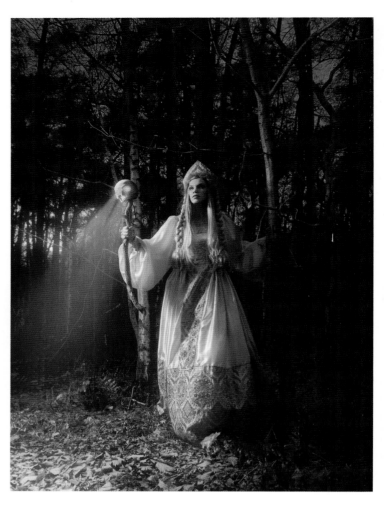

John A. Esh
Title: Hero X *Size:* 18"x21" *Medium:* Oil

Viona Ielegems
Title: Vasilisa the Brave *Medium:* Photography

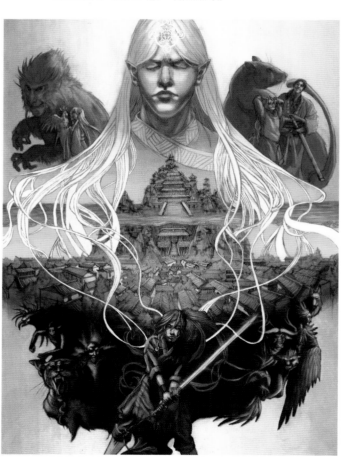

J.S. Choi
Title: 12 Kingdoms: Sea of Shadows *Size:* 12.5"x16.625" *Medium:* Mixed, digital

Lisa Falkenstern
Title: Humpty Dumpty *Size:* 8"x14.5" *Medium:* Oil

Tohru Patrick Awa

Title: Let It Snow *Size:* 9"x14.5" *Medium:* Watercolor

Shelly Wan

Client: Gallery Nucleus *Title:* The Girl With the Dragon Scarf *Medium:* Oil on masonite

Bill Carman
Title: I Think We Need a Bigger Tramp *Size:* 6"x10" *Medium:* Acrylic on wood

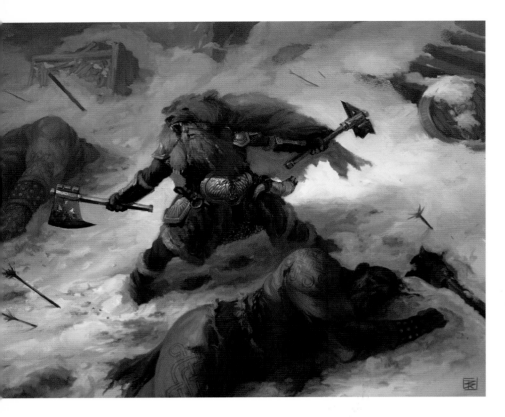

Denman Rooke
Title: Bear Warrior *Size:* 10.5"x8" *Medium:* Photoshop

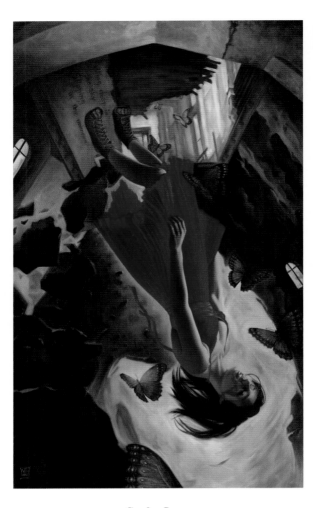

Sacha Lees
Title: Downside Up *Size:* 35"x59" *Medium:* Oil

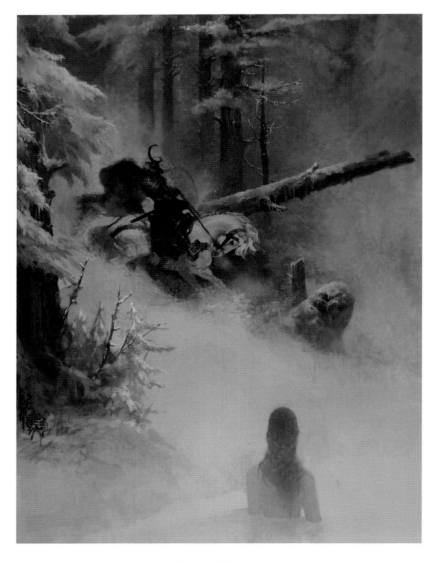

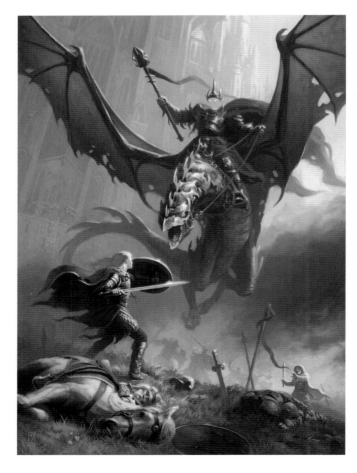

Bayard Wu
Title: Glimpse of Snowy Mystery *Size:* 6.7"x9.3" *Medium:* Digital

Craig J. Spearing
Client: ArtOrder *Title:* Carrion Lord *Size:* 11"x15" *Medium:* Photoshop

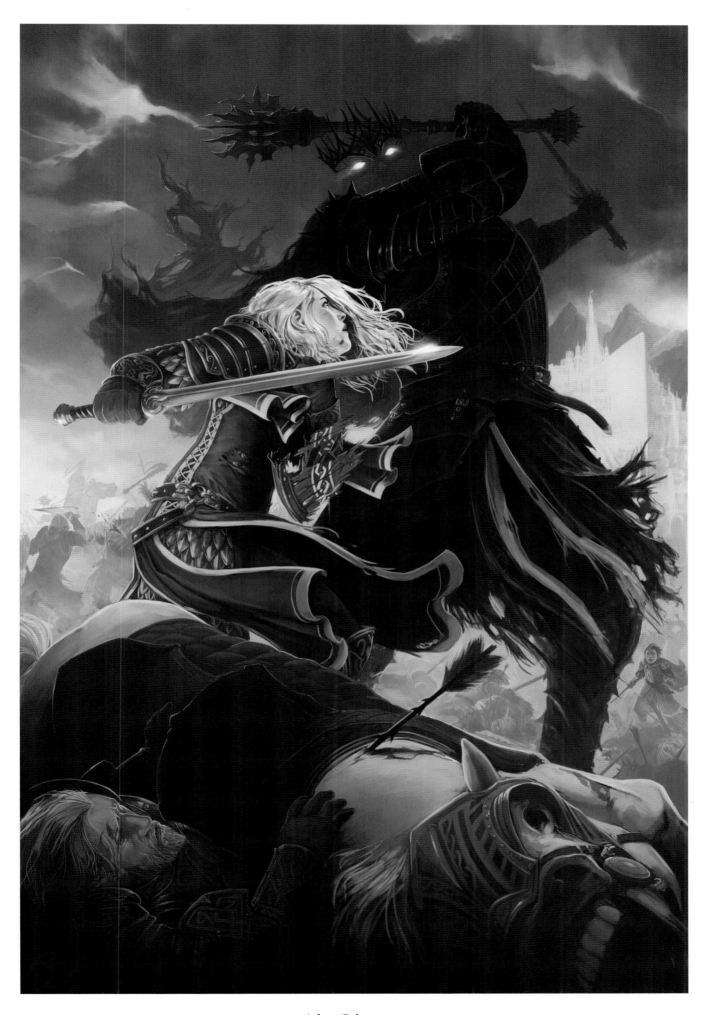

Adam Schumpert
Title: Eowyn Vs The Witch King *Size:* 12"x18" *Medium:* Digital

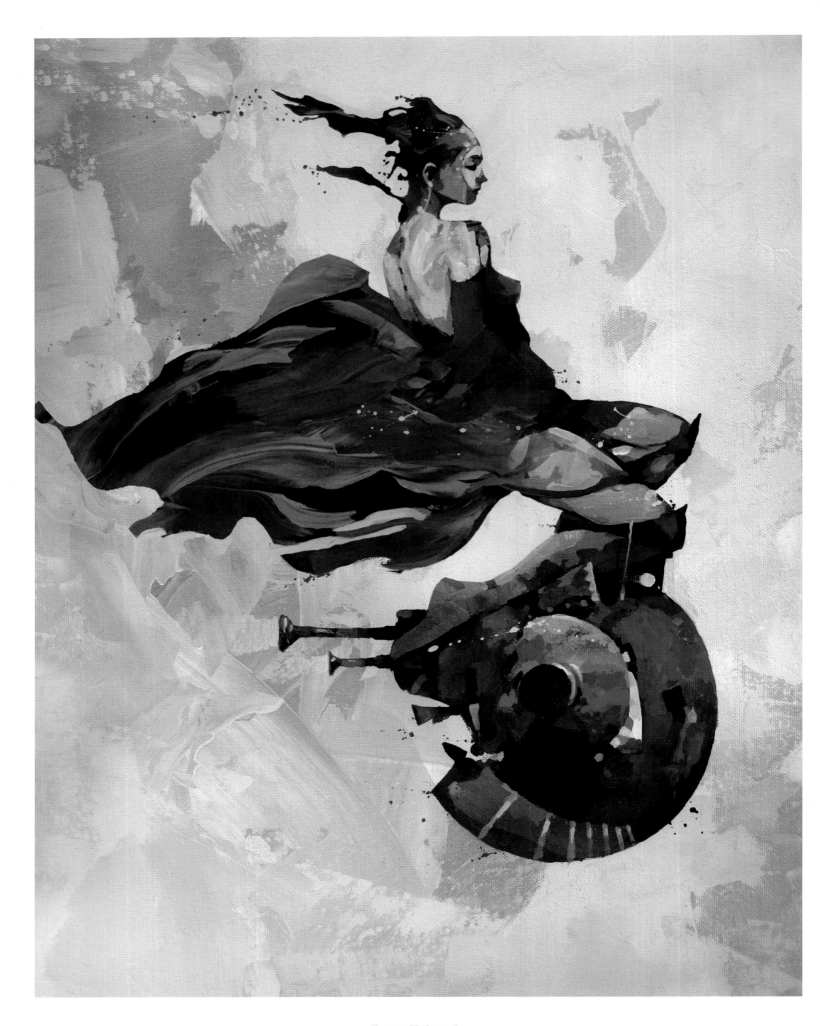

Bruce Holwerda
Title: Star Drifter *Size:* 18"x24" *Medium:* Acrylic

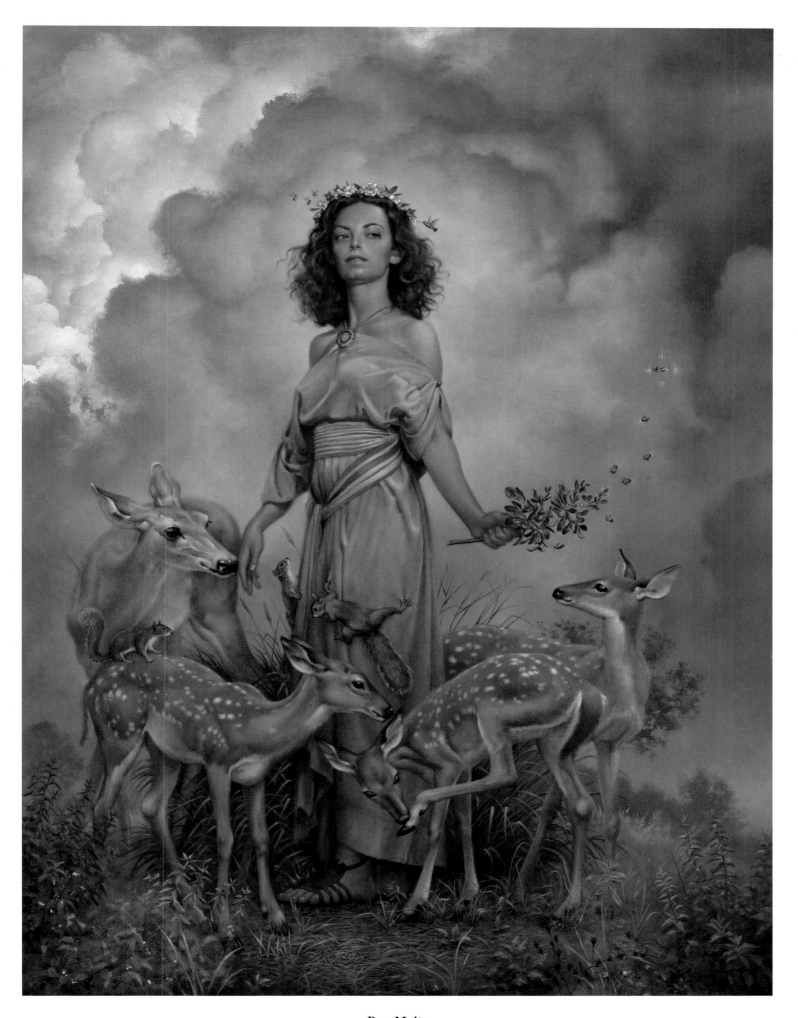

Don Maitz
Title: Golden Moment *Size:* 30"x40" *Medium:* Oil on linen

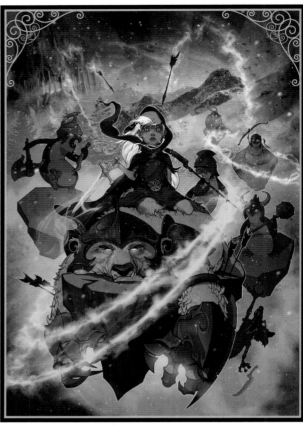

Kamala Dolphin-Kingsley
Title: Fantasy Island *Size:* 28"x22" *Medium:* Watercolor, acrylic, glitter

Vanja Todoric
Title: The Little Match Girl *Medium:* Digital

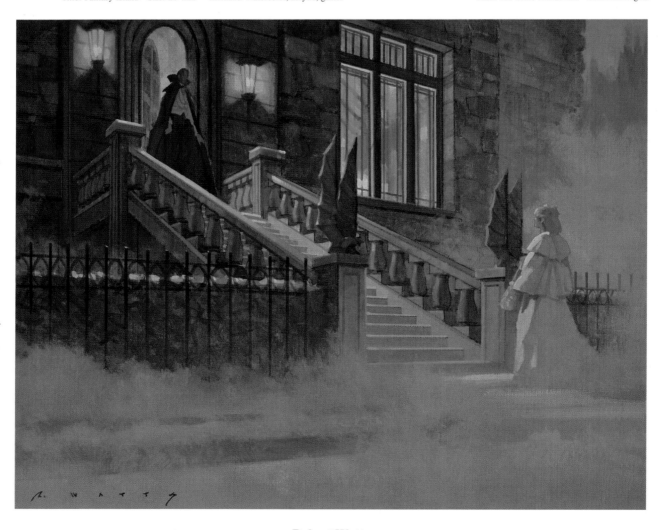

Robert Watts
Title: Stairway Into Nevermore *Size:* 10.75"x8.5" *Medium:* Gouache

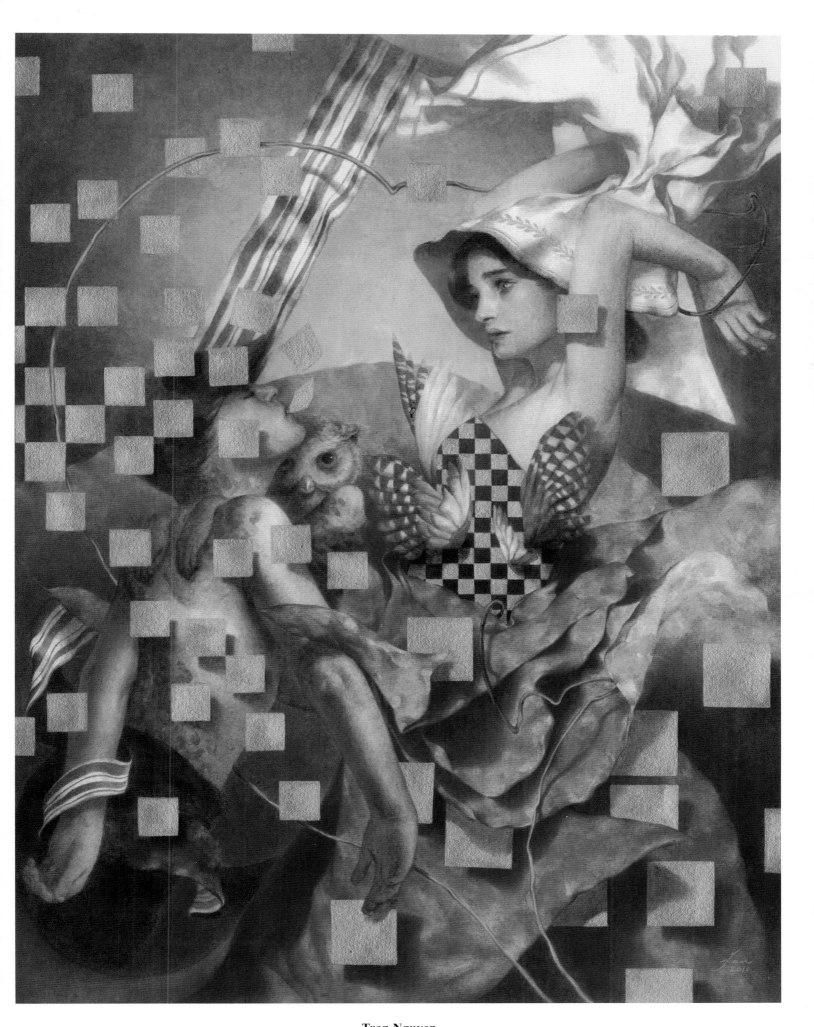

Tran Nguyen
Title: Living Parallel to an Infectious Pigment *Size:* 13"x18" *Medium:* Acrylic, color pencil

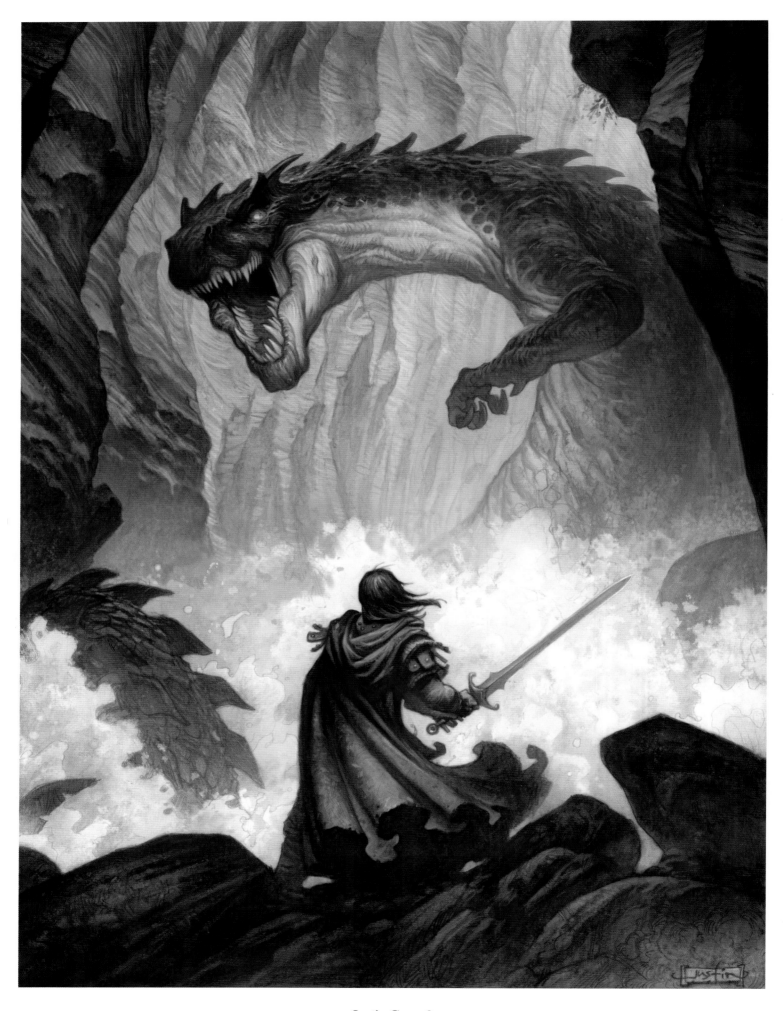

Justin Gerard

Title: St. George No. 8 *Size:* 11"x15" *Medium:* Pencil, digital

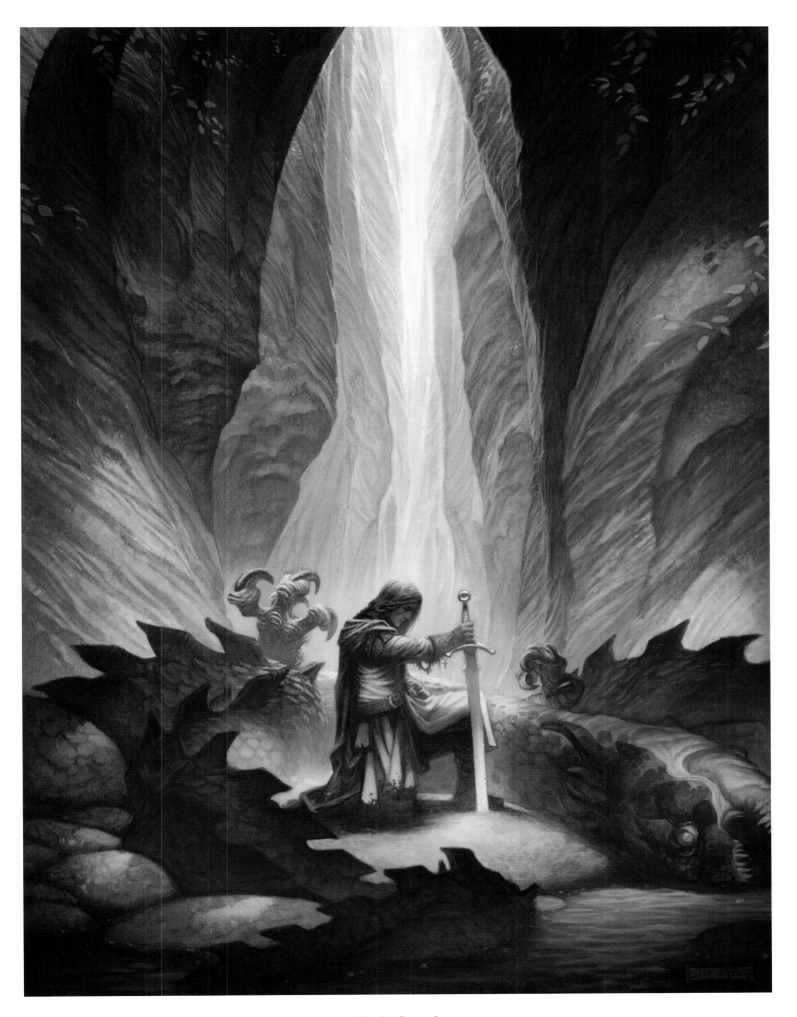

Justin Gerard

Title: St. George No. 10 *Size:* 12"x16" *Medium:* Pencil, digital

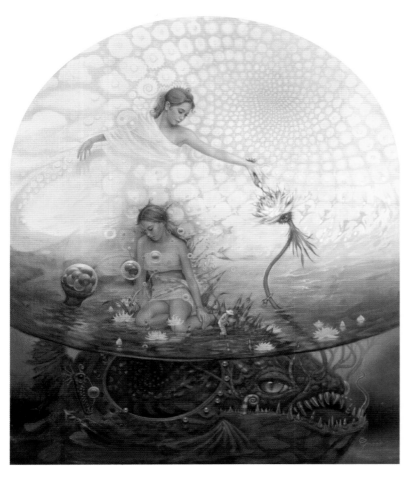

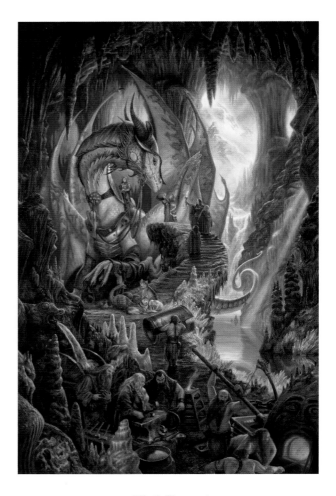

Mark Garro
Client: Copro Gallery *Title:* Just a State of Confidence *Size:* 22"x29" *Medium:* Oil on panel

Matt Stewart
Title: Dragonforge *Size:* 28"x44" *Medium:* Oil on panel

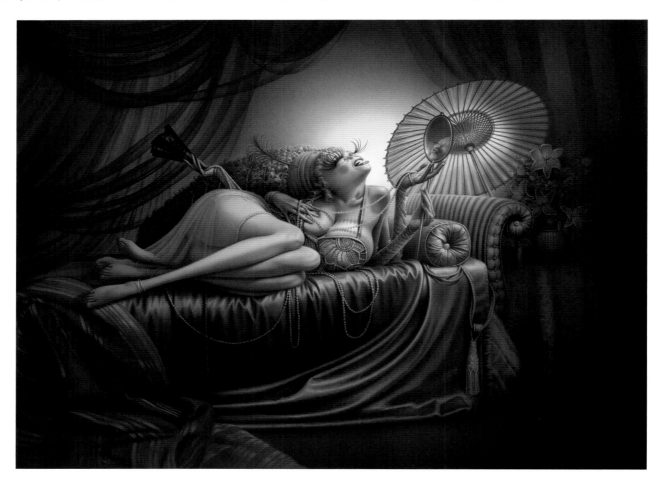

Kirk Reinert
Client: Animazing Gallery: "Hooch, Cooch, & Scootching *Title:* Ida, Slave to Love *Size:* 40"x30" *Medium:* Acrylic

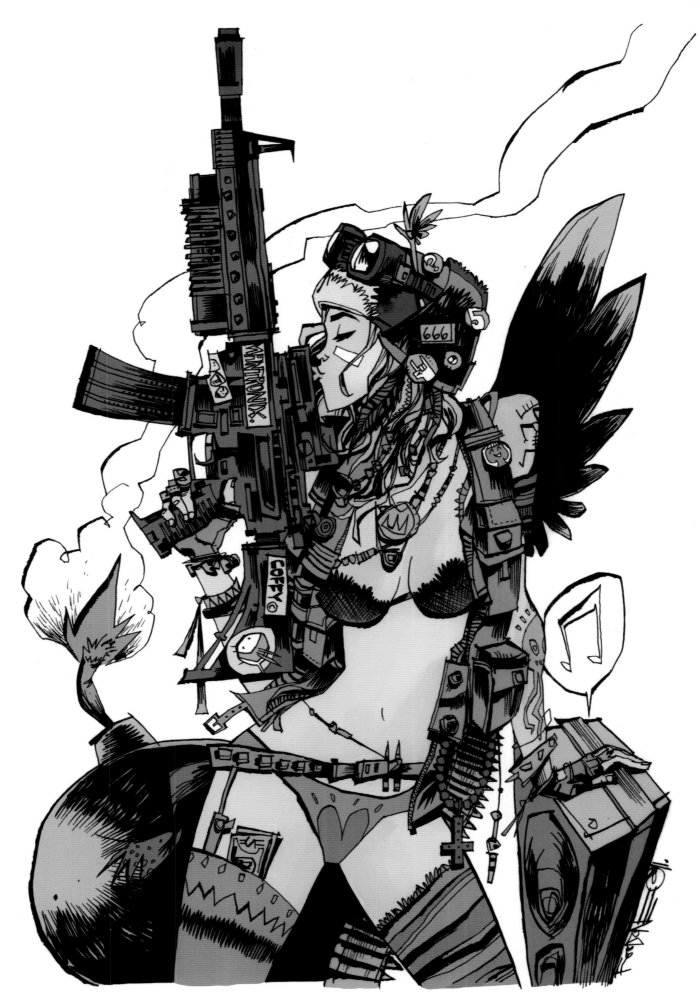

Jim Mahfood

Art Director: Steve White *Colorist:* Anne Masse *Client:* Titan Books *Title:* Everyone Loves Tank Girl #1 *Size:* 6"x9" *Medium:* Ink, digital

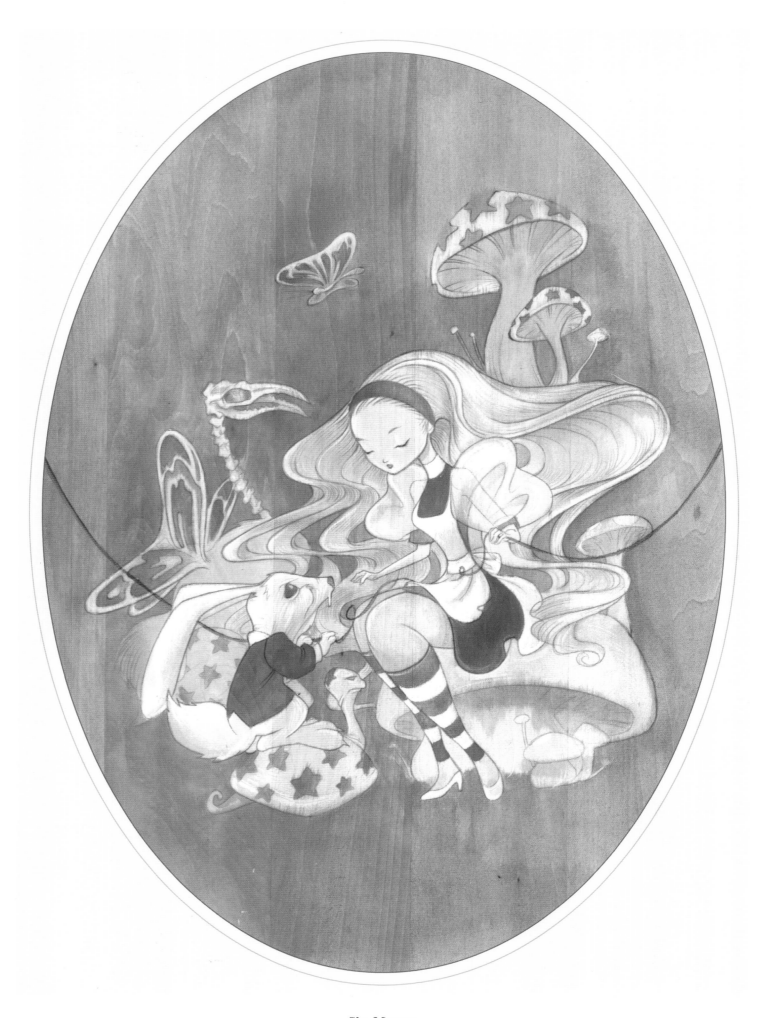

Sho Murase
Title: Alice *Size:* 12"x15" *Medium:* Gouache on wood

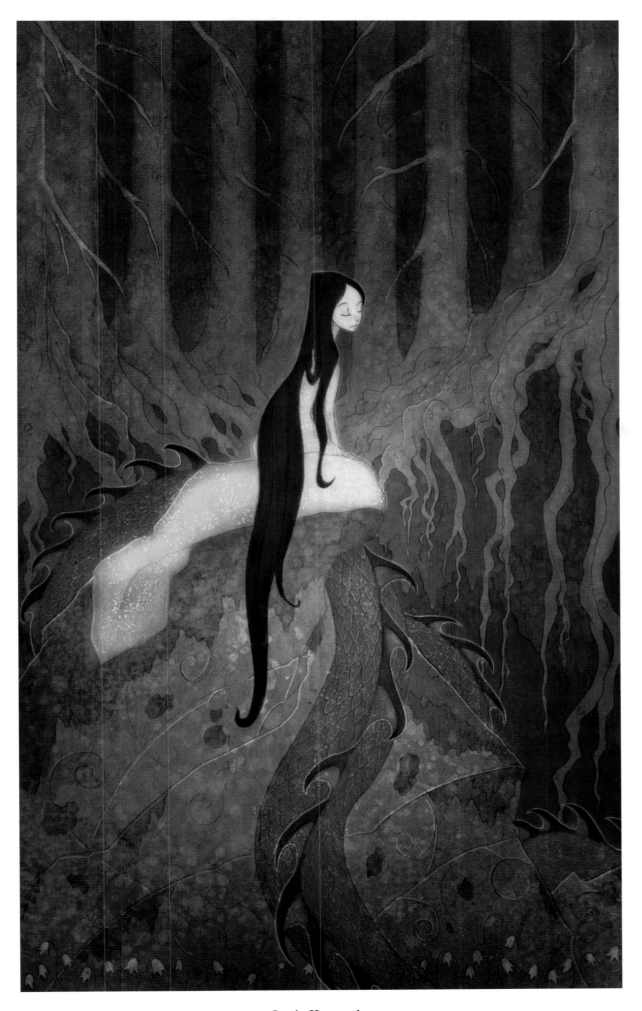

Justin Hernandez

Title: Lady In Waiting *Size:* 7.5"x12.5" *Medium:* Pencil, digital

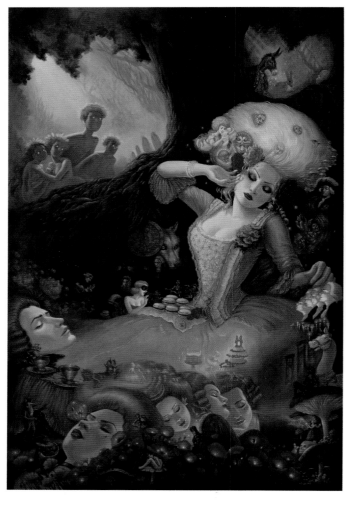

Mia
Title: Sleeping Sickness *Size:* 24"x36" *Medium:* Acrylic on wood

Peter Chan
Client: Iamginism Studios *Title:* From Then to Now *Size:* 8"x12" *Medium:* Digital

John Brosio
Title: Fatherless Bride *Size:* 45"x60" *Medium:* Oil on canvas

Sergio Lopez
Art Director: Modern Eden Gallery *Client:* Rugosa Alba *Size:* 14"x14" *Medium:* Oil on canvas

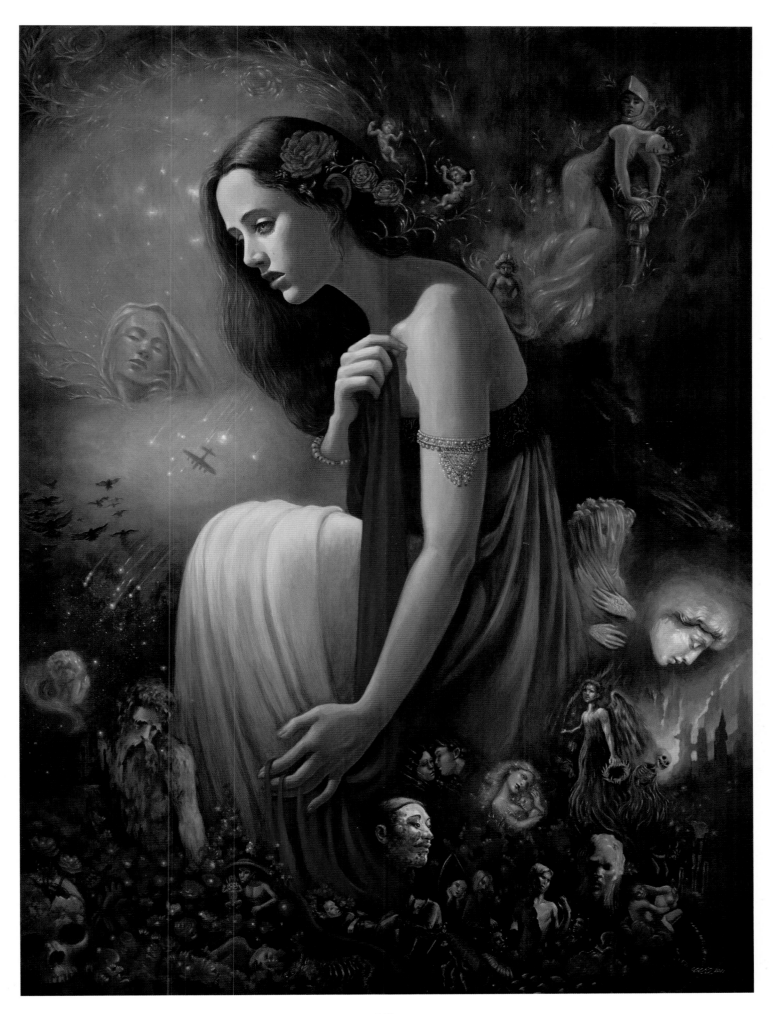

Mia
Client: Roq la Rue Gallery *Title:* Requiem (For the Damaged) *Size:* 22"x30" *Medium:* Acrylic on wood

Tony Weinstock
Title: Helmet Hair *Medium:* Photoshop

Wayne Haag
Title: Sky Burial #2 *Size:* 66"x26" *Medium:* Oil on linen

Viktor Koen

Title: Warphabet *Size:* 10"x10" (per letter) *Medium:* Digital

HYSTEROTICUS

Jerome Podwil

Title: Hysteroticus *Size:* 26"x48" *Medium:* Oil

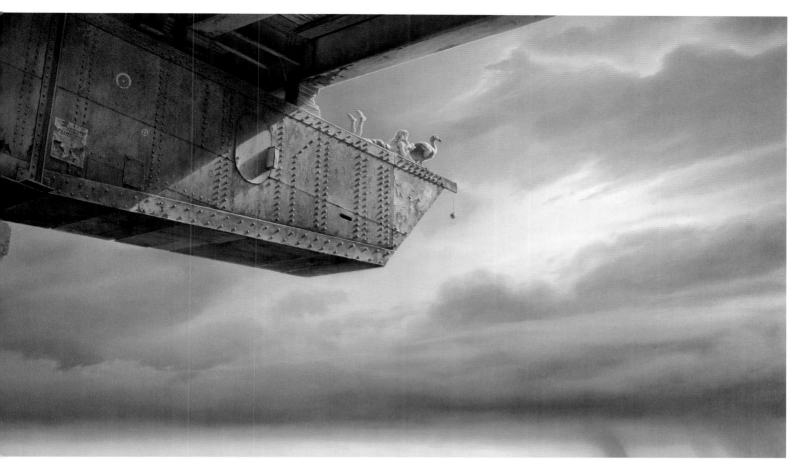

Michael Whelan
Client: Tree's Place Gallery *Title:* World of Light and Shadow *Size:* 36"x24" *Medium:* Acrylic on panel

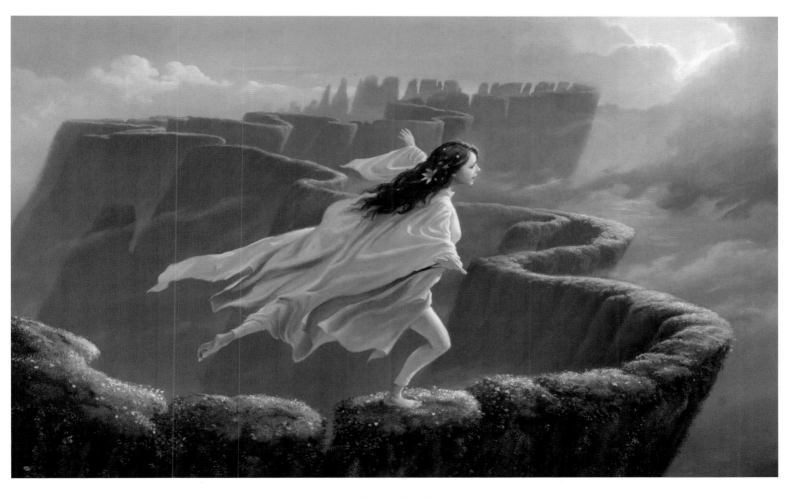

Michael Whelan
Client: Tree's Place Gallery *Title:* Edgerunner *Size:* 28"x18" *Medium:* Oil on panel